AFRICA'S STRUGGLE FOR ITS ART

AFRICA'S STRUGGLE FOR ITS ART

HISTORY OF A POSTCOLONIAL DEFEAT

Bénédicte Savoy

Translated by Susanne Meyer-Abich

PRINCETON UNIVERSITY PRESS

PRINCETON AND OXFORD

First published in German under the title *Afrikas Kampf um seine Kunst Geschichte einer postkolonialen Niederlage* by Bénédicte Savoy. Copyright © Verlag C.H.Beck oHG, München 2021

English translation copyright © 2022 by Princeton University Press

Published by Princeton University Press, 41 William Street, Princeton, New Jersey 08540
In the United Kingdom: Princeton University Press, 99 Banbury Road, Oxford OX2 6JX

press.princeton.edu

Jacket illustration: Trophy head, 18th or 19th century. Ghana. Gold; 20 × 14.5 × 14 cm. Wallace Collection, London, UK. Photo © Wallace Collection, London, UK / Bridgeman Images

Library of Congress Cataloging-in-Publication Data

Names: Savoy, Bénédicte, author.
Title: Africa's struggle for its art : history of a postcolonial defeat / Bénédicte Savoy ; translated by Susanne Meyer-Abich. Other titles: Afrikas Kampf um seine Kunst. English
Description: Princeton : Princeton University Press, 2022. | "First published in German under the title Afrikas Kampf um seine Kunst Geschichte einer postkolonialen Niederlage by Bénédicte Savoy. Copyright © Verlag C.H.Beck oHG, München 2021"—Title page verso. | Includes bibliographical references and index.
Identifiers: LCCN 2021038304 (print) | LCCN 2021038305 (ebook) | ISBN 9780691234731 (hardcover) | ISBN 9780691235912 (ebook)
Subjects: LCSH: Cultural property—Repatriation—Africa—History—20th century. | Cultural property—Protection—Africa—History—20th century. | Art, African. | Museums—Acquisitions—Europe.
Classification: LCC N9073 .S2813 2022 (print) | LCC N9073 (ebook) | DDC 709.60744—dc23
LC record available at https://lccn.loc.gov/2021038304
LC ebook record available at https://lccn.loc.gov/2021038305
British Library Cataloging-in-Publication Data is available

Design and composition by Julie Allred, BW&A Books, Inc.
This book has been composed in Portrait Text and Open Sans
Printed on acid-free paper. ∞
Printed in the United States of America
10 9 8 7 6 5 4 3 2 1

CONTENTS

Plates follow page 86

PREFACE

Almost all of Africa's ancient artistic heritage is now preserved in European countries: in the United Kingdom, France, Germany, the Netherlands, Vienna and Belgium. It is difficult to convey the magnitude of this reality in numbers, to physically experience the space it occupies, to imagine the weight it represents, the forces it took to move these pieces and the time it would take to physically lift them one by one. The British Museum alone has sixty-nine thousand objects in its inventory from African countries south of the Sahara. The Weltmuseum in Vienna has thirty-seven thousand. The Royal Museum for Central Africa in Tervuren, Belgium, has one hundred and eighty thousand. The Nationaal Museum van Wereldculturen in the Netherlands holds sixty-six thousand, the Ethnologisches Museum in Berlin seventy-five thousand, and the Musée du Quai Branly-Jacques Chirac in Paris almost seventy thousand.[1] The major public museums in Paris, Berlin, London, Brussels, Vienna, Amsterdam and Leiden together hold more than half a million African objects.

These figures do not even include European regional, military, university or missionary museums—from Oxford to the Vatican, via Le Havre, Lyon, Stuttgart or Leipzig—which possess several more tens of thousands of objects. Not to mention natural history collections that contain countless botanical, geological and human specimens, prestigious unique specimens taken from Africa: the fossil bones of the largest dinosaur known today, for example, lay for one hundred and fifty million years in the soil of what is now Tanzania before being removed and assembled in Berlin, where they have been on public display since the 1930s. The same applies to libraries: since the beginning of the twentieth century, to study the manuscript heritage of African countries south of the Sahara required trips to the British Library in London, the Bibliothèque nationale de France in Paris or the Vatican Library in Rome.

Nowhere else in the world, neither in the Americas nor in Asia, nor in

Africa especially, have such collections been accumulated. In the United States, the total number of objects from African countries south of the Sahara in the inventories of art and ethnology museums barely reaches fifty thousand pieces in total: about twenty thousand in the Penn Museum in Philadelphia, thirteen thousand in the Department of Anthropology of the Smithsonian Institution in Washington, DC, four thousand in the Brooklyn Museum in New York and only three thousand in the famous African art collection of the Metropolitan Museum in New York. Taken together, American museums hold fewer African objects than the African heritage department of the Musée du Quai Branly-Jacques Chirac alone.

This very particular geographical distribution is inextricably linked to the nineteenth and twentieth centuries occupation of the African continent by European states. It also explains why the first major global debate on restitution of these objects emerged in Europe in the 1970s. And within Europe, it was certainly in the Federal Republic of Germany (FRG), during this period of the Cold War that the public debate was most intense, most rich in content and most enduring, spanning museums, politics, administrations, media and television. While Germany may not have been a major colonial power in terms of the number of its colonies, its historical development from dozens of monarchies, principalities, bishoprics, duchies and city states—to some extent reflected in its federal government structure today—translated into an unusually varied and rich museum landscape, with competing institutions jockeying for position and influence, often led by ambitious professionals and documented extensively in associated archives.

This book is devoted to the European debate on the restitution of Africa's cultural heritage in the aftermath of the independence of former colonised countries. Nigeria and the FRG play a central role. In 1976, the *Christian Science Monitor* called the global debate on restitution a "German debate." But the arguments, speeches and rhetoric of these countries and the political strategies they adopted at the time are precise reflections of those deployed in other countries, for example, in the United Kingdom and France. They were pervasive until very recently, and in some cases even continue to be.

The present book was published in Germany on 18 March 2021. At that moment, and for several years before—despite increasing pressure from the public, scholars and activist organisations, despite the intervention of the Nigerian ambassador to Berlin, Yussuf Tuggar, and despite the historical evidence of archival documents—the management of the Staatliche Museen zu Berlin (Berlin State Museums) still continued to deny any direct involvement in the often violent cultural plunder of African countries, while burying the possibility of restitution under a ubiquitous discourse about the costly and timely exercise of provenance research.

It was also claimed that no African country had ever put forward a restitution request to Germany. It therefore came as a considerable surprise when four days after the German publication of this book, during a press conference on 22 March 2021, the Staatliche Museen zu Berlin administration suggested—in what appeared a well-calculated leak—that Germany was committed to returning the famous Benin bronzes looted by the British army from Benin City, Nigeria, and acquired in large numbers by German museums around 1900. If these restitutions do indeed take place, they will come almost fifty years after Nigeria's first requests in 1972. They are also expected to have a knock-on effect for other institutions and countries.

The present investigation therefore reconstructs half a century of resistance by European collecting institutions in the face of legitimate demands for restitution from African countries. By taking a long, hard and unflinching look at European museums' disavowal and arrogance towards these demands we must now be compelled to enter a new era in this history. It is hoped that this book will contribute to this movement.

In this aim, I would like to express my gratitude to my excellent editor, Michelle Komie, and my wonderful translator, Susanne Meyer-Abich, without whose professional support this English edition could not have been realised.

<div align="right">Berlin, July 2021</div>

AFRICA'S STRUGGLE FOR ITS ART

INTRODUCTION

Forty years ago, a discussion was started in Europe about the restitution of European museums' colonial holdings back to Africa. Yet, the debate fizzled out; talks were forgotten, or rather, successfully repressed. This was perhaps the most important finding that emerged from the work I conducted in 2018 together with the Senegalese economist and writer Felwine Sarr on behalf of the French president Emmanuel Macron.[1] Not only did we gain fundamental insights through our work in Africa itself; we also discovered entire reams of documentation buried in administrative and press archives in Paris and Berlin confirming that a detailed debate about collections from colonial contexts in European museums had already been held before, when we were both still children in school, reaching its apex between 1978 and 1982.

During those four years, politicians, journalists, museum and culture professionals all over Europe, "applied their intelligence"—as the inspector-general of the French national museums Pierre Quoniam put it in 1981—to finding a fair and appropriate position on the restitution issue.[2] The impetus came from African intellectuals, politicians and museum professionals just after 1960— the so-called Year of Africa in which seventeen colonies belonging to Belgium, France and Britain gained independence. Whether in Lagos, Kinshasa, Paris or elsewhere, voices pleaded for restitution. Demands were restricted to a few objects but raising them emphasised the role culture played in the decolonial process of shaping newly formed national identities and advocating against merely a Western understanding of the universalism of art.[3]

From the middle of the 1970s, these voices were echoed widely in international organisations like the United Nations. Restitution was discussed on television and in newspapers. Those in the art trade were irritated; museum staff groaned. For example, Stephan Waetzoldt, the director-general of the Staatliche Museen Berlin, Stiftung Preußischer Kulturbesitz (Berlin State Museums, Prussian Cultural Heritage Foundation), the cultural umbrella organisation for the Berlin state museums, gave an interview to the magazine *Der Spiegel* in 1979 in which he declared that it would be "irresponsible to give in to the nationalism of the developing countries."[4] For his part, David M. Wilson, director of the British Museum in London from 1977 to 1992, put forward the usual legal arguments against the restitution project: "Everything we own we received legally."[5] The dangers of nationalist desires and good old common law were the arguments put up in Europe in order to rebut demands from Africa, to stifle debate and to derail solutions.

Yet, representatives from civil society, the media and politics in Africa and Europe at the time were not discouraged; they persisted. Archival research shows that the mobilisation for or against restitution forty years ago did not take place simply along national or continental divides (Africa vs. Europe) and it cannot be solely explained by institutional reflexes or political templates (museums against politics, Left against Right). Divisions ran differently, for example owing to real or imagined knowledge about Africa, between generations, even between genders—it was often women in Europe who showed solidarity with the claimant African countries. However, ultimately the efforts of civil society failed.

It is hard for historians to write about a period of missed opportunities, about the stifling and repression of history.[6] Text-based sources are often absent as lobbying with an agenda to undermine often takes place outside the coordinates of written frameworks. In the case of restitution, however, a surprising volume of material lurks under the carpet of oblivion. It allows a glimpse of the actors and structures, arguments and pathos formulas that contributed to the failure of an orderly and fair restitution of the "Third World's" cultural property in the 1970s and '80s.

In many ways, the initial restitution debate in Europe and the collective amnesia of its existence resembled the climate debate, which also gained momentum at the end of the 1970s. In 2019, in *Losing Earth*, the US author Nathaniel Rich reconstructed the history of the failure to take steps to tackle climate change in the face of emerging science, describing how climate change came to be flatly denied until today, with well-known consequences. He showed how scientists in the 1980s tried to make their alarming research understood by political and economic decision-makers to encourage them to take measures, and how they tried to win over public opinion with the help of activists and almost

INTRODUCTION

succeeded—almost.[7] Significantly, in historian Frank Bösch's recently published book *Zeitenwende 1979*, he states that our present world began in the year 1979.[8] This is also true for the question of the restitution of non-European cultural goods, as novel as it may seem to us. Theoretically and methodically, this book's reconstruction of the history of restitution is indebted to those studies.

What role did museums play at the time? Or the press, politics and international organisations? Who were the actors in offices, on the telephone and in committees, who made the question of restitution disappear so successfully? What alliances were formed? At what point did the discussion about the colonial past of collections fall silent? Is it even possible to tie historical mechanisms of forgetting, renunciation and silence to people and institutions? One thing is certain, the restitution debate of the 1970s and '80s disappeared from collective memory so completely that Hermann Parzinger, the president of the Stiftung Preußischer Kulturbesitz, was able to declare in an interview in 2017 that "the provenance of ethnological holdings is a relatively new subject."[9]

However, nothing about this subject is new. In the archives of the Stiftung Preußischer Kulturbesitz alone there are thousands of pages from the period between 1972 and 1982 about (unrealised) restitutions documented in correspondence, memoranda, strategy and position papers, press cuttings and statements. The same applies to museums in Paris, London, Stuttgart, Brussels and so on. The archives speak for themselves: the twenty-first-century idea to return cultural goods that were taken *en masse* to fill European museums during colonialism, in the spirit of postcolonial and post-racial solidarity, is anything but radical or groundbreaking. We have been there before. The impact of this subject on many societies today is boomerang-like: it is an exponential return to the historical stage of something that had been repressed and cannot be ignored again. Restitution, decolonisation, social justice and the question of racism go hand in hand.

This book is dedicated to the objects of repression. It begins with one of the first calls for the return of art to Africa in 1965 and ends in 1985 on Museumsinsel (Museum Island), in what was then East Berlin, where the non-aligned state of Nigeria made a guest appearance at the Pergamonmuseum with an exhibition of its archaeological treasures—having lost any hope of restitution after a two-decade fight. For the first time, this book attempts to tell the coherent story of a postcolonial defeat, based on a wealth of material scattered across countless European archives and African publications. However, this was a defeat shared by both sides, because the refusal to restitute cultural objects to African countries during the first decades of their independence was certainly not a credit to Europe.

1965

BINGO

In 1960, or the Year of Africa, seventeen former African colonies gained independence together with membership to the United Nations (UN). On 14 December 1960, the UN General Assembly in New York adopted the Declaration on the Granting of Independence to Colonial Countries and Peoples.[1] With it, the world organisation committed to the right to self-determination for all nations, including, and expressly, with regard to culture: "By virtue of that right they freely determine their political status and freely pursue their economic, social and cultural development," as stated the second paragraph of the declaration. The third paragraph dealt with the tactics colonial powers might use to delay independence, especially with regard to structural preconditions: "Inadequacy of political, economic, social or educational preparedness should never serve as a pretext for delaying independence." The resolution demanded a swift and unconditional end to colonisation and became a key document for African independence movements.

Yet, these movements were not new. For several decades, in the capitals of Anglophone and Francophone Africa as well as in London, Paris and New York, high-profile Black intellectuals, artists and writers—including several women—had focused on the political, economic and cultural future of colonial subjects and territories. In April 1955, at the Bandung Conference in Indonesia, over a thousand representatives assembled from twenty-three Asian countries and six African states giving a decisive impulse to decolonisation. From beyond the established geopolitical blocs and bandwagon mentality of Cold War ideologies, the "Third World" emerged, which was to become a fixed term for the

"non-aligned" countries. In September 1956, the Pan-African magazine *Présence Africaine* organised the First World Congress of Black Writers and Artists, where a number of prominent Black thinkers—including James Baldwin and Richard Wright to Aimé Césaire, Frantz Fanon and Édouard Glissant, as well as Léopold Sédar Senghor and Amadou Hampâté Bâ—discussed the cultural consequences of colonisation and formulated visions for a post-colonial world order.[2] At the centre of the discussions was the idea of a defining a possible united Black culture that transcended national borders and ethnic differences. "One cannot raise the problem of black culture today without raising the problem of colonialism, since all black cultures at present develop in this particular condition, where they are colonial or semicolonial or paracolonial," as Aimé Césaire succinctly described the relationship between colonialism and cultural development.[3]

An article published at the time in the West German magazine *Der Spiegel* exemplified the unpleasant reflexes of paternalism and self-righteousness with which the wider European public reacted to such thoughts. Under the heading "Negro Congress: The First Tooth," the writer of the article commented on the idea of a supposed Black culture using inverted commas: "All participants of the conference were united…in a belief in the existence of a 'black culture.' The existence of such a 'black culture' was so much a fact for the dark-skinned brainworkers and artists from Senegal and Madagascar, Cameroon and Martinique, from the United States and North Africa, that the participants of the conference even diagnosed a 'crisis of black culture.' The delegates were however nearly united in apportioning the blame for an underdeveloped negro culture to centuries of white rule in the settlement areas of the negroes."[4] The article ended without further analysis but with an quote alleged to be from the Paris press: "The first great crisis of black culture is perhaps comparable to the reaction of a child getting its first little tooth."[5]

In 1956, the term "negro" was still commonly used in the media; it was not until the mid 1960s that it gradually started to disappear from the newspapers.[6] But even after decolonisation terms were formed, and a deep chasm—from today's perspective, an inconceivably deep one—remained to be overcome between endeavours of African intellectuals founded on theory and literature, on the one hand, and, on the other, the arrogant demeanour of many protagonists in Europe. This was the background against which the restitution debate played out from 1960 onwards. Like *Der Spiegel*, many members of the wider public still tended to ridicule the belief of an African culture maintained in Africa and African diasporas worldwide. Conversely, the European and American art trade, museums and cultural administrations knew very well that such a culture existed and what its benefits were—not least in material and economic terms.

Fearing the loss of this very African culture—at least, in its material form—the former colonial powers of Belgium, France and the United Kingdom began

to protect their own museum collections immediately after 1960. To shield themselves from restitution demands and to legally safeguard the ownership of collections amassed in museums in Brussels, Paris or London since the nineteenth century they used varying strategies. Historically, the holdings of the Musée national des arts africains et océaniens in Paris were under the stewardship of the Ministry of the Colonies but in 1960, they were transferred with the stroke of a pen to the impenetrable Ministry of Culture and thus confirmed as part of France's inalienable national heritage.[7] In Belgium, the director of the vast Ministry of Culture successfully lobbied for the early restitution claims from the newly independent Congolese government to be *excluded* from the framework of general economic separation discussions between Belgium and the Democratic Republic of the Congo; artworks from the museum in the colonial capital Léopoldville, which had been sent to Brussels as loans for the Expo '58, the 1958 World's Fair, were not returned by Belgium in 1960.[8] Immediately after the Évian Accords had been signed in 1962, and several months prior to the independence of Algeria, the French government had ordered the transfer of three hundred paintings from the Musée National des Beaux-arts d'Alger in Algiers to Paris in a cloak-and-dagger operation that was contrary to contract. They were only returned to Algeria seven years later after lengthy negotiations.[9] Eventually, in 1963, the British parliament issued an amendment to the British Museum Act of 1902: henceforth, the museum was prohibited, almost without exception, of disposing of its holdings.[10]

In January 1965, against this background, a bombshell was launched in museum circles by an editorial published in *Bingo*, a monthly magazine produced in Paris and Dakar, the capitals of France and Senegal, and widely read in Francophone Africa and the African diaspora. With the title "Give Us Back Negro Art" the magazine launched the first widely shared public call from Dakar for the general restitution of cultural assets to Africa (plate 1).[11] The appeal had been preceded by a few articles in the Congolese and Belgian press, but now the magazine took up the issue. The article was authored by the respected poet, journalist and editor of *Bingo*, Paulin Joachim. He was born in what was then the French colony of Dahomey (today's Republic of Benin), grew up in Libreville (the capital of French colony Gabon), had studied in France in Lyon and made a name for himself in 1950s Paris among young African intellectuals intent on giving a voice to the colonised in France and the world—he appears in an official photograph of the Paris Congress of Black Artists and Writers in 1956. After the independence of Senegal from France, Joachim had returned to Africa to comment as a journalist on the first years of decolonisation from his base in Dakar.[12]

Joachim's editorial began with an explicit call to arms: "There is a battle that we must valiantly fight on all fronts in Europe and America, as soon as we

have found a solution for the most urgent problems currently gnawing at us: the battle for the recovery of our artworks which are scattered across the globe."[13] These "material witnesses of the black African soul" had been abducted during the heyday of colonialism from remote villages and temples by "patronizing monsters" and "experts in negro art" for commercial purposes, including priests who "killed the spirituality of the black peoples," Joachim wrote.[14] Assuming for a brief moment the mantle of a European, the virtuoso journalist enacted the very arguments against restitution that would soon become ubiquitous in the restitution debate: "We plundered in order to save the artistic output of the black word from worms and termites, from the smoke of your huts. In reality, the Africans owe us interminable gratitude for the work we achieved. They owe us the survival of their traditional art, which today demonstrates their long denied genius in the eyes of the entire world."[15]

Joachim deconstructed the legitimising rhetoric of the colonial powers, which he denounced as Western lies and excuses: Europe's "dazzling dialectics" he called it, which however "no longer deceived anyone" in Africa.[16] He described how the art that was brought from Africa to Europe around 1900 had worked as "a shot in the arm" for the European avant-garde, inspiring Pablo Picasso, Maurice de Vlaminck, André Derain, Henri Matisse, Amedeo Modigliani and Guillaume Apollinaire. He also lamented the overcrowded museum storage spaces in Rome, Paris and London, where "bronzes and wooden sculptures from Africa were stacked in glorious uselessness, in a frigid universe of galleries without sunlight and colour, where they conduct a high-flying monologue never understood by either collectors or experts."[17]

Yet, Joachim did not pose the question of returning cultural property in terms of a reckoning with the past but rather as an investment into the future: "For a long time we have been described as a people without culture and without a past. We never invented anything, nor could we sing of anything. The legitimate recovery of our fine arts could put an end to this historical lie and give us some of the pride of Greece, mother of the arts, and also plundered like we have been. For the path that lies ahead of us, we need consistency."[18] His appeal in *Bingo* read like a reflection on the end of internalised forms of colonial disregard, extended by questions of cultural ownership. It made the act of restitution appear like a counter to racism and Eurocentrism. With it, Joachim presented the vision of Africa's collective return to the historical stage. In addition, he stated that the recovered material culture should also provide the energy for building an independent democratic future. The recovery of art and the recovery of dignity were inseparable elements in Joachim's postcolonial vision.

What appeared in *Bingo* as a general appeal for restitution, above all directed towards the former colonial powers, must also be seen in the context of West Africa in 1965: as a sideswipe against the politics of the first elected head of state

of independent Senegal, Léopold Sédar Senghor. From the middle of the 1930s onwards, for two decades Senghor had been a pillar of "Black Paris" and was one of the most prominent champions of decolonisation.[19] Because of his great affinity to the French colonial power and his demonstrative policy of accommodation with Paris, he had already come under increasing criticism from the middle of the 1950s, especially from a younger generation of anticolonial minds. As Joachim wrote his editorial, preparations were in full swing in Dakar for an event that Senghor had pursued enthusiastically for many years, the Festival mondial des arts nègres (World Festival of Black Arts), which was to include an extensive exhibition of early African art.[20] To the annoyance of some of the collaborating African partners, preparations for the exhibition took place exclusively in Paris, even though the organisation committee had been composed with equal representation between European and African participants. Furthermore, most of the objects that had been planned to be on view were loans from museums and private collections in France, Switzerland, the United Kingdom and the United States. "It can be argued," Joachim commented, "that it is as insulting as it is paradoxical for us Africans that of all the pieces, all the artworks, which are to be shown at this festival and presented for admiration to the entire world, up to ninety percent are meant to come from Europe and the United States. Is it not time to ask these countries at the end of the festival…to be generous and, instead of packing everything up again, to give to Caesar what is Caesar's, and to liberate the black deities, which have never been able to play their role in the frosty universe of the white world where they are held captive?"[21]

In the small world of Western museums and collectors, Joachim's editorial caused quite a stir. The festival's organisation committee had already anticipated restitution claims from African countries, but now needed to handle the concerns of institutions and collectors who suddenly wanted to withdraw loans that had been agreed in principle. To remedy this situation, the Senegalese organisers were forcefully urged by their French counterparts to put a stop to the issue of restitution and to ensure "that no claims for property rights would be tolerated."[22] As guest of honour at the festival and main African lender, Nigeria also had to accept that many of its objects would travel to Paris after the show in Dakar, even though Western museums hardly ever reciprocated when organising exhibitions in African countries. In the end, the exhibition *Art Nègre* took place after some delays in April 1966 in Dakar and moved on to Paris where it was on view at the Grand Palais from July to August 1966.

Even though the exhibition resonated strongly, the question of restitution that Joachim had raised was not discussed. Many years later a high-ranking official in the French Ministry of Culture remembered that among African diplomats, the exhibition in Paris had caused a "feeling of frustration" and "bitter disappointment," so much so they had even boycotted a similar exhibition

in 1972.[23] Even Nigeria, the guest of honour that was to take a leading role in the global restitution debate during the subsequent decade, remained notably silent in 1966. Lagos did not articulate its claim to its own cultural heritage verbally, but instead diplomatically, with a sophisticated contribution to political iconography.

On the occasion of the Dakar festival, the Nigerian Federal Ministry of Information ordered a large printrun of a special edition of the magazine *Nigeria Today*, which was widely distributed in both English and French.[24] On the cover, there was a dramatically lit black-and-white photograph of an artwork kept at the British Museum since 1910: a mask of the Beninese Queen Mother Idia (plate 2). The delicately carved ivory relief from the sixteenth century is thought to show the queen mother, or Iy'oba, of Oba Esigie, one of the most powerful kings of Benin.[25] The precious object had been kept under royal possession where it was used for ceremonial purposes in Benin City, approximately three hundred kilometres east of Lagos, until the violent plunder of the city by British troops in 1897. It was then moved by the British military to Britain, together with thousands and thousands of other art and ritual objects. Eventually, in 1910, the British ethnologist Charles Gabriel Seligman sold it to the British Museum.[26]

In 1966, the queen mother's mask adorned thousands of copies of the Nigerian pamphlet for the Dakar festival. The photograph of the mask was an artwork itself, taken in 1960 at the British Museum by Werner and Bedřich Forman, the renowned book designer and photographer team from Prague. The image had circulated prior on the dust cover for their 1960 artbook entitled *Benin Art*, which was widely available in the newly independent Nigeria.[27] In Dakar, the mask shared half the cover with a glaring yellow vertical strip with three words in black font: "Our Cultural Heritage." The message was clear, even though the pamphlet, itself an undemanding assemblage of brief texts and bad reproductions, did not breathe a word about British colonial looting or address the whereabouts of the goods. The picture of a work of Nigerian origin located in the British Museum on the cover of a publication dedicated to Nigeria's "own heritage" sent out a strong political signal in the context of the Dakar festival.

Nevertheless, such clear statements, like the pamphlet cover or Joachim's editorial, remained few and far between until the beginning of the 1970s. These efforts were also hardly noticed in Europe, if at all. In a special issue of a magazine issued by UNESCO in 1967 about the art and museums of Africa, the young head of the Nigerian Antiquities Service, Ekpo Eyo, made no mention of the subject of restitution, while only a few years later, his persistent requests for permanent loans of artworks from Benin to Nigeria would raise defences in museum administrations all over Europe (see 1972: Prussian Cultural Property).[28] Though UNESCO did discuss the subject internally in 1968, discussions went nowhere and were not noticed by the public at large.[29]

The absence of written sources, however, does not mean that the subject was absent; it ran like a baseline through individual and collective discussions. This is evidenced by the "Pan-African Cultural Manifesto," which had been formulated in the context of the first Pan-African cultural festival in Algiers, Algeria, and published in various newspapers from Algiers to Abidjan in the Ivory Coast in the summer of 1969. The French director of the Musée National des Beaux-arts d'Alger in Algiers had actually managed to obtain around one hundred loans of African objects for the period of the festival from museums in Belgium, France, Switzerland and the United Kingdom—as well as from eighteen museums in Africa.[30] The manifesto stated: "The preservation of culture prevented the African peoples from becoming peoples without a soul and without a history. Culture protected them. It therefore makes sense that they now desire for culture to assist them in finding a way towards progress and development; since culture, as permanent and continuous creation, not only determines personalities and connects people, but also supports progress. For this reason, Africa takes such care, and attaches such value to the recovery of its cultural heritage, to the defence of its personality, and to the flourishing of new branches of its culture."[31] Some European observers dismissed this appeal as meaningless words: "Art treasures which had been stolen by the colonial powers and put in European museums are supposed to be returned (but after the festival the sculptures dutifully return to their lenders)," as the Africanist Janheinz Jahn wrote in the West German daily newspaper *Frankfurter Allgemeine Zeitung.*[32]

At the end of 1969, the Congolese government tried once again for the second time to persuade Belgium to restitute. From 1967 to 1969, the Royal Museum for Central Africa in Tervuren had sent two hundred masterpieces of Congolese art on tour to North America, specifically, Minneapolis, Baltimore, New York, Dallas, Milwaukee and Montreal. The widely reviewed exhibition, entitled *Art of the Congo*, was the epitome of an event where control over both the narrative and the circulation of African art lay with the former colonial power. Kinshasa demanded the return of the two hundred works. But instead of restitution, Brussels's response was cooperation. The Royal Museum for Central Africa in Tervuren offered assistance in building a national museum in the Democratic Republic of the Congo, which was to function as a prerequisite for possible "(permanent) loans without an official transfer of ownership."[33] In this context it is not surprising that the first director of the Democratic Republic of the Congo's institution—which was founded in the Congolese capital Kinshasa in 1971—was the mining engineer and geologist Lucien Cahen, who had also led the Royal Museum for Central Africa in Tervuren since 1958 and had always refused to enter into bilateral discussions about restitution with Congo. Postcolonial ambitions and museological paternalism went hand in hand, and restitutions or permanent loans failed to materialise for the time being.

1971

YOU HIDE ME

On 20 January 1971, *You Hide Me*, a short film by the Ghanaian film director Nii Kwate Owoo, premiered at London's Africa Centre, attracting interest far beyond London.[1] The Africa Centre hosted cultural events and was at the heart of the Pan-African scene in London (see 1981: Lost Heritage). Film and literature played a central role in the restitution debate of the 1970s, opening a space for political imagination. As early as 1953, the Paris-based magazine and publishers *Présence Africaine* had commissioned the anticolonial film essay *Les statues meurent aussi* (Statues Also Die), in which the French directors Chris Marker, Alain Resnais and Ghislain Cloquet used African artworks in European museums and colonial grievances in Africa as brackets for a pointed attack on colonialism. The much-referenced film had not received accreditation from the French National Film Commission in 1953 because of its "biased and subversive character" and was only allowed to be screened in France eleven years later, from 1965, in a slightly modified version.[2]

In the middle of the 1960s, more and more intellectuals on the African continent took up the camera themselves in a conscious stance against the European monopoly on African representation. They brought their own films to the screen while great Pan-African film festivals were established and some governments like those in Ghana and above all Nigeria invested in the development of a commercial film industry. Whether they came from Anglophone or Francophone regions, represented an intellectual or entertainment-driven cinema, the first protagonists of African postcolonial film received their training almost without exception abroad, studying at the film academies of London

and Paris and, less commonly, Moscow. As a result, many African filmmakers' reappropriation of African cinematic representation began in the heart of former colonial metropolises. The "simultaneity of what was one's own traditional Africa on the one hand, and what was foreign, modern, European on the other" became a recurring subject in many African films of the 1960s and 1970s.[3]

It is therefore not surprising that these nascent African film directors chose as their subject the museums of colonial capitals: public temples to foreign cultures. It was in these spaces, especially in front of African objects, where they experienced the possibilities and boundaries of an aesthetic, spiritual or even political reappropriation of their own culture and past. For many Africans, a visit to the British Museum provided their first ever contact with historical objects from Africa. *You Hide Me* was made this way, from a visit to the storage rooms of this London institution in 1970. Nine years later, the same museum was at the centre of *The Mask* (1979) by the Nigerian director Eddie Ugbomah (see 1979: A Spectre Is Haunting Europe). Both films passionately focused on the return or taking back of African cultural property, one in the form of a documentary, the other as an action film. Writers like Niyi Osundare also repeatedly expressed in poetry what they felt when confronted with African works in European museums (see 1977: Festac '77).

The forty-minute, black-and-white film *You Hide Me* was twenty-six-year-old Owoo's graduation project for the London Film School, where he had studied for two years, adopting the name James Nee-Owoo.[4] In the first part of the film, three active representatives of the London Pan-African art scene at the time spoke about art: Ibrahim el Salahi from Sudan, Uzo Egonu from Nigeria and Dumile Feni exiled from South Africa; in addition, the Nigerian sculptor Emmanuel Jegede is shown at work in his London studio.[5] It is not until the second half of the film that allusions made by the title, *You Hide Me*, become clear: the camera accompanies a young Black man and woman (Owoo and Margaret Prah) through the basement vaults of the British Museum where they unwrap African objects hidden away in boxes and plastic bags, among them wooden statuettes, jewellery, a sword, a stool and various masks.

"The film was shot in a day," Owoo recalled.[6] "We started work at 9 o'clock in the morning and wrapped at about 5 in the evening. Those were the conditions under which we were allowed to shoot. We came across an enormous collection…thousands of important works of art that had never been exhibited. Deep underground, in the basement. We spent a lot of time examining the artefacts we came across. Half of the time was spent filming, and half just satisfying our curiosity."[7]After about ten minutes of filming, the protagonists leave the museum basement. The camera follows the young man into the high-ceilinged exhibition hall, where he opens enormous glass showcases full of well-ordered

African works. The centre of the room is dominated by the magnificently arranged royal objects from the Asante Empire in Ghana, which were soon to be the focus of the first public debate about restitution in the United Kingdom (see 1974: Increasingly Global). The camera also glides along delicately carved heads from the kingdom of Benin in Nigeria.

The whole film is accompanied by a voiceover featuring a male voice speaking African-accented English. The commentator describes the violent provenance of the objects using terms such as "loot" and "sack" (in relation to Benin City, for example). He speaks of their invisible "captivity in boxes and plastic bags" and condemns the systematic, "tactically" intended destruction of cultural, religious and artistic traditions in Africa by colonial administrations. He speaks of the hierarchisation of cultures by ethnological museums while underlining the ideological instrumentalisation of African collections in Europe and the United States: "The material they collected in Africa was used as propaganda material against Africa and people of African descent."[8]

As the protagonist moves into the exhibition halls, the commentary moves from the colonial to the postcolonial period, describing the "suspicious" rehabilitation of African art by the former colonial powers as another asymmetrical relationship. The voiceover deplores the fact that Europeans and Americans "present themselves as the experts on the subject and decide which are the masterpieces of African art."[9] The film ends with an urgent appeal: "How can the government of independent African states explain to the generation that is now growing up that they can't see their cultural heritage in their own countries?"[10] "We, the people of Africa and of African descent, demand that our works of art, which embody our history, our civilisation, our religion and culture, should immediately and unconditionally be returned to us."[11]

You Hide Me is a pointed political attack against the uselessness of keeping African cultural goods in the depots of museums, in Britain or elsewhere. Unseen in the West and inaccessible for Africans—the objects shown in the film appear as an enormous capital hoarded in the basement of the museum, both buried in the collective unconsciousness of African and European societies. Owoo lamented the lack of information about the colonial provenance of the works and the rhetoric of assistance instead of restitution: "They don't say how these objects were acquired.…They offer aid, but refuse to return our works of art. Books cannot replace materials kept outside Africa."[12]

The young Ghanaian film graduate won applause far beyond London for his statements and his work. Owoo recalled that he had invited to the premiere "professors of African history from the School of Oriental and African Studies, and from Oxford and Cambridge. It was very successful. The room was packed. The curator of the British Museum sent his representatives. I was sitting at the

back of the hall. In the middle of the film, the analysis and the passionate form of the presentation began to arouse sentiments. People were responding, gasping in the middle of the movie. The curator's representatives got up, started tiptoeing round to where their coats were, and they very quietly sidled out of the room. When the lights came back on, there was an amazing discussion which lasted for about three hours. Some people describe *You Hide Me* as an agitprop film."[13] After a second screening in March 1971, the widely circulated London-based magazine *West Africa* wrote that the film was a "frontal attack" on the legitimising rhetoric of Western institutions, which "had first of all despoiled" African culture by "the lootings of a conquering army," and then, "gradually… presented [it] as something that the West had somehow discovered, and not nearly destroyed."[14]

You Hide Me continued to attract attention for years; it was much reviewed in English- and French-language periodicals, circulated at Pan-African events and was mentioned in any early compendium on the history of African cinema.[15] "This film is a must for those interested in art or Africa. What it lacks in technical polish it makes up for by its uncomplicated, sincere approach," Jeff Francis wrote in 1972.[16] Some critics unexpectedly encountered it in the following years in remote places such as Dinard in Brittany or Tashkent in Uzbekistan.[17] The film set standards. Future attempts to address the subject of restitution, like *The Mask* (1979), were always measured by critics against *You Hide Me*. Ten years after *You Hide Me* was finished, the BBC purchased the rights to show the film's final scene in a sequence for its own TV production on restitution, allowing the film to reach millions of potential viewers.[18]

It is surely no coincidence that the demands raised by a young Ghanaian director, using the medium of film in London in 1971, simultaneously concerned those of a museum official in Nigeria, thousands of kilometres away. In Lagos, the head of the Nigerian Antiquities Service, the archaeologist Ekpo Eyo, worked on a plan in 1971 to convince Western museums to give permanent loans to the young and newly independent state. The well-connected Eyo had been born in 1935 in Calabar (southern Nigeria) and had been one of the first African students of archaeology and anthropology at universities in Cambridge and London at the end of the 1950s before he decided to return to the newly independent Nigeria. There, he obtained a doctorate in archaeology at the University of Ibadan and was appointed head of the Federal Department of Antiquities in Lagos in 1968.[19]

His plan culminated in September 1971, in the resolution made by the International Council of Museums (ICOM), which had gathered in Grenoble in France—Eyo was one of its four vice presidents at the time. The resolution stated "that all large museums holding important collections of foreign origin

in their reserves, help, by all the means in their power (gifts, loans, deposits, exchanges, research scholarships, training of personnel, etc.), the countries of origin of these collections, so as to allow them to establish and develop modern museums which are truly representative of their specific cultures."[20] With this resolution, for the first time, African restitution efforts were adopted into the language of international associations and authorities and discussed in European specialist circles. At this point, the issue of restitution began to transcend the Pan-African, journalistic and artistic space in which it had previously operated.

1972

PRUSSIAN CULTURAL PROPERTY

"Dear Mr President! I would like to return to our conversation yesterday at the guesthouse of the Senate on Nigeria's efforts to obtain a loan for German-owned bronzes from Berlin....Our embassy in Lagos supports the Nigerian request for political reasons, as they are convinced that Nigeria is surely unlikely to let the matter rest, considering its ever increasing awareness of its own tradition and culture, and that this might possibly develop into an unpleasant point of contention for us. Thanks to your kind intervention, I will host a small reception on 13 June at 5pm at the Völkerkundemuseum....I would be delighted to welcome you and your wife at this small reception where there will also be an opportunity for a representative from our embassy in Lagos to present our arguments to you in person. Yours Sincerely, Dr D. Stoecker."[1]

On 25 May 1972, during the middle of the Cold War, the West German Foreign Office presented this gracious invitation to the president of the Stiftung Preußischer Kulturbesitz in West Berlin, marking the beginning of the "German" (see 1976: "German Debate"), and European, history of the debate about the restitution of African cultural goods. The invitation had been prompted by an official enquiry from Ekpo Eyo, who was the first representative of an African government to take up the global fight for restitution after the first decade of Nigerian independence from the United Kingdom. His efforts were directed at the United Kingdom, with countries that had purchased significant collections of Benin bronzes on the British art market around 1900, like Germany and Austria, on the periphery. At this early stage, the Nigerian agenda was much less focused on a desire for a postcolonial debate with the United Kingdom, but

rather on a widely discussed cultural requirement to create a collection that was representative of its own country. In this aim, Eyo's statements and petitions, always reflected his position as an archaeologist and museum professional.[2]

Nigeria's loan request to Germany in 1972 was made in an ever-changing geopolitical framework. Germany was negotiating both postcolonial foreign policy in Africa and the issue of world cultural heritage in Berlin as a divided nation: since 1949 Germany had been split into the German Democratic Republic (GDR) or East Germany and the Federal Republic of Germany (FRG) or West Germany. With regard to foreign policy, the GDR (led by Walter Ulbricht from 1960) and the FRG (led by Willy Brandt from 1969) were on the brink of overcoming the Hallstein Doctrine formulated from 1955 to 1970. The doctrine postulated that the recognition of the GDR by newly independent African states constituted an "unfriendly act" towards the Federal Republic under international law, which was the reason why this acknowledgment had almost never happened since the GDR's inception. The GDR did not maintain diplomatic relations with Nigeria (this only changed after 1973). This probably explains why the FRG alone was confronted with the first Nigerian loan request, even though there were rich Benin holdings in the GDR, which the Socialist state liked to boast about. In 1971, of all years, the GDR issued a postage stamp depicting against an orange background the "memorial head in the Udo style": a roughly drawn bronze head with plaited hairstyle from the southern Nigerian kingdom of Benin from the Völkerkundemuseum in Leipzig, framed by the words "Deutsche Demokratische Republik. Völkerkundemuseum Leipzig. Bronzekopf Afrika" (German Democratic Republic. Anthropology Museum Leipzig. African Bronze Head) (plate 5).[3] Many years later, the FRG would also issue a stamp, in this case with the bust of Nefertiti, which was exhibited in the Ägyptisches Museum und Papyrussammlung (Egyptian Museum) in West Berlin.[4] Image politics, stamp-size, were another way of taking a position on who represented world cultural heritage in a divided Germany.

After the division of Berlin in 1949 into East and West Berlin, the historical core of the German Prussian collections had remained on Museumsinsel in East Berlin. In response, West Berlin created the Stiftung Preußischer Kulturbesitz (Foundation for Prussian Cultural Heritage) in 1957 with the purpose of preserving and maintaining cultural property from the former state of Prussia. Since its foundation, power struggles and mutual distrust had been frequent.[5] When the Nigerian loan request arrived in West Berlin, the Stiftung Preußischer Kulturbesitz had just inaugurated its new rooms in the Ethnologisches Museum Berlin (Ethnology Museum) in the West Berlin suburb of Dahlem, which had been conceived in 1963 as a modern counterpart to Museumsinsel.[6]

The administrative archives of the Stiftung Preußischer Kulturbesitz contain a slim file with the heading "Loan Requests to Our Museums: Case: Benin

bronzes from Nigeria," dating from 1972 to 1975.[7] It includes the president of the Stiftung Preußischer Kulturbesitz's formal correspondence with various ministries, draft letters, instructions, memoranda and excerpts from minutes regarding the handling of Nigeria's permanent loan request. This archival material not only invites a contextualisation of today's restitution debate in Europe and Germany within the *longue durée* of laborious historical processes, but also gives an unfiltered insight into the political, personal, administrative and ideological constellations of the early 1970s in the FRG, when the West Berlin enclave of the Stiftung Preußischer Kulturbesitz first succeeded in stifling a debate on the possible restitution of cultural property from former colonised countries. These documents are also noteworthy because they show the historical rationale on which the institution continues to build and are therefore worth considering further.

The file opens with Heinz Dietrich Stoecker's aforementioned invitation for an informal conversation. Stoecker, born in 1915, was the head of the West Berlin department of the Bonn-based foreign office.[8] His name later became briefly known to the public during the siege of the West German embassy in Stockholm in spring 1975, when during his tenure as ambassador a group from the Red Army Faction attacked the embassy and shot dead two of his staff. When Stoecker dealt with Nigeria's permanent loan request in 1972, the young African state was on the cusp of a more stable situation following a decade of unrest and violent outbreaks after indepddence, including the Biafra War, the brutal civil conflict from 1967 to 1970. Under the motto "Reconciliation, Reconstruction and Rehabilitation," the government of General Yakubu Gowon pursued a policy that actively encouraged a decentralised process, producing visible results across infrastructure and social programmes funded through growing oil revenues. In the hope that tribalist particularism would dissolve in the long term in favour of cultural homogeneity and national integration, the cultural politics of the postwar years were generous by nature.

Museums in particular promised to provide internal social cohesion to Nigeria with its great ethnic, religious and linguistic diversity, whose vast territory was a legacy of the arbitrary demarcation of British borders. Externally, museums seemed an appropriate means of demonstrating the will and ability to participate in universal human values. "[W]ith more political and economic stability, the government and people are increasingly aware that culture is the essence of civilization," as the Nigerian painter and cultural politician Timothy Adebayo Fasuyi wrote in an official booklet on Nigerian cultural politics published in 1972, "and the federal and state governments are getting more and more involved not only in promotion but also in cultural education and in preserving the national heritage."[9] He described among other things how the existing Nigerian museums contributed to knowledge of the past and thus "bring…

honour and respect to the African race."[10] In 1972, the first African museums' conference took place in Livingstone in Zambia, where museum professionals from Tanzania, Botswana and Uganda exchanged views on the decolonisation of museums and the postcolonial resocialisation or reintegration of objects back into society after their colonial museumification.[11]

Ekpo Eyo's loan request campaign should be read against this background. In spring 1972, the archaeologist sent a circular via the Nigerian Foreign Office to the embassies of several European countries. In it, he referred to the ICOM resolution of 1971 (see 1971: You Hide Me) and expressed a desire to receive some artworks of Nigerian origin from these countries as permanent loans to enhance the emerging Nigerian museum landscape. The letter had blanks where the country and the embassy to which it would be directed could be filled in by hand. One copy is still preserved today in the archives of the Museum für Völkerkunde (Museum of Ethnology) in Vienna, where it had been forwarded by the Austrian embassy in Lagos.[12]

The Viennese Ministry of Economics and Research responded that the pieces in the Museum für Völkerkunde of Nigerian origin had been acquired entirely legally, that a handover was therefore out of the question and that even fixed-term loans were impossible for conservation reasons. Under certain conditions, it might be possible to consider an exchange of individual objects against ethnographic artefacts of comparable value, but the museum holdings were hardly suitable for this. It would be better if Nigerian scholars or students came to Vienna to do research directly in the museum; related costs, however, would need to be borne by international scholarships.[13] After this statement, no further negotiations appear to have followed.

The West German embassy, for its part, informed the Foreign Office in Bonn that Eyo had asked them for direct assistance in Lagos in addition to his letter requesting "to receive a few pieces as 'permanent loans,'" since he was of the opinion that "Nigeria had a moral claim to these pieces."[14] The embassy in Lagos gave express support to the request of the young state and asked the Stiftung Preußischer Kulturbesitz—which held the second largest collection of Nigerian objects worldwide, mostly acquired from the British art trade around 1900—to give favourable consideration to the project.

Stoecker's invitation to talk was answered by a letter from the president of the Stiftung Preußischer Kulturbesitz, Hans-Georg Wormit, which declared that he was unfortunately unable to attend the planned reception himself, but he promised to look into the matter.[15] Wormit had been born in what was then East Prussia in 1912 and was a typical representative of the generation of German men who had begun their administrative careers in the National Socialist state and continued seamlessly into the German Federal Republic. The high level of personal continuity between the politics of National Socialism and the

emerging FRG has recently been repeatedly highlighted in several studies.[16] In 1938, Wormit had joined the National Socialist party,[17] and had continued his career after 1945 at the regional civil service in Schleswig-Holstein and later in several of its ministries until he was appointed first president (initially titled curator) of the Stiftung Preußischer Kulturbesitz, which had been created only a few years before.[18]

Wormit promptly informed his subordinate, the director-general of the Staatliche Museen zu Berlin—the art historian Stephan Waetzoldt, who had held the directorate since 1965—about the Nigerian initiative and the request from the Foreign Office (plate 6).[19] In addition, he noted that not only the Foreign Office, but also a Conservative politician who was influential at the time, the Christian Democratic Union (CDU) parliamentarian Franz Amrehn, had contacted him on the Nigerian matter "by telephone." The politician, according to Wormit, had "recently been on a trip through Africa and [had been] influenced by our representatives in Nigeria in the same vein."[20] Franz Amrehn's archival records show that he did indeed travel to six African countries in 1972, among them Nigeria, as well as the former German colonies of Cameroon and Togo.[21] At the beginning of the 1970s, Africa became an increasingly attractive field for politicians, too. "What does Bonn want in Africa?" the Cameroonian historian Kum'a Ndumbe asked retrospectively in one of the first studies on German politics in Africa from an African perspective.[22]

At the end of May 1972, the Stiftung Preußischer Kulturbesitz was under considerable political pressure from Nigeria. While it did not at first provide a response to the enquiries from the Foreign Office and Franz Amrehn, the surviving documentation shows that after just a few days a negative decision had been made: no loans. The minutes from the meeting held on the 2 June 1972 noted that even though "the matter was not yet official," one would "hardly be able to meet such a demand, as a matter of principle."[23] The reason for this instinctive refusal failed to materialise for the time being. Three months would pass before the Stiftung Preußischer Kulturbesitz could also deliver substantive arguments.

During this period, the Foreign Office—this time from Bonn—and the federal parliamentarian Franz Amrehn renewed their requests to the museums with visible impatience. "Since the Nigerian wish becomes more sensitive politically over time," the Foreign Office practically implored the Berlin museums to finally prepare a draft "for consideration and decision by the board of trustees."[24] The ministry pointed to the important role of culture in the process of decolonisation and set out a vision of a relationship based on positive emotions between the Federal Republic and the emerging African state, even the African continent in general. "There is no doubt that a positive gesture from us at this point would meet with great approval from many Africans in this phase of their cultural self-determination," Bonn argued.[25] The CDU politician Amrehn also

stayed on the case. Once again he picked up the telephone; a member of staff at the foundation took the minutes for the conversation: "This young nation should also receive small gestures of support in cultural matters," Amrehn stated. It was unimaginable "that such measures would lead to greater consequences"; in any case "Nigeria's wishes were modest," and one should "also consider that one might perhaps also want to gain something from Nigeria or another developing country"—at this point the minute taker noted: "Mr Amrehn is probably thinking of excavations or something similar."[26] Initially, the president's office at the Stiftung Preußischer Kulturbesitz did not react to this follow-up either.

But its silence was not an indication of institutional inertia. On the contrary: the administration swiftly did all it could to get out of the firing line, to present the Nigerian request as a federal matter, and to suggest the inevitability of involving the Assembly of Ministers of Education of the German states (Kultusministerkonferenz (KSK))—a famously inflexible body in charge of cultural matters. This was firstly meant to gain time. Yet there was hardly another museum in Germany that owned a Benin collection as large as that in Berlin. "We have long known," as Stephan Waetzoldt wrote, "that the return of museum objects to their countries of origin is being discussed by ICOM and UNESCO—including those acquired before World War I. The pressure from the developing countries in this matter is extremely strong. Based on our experiences, it can surely be expected that further developing countries make claims and that other German museums must be affected."[27]

Through a tactical exaggeration of the Nigerian loan request, the foundation could move into a position where it could present a fundamentally simple task—loan requests, even permanent loan requests, have been a core activity of museums for decades—as almost unsurmountable: "The wish of the Nigerian authorities is understandable from their point of view," as Wormit stated in his response on 14 July 1972 to the second query from the Foreign Office, which had reached him four weeks earlier. "However, it generates extremely far-reaching problems not only for us (and not just the Prussian cultural holdings but the entire German museum community). I would therefore ask you to appreciate that a decision cannot be taken that quickly."[28]

First the Assembly of Education Ministers would need to be summoned. On 7 August 1972, Wormit formulated a detailed, carefully prepared letter in order to convince the responsible Ministry of the Interior of this step.[29] He addressed the letter to Carl Gussone, who had been the head of subdivision SK II (Matters of Cultural Conservation) in the Ministry of the Interior since 1970 and was directly responsible for the concerns of the Stiftung Preußischer Kulturbesitz.

Gussone, who was born in 1907, was just approaching retirement as Wormit's letter reached him. Like Wormit, he was a lawyer and a former member

of the National Socialist Party as well as a member of the SS from 1933 and of seven further National Socialist organisations. His professional career, which was geared towards anti-Semitic traditions of thought, has recently been the subject of extensive research: "Quite obviously, Gussone's National Socialist past characterised his administrative practice after 1949," the historian Stefanie Palm pointedly observed with regard to Gussone's postwar career.[30] From 1951 he led several different departments in the Ministry of the Interior and in this context, he had been directly involved in the founding of the Stiftung Preußischer Kulturbesitz in 1957. Bearing in mind recent studies of institutional history, from today's perspective it is striking that the two architects of this institution—Gussone and Ernst Féaux de la Croix, the minister from the Federal Finance Ministry—as well as its first president Wormit had all been fervent supporters of National Socialism, whose influence was undiminished in the political world of the FRG at the beginning of the 1970s.[31] Whether the initial position of the Stiftung Preußischer Kulturbesitz concerning the Nigerian request was also related to the racist thinking of the National Socialist period is a legitimate question. In the first draft of his letter to Gussone, Wormit argued as follows:

> As I already mentioned in the meeting of the Foundation board on 2 June 1972, the Foreign Office informed me about the efforts of the Nigerian government to recover artworks which left Nigeria at the end of the last century and are today legally owned by the Stiftung Preußischer Kulturbesitz.
>
> In particular, these are bronzes and ivory carvings from the kingdom of Benin dating from the 15th to the 17th centuries, which entered the art trade after the conquest of Benin in 1897. Out of an original total of circa 2,400 objects, approximately 600 that had been acquired in the United Kingdom at the beginning of the century were owned by the Prussian museums until 1945. Currently, the Stiftung Preußischer Kulturbesitz still owns more than 181 artworks, mostly bronzes. The bulk of the historic stock—the less important parts—is presumed lost.[32]
>
> In recent times, more and more people from the developing countries, but also in international cultural organisations, argue in favour of handing over part of such artworks to the countries of origin. The background for this development is most likely the desire of many developing countries to also achieve national self-representation in the field of their own cultural past.
>
> The resulting problems not only concern the Stiftung Preußischer Kulturbesitz but also all major museums in the Federal Republic. Of these, ethnological departments are likely to be particularly affected.
>
> I therefore consider it indispensable that uniform opinions are reached

with regard to this wide-ranging issue, and I would welcome it if the Committee on Art and Adult Education of the Joint Assembly of Ministers of Education were prepared to provide a fundamental statement.

At the same time, I must say that I consider the argument based on foreign policy considerations with view to the developing countries as dangerous and facile:

If it became customary to give presents from valuable collections in our museums as support to museums of emerging nations for building their own collections, such a practice could not be restricted to individual cases. The endangerment of important collections, which have been laboriously gathered over long periods of time, would be the inevitable consequence. Especially ethnological collections are, however, suited to deepen intercultural understanding. From this perspective it cannot be said that artworks should if possible be kept and exhibited in their countries of origin. Nevertheless I do not deny that the wish of the emerging national states for representative self-expression is to some extent understandable.

Any yielding to the, initially "moral," demands of the developing countries would however in my opinion also weaken the legal position of all those museums that possess and legitimately own artworks from other countries of origin.

An inspection of the entire field would therefore also need to include the repercussions on international law and its norms regarding the territorial relationships of artworks.

I would be grateful if you could let me know if you intend to contact the Assembly of Ministers of Education, or if you will ask the Berlin Senator for Science and Art to take this step. Prof. Dr. Stein will receive a copy of this letter.

<div style="text-align:right">

Yours sincerely
Wormit[33]

</div>

Wormit's highly instructive letter is most likely the first ever written response from a German museum official to a modest loan request from a newly independent African state. While the authorities in Lagos, the Foreign Office, and the West Berlin politician Amrehn had repeatedly emphasised in their respective letters to the foundation that Nigeria sought a permanent loan of "some few pieces" (Lagos), "some Benin bronzes" (Foreign Office) and "some few objects from the Benin collection" (Amrehn), Wormit left the quantitative dimension of the Nigerian request nebulous from the outset. In the unspecific plural, he refered to "artworks," which Nigeria wanted to "recover." The choice of the word "recover" instead of "permanent loan," the legally defined term used in requests, as well as the use of terminology denoting danger and jeopardy

scattered throughout the letter, all contributed to make the request from the Nigerian republic appear like a dark threat.

Wormit, however, described what exactly was threatened in West Berlin with legal accuracy. In order to avoid doubt about the legality of the Berlin holdings, he mentioned the acquisition of the cultural goods on the London art market at the turn of the century. At the same time he concealed the historical background about how the goods were obtained—by an attack by the British military in 1897 culminating in the theft of the religious and cultural goods from Benin City. Concurrently, his use of euphemistic or adulatory expressions helped to mask historical facts, like the statement that the works had "left" Nigeria in the nineteenth century, or that the brutal British colonial war had been a "conquest." Even though Wormit touched on the moral dimension of the request in a drafted paragraph, he denied it three times: by putting "moral" in inverted commas, thus marking morality as a rhetorical construct, by suggesting toughness towards the "Third World" and, finally, by striking out the entire paragraph. In this way, the final version of the letter reduced the perspective of the dispossessed to their supposed desire for self-representation—a category well-known to Wormit, whose patriotism was mentioned as one of his defining "characteristics" in the obituaries following his death in the early 1990s.[34] "Hans-Georg Wormit was," according to the eulogy of his successor Werner Kopp, "very consciously, and yet quite naturally, German."[35]

It is hard to say whether Wormit also chose to strike from his draft letter the paragraph that frequently invoked the function of ethnological museums as a place of intercultural understanding because he was at a loss for arguments against Nigeria's loan request. He replaced this with a new paragraph emphasising the traumatic losses of the Berlin museums during the Second World War.[36] In any case it is noticeable that he stylised the museums as victims of the Second World War and the immediate postwar turmoil in order to communicate to the Ministry of the Interior official Carl Gussone that even twenty-seven years after the war, loans of individual works to newly independent states were indefensible. This *non sequitur* permitted offsetting the suffering of others against one's own suffering (and self-pity).

A few days later, Wormit drafted a second letter where he laid out his position regarding Nigeria's request, this time addressed to Franz Amrehn. This letter operated with a certain candour and contained new arguments formulated with Berlin in mind, thus demonstrating that the reasons used to justify the foundation's defensiveness varied depending on the addressee. It also showed that issues of national and local prestige were inseparably linked with the politics of world cultural heritage in Berlin (as they still are today). For this reason, the letter deserves to be quoted in detail:

Dear Member of the Bundestag, Mr Amrehn,

At the beginning of June this year we spoke on the telephone about the Nigerian government's wish for some of our Benin bronzes, and I assured you that we would conduct a thorough review. It has begun, but will still take some time since, owing to the fundamental importance not only for the board of our foundation but also for the Assembly of Education Ministers, who will need to be involved.

All of the world's great museums are ranked primarily on the quality and variety of their collection holdings. The extent to which they reflect the culture of periods and nations determines their reputation and their standard. All of them only contain a small part of the collections from their own country. The collections of the Stiftung Preußischer Kulturbesitz in Berlin have suffered like no other comparable collection: from Hitler's campaign against "Degenerate Art" in the 1930s, from the Second World War and the chaos after the end of the fighting, as well as from the split of museum holdings between East and West Germany. In addition, because of the extremely high cost of new buildings in Berlin, which will continue for many years, new acquisitions can only be made to a very modest extent. Every reduction of their substance would therefore be felt most acutely. It is not relevant whether this affects only a few pieces. As far as I could ascertain, no large German museum has given a donation or permanent loan from its holdings to a foreign government since the end of the war. Were we to do so, such a gesture would never remain hidden from the public view and would surely prompt a flood of further claims, owing to the large number of other interested parties. On what grounds could these be denied? How could one apply different standards?

The Benin holdings of our Völkerkundemuseum have shrunk from nearly 600 pieces at the end of the war to 181 pieces. The remainder must be considered irretrievably lost. If one argues that Nigeria has a moral claim against us, and that the British Museum returned part of its bronzes—which I have not been able to ascertain to date—it is important to remember that the Berlin holdings were purchased legally at the time. Our situation is in no way comparable to the British one. British troops conquered the kingdom of Benin in 1897 to 1899 and carried away its famous bronze works and ivory carvings; the Berlin acquisitions are untarnished.

Please accept from all this that the matter is not simply a small favourable gesture. To the best of our ability, I have always regarded and still regard our main task as conserving our holdings, regaining losses, and raising Berlin to a cultural site of the highest rank, where excellent museum collections form a harmonious whole, with an exemplary presentation based on today's museum standards. Recurring wishes for donations and permanent loans,

which we continue to receive from a variety of parties, make our work so much harder and are disappointingly disproportionate to the support often given to Stiftung Preußischer Kulturbesitz for new acquisition plans. They also misjudge the extent of our losses in the recent past, which can reach 90 percent for some collections, and they overlook the difficult position regarding East Berlin, whose highly important holdings are backed by the purposeful cultural political activity of the GDR for its capital. I would also ask you to bear in mind the fundamental consequences that could be triggered if—certainly plausible, in some cases quite likely—holdings were given away, which used to be unthinkable in Berlin. Nobody can foresee political developments, and situations may be envisaged where forces are unleashed against which the Stiftung Preußischer Kulturbesitz would be powerless.

This is not the official position of our foundation, which will be decided in the near future by the foundation's board. However, I feel obliged to explain the reasons for which I am unable to support the fulfilment of the wishes with which you approached us, which we received in similar form from the German embassy in Nigeria, and which are also in line with something myself and our scholars have to deal with constantly.

Berlin's ethnological collections in Dahlem are on the point of receiving worldwide recognition. We keep hearing words of praise and gratitude from visitors from the countries where the collections originated, for preserving and maintaining with meticulous care a cultural heritage as a cohesive ensamble that has often been forgotten in the countries of origin. We are delighted that our collections form an excellent means of international understanding. To keep them responsibly must continue to be an important task of the Stiftung Preußischer Kulturbesitz for the future.

> I hope that this meets with your understanding
> and remain sincerely yours
> [Wormit][37]

Rights against morals, museums as victims, cultural property as a means of national prestige—in his letter to Amrehn, Wormit adopted tried and tested defences. Once again, he pointed to the incredible complexity of the subject, meaning a quick response was not possible. Once again, he put forward the legal situation, the rightful acquisitions of the Benin objects and the far-reaching consequences of a potential restitution. And once again the president of the Stiftung Preußischer Kulturbesitz presented the German museums as victims, not only of the Second World War and the subsequent division of Germany, but—somewhat surprisingly—of Hitler's 1937 order for the confiscation of works of modern art (the so-called "degenerate art") in public and private German collections.

What was new in Wormit's reasoning, however, was his presentation of the German museums as authoritative places of national self-representation that compete for rank and reputation with other museums in the world. As is easily recognisable here, even in the early 1970s the Stiftung Preußischer Kulturbesitz president upheld the principles of the nineteenth-century museum. Wormit further argued that West Berlin museums in particular needed to hold their ground in the competition of two political systems. Further "losses," for example permanent loans to Nigeria, could not be borne because they endangered the new cultural centre of the "free West," that is the museum complex in the Berlin suburb of Dahlem that had been inaugurated in 1970, thus weakening its position regarding the GDR's art institutions in East Berlin. Not only did Wormit see comparisons with London and Paris as a useful argument to repel the Nigerian request, but the Cold War too.

In Wormit's letter, he added a new addition to established arguments against restitution: the motif of the "good shepherd" of foreign culture and the grateful foreign visitor to German museums, which Paulin Joachim had already parodied in *Bingo* in 1965 (see 1965: Bingo) and that still reappears in discussions today. The historian Sarah Van Beurden defines this approach as "the older narrative of the 'civilizing mission,' in which the objects were proof of the need for the transformation of 'primitive' African cultures" had finally "shifted towards a rhetoric of cultural guardianship."[38]

Especially noteworthy is Wormit's remark on the necessity of maintaining secrecy in public about restitution, if such a step were to be considered at all. An institutional practice of secrecy had indeed governed the restitution debate for decades, both outwardly (by withholding information) and inwardly (with a culture of silence still in force today). Not only did a potential chain reaction among former colonised countries need to be prevented but also possible solidarity with the requests from the "Third World" at the beginning of the 1970s by West German civil society and by a new generation of museum professionals.

In the summer of 1972, the tactical manoeuvres of the Stiftung Preußischer Kulturbesitz against Nigeria's permanent loan request proved to be successful. Carl Gussone stated that the Ministry of the Interior was indeed willing to appeal to the Assembly of Education Ministers to ask the Foreign Office "for cautious handling of such requests."[39] Amrehn, the ambitious politician, also gave in, even though he was not convinced by Wormit's arguments: "Not all arguments you put forward to me convince.…But I just wanted to put a good word in with you regarding this matter, which in my view is reasonable, without becoming active myself."[40]

By eliminating the Christian Democratic parliamentarian as an advocate for Nigeria and activating the Assembly of Education Ministers as a counter-weight against the Foreign Office, the Berlin museums had succeeded in the

course of a few weeks in sidestepping a discussion with representatives of the Foreign Office—as offered by Stoecker in May. The Prussian foundation also no longer saw the need to present its own position in response to Nigeria's request. On 7 December 1972, its president stated in a letter to the Berlin minister for culture: "Following discussions in this matter in the meantime, I have now received a final answer from the Federal Ministry of the Interior that the Foreign Office does not intend to further support the wish of the Nigerian government for donations or permanent loans of Benin bronzes from the holdings of the Stiftung Preußischer Kulturbesitz. The embassy in Lagos has been informed accordingly. I am pleased about this outcome and feel that a fundamental discussion of this issue in the context of the Assembly of Education Ministers should now be abandoned."[41]

The fact that the involvement of the Assembly of Education Ministers no longer seemed important and could even be dropped, even though just a few weeks earlier it had been argued that the pressure from developing countries was so great that a fundamental discussion at the federal level was unavoidable, retrospectively confirms the purely strategic character of the manoeuvre. The Stiftung Preußischer Kulturbesitz's objective had never been a proposal for a national discussion about the handling of requests from formerly colonised countries, but rather an efficient rebuttal of the concrete Nigerian request for a few permanent loans. During 1972, the German public never heard anything about this request and its outcome. On 7 December 1972, Hans-Georg Wormit noted with satisfaction in a letter to Stephan Waetzoldt: "We can probably regard this matter as closed."[42]

1973

ZERO

1973 is generally referred to as year zero in the restitution debate, marked by the Zairean president Mobutu Sese Seko's address to the United Nations (UN) in New York on 4 October.[1] In the first decade after the independence of colonial Africa, restitution had been mainly discussed on the African continent and in its diasporas among intellectuals and artists. Few discussions occurred in Europe, if at all, and always behind the closed doors of political offices and museum administrations. 1973, therefore, marked the emergence of the restitution debate on the international stage. It also marked the beginning of the long trajectory of restitution claims in the committees and writings of the global organizations of the UN and UNESCO: from one general assembly to another and from one resolution to the next.

President Mobutu's UN address in the autumn of 1973 was well prepared. His campaign started on 14 September 1973 when the Kinshasha-based Zairean daily newspaper *Salongo* published a long report on the conference held in Kinshasa by the International Association of Art Critics (AICA), founded in Paris in 1948.[2] Under the slogan "AICA Meets Africa," nearly two hundred art critics had come to the capital of Zaire (formerly known as the Democratic Republic of Congo) to hear lectures and take part in excursions over a period of ten days. This was the first and to date the last time that the international elite of art critics met on the African continent south of the Sahara. Mobutu, president since 1965 and the self-styled "father of the nation," insisted on greeting the participants on the first day of the conference. *Salongo* printed in full his speech, which he made in French.[3]

Even though the dictatorial character of Mobutu's regime in the early 1970s was unquestionable and widely known at the time, the general still enjoyed international recognition. The influential art critic of the *New York Times*, John Canaday, took part in the Kinshasa conference and wrote excitedly about his impressions of Zaire's authentic approach to its culture: "Zaïre must be unique among all the countries of the world in its sponsorship of art as a revelation, or a verification, in a new nation's search for its spiritual identity. For Zaïre, this does not mean the simple, familiar business of capitalizing on art as a political instrument, though that is part of the game."[4] Indeed, Mobutu—himself a long-standing journalist with an obvious talent for public relations—had made use of the concentrated presence of the arts intelligentsia to once again present his new country's ideology, which combined societal "reconciliation" with precolonial values and deep-rooted traditions, elevated to a governing principle under the banner of "authenticité." In this context, in 1971, Mobutu had rechristened the Democratic Republic of the Congo as Zaire, and its capital city Léopoldville as Kinshasa.

This time, however, the focus of his argument was not on precolonial values and the principles of his new state—proximity to nature, strong sense of community, respect for ancestors and so on. At the heart of his speech were works of art. Mobutu connected them in his appeal to solidarity: "Our artistic heritage was, as you know, systematically plundered. And we, who speak to you and try to reconstruct this rich heritage, are often helpless. Because the artworks, which are often unique, are located outside Africa. For this reason we believe that AICA could write history if it drew the world's attention in one of its resolutions to the fact that the rich countries that own works from poor countries could return some of them, especially as the latter are not in a financial position to buy these back....This would be a gesture of good will."[5] Mobutu then thanked some private individuals who had worked in the former colonial administration and had restituted works to his country. He pointed to the economic value of African sculpture in the art market—objects from central African regions in particular were highly sought after at the time—and drew a parallel between the extraction of natural resources and the removal of artworks. After years of fruitless bilateral discussions with the Belgian government he was now clearly determined to move the restitution issue to the platform of the international stage and speak not only for Zaire but for all other former colonised African states.

Mobutu's appeal to the art critics did not go unheard. The AICA responded and did indeed issue a resolution, which was published soon afterwards in the magazine *Afrique contemporaine*.[6] But the short statement was limited to denouncing the current illegal export of African artworks and conspicuously avoided mention of the colonial dimension of the subject as addressed by Mobutu. In

addition, the specialist journal on Africa financed by the French government, which published the statement, did not have great journalistic reach. The AICA's resolution did not go any further.

Almost three weeks after Mobutu's speech in Kinshasa, he took advantage of another opportunity, in fact *the* opportunity *per se*, to raise the restitution issue again, this time in front of live cameras (plate 3). On 4 October 1973 he accepted an invitation by the United Nations to speak before their General Assembly in New York on the fundamentals of Zairean politics. Here, Mobutu launched what was to become a legendary full-frontal attack on the Western industrial nations, lasting ninety minutes and repeatedly interrupted by enthusiastic applause from the audience. He denounced the ubiquitous continuation of colonial structures, disassociated himself from terms like "developing countries" and "Third World," pilloried the environmental destruction by "rich countries," and after about an hour arrived at the subject of restitution:

> During the colonial period we suffered not only from colonialism; slavery, economic exploitation, but also and above all from the barbarous, systematic pillaging of all our works of art. In this way the rich countries appropriated our best, our unique works of art, and we are therefore poor not only economically but also culturally. Those works of art, which are to be found in the museums of the rich countries, are not our primary commodities but the finished products of our ancestors. Those works, which were acquired for nothing, have increased in value so much that none of our countries has the material means to recover them. What I am telling you is fundamental, because every rich country, even if it does not possess all the masterpieces of its best artists, has at least the bulk of them. Thus, Italy has those of Michelangelo; France, of Renoir; Belgium, of Rubens; and Holland, of Rembrandt and Vermeer. Another circumstance which demonstrates that what I am saying is right is that Hitler pillaged the Louvre during the Second World War and took away the magnificent works of art which were there. When liberation came, even before thinking of signing the armistice France did everything in its power to recover its art objects, and that is quite right. That is why I would also ask this General Assembly to adopt a resolution requesting the rich Powers which possess works of art of the poor countries to restore some of them so that we can teach our children and our grandchildren the history of their countries.[7]

Four weeks after Mobutu's speech, Zaire used an emergency motion to put the subject of the "Restitution of Works of Art to Countries Victims of Expropriation" on the agenda of the 28th Regular Session of the UN General Assembly.[8] In its reasoning, Zaire pointed out that losses of cultural property were

the "evil consequences of a ravaging colonization" and a collective experience of many countries in the world, which should by no means be confused with a natural, invigorating circulation of cultural assets.[9] A corresponding draft resolution was presented, which was supported by twelve (without exception, African) countries: in addition to Zaire, these included Burundi, Chad, the People's Republic of Congo, Guinea, Mali, Mauretania, Niger, Senegal, Uganda, Tanzania and Zambia.[10]

One reason why the resolution was rejected by the West was the fact that in international law the term "restitution" refers to reparations for prior injustice and thus has strong moral connotations.[11] Nevertheless, confrontation was avoided and on 18 December 1973 the UN General Assembly issued the soon to become famous Resolution 3187 on the Restitution of Works of Art to Countries Victims of Expropriation, with 113 votes in favour, 17 abstentions and no dissenting votes.[12]

The abstentions came from the former colonial powers of France, Belgium, the United Kingdom, Ireland, the Netherlands, the FRG, Denmark, Portugal and Italy, as well as Austria, Luxembourg, Norway, Sweden, the United States, Canada, Japan and South Africa. All other states voted in favour, among them Greece and Finland, as well as the GDR, which exercised its new voting rights in line with the Soviet Union. The resolution stated that the massive dislocation of cultural property in the past had often been the result of "colonial or foreign occupation" and that its restitution must be handled by those countries that had access to it "only as a result of colonial or foreign occupation." It was also significant that the terms "victim" and "expropriation" were used in the title.

This time, the public was not kept in the dark. The international press reported on Mobutu's campaign. On 9 November 1973, the German *Frankfurter Allgemeine Zeitung* noted that Zaire "considered compensation for the damage caused to poor countries through the sellout [of their] artistic treasures" desirable; it had been "generally customary under colonial rule…to plunder the colonised countries which were rich in culture and artistic traditions."[13] On 20 December 1973, the same paper stated, this time referencing Reuters, that the permanent institutions of the UN were now called upon to prepare "a list of those artworks in museums which were taken from their countries of origin during military or colonial occupation," with the objective of a "return of these art treasures at no cost."[14]

How museum administrations handled such reports becomes apparent in the detailed records of the Stiftung Preußischer Kulturbesitz in Berlin. On the very day when the second *FAZ* news report appeared, the board convened. The Stiftung Preußischer Kulturbesitz president Wormit noted that "according to newspaper reports, the United Nations had recently issued a resolution upon

request of African states which requires that cultural property, which was removed from the countries of origin as a consequence of warfare and colonisation measures be returned to them."[15] But the culture official took a relaxed view and once again expressed to the panel the blamelessness of his institutions, since "with regard to the Berlin collections one could safely assume that they did not hold objects from warfare or similar looting expeditions."[16] Coming from a civil servant who less than a year ago had to deal with the consequences of the 1897 British military attack on Benin City, such a statement seems a somewhat bold claim.

All the more so, since in the meantime the celebratory volume for the centenary of the Ethnologisches Museum Berlin had been published, which laid out in extensive detail the collection history of the institution.[17] It contained dozens of names of high-ranking officers who had collected on behalf of the museum during the German colonial period in the so-called protectorates and in the German Pacific colonies, as well as statistics on the dizzying expansion of the collections during the thirty-four years of German colonial rule.[18] If Wormit dared to state with utter conviction in front of his foundation board at the end of 1973 that the Berlin collections were free of any objects acquired in a context of war, he was probably just trying to maintain the legal fiction of a "clean" museum. Either that or he had not taken notice of his own institution's publications. In any case, with such false statements he contributed to the prevalence of colonial amnesia in German federal cultural politics.[19]

But behind a mask of indifference, there was considerable agitation in European museum administrations after Mobutu's speech in October and the UN resolution issued in December 1973, at least in Germany, Belgium and the United Kingdom (see 1974: Increasingly Global)—in France, no such reaction could be found.[20] In Belgium, the initiative from Zaire at the United Nations caused a brief tussle between foreign policy and museum administration. As in the case of Nigeria in Germany in 1972, Belgian foreign policy had an apparent interest in dangling the prospect of cultural property restitution to Zaire, while the Royal Museum for Central Africa in Tervuren had already successfully stonewalled the subject from 1960.[21] Shortly after Mobutu's speech, the Belgian foreign minister Renaat Van Elslande promised a prompt restitution of artworks at a press conference in Kinshasa, without consulting the affected museum. He was quoted in the Belgian newspaper *La Libre Belgique*: "In accordance with the wish expressed by President Mobutu at the United Nations, Belgium is determined to return the artworks to the Republic of Zaire which it needs in order to complete a collection of Zairian art both in historical and geographical terms."[22] The publication pointed out that "this official statement from Minister Van Elslande met with applause from Zairian journalists at the

press conference," and was by no means "equivalent to the abolition of the museum in Tervuren," especially since a number of objects were held there in duplicate. In Tervuren, the museum directors were not amused.[23] Once again, restitutions did not come to pass. Nevertheless, the discussion would from now on no longer be restricted to bilateral cases. On 14 September 1973 The *Guardian* led with the headline "Return Our Lost Art," now referencing an increasingly global project.[24]

1974

INCREASINGLY GLOBAL

In the aftermath of the shock UN resolution of December 1973, *Africa Report*, the magazine of the African-American Institute in New York, produced a striking cover image for its first issue of 1974. The cover depicted an African statue the size of a toddler in the aisle of an empty airplane looking for a seat (plate 4).[1] The statue stands with its back to the viewer in the center of the image surrounded by the comfort and order of modern travel: two rows of endless empty seats with geometric fabric covers, bolstered headrests, integrated reading lights and luggage in the hold above. Light enters through the cabin windows, creating shadows on the floor in the pattern of a ladder with alternating light and dark lines leading the gaze towards the vanishing point, the end of the plane. Directly above the head of the small wooden figure, white letters spell the question: "Will African art ever go home again?" The hesitant advance of the statue onto the airplane and to Africa is suggested: boarding is *not yet* completed. The cover with its direct question, enforced by the anthropomorphisation of a wooden object, and combined with the large printrun of *Africa Report* all marked the entrance of the restitution debate into the awareness of an increasingly wider, and in this case US, public. By the beginning of 1974, at the latest, restitution was on the global agenda.

Africa Report's arresting cover image was created by the New York press photographer Nate Silverstein using a DC8 passenger plane made specially available for the shoot by the airline Air Afrique—jointly founded in 1961 by several West African countries to provide a transatlantic connection to New York. The cover was combined with a long report inside the magazine on the global trade in African art by the New York journalist Susan Blumenthal. At the time of writing, Blumenthal was twenty-eight, the daughter of a Jewish couple who had emigrated from Berlin. She had lived in various African countries south of the Sahara taking long trips and carrying out research, which she published at the end of 1974 in her voluminous, and still much-quoted, travel guide to Africa: *Bright Continent.*[2]

Although Blumenthal's article did not focus on the forms and consequences of past displacements of African cultural property, the colonial period formed the historical framework for her description of contemporary artistic developments for US readers. Those who were seriously interested in African art in the United States, she declares at the beginning of the article, "might start by purchasing a ticket to Paris, London, or Berlin"—as the majority of the most important African treasures of the world were long gone from the African continent and had been "spirited away" into European museums.[3] "The plunder of African art by the 19th-century colonizers stocked the museums of London, Paris, Stuttgart and Antwerp," Blumenthal wrote.[4] While her article neither mentioned Mobutu's October 1973 appeal nor the UN resolution two months later, readers were informed about Ghana's timely efforts to obtain the return of their objects from the United Kingdom.

Following Zaire and Nigeria, Ghana, the former British colony known as the Gold Coast, was the third African state in the early 1970s to present Europe with an official claim for restitution. As Blumenthal wrote: "In anticipation of the 100th anniversary of the regalia's removal to Britain this month, the Kumasi Traditional Council has petitioned the British Government for the return of its cultural property."[5] The journalist was not only concerned with denouncing the smuggling of African art and its actors but also with Europe's historical responsibility and the consequences for Africa's present and future: "The point is not to keep a nation's cultural property at home—an isolationist act unbecoming to the 1970s," Blumenthal commented on Ghana's restitution claim. Rather, direct contact between African people and their cultural property needed to be reestablished. With regard to the crucial question of whether African museums were in fact "able to play a significant role in slowing the movement of art out of the continent or in bringing major pieces back to Africa," Blumenthal was nevertheless pessimistic.[6] The "game," as she referred to the global trade in African

art in the conclusion of her article, was much too lucrative, and there were no indications that the players on the market for African art had an interest in strengthening the emerging African museums in their efforts.

But in reality, it was not only the international art trade that ensured the continuation of the status quo. Many public museums in Europe also systematically prevented the restitution of colonial-period holdings to Africa in the 1970s. In the follow-up to the 1973 UN resolution, the defensive measures of the United Kingdom and the FRG are well documented. While Belgium continued to pursue the project of museum cooperation between Tervuren and Kinshasa in spite of growing dissatisfaction in Zaire, France only became active several years later.[7]

MOBILISATION IN THE FEDERAL REPUBLIC OF GERMANY

In the Federal Republic of Germany, the authorities raised the alarm directly after Mobutu's speech at the end of 1973. The Foreign Office, the Assembly of Education Ministers, some culture departments in the regional states, as well as the German Museum Association asked selected German museum directors to give a written statement about their thoughts on the "restitution of artworks from developing countries."[8] The statements from the president of the Stiftung Preußischer Kulturbesitz and the director of the Linden-Museum in Stuttgart, Friedrich Kußmaul, were evaluated by the Foreign Office.[9] A further statement, written by the director-general of the Berlin museums, was designated for the administration of the Berlin city senate.[10] A fourth statement was commissioned by the German Museum Association from Jürgen Zwernemann, the director of the Museum für Völkerkunde Hamburg (Museum of Ethnology) from 1971.[11] These statements provide excellent snapshots of different positions regarding restitution, all characterised by a fundamental and harsh, both in tone and content, rejection of claims from former colonised countries. Two of them will be analysed in more detail.

The first statement dates from 22 March 1974 and was authored by Stephan Waetzoldt, the director-general of the Staatliche Museen zu Berlin, who was a specialist in German Romanticism and the second generation of his family to hold the museum directorate. He responded to the Berlin Senate Administration for Science and the Arts stating, "Your letter of 18 February 1974 has long remained unanswered because it is indeed difficult to adopt rational arguments to confront, in my view, the absurd demand for the return of practically the entire collection holdings which come from the Third World and are now in Western museums. Nevertheless, I would like to list a few points—although I am aware that these will not carry weight with the nationalist dialogue partners in Africa, Asia and South America."[12]

He followed this statement by a numbered list of arguments against the

return of cultural goods. *First*: the appalling condition of museums in the "Third World" (so "catastrophic, that potential returned works of art and collection objects would soon fall into decay"). *Second*: the "Third World" was incapable of preserving and presenting its own history. *Third*: the cosmopolitanism and social role of German museums ("a showcase of the Third World, funded with means from our tax payers"), were actually the main reasons why the German public was interested in foreign culture at all. Waetzoldt recommended museums should respond to requests from former colonised countries in their own interest at a leisurely pace, to treat "the whole issue as dilatorily as possible."[13] Four months later, the president's office of the Stiftung Preußischer Kulturbesitz picked up these points in a slightly amended form in its own statement to the Foreign Office. Concerningly, it also argued that the danger of a radical emptying of German museums was "the dissolution of all central public collections and thus the end of a very significant part of or cultural life."[14]

The second statement was undated and came from the state of Baden-Württemberg. Its author was the director of the Linden-Museum, the ethnological museum in Stuttgart. The Swabian Friedrich Kußmaul, born in 1920, who had been at the helm of the institution since 1971, was an ethnologist who had received his PhD at the university of Tübingen in 1953 with a thesis on the "Early History of the Inner Asian Nomadic Horsemen."[15] The most significant part of his academic life, according to contemporaries, had been an expedition in 1962 to northeast Afghanistan, which he had been forced to abandon early owing to health issues. Otherwise, Kußmaul had spent his student days and his entire professional career within a radius of fifty kilometres of his birthplace of Bondorf in the district of Böblingen.

In response to the UN restitution resolution of 1973, the museum official penned a neatly enumerated statement covering nine pages, in which he *first* declared the term "looting" to be "incorrect," then praised the preservation of perishable material as a great achievement by ethnological museums, and emphasised the agreement of "indigenous people" in handing over cultural property.[16] *Second*, he considered the illegal export of artworks since 1960 much worse than the losses of the colonial period. *Third*, Kußmaul, who had never been to Africa, outlined "today's cultural situation" on the continent: in the course of the independence movement, a "sometimes exaggerated sense of one's own dignity, achievements, tradition, and solidarity" had arisen "within African intelligentsia circles," a sense of so-called "negritude." Consequently, "hardly any Africans are likely to be interested in the collections in question for reasons of cultural awareness, especially not those in the cities," Kußmaul maintained. *Fourth*, the museum director disputed any ability by African states "to maintain modern museums, not least because the staff were "hardly sufficiently educated and unfortunately in many cases rather susceptible to corruption." Conversely,

and *fifth*, ethnological museums in Europe researched and presented "these foreign cultures in wonderful cross-sections" so effectively that "European artists and scholars became familiar with 'negro art' since the last turn of the century, and recognised and promoted it as an important part of world art." For this reason, restitutions from such collections would amount to a betrayal of generations of Europeans. *Sixth*, Kußmaul reached the conclusion that "there is no legal right to return our collections to developing countries" and "that a moral duty of return does also not exist." *Seventh*, his answer to the self-defined question of "What to do?" focused mostly on measures against the illicit trade in cultural objects and on the compilation of lists of "national cultural property" by the formerly colonised countries themselves, to be drawn up by "mixed commissions" consisting of European and American museum professionals, "as only then, a knowledgeable, reliable basis could be established." Finally, Kußmaul did outline an option of releasing cultural goods, in isolated, specific cases and "as part of a good will initiative" as "donations to the countries in question," which would require "firm conditions" to be formulated. Thanks to such measures, "the nations from the Third World would have a greater opportunity than before to research their own cultures, which would benefit their sense of identity and thus engender a correct self-perception."

Kußmaul's paper was met with great deal of positive attention in German museum circles. Waetzoldt was thrilled to pass it to his superior, since it contained "new and very plausible arguments against the claims from developing countries."[17] In the Foreign Office, however, scepticism was palpable: "The claim that museums in the Third World are incapable of preserving and caring for artworks and cultural goods in an appropriate manner cannot be accepted in this generalised form."[18] Furthermore, the Foreign Office pointed out that even though many cultural goods from the "Third World" had been saved from destruction by being transferred to the museums of the Western world, one could not deny that "mainly European collectors and excavators" had "taken advantage" of the prevailing conditions in the past for their own purposes. The existing tension between the Foreign Office and museum administration in West Germany—also virulent in Belgium—continued, albeit on an abstract level, since no more claims had been received from former colonised countries after Nigeria in 1972.

ASANTE REGALIA

In London, the situation was much more specific. While throughout 1974, West German authorities tried to produce a theoretical position to safeguard against potential restitution claims, the United Kingdom had to deal with a new claim for the return of so-called Asante regalia held in the British Museum

and the Wallace Collection in London. This claim had emerged at the beginning of the year and had been closely monitored by the press and the general public. At the time, the term "Asante regalia" referred to a substantial number of objects in connection with Ghana made from solid gold, among them many royal insignia, which had been removed from their original home and brought to London in the course of several British colonial wars against the Asante people before Ghana's independence in 1957. The British and the American press had reported extensively on the Anglo-Asante wars in the nineteenth century; together with the seized regalia, they had entered the British heroic collective memory. The claim for the restitution of these treasures was put forward at the beginning of 1974 by the then head of the Asante people, Otumfuo Opoku Ware II, who had formulated his claim in the run-up to the commemoration events for the centenary of the destruction of the Asante capital Kumasi. The British press reported on it widely and incessantly. The *Guardian* mentioned a "'Return Regalia' Appeal."[19] *The Times* alone published nine articles on Ghana's request between February and December 1974, including several informative letters from readers that provided an insight into postcolonial British society.

Once Otumfuo Opoku Ware II had made the first move, the journalist Nicholas Ashford, an Africa specialist, published an article in *The Times* on 5 February 1974 on the "golden stool" that "the Asante nation still yearns for."[20] In the article, he referred in great detail, although with some historical inaccuracies, to the alleged removal of a certain sacred stool to London during the colonial period. Ashford expanded on the symbolic dimension of the royal attribute, the "spiritual unity of the state and the authority of its rulers," without which "the Ashantis are a people without a soul."[21] He also reported on the commemorative event in Kumasi quoting the Asantehene, head of the Asante people, Otumfuo Opoku Ware II: "the time is ripe for Britain to comply with requests to return the regalia."

This article prompted a large number of reactions. On 28 February 1974, *The Times* printed its first letter from a reader from Legon near Accra, written by the then unknown Ghanaian historian and university professor Albert Adu Boahen. He accused the journalist of historical inaccuracy. The British loot that was *actually* being claimed back by the Asante was not the Golden Stool, which the Asante had always successfully defended and which had never left the region, but the "regalia and ornaments that were taken away when the expeditionary force commanded by Sir Garnet Wolseley sacked Kumasi in February 1874."[22] These included precious jewellery made with pearls and gold, fine textiles, gilded arms, masks made out of solid gold. With this letter, the young historian from Ghana established his exepertise in the subject and demonstrated his own precise knowledge of historical sources as well as his determination to reach his own interpretation of events.

This letter enraged Humphrey John Frederick Crum Ewing, an entrepreneur from Kent, England, who responded to the Ghanaian professor with a colonial history lesson in *The Times* on 5 March. He pointed out that, through military action, the British had prevented atrocities by African rulers in the nineteenth century.[23] The "so-called regalia," as he referred to the plundered objects from Kumasi, should be regarded in the context of the slave trade by African rulers. Furthermore, they had come to British collections entirely legally, that is as an "indemnity." British colonisation was a beneficial civilizing force to a barbaric region of the world. His argument reflected the European legitimising colonial rhetoric of the nineteenth century, now adopted to justify the retention of the Asante regalia in British museums.

Yet this letter also did not pass without comment. On 8 March 1974, *The Times* published a statement by an outraged reader, Joanna M. Hughes from London, who while deconstructing Crum Ewing's rhetoric deplored the "harsh and legalistic manner" of his argument. The restitution debate, according to Hughes, was a matter of taking a stance with regard to the future, not a reckoning with the past: "*Please* could we have an end to the distasteful dragging in of the subject of human sacrifice, just because African history is being mentioned? It is more courteous, and more accurate, to take it for granted that all countries acted in ways which they would not now justify. (Our own share in the African Slave Trade should make us particularly chary of condemning other people.) What we are concerned with at present is a suggested return of long-absent treasure which would give pleasure to many people in Ghana and which would show our respect for their traditions and their feelings."[24] For these reasons, Joanna Hughes called for a "reasonable" discussion about Ghana's restitution request and pleaded, notably in the plural ("we"), for returns as acts of fairness and friendship. "All that many of us would like to see is the return to Asante of a treasure which was removed forcibly, a hundred years ago, in time of war, from a people with whom we now have ties of friendship and respect....I believe that some of this treasure is not even on display in this country; in Kumasi it would be shown in its proper home."[25]

The idea of restitution as providing a fair gesture among equals and a new relational ethic for the future seemed to have been widespread among the population in the United Kingdom during 1974, in spite of ongoing colonial discourse. *The Times* in September 1974 also reported from a "deputy headmistress," from the West Midlands town of Stafford, who had encouraged her pupils after returning from a recent trip to Ghana, to put pressure on members of parliament to support the restitution of the Asante regalia.[26] It is noticeable that female voices, while rare in the European restitution debate of the 1970s and '80s, argued almost without exception for a constructive debate regarding the African claims.

By the end of 1974, restitution had reached the United Kingdom's parliamentary agenda, documented in the minutes of sessions in the House of Lords. On 10 December, a discussion took place in the House of Lords about the Ghanaian restitution request brought forward by Edward Douglas-Scott-Montagu, a Conservative MP born in 1929, and addressed to the Parliamentary Under-Secretary of State on Foreign and Commonwealth Affairs, the Labour politician Goronwy-Roberts. Further requests to speak were made, with spirited remarks each by the then elderly Scottish Labour member Baroness Lee of Asheridge, minister for the arts in Harold Wilson's government from 1963 to 1970, as well as Lord Gisborough, a Conservative MP. *The Times* printed an abbreviated version of the debate on 11 December 1974:[27]

Lord Montagu of Beaulieu asked the Government whether, with a view to fostering Commonwealth relations, they would use their good offices to facilitate the early return of the Asante Regalia to the Ghana nation.

Goronwy-Roberts: The regalia is not at the disposal of the British Government. The majority of it forms part of the collections of the British Museum and the Wallace Collection. Neither body may legally dispose of these exhibits.

Montagu: These relics were originally war booty, captured by the British Army. The Ashanti people have deep feelings about the return of these sacrosanct objects which are supposed to contain the soul of the Ashanti people. A special Act of Parliament may be needed to release these objects from the museum. Will the Government facilitate the passage of such a Bill?

Goronwy-Roberts: I cannot give an undertaking that we will seek passage of such legislation, nor could I advise that we should do so. Far-ranging implications may ensue from dealing with such a case because a variety of other cases would immediately come up for consideration. The Council of Chiefs have petitioned the Government on this matter and we have replied in terms of my answer here. So far they have not commented on that answer.

Lee of Asheridge: When it comes to returning booty from this country we should tread warily because it may turn into a striptease.

Goronwy-Roberts: Perhaps the term booty is not appropriate here. It is part of an indemnity agreed by the former King of Ashanti, the proceeds of which were devoted to compensation for dependants of British troops killed in horrific conditions in that part of the world at that time. I sympathise with the motivation of the question that we should do everything possible to promote an improvement in Commonwealth relations—but this is not the best way to do it.

Gisborough: Gentlemen, would it be possible to keep the booty and return the soul?

This parliamentary exchange does not require a detailed commentary. At the end of 1974, the attempt by the Kumasi Traditional Council in Ghana to recover the Asante regalia one hundred years after their violent extraction to the United Kingdom was thwarted by the resistance of both the British museums and government. On 11 December 1974, a headline in *The Times* read: "Ghana Plea for Return of Ashanti Regalia Rejected."[28] Yet, the topic had now aroused public interest, and voices had been raised from the heart of British society that spoke in favour of supporting the Ghanaian claims. While British institutions continued—like those in Germany—to point to the legality of their acquisitions and to the restrictive legal situation that prevented restitution, civil society articulated an increasing desire to rebuild the relationship with the former colonies and to acknowledge the emotions that were connected with their lost cultural heritage.

The final letter in this matter was printed by *The Times* in 1974 and came from Peter Shinnie, one of the founders of African archaeology and British professor at the University of Calgary since 1970:

As one deeply interested in the history and antiquities of Ghana, I was extremely disappointed to read in your issue…of the unsympathetic reply of both the British Government and the Trustees of the British Museum to the request for the return of the Asante regalia….[The response] can only be interpreted in Ghana as a rather insulting refusal to repair part of the great damage done to the old city of Kumasi by a British army….surely the time has now come to make a generous gesture to a people who maintain feelings of friendship for Britain. This cold refusal is surely a certain way of destroying some of this friendship….If [the government] were to provide parliamentary time and to indicate to the trustees that they would look with favour on the transfer of the objects I cannot imagine that there would be an insuperable difficulty in returning to the Asante objects which have far greater emotional and historical meaning for them than they have for us…. It is difficult to see what Britain has to lose by accommodating Ghana in this way. Many of the objects, including the famous gold head, usually incorrectly known as the "death mask" of Kofi Karikari, are not available for the public [in London] to see. If exhibited in Kumasi not only would Ghanaians be able to see them but it is not improbable that they would be visible to more British citizens than they are at present.[29]

It was precisely the solidarity of the public with the restitution requests of the so-called developing countries and the acknowledgement of the uselessness of keeping the objects in European museum depots that would severely challenge many European museum administrations over the following years.

1975

PAUSE

1975 was a quiet year in the history of restitution. The Nigerian and Ghanaian requests for loans and restitutions, respectively, had failed and the sensational UN resolution submitted by Zaire in 1973 had not led to any consequences. Indeed, directly after the resolution was passed UNESCO, as the executive arm of the United Nations, had been charged to adopt it and work on its implementation.[1] However, the organisation initially focused on establishing rules for the *exchange* of artworks on the basis of more or less long-term international loans—a project which only partially coincided with the demands for restitution while tying up considerable energy at UNESCO.[2] At least in German museum circles, this modest idea of systematising exchange was overwhelmingly rejected.[3]

In addition, by the end of the year a preliminary statement had been drafted by the Assembly of Education Ministers (KSK) of the FRG in accordance with major German museums. This expressly warned against such international exchanges and instead demanded that the formerly colonised countries "set up a list of the really important cultural inventory and effectively protect the listed objects…as a prerequisite to ease international difficulties."[4]

On 12 January 1976, FRG government reaffirmed its negative stance towards UNESCO in a statement that pointed out that the envisaged exchange process and the passing of "moveable cultural assets" into the hands of "new custodians in other continents" would "inevitably endanger the existing cultural property stock and eventually decimate it by degrees."[5] At this point, German museum

44

circles were not prepared to envisage either restitutions or alternative loans to formerly colonised countries.[6] After all, as the director of the Museum für Völkerkunde in Hamburg had once confidentially told the Foreign Office, there was a concern "that objects on loan…could be seized for purposes of restitution."[7] Excessive trust was not part of the museums' DNA.

Nor did the willingness of West German museum authorities to engage with their colleagues from Africa increase. In the administrative archive of the Stiftung Preußischer Kulturbesitz, the announcement of a visit by Ekpo Eyo in the summer of 1975 is documented as follows: by mid-July, the director of the Ethnologisches Museum in Dahlem, Kurt Krieger, heard that the director of the Department of Antiquities in Lagos planned a trip to Berlin together with the Undersecretary of State in the Nigerian Ministry of Education.[8] The director-general's office of the museums was informed, and a note was promptly filed: "A connection with the former desire for 'permanent loans' of Nigerian artworks (Benin bronzes) or with requests for loans for the 'Second World Festival of African Art and Culture' is assumed.…[We] all agree that it would be opportune if Prof. Krieger were to receive the two gentlemen on his own, should the visit come to pass. He could then listen to potential loan requests while referring to his lack of competence in such decisions. This would buy time for a decision to be reached eventually, which will surely not be easy."[9] In the end, the meeting did not take place.

At the end of 1975, Zaire submitted a new draft resolution to the UN General Assembly in New York, since there seemed to be no movement at all in the matter of restitution. It was almost identically worded and passed, with nearly the same votes and abstentions as the draft resolution of two years before.[10] A coded telegram from the German UN representation in New York to the Foreign Office in Bonn described the atmosphere during the voting session: "Zaire submitted the draft res[olution] and…regretted that the appeal of 1973 had not received a greater response. Egypt used its statement to attack Israel, accusing it of looting Christian and Arab cultural property in the occupied Arab territories. Belarus launched into a general description of the destruction of cultural assets by Hitler's Fascism (destruction of 427 museums, overall half of the cultural heritage in Belarus).…Greece expressed the hope that the resolution would not become a dead letter. Like Belarus, Poland pointed to the losses of its cultural property caused by the National Socialist occupation, which are partly irreplacable. Algeria saw the restitution of art treasures plundered by colonial powers as a contribution to peace."[11] The European public heard practically nothing about the discussions of 1975 and the violent emotions—often still—associated with them.[12]

As director-general of UNESCO, René Maheu had proposed the *exchange*

of cultural assets in response to the restitution demands from Zaire and other African states.[13] His successor Amadou Mahtar M'Bow introduced a clear change of course from 1975. M'Bow, born in Dakar in 1921, was the first African to be voted to the top of a UN organisation. His election as director-general at the end of 1974 (plate 10) testified to the growing influence of emerging states from former colonised countries in the global organisation. Under his mandate, the restitution issue advanced to senior management level.

1976

"GERMAN DEBATE"

On 11 June 1976, the *Christian Science Monitor* published an article by the Cologne-based Reuters correspondent Jochen Raffelberg, entitled "German Debate: Should Art Return to Former Colonies?"[1] In the mid-1970s, the *Christian Science Monitor* was an established independent moderate English-language daily newspaper based in Boston, with a daily printrun of approximately 177,000, an international readership and a worldwide network of correspondents.[2] Even though Germany had not received any claims from former colonised countries since Nigeria's loan request in 1972, and in spite of the strict discretion of all involved German authorities, from a US perspective the restitution debate had become German. Why so?

In the first half of 1976, the topic of restitution had moved beyond the confines of German state authorities and ministries, attracting public interest, as had been the case in the United Kingdom in 1974. The institutional framework for a public discourse had been formed in the German-speaking world at various meetings, including one on the "Return and restitution of cultural property" for UNESCO international experts in Venice, Italy, in March 1976; at a meeting for the German national committee of the International Council of Museums (ICOM), a few weeks later in Lindau on Lake Constance, Germany; and at the 19th UNESCO General Conference in Nairobi, Kenya, at the end of the year. Notably, a new protagonist had emerged: Herbert Ganslmayr, an African specialist and the director of the Übersee-Museum in the north German port city of Bremen. "Sixty years after Germany lost its colonies, German ethnologists are deeply split over the question of returning works of art

brought to German museums during the colonial period to their countries of origin," the introductory sentence of the *Christian Science Monitor* article stated, putting a stop to the polite silence on the provenance of German museum collections.[3] The second sentence further probed a sore point: it could be assumed that "From three decades of colonial history—ended by the Treaty of Versailles after World War I—West Germany still is believed to have a wealth of statues and totems from remote areas of the Pacific, as well as masks and other valuable religious artifacts from Africa." The paper then quoted Dr. Herbert Ganslmayr, chairman of the International Committee for Museums of Ethnography and head of the Übersee-Museum: "One does not only have a legal obligation to hand things back, but also a moral one....Full enjoyment of this (cultural) heritage is for each people an indispensable condition for its self-realization." Ganslmayr planned to recommend that the Bremen Senate should restitute a "carved Benin mask" from the Übersee-Museum to Nigeria. In closing the article, the *Christian Science Monitor* quoted from an unreferenced critical statement on restitution drawn up for internal purposes two years earlier by the director of the Stuttgart's Linden-Museum, Friedrich Kußmaul: "There is no legal basis for developing countries to claim artworks located outside their territories.... There is also no moral obligation."[4] Not without mentioning the considerable value of the cultural assets brought to Germany during the colonial period, the article ended with a reference to what was probably the best-known object of African provenance in a German museum: the throne of the Cameroonian King Njoya in the Ethnologisches Museum in West Berlin.

All of a sudden, the entire "German" restitution subject matter was on the table again and the article prompted an avalanche of reactions in German museums. Who was the Bremen museum director who in 1976 dared to take a public position so diametrically opposed to that of his German museum colleagues? Why had his name only appeared after numerous internal museum statements of the previous years? Where did his convictions come from, and why did his appearance lead to an external, public perception of the restitution topic in Germany as a "German debate"? Just how sound was Ganslmayr, and did he have allies?

Significantly, Ganslmayr was young. Born in Nuremberg in 1937, he was part of a generation that had been politicised during 1968 and was determined to question certain structures, unlike the conservative previous museum directors Friedrich Kußmaul (born 1920), Hans-Georg Wormit (born 1912) or Stephan Waetzoldt (born 1920). Unlike many of his colleagues who were involved in the restitution debate, Ganslmayr had spent several years living on the African continent during the emerging debate and had an academic interest in the topic. Even before finishing his PhD thesis entitled *Das Krokodil im Kult und Mythos afrikanischer Stämme* (The Crocodile in the Cult and Myths of

African Tribes), he had worked as an assistant lecturer from May to July 1968 at the Institute for Ethnology at the University of Munich on an African mapping project funded by the German Research Association (DFG) in Nigeria.[5] As soon as he had completed his PhD, he returned to Nigeria from August 1969 to May 1971 to finish the project, this time as a research fellow at the Institute of African Studies at the University of Ibadan.[6] Ganslmayr had established many connections within the academic and museological elite in Nigeria, even during the Biafra War.[7] Later, he was appointed curator at the Übersee-Museum in Bremen, where he became director in 1975 at just thirty-eight years of age. Within German rigid cultural bureaucracy, this job gave Ganslmayr authority and autonomy. Externally, it opened doors to numerous international bodies, and internally, it gave him the possibility to transform his institution, which was mired in nineteenth-century traditions. While the young museum professional had already actively engaged in a reform of German museum ethnology, from 1976 he used his institutional force, solid international network and excellent media relations[8] to support restitutions to former colonised countries.[9]

Ganslmayr's first intervention had taken place at the UNESCO meeting in Venice and was initially unnoticed by his German colleagues. At the end of November 1975 the United Nations passed the aforementioned (see 1975: Pause) Resolution no. 3391 on the "Restitution of Works of Art to Countries Victims of Expropriation." It stipulated an expert committee meeting as a mandatory for moving ahead. As the UN subsidiary organisation, UNESCO was tasked with organising the meeting scheduled for late March 1976, which had been meant to take place in Cairo, Egypt, but was moved to Venice, Italy, for organisational reasons. At the same time, there was a close succession of related expert conferences on the subject, for example in Paris, France (on the exchange of cultural property), and in Warsaw, Poland. The Venice meeting was not at government level and thus not subject to directives. Nevertheless, governments dispatched their respective experts.

Ganslmayr was well connected within UNESCO. Through his work as chairman of the ethnological section of ICOM (with its head office in the UNESCO main building in Paris), he had insider knowledge and seems to have directly sent his request via Paris to attend the scheduled meeting as German expert. Through the Permanent Representation of the Federal Republic of Germany at UNESCO, his enquiry was passed to the Foreign Office in Bonn, which approved his attendance on 10 March 1976.[10] He was personally instructed with regard to the position that was to be taken in Venice, especially with view to possible demands from Poland against Germany as well as to the "Claims of the GDR for Prussian Cultural Property"—two areas that were on the restitution agenda in addition to the demands from former colonised countries.[11] Furthermore, Ganslmayr received all the statements and position

papers from the culture department at the Foreign Office that had been prepared by the museum and cultural administration at the federal, regional and communal level on the subject of restitution since 1974, including the harsh anti-restitution statement by Friedrich Kußmaul from 1974. In addition, the Foreign Office emphasised in writing that it "had only agreed for a German specialist to attend the expert meeting…with the restriction that the German government would in no way" be bound by it, and therefore it would be pleased if Ganslmayr acted "within the framework of the arguments expanded in the attached documentation."[12]

However, in Venice Ganslmayr acted in a manner that radically deviated from the script. He followed a framework of his own making and sided with his colleagues from Zaire, Nigeria, Senegal and other countries in his unequivocal advocacy for restitution. When questioned later, he kept emphasising that he had attended the expert meeting as an independent specialist and not as an emissary of the German government. A document from the Foreign Office retrospectively notes: "From the final document [of the Venice meeting], it does not become apparent that [Ganslmayr] expressed reservations on any point."[13]

This final document shows that a total of seventeen international experts were present in Venice: from France, the United States, Belgium, the Federal Republic of Germany, Sweden, Greece, Poland, Yugoslavia, Egypt, Mexico, Thailand, Indonesia, Zaire, Senegal and Nigeria, with the latter represented by the still fully committed Ekpo Eyo.[14] The group met in private and after a heated discussion compiled a five-page report, which at first only circulated within UNESCO and therefore did not stir German governmental and museum circles. In the document, the expert once again repeated the formula according to which "cultural property is a basic element of…identity" and "full enjoyment of this heritage is for each people an indispensable condition for its self-realization." Therefore, the "restitution or return of these objects to their countries of origin is a principle which should govern the action of Member States and to which they should give concrete form in a spirit of international solidarity and good faith."[15] The experts also agreed that "a favourable current of public opinion" was essential.[16] They explicitly refused "to link the debate about the return of cultural property with questions of exchange."[17]

While Ganslmayr campaigned for restitution at an international level, his West German colleagues—primarily Friedrich Kußmaul in Stuttgart—did not remain idle. In advance of the committee meeting in Venice, Kußmaul had sent a long letter to the Representation of the Federal Republic of Germany at UNESCO in Paris where he affirmed his strong opposition to restitutions, which he had already expressed in 1974. With this renewed missive, he hoped to influence the course of the Venice conference, albeit at somewhat short notice.[18] Kußmaul was the head of one of the greatest ethnological collections

of colonial provenance in Germany, with African holdings almost exclusively from the former German colonies of Cameroon and Namibia. The collections had reached Stuttgart mostly through members of the so-called *Schutztruppe* [protective squad], the military units operating in the African German colonies between 1891 and 1919, as revealed in recent research.[19] In his letter to the representatives of the Federal Republic, however, Kußmaul expressed the conviction that "by far the largest part of our collections (and not just those we have here) were acquired and brought to our country under perfectly legitimate circumstances at the time. Looting expeditions in the actual sense are likely to have taken place rarely or not at all in the former German colonies." To support this argument, he added figures: he felt able to say that "not even 2% of our collections came here under pressure."[20]

Such statements bolstered with purely fictional statistics, even at the time, contradicted the state of knowledge about the history of the ethnological collections in Germany. Using his authority as an ethnographer and museum professional, Kußmaul thus actively contributed to spreading historical misinformation in government circles, like his colleagues at the Stiftung Preußischer Kulturbesitz had done in 1972. "It is advisable to avoid showing or documenting a bad conscience in all these talks," he added in his letter.[21] Instead of engaging with restitution claims from former colonised countries, Kußmaul continued, it would be better to ensure that "the individual countries could collect in their own territories, maintain the collected objects, and research them."[22] Only then, if at all, restitutions might be considered, as a "noble gesture" by Western countries, as Kußmaul termed it. He concluded his train of thought with cynical candour and foresight: "But I am convinced that this will not come to pass before 1990, and there is a lot of time until then."[23] Apart from a lack of historical transparency, playing for time was another key guiding principle. But in vain did Kußmaul hope to influence the events in Venice. Nevertheless, it would take months for the museum community to find out what had been discussed there.

This happened in the course of a conference about the German national committee of ICOM: from 9 to 17 May 1976 where more than 130 museum professionals from Germany, Switzerland, Austria as well as individual representatives from the United States, France, Portugal, Belgium, Luxembourg, Yugoslavia and Czechoslovakia gathered in Lindau on Lake Constance for a week to hear around thirty talks about "Space, Object and Security in Museums." The talks were documented by tape recording, with a printed volume to follow later.[24] Ganslmayr, whose statement from Venice had not yet circulated—although he had written a very candid article in the *3. Welt Magazin* soon after his return—was invited as a young new colleague.[25] He presented a paper far removed from the actual conference subject on the "Return of Cultural Property."[26]

In his talk, he gave an unvarnished account to the expert audience of the state of discussions in the German Federal Republic, hitherto kept confidential: "The general thrust is a rejection of the resolution [of 1973]: we are not returning anything."[27] He also commented expressly and critically on the position paper written by Kußmaul in 1974—"who also strictly rejects a return…and suggests a number of measures…that do not address the heart of the matter, which actually have nothing to do with the heart of the matter."[28] Eventually, he reported in detail on the expert committee meeting in Venice. He emphatically underlined the involvement of a larger public that had been recommended there: "It was considered entirely obvious that it would unfortunately be futile to hope for any kind of concrete result—apart from perhaps under pressure—as long as it is not possible to have a wider public discussion on this issue."[29]

Ganslmayr spoke openly with the press both during and after the Lindau conference. On 1 June 1976, Reuters, the biggest international news agency at the time, distributed a long report on the subject of German restitution, which not only extensively quoted Ganslmayr but also referred to the documents he had received from the Foreign Office.[30] Ten days later, the *Christian Science Monitor* in Boston picked up the report and printed it in abbreviated form.[31] By July, the leading Paris-based magazine, *Jeune Afrique*, reported on Ganslmayr's position under the heading "Une bonne querelle" [A nice bust-up]. "Are the African works of art which are held in Western museums going to see their countries of origin again?," asked the French-language magazine.[32] "This is a wish expressed by Dr. Herbert Ganslmayr. And as it is known that the latter is president of the ethnological museums at ICOM and director of the Übersee-Museum in Bremen, it is not surprising that his wish caused an almighty hue and cry among the responsible curators."[33]

On top of this, a few months later the well-known German TV journalist Gert von Paczensky broadcast a long feature on the restitution subject on Radio Bremen. He was a friend of Ganslmayr's and had witnessed the end of the colonial era as a correspondent in Paris and London. He had made a name for himself as a pugnacious expert in anti-colonial matters by publishing a scathing five-hundred-page pamphlet in 1970, entitled *Die Weißen kommen: Die wahre Geschichte des Kolonialismus* (The Whites Are Coming: The True Story of Colonialism).[34] In his broadcast on 22 January 1977 he referred to the "rather deaf ears" of German museum directors and lashed out at Kußmaul's confidential anti-restitution statements.[35] According to the Stuttgart director, Paczensky said, the treasures in the German museums had been "acquired correctly." Speaking on the radio he commented that "we should of course ask what correctly means exactly, is it the violation of the weaker party, the cultural exploitation of colonies, might is right, respect for receivers of stolen goods, profiteering by smugglers—all these sources contributed to filling the collections and museums of the West."[36]

Indeed, Ganslmayr's conversations with the press raised an "almighty hue and cry." There are countless documents relating to the response to his activities in the administrative archives of several ethnological museums, in the archives of the German Commission for UNESCO and the German Museum Association, in the Geheimes Staatsarchiv Preußischer Kulturbesitz (Secret State Archives of the Prussian Cultural Heritage Foundation), and in the Political Archive of the German Foreign Office. The archives also preserved numerous photocopies of an angry letter by Kußmaul on seeing the *Christian Science Monitor* article, addressed to the culture ministry of his state Baden-Württemberg and dated 15 July 1976, which he had copied, together with the *Christian Science Monitor* article, to a dozen museum directors, culture officials and ministerial civil servants across the FRG.[37] This letter, its numerous recipients and their replies are remarkable for three reasons: they demonstrate the mechanisms of institutional solidarity and conservatism in the cultural offices of the FRG, which one may only have otherwise suspected. They show how unverified and even false information was circulated to support certain arguments and influence opinion. And finally, they reveal how non-compliant behaviour (as in the case of Ganslmayr) caused massive and sustained reflexes of marginalisation and combat, a phenomenon still known today.

In his angry letter, Friedrich Kußmaul frankly asked the regional government of Baden-Württemberg—and all his male colleagues and contacts in ministries and offices to whom he sent copies—for a united front against Ganslmayr in order to prevent "individuals from going rogue."[38] Once again he argued against restitutions because of the supposed inability of countries of origin to preserve their cultural heritage. He described the consequences of the "uncompensated" restitution of *one* object from the Übersee-Museum to Nigeria, as announced by Ganslmayr in the *Christian Science Monitor*, as "devastating" for museums. Finally, he presented three examples to support his argument that formerly restituted artworks inevitably reappeared in the European art trade, and must therefore on no account be handed over.

It is worth briefly reviewing these three examples. They show very clearly how a museum director used his supposed expertise in order to spread unverified rumours among his colleagues, but above all in political departments and ministries to influence political decisions with fake news. In the first case, Kußmaul maintained to have been contacted shortly before by a dealer who wanted to sell him "West African carvings from the Völkerkundemuseum in Dresden."[39] While these still bore Dresden inventory numbers ("even though slightly blurred"), they had not arrived directly from the GDR. Rather, they had found their way back to Europe, and in this case to the FRG, after being restituted from the Dresden museum to the National Museum of Mali in Bamako. "According to a credible account of the person I spoke with at the time," Kußmaul elaborated

without naming him, "an acquaintance of his could select the pieces [in Bamako] from a larger group of similar objects."[40] Even though Kußmaul corrected his misinformation in a subsequent letter and no longer mentioned Dresden but rather Leipzig as the original location of the objects, research has shown that no restitutions took place from either Leipzig or Dresden to Mali in the 1970s, so the "West African carvings," if they really were offered to Stuttgart and actually bore inventory numbers, may have come directly from the GDR.[41]

The second example was a prominent case at the time and had made headlines in the international press. In 1973, a member of the Cameroonian Kom community had recognised a statue that had been stolen seven years earlier from Laikom, his hometown and Cameroon's capital, when he visited Dartmouth College in Vermont. The object was soon claimed by Cameroon and indeed returned after some negotiations. Known as the famous "Afo A Kom" case, this is an example of the private restitution of an object that had left its source country illegally only after Cameroon's independence. Now, Kußmaul informed the Baden-Württemberg culture ministry with typical impudence: "According to information received here, the piece is said to have passed through the London art trade already in the autumn of 1975."[42] In reality, at that time the Kom statue was back with its rightful owner, the king of the Kom in western Cameroon, who used it for ritual purposes. Not until 1985 did he agree again to send it on loan for a travelling exhibition in the United States. The case was recently researched in detail by a team of lawyers at the university of Geneva.[43]

Kußmaul's final example regarding the risk of returns concerned Nigeria. The Swabian museum professional maintained that a "Swiss dealer" had recently "shown him an important Benin mask" that had once been restituted but had been "resold by the Nigerian government itself in exchange for a multi-million sum."[44] The piece had only been shown to him "as a photograph," but a co-worker of Kußmaul's had described it as "probably the most important among the known Benin masks" ever. A few months later, a letter from Ekpo Eyo in Lagos, Nigeria, arrived in Stuttgart. Eyo had heard of Kußmaul's statement and called it a "complete fabrication,"[45] and he took his Stuttgart colleague to task and gave him a lesson in museum ethics: he strongly urged Kußmaul to adhere to a more scholarly approach to provenance information, in the interest of "our profession...museology."[46]

Over the following days, Kußmaul's initiative achieved maximum impact. Responses to his letter soon began to arrive, and a clear front formed against Ganslmayr, who was excluded from all further meetings and agreements. On 28 July 1976, the Africanist Jürgen Zwernemann, director of the Museum für Völkerkunde Hamburg and a former colleague of Kußmaul's ("Dear Fritz!") wrote that he was "certainly ready to participate in a joint initiative."[47] On

5 August, the president of the Stiftung Preußischer Kulturbesitz wrote in a letter to Kußmaul that his "view was fully shared here" and announced that he would pass Kußmaul's letter to the Federal Ministry of the Interior, which he duly did in duplicate.[48] On 11 August, even the moderate Africanist Eike Haberland, a professor in cultural and ethnological studies at the Johann Wolfgang Goethe university in Frankfurt am Main since 1968 and head of the local Frobenius Institute, declared that it was "utterly impossible [for Ganslmayr] to give statements here without agreement with all concerned in Germany."[49] A few days later, Kußmaul reported with satisfaction that "all major German museums [had] unanimously agreed with him...all—like myself—terribly alarmed by this threat."[50] Ganslmayr himself also received angry letters, which his colleagues copied to Kußmaul as a sign of solidarity.[51]

Why West German museum professionals experienced such a jolt of fear and why they reacted so decisively in the summer of 1976 can probably only be explained by the previous sense of security they had gained through manoeuvering behind closed doors in 1974 and 1975. "We had come to the conclusion," Kußmaul wrote in July 1976, "that the Africans' claims had hardly any legal or moral foundation. With great satisfaction we later found that the government of the country had largely agreed with our view."[52]

The dismay must have been all the greater when a young colleague with different networks, a different horizon of experience, a close relationship to the press and a different set of loyalties questioned this "conclusion" reached in the smallest of circles. The president of the Stiftung Preußischer Kulturbesitz came straight to the point on 2 September 1976, expressing a sense of failure of the strategy he and others had previously adopted: "The report by Dr. Herbert Ganslmayr on the UNESCO expert commission meeting in Venice (March/April 1976) shows that African and Asian countries, but also countries like Greece, are clearly still eager to continue the debate about the 'restitution' of cultural property to countries of origin. The preparatory UNESCO recommendation regarding the exchange of cultural property from museum collections therefore does not seem to have curbed the activities as expected."[53] The diversionary tactic of replacing a discussion about the restitution of artworks—as demanded by the former colonised countries—by a discussion about their circulation did not prove to be successful even then.

A large gap appeared in 1976 between the strategic "expectations" of West German museum officials and the actual developments of the global restitution debate. It was all the more visible when in 1976 all efforts finally failed to keep the issue out of the public eye. Now, even German newspapers published articles on the subject, for example the *Mannheimer Morgen*, which produced a long and thoroughly researched article by Renate Schettler on 23 August 1976 that commented once more on the expert committee meeting in Venice. Based

on an overall view of the "difficult subject," it concluded: "Dismay, rejection, timid signs of good will in the Western world are facing further demands from the Third World."[54]

Especially instructive with regard to the new role of the press in the debate was a report on 10 November 1976 by the daily newspaper *Frankfurter Allgemeine Zeitung*.[55] With reference to a dpa press report, the paper reported on urgent requests from "countries on the southern hemisphere" to effect a return of their abducted artistic treasures from the "industrial nations." In November, the UNESCO General Assembly was scheduled to take place in Nairobi in Kenya. The choice was loaded with symbolism as for the first time since 1954 it was not to be held in Paris but in an African country. The German newspaper *FAZ* announced that the Frankfurt Africanist Eike Haberland—not a museum professional—would represent the German Federal Republic in Nairobi. He was quoted prior to departure with words that were marked in red pencil by the Stiftung Preußischer Kulturbesitz in Berlin and prompted renewed upheaval, confidential letters to the Federal Ministry of the Interior, an acrid letter from the Assembly of Education Ministers to the Foreign Office and many photocopies: "The Federal Government," Haberland said, would "be open to negotiations in this matter." It felt obliged to "gestures of goodwill…especially from a moral perspective." "The patrons of the German museums—the Federal Government, the regional states, the municipalities, and private organisations"—would still need to put in some "hard graft," but from his point of view "the return of artworks, while controversial, [did] not [pose] an existential question for ethnological museums in the Federal Republic."[56]

This moderate statement reflected the line of argument already pursued by the Foreign Office since 1972. It was, however, still forcefully rejected by the museums: "Although I can understand that the Federal Government finds it necessary to take a 'harmonising and conciliatory stance on the restitution question,'" as the president of the Stiftung Preußischer Kulturbesitz, Wormit, appealed to the federal interior minister, "this should nevertheless be prevented under all circumstances."[57] The struggle for Africa's heritage was therefore not a struggle of the Africans. In Europe, it was also a struggle between foreign and interior policy, between diplomacy and museums, between information and disinformation.

In Nairobi, following intense discussions, the UNESCO member states passed a new, far-reaching resolution (no. 4.128) for the purpose of founding an "intergovernmental Committee entrusted with the task of seeking ways and means of facilitating bilateral negotiations for the restitution or the return of cultural property to the countries having lost them as a result of colonial or foreign occupation." The lengthiness of the title reflects the political and semantical trench warfare over the resolution.[58] The decisive element for the next steps

until the actual founding of the committee was the resolution's recommenda-
tion that UNESCO should seek advice from an associated non-governmental
institution. This was done: the International Council of Museums was tasked
with compiling a report about the forms and functions of the future restitu-
tion committee. To this purpose, it nominated an internal and very high profile
special commission at its general conference in Moscow in 1977, the Ad Hoc
Committee for Restitutions consisting of the French Hubert Landais (ICOM
president at the time); the Algerian Tayeb Moulefera, well versed in museum
ethics (director of the Independence and Resistance museum in Algiers, the
Musée National du Moudjahid)[59]; the Congolese Pascal Makambila (museum
director in Brazzaville in the Republic of Congo); the British Geoffrey Lewis
(museologist at the university of Leicester); the French Paul N. Perrot, who
had emigrated to the United States after the Second World War (staff at the
Smithsonian Institution in Washington, DC); and some others, including Her-
bert Ganslmayr from Bremen.[60] The Ad Hoc Committee for Restitutions had a
decisive role over the next few months, yet from the West German perspective
it was seen as a provocative red rag. The seasoned journalist Doris Schmidt,
who had travelled to Moscow, commented in *Süddeutsche Zeitung* newspaper:
"There is even talk of a professional code of ethics for museum people, they
could be required to swear a sort of Hippocratic oath."[61]

Three days after the end of the Nairobi conference, where the issue of resti-
tution had risen to the surface yet again, the board of the Stiftung Preußischer
Kulturbesitz had a meeting in Berlin. On this occasion, a board member posed
the question whether it could really be proven that *all* objects in the Prussian
Heritage collection had been acquired legally. The response by the Berlin
museum directors recorded in the minutes was brief, concise and brazen: "The
President and Professor Dr. Waetzoldt answers in the affirmative."[62] By 1976, it
was obvious that when it came to provenance, museums were lying, too.

1977

FESTAC '77

Wole Soyinka, the Nigerian writer who would win the Nobel Prize for Litera-
ture, had been professor for a year and a half at the University of Ife in Ile-Ife,
the sacred Yoruba city in the state of Osun in Nigeria, when the Pan-African
World Black and African Festival of Arts and Culture (Festac) took place in
the capital Lagos at the beginning of 1977. The major event was the follow-up
to the Festival mondial des arts nègres (World Festival of Black Arts), which
had been inaugurated in Dakar, Senegal, in 1966. Its objective was the revital-
isation and promotion of "black and African cultural values and civilization."[1]
However, the festival had been appropriated by the Nigerian military regime to
a considerable extent and was accompanied by a whiff of unbridled oil-fuelled
capitalism, and as such was criticised by many contemporaries, perhaps most
poignantly by Soyinka. He left the organisation committee and even years later
described the event as "a gargantuan orgy of ill-organised spectacles."[2] But in
spite of immense costs, megalomaniac construction projects and a large num-
ber of shortcomings, Festac '77 is today regarded as one of the greatest cul-
tural events of the twentieth century on the African continent. Because of the
speeches and the events held there, it occupies a crucial position in the history
of the Pan-African movement and the restitution debate.[3]

Festac was meant to take place in 1970, however, owing to the Biafra War,
it was first moved to 1975 and then, because of government crises, to 1977. For
the festival, the Nigerian government erected a futuristic cultural centre in
the heart of Lagos, based on the design for the Palace of Culture and Sports
in Varna, Bulgaria, and erected by the Bulgarian company Technoexportstroy.

The new complex offered two exhibition halls, a hall for concerts and events seating five thousand people, a conference room seating sixteen hundred people and two cinemas. Most of the Festac '77 events took place there and in the Lagos national stadium. In parallel, the Nigerian National Museum showed highlights of two thousand years of Nigerian art in an exhibition curated by Ekpo Eyo.[4] On the outskirts of the city construction began, but was not completed in time, on the Festac Village, a state-of-the-art residential quarter for several thousand participants.

Beyond Pan-African ideals, the million-dollar event was designed to demonstrate Nigeria's entry into the modern world and to prove the economic as well as cultural power of the youthful petrostate. Despite widespread poverty, the country was bursting with vitality. It had recovered from civil war, had become Africa's largest oil exporter, maintained a lively art and literary scene, and had developed several well-equipped universities, a solid antiquities administration, several museums, cinemas and theatres across the country. "We are no longer the Third World. We are the First World"—this phrase by the festival president and military officer Ochegomie Promise Fingesi was much quoted in the press and can be read as a subtext for the entire event.[5]

Between 15 January and 12 February 1977, hundreds of intellectuals and artists from all over the African continent encountered representatives from the North and South American, Caribbean, European and Australian diasporas in the Nigerian capital. Among the guests were figures as diverse as the then incumbent president of Senegal and poet, Léopold Sédar Senghor—father figure of the black dawn in the Francophone world and the guiding spirit of the precursor festival in Dakar—the UNESCO director-general Amadou Mahtar M'Bow, African American pop stars like the young Stevie Wonder or the South African anti-apartheid activist Miriam Makeba who lived in exile in the United States, the Brazilian singer Gilberto Gil as well as artists, scholars, film directors, writers, dancers and actors. From Germany came the twenty-seven-year-old Togolese painter, printmaker, sculptor and writer Edoh Lucien Loko (El Loko), who was already on the path to an international career as a student of Joseph Beuys and graduate of the Düsseldorf art academy.[6]

The international press reported on the spectacular occasion. In the high-circulation *Jornal do Brasil*, the art critic Roberto Pontual described the event over two full pages under the heading "Consciència e destino do negro a través da arte" [Awareness and destiny of blacks as reflected in art].[7] In London on 18 January 1977, *The Times* featured an eight-page special on "black arts and culture," where different writers dealt with the "outbursts of creativity" of black arts and culture professionals.[8] On 27 January 1977, *Le Monde* ran the headline "Africa single-handedly reconquers itself."[9] In *The New York Times* on 13 February, a headline noted the "decided success" of the event,[10] and the US magazine

Newsweek referred to the festival as "a seminal event for thousands of Africans and hundreds of American blacks."[11] In the German-speaking world, however, the event was either hardly mentioned at all or rather unfavourably: "15,000 people with dark skin colour from 57 countries, from Jamaica to Papua New Guinea, among them also 500 US negroes, were exploring common roots in Africa through dance, theatre, song and discussions—and were mostly united only in their rejection of the white world," as the magazine *Der Spiegel* noted on 14 February 1977.[12]

In fact, Festac '77 revolved around issues of self-empowerment and independence—that is the radical shaking off of colonial dependency in aesthetic, linguistic, spiritual, academic and epistemic terms. "White friends of black art did not feel very welcome at the festival," *Der Spiegel* noted accordingly and reported that about 150 Frenchmen had "needed to cancel a Boeing airplane chartered for the sole purpose of an educational trip to Lagos, since the Nigerian embassy in Paris had refused to issue them with visas without providing any reasons."[13] While France as Senegal's former colonial power had exerted decisive influence over the festival's programme during its first instance in Dakar in 1966, especially with regard to the large exhibition *Art Nègre* (see 1965: Bingo), the organisers of Festac '77 insisted on independence from the outset. As early as 1973, they urged their Senegalese partners in the organisational committee to change the festival's name from "negro art" to "black and African culture," thus expanding the radius of Africa to include all diasporas.[14] They also pushed through a new logo early on, much to the chagrin of their Senegalese co-organisers: the Queen Idia mask from the British Museum.[15]

The choice of the Queen Idia mask for the festival's logo was a conscious act of political iconography that had been planned long in advance. Festac was supposed to have adopted the Dakar festival's logo—an abstract print reminiscent of a figural relic by the artist Ibou Diouf. But Nigerian committee members made it known at an early stage that they found it too primitivist, too totem-like and that it "did not represent Black culture in a proper manner"; they would therefore look for alternatives.[16] The logo issue then turned political, causing a split in the festival's committee and leading to a temporary boycott by the Senegalese members.[17] Nevertheless, Nigeria prevailed with its choice of Idia, and an agreement was reached for a solution that was unusual even in 1970s advertising: a black-and-white photograph of the artwork surrounded by simple lettering. The choice of logo was politically signficant: the precious artwork recalled the rich precolonial history of Nigeria; it was institutionally explosive because of the mask's location in the British Museum; and it was based on the politically charged photograph that had been used as the cover image for Nigeria's official pamphlet for the festival in Dakar in 1966 (see 1965: Bingo).

Eleven years after the Dakar festival, the Queen Idia mask was branded as the

Festac '77 logo leaving an indelible mark in the collective image consciousness and historical awareness of an entire generation far beyond Nigeria. From the festival archives it is clear that the image policy was well considered and oriented along the lines of standards emerging at the time for modern public communication and corporate design. The use of the logo was precisely defined and private companies were urged to apply for commercial use.[18] The logo appeared in the hundreds of thousands on all of the festival's official letterheads, entry tickets, flyers, catalogues, programmes and posters; it hung on huge black-and-gold festival flags in Lagos and adorned the Nigerian capital's promenades, parade grounds and stadiums on large textile banners; it also appeared in advertisements by shoe companies, travel agents and breweries, on finely 1970s-designed record covers (plate 7) and on the stamps of various countries (including Brazil). The Nigerian Central Bank even later put the mask on its new one naira note.[19] In every single one of the official publications for Festac '77, even in the most basic information pamphlets, the logo was accompanied by the following text:

> The Festival Emblem: This 16th-century Ivory Mask from Benin has emerged through the years as one of the finest examples of known African and black art. It was worn as a pectoral by Benin Kings on royal ancestral ceremonial occasions; was last worn by King Ovoramwen who was dethroned at the fall of the Benin Empire in 1897. The same year, it fell into the hands of the Consul-General of the Niger Coast Protectorate, Sir Ralph Moor, and now rests in the British Museum. The tiara formation at the crest of the mask is made of ten stylized heads and symbolizes the King's divine supremacy and suzerainty. The two incisions on the forehead which were originally filled with iron strips are royal tattoo marks. Round the neck, the artist has carved the coral bead collar which is a common feature of the King's paraphernalia.[20]

This precise art historical and cultural placement of the British Museum artwork with its text that was reproduced a hundred thousand times was part of a distinct Nigerian strategy. Broadly communicated, presented alongside sound knowledge, yet eloquently silent about the Nigerian implications of its London location—the subtext of the image was clear, memorable and ubiquitous.

The organisers, as Wole Soyinka recalled, had chosen the ivory mask from the British Museum "in the confident belief that it would be released by its keepers and put on display."[21] From 1973, to just before the opening of the festival at the end of 1976, the Nigerian Department of Antiquities under Ekpo Eyo had indeed tried to get not only this celebrated artwork but also several other African and early Egyptian objects on temporary loan from Western museums for an exhibition planned to coincide with Festac. Eyo's historical exhibition

project featuring African art with international objects was a continuation of the model tried and tested in Dakar, Senegal, in 1966 and in Algiers, Algeria, in 1969. But while in Senegal the French museums had been co-organisers from the start, and in Algiers the museum director was French, in Nigeria the authorities had tried on their own to encourage museums to become lenders—in vain. Entire reams of documentation in European archives, including protocols, letters and newspaper clippings, bear witness to the intense yet unsuccessful negotiations by the exhibition curator Ekpo Eyo and his colleagues in the state museums of the "North" and in diplomatic circles. These documents clearly reveal how the European museums evaded entering into a dialogue.

Ekpo Eyo seems to have twice—in 1973 and 1975—abandoned a planned trip to Vienna, Stuttgart and Berlin, after the mere announcement prompted these European museums to adopt a defensive position (see 1975: Pause).[22] Nevertheless, he went to London for several months in 1976, as becomes clear from a letter *inter alia* written to his Bremen colleague Herbert Ganslmayr.[23] At the end of the 1950s, Eyo had spent several years in the British capital and in Cambridge as a student; he had an excellent network there. Thanks to a group of files with hundreds of confidential documents and letters from the British Foreign & Commonwealth Office (FCO) recently released for research purposes, his efforts to be granted loans from the British Museum can be reconstructed in excellent detail.[24] These documents show, for example, how the FCO—which for obvious geopolitical and economic reasons was greatly interested in good relations with Nigeria—supported Eyo's scheme and, unsuccessfully, put pressure on the British Museum for months to grant loans. Even when the Nigerian authorities abandoned the plan to receive several objects on loan in order to focus the negotiations solely on Queen Idia, the British Museum did not give in.

In a confidential document first published by Dr. Felicity Bodenstein, an FCO employee characterised the arguments of the British Museum: "Firstly, they do not entirely trust the Nigerians to return it....Secondly, the mask is extremely delicate and apparently needs to be kept free from vibration and movement....The Museum could reasonably anticipate that the Nigerians would not treat it with the care it demands, especially since the Nigerians would tend to think of it as their own property."[25] This is another example of the restitution issue leading to tensions between foreign policy and museum administrations. In addition, technical arguments were raised against the circulation of objects even though these did not play a role in other constellations—such as loans within the Western world—or seemed surmountable. The concern that the Nigerians could regard the object as "their own property" and therefore neglect to care for it speaks volumes about the self-perception of Western institutions.

The sole concession was that the FCO was able to eventually wrestle from the British Museum, after a great deal of toing and froing, the production of

1977

a faithful copy of the ivory mask from man-made material, which was to be offered to Ekpo Eyo as a substitute for the original. Eyo made it unmistakably clear that he considered the offer insulting.[26] The copy was only made after Festac had ended and it is still in the British Museum today. In the object database it is listed as follows: "This cast...was made in June 1977 but was not requested by the Nigerian government."[27] The art exhibition curated by Ekpo Eyo to coincide with Festac ultimately had to go ahead without British loans, without Queen Idia and without a whole lot of visitors.[28] A carefully but simply designed illustrated booklet was published in which Eyo presented almost one hundred sculptures from different museums in Nigeria in a chronological sequence, each with a brief academic text. The selection was, according to Eyo, "the most authentic evidence of Nigeria's past."[29] In addition to this modest publication, a sumptuous catalogue was published in the same year as Festac, printed in Switzerland and clothbound, with high-quality black-and-white illustrations of more than two hundred and twenty works of Nigerian provenance—almost all of them from museums in Lagos, Jos and Ife—and an extensive scholarly text by Ekpo Eyo.[30] The illustrations were provided by the renowned Swiss couple André and Ursula Held, photographers and collectors from Lausanne, who had completed their photo campaign in 1974. In his commentary, Eyo expressly called for a revision of the art historiography of Nigeria by Nigerian scholars. At the same time, he deconstructed European art historical categories and terminology as only partially useful for understanding and researching African art. In the preface to the catalogue, still considered a standard reference book today, the popular Nigerian President Murtala Muhammed, who governed until his assassination in 1976, welcomed the fact that the book had been written by an "indigenous author" and that there finally was a publication where "Black men and women" could quench their thirst for knowledge about their heritage in an academically sound and aesthetically pleasing presentation.[31] "It is to be hoped," the foreword concludes, "that the book will stimulate a deeper interest in the subject, heighten the desire to see the objects themselves and assist towards their preservation in the museums throughout the country which, as the author rightly says, house the ethos of the nation."[32]

Ekpo Eyo's ambitious exhibition project in the framework of Festac '77 had failed because it was opposed by Western museums, and was met with little response in Lagos. But because the Queen Idia mask had remained in London, further impressive contributions by African scholars, or scholars from the United States with African heritage, appeared in addition to Eyo's publications. Their contributions dealt with the issue of cultural property, with the epistemological access to African art, with historiography, with the role of museums in the emerging state and with the necessity of a collective, not least intellectual, reappropriation of one's own cultural heritage. One article by a

young Black lawyer and lecturer at Stanford University, Alma Robinson, stands out. Writing in one of the main Festac publications, on "African Art in Foreign Hands" from a legal and African perspective,[33] she did not mince words when criticising, for example, the lack of support for UNESCO resolutions by European countries, or when stating that Africans demanded access to their own history and their own cultural heritage "with justifiable urgency."[34] In addition, the article, extensively researched and sourced, addressed the contemporary fight of African authorities against the illegal export of antiquities by "art dealers, diplomats, airline crews, military experts and foreign aid professionals," in Robinson's words: "the crème de la crème of illegal traffickers."[35]

Robinson's article was widely read. It inspired, for example, the archaeologist and museum curator Emmanuel Kofi Agorsah from Accra in Ghana, who copied large parts of it verbatim—without citing the source—and added a few thoughts and examples from his own museum practice published under the heading "Restitution of Cultural Material to Africa" in the specialist journal *Africa Spectrum* issued by the Institute for African Research in Hamburg.[36] In the article, Agorsah justified the necessity of restitutions, among other points, with the argument that knowledge associated with the objects was only available in a local context and urgently needed to be recovered from older generations in order to avoid misinterpretations. Furthermore he described the positive role of culture for the postcolonial nation-building process on the African continent and repeated Robinson's observation that "some people…still deride the current efforts for restitution as a 'nationalistic' drive contrasting it with nobler sentiments of the 'universality' of art."[37] Clearly, Agorsah was already familiar with the ongoing discussion in Western countries. He also emphasised that restitution demands only concerned a few objects. In closing, he pointed to the still important fact that the restitution debate was an element "in the on-going struggle against colonialism, racism and apartheid."[38]

In Nigerian academic circles, the focus was on intellectual reappropriation of the nation's cultural heritage. Therefore, Nigeria's concrete demands to German and British museums were not often commented on. However, the fact that these demands were very much on everybody's mind during Festac and were constantly discussed in artist circles and in the popular press should not be underestimated: in 1977 the subject of the absent yet ubiquitous Queen Idia mask rapidly proliferated in the media and in literature, both in Nigeria and beyond. A melancholy poem by the thirty-year-old lyricist Niyi Osundare gives a hint of the rich world of emotions and nostalgia which he associated with the work. The poem was only published in 1983, but according to its title it was written on the occasion of Festac '77. Just as Friedrich Schiller wrote in 1802 that the antique statues seized by the sacrilegious French in Rome during the Napoleonic art raid would "be forever silent" in Paris, Osundare wrote of the

silent language of the uprooted object. He interwove Yoruba proverbs with the English lines, which evoke the experience of exile while eluding the comprehension of the "mere" English-language reader:

On seeing a Benin Mask in a British Museum (For FESTAC '77)

Here stilted on plastic
A god deshrined
Uprooted from your past
Distanced from your present
Profaned sojourner in a strange land
Rescued from a smouldering shrine
By a victorianizing expedition
Traded in for an O.B.E.
Across the shores

Here you stand, chilly,
Away from your clothes
Gazed at by curious tourists savouring
Parallel lines on your forehead
Parabola on your cheek
Semicircles of your eye brows
And the solid geometry of your lips
Here you stand
Dissected by alien eyes.

Only what becomes is becoming
A noose does not become a chicken's neck
Who ever saw a deity dancing langbalangba
To the carious laugh of philistine revelers?

Ìyà jàjèjì l'Egbè
Ilé eni l'èsó ye'ni

Retain the tight dignity of those lips
Unspoken grief becomes a god
When all around are alien ears
Unable to crack the kernel of the riddle.[39]

Even beyond literary circles, Queen Idia was omnipresent. The Nigerian press had closely followed the negotiations in London about its loan for a considerable time. Even in the summer of 1976 it had warned against the profound disappointment that would be caused by retaining the mask in London. "If we failed to retrieve all our priceless antiquities from the looters, it would always

be on record that the hands that gave expression to the IFE and Benin bronzes now lying in the mortuary of British, American and the European museums are those of authentic Black Nigerians," as the journalist Willy Bozimo wrote in a long article in the summer of 1976 about "Nigeria's Antiquities Abroad" in the Lagos-based *Daily Times*, Nigeria's most important daily newspaper.[40] After the actual opening of Festac, the tone became more critical as it was finally clear that the Idia mask would not be visiting. On 15 January 1977, the young journalist Mahmoon Baba-Ahmed suggested in the Kaduna-based *New Nigerian* that "Britain should be condemned for her intriguing attempts to undermine the success of the festival."[41]

The international press also picked up the subject. In Paris, *Le Monde* reported about the frustration caused in the Nigerian press by the absence of a "noble gesture" from London.[42] In the United States, the *Washington Post* published a detailed report on 11 February about the "controversial mask of Benin," written by Alma Robinson, the aforementioned lawyer who connected the Nigerian case with UNESCO's general efforts on restitution.[43] And the US fashion magazine *Ebony*, whose explicit goal from inception had been to strengthen the confidence of African Americans, started its eleven-page report about Festac '77 with the potent image of the ubiquitous, mysterious Queen Idia in the sweltering heat of Lagos, drawing a bold comparison between its fate and that of the African diaspora: "Like those millions of blacks, uprooted from Mother Africa and enslaved on foreign shores, the original mask had been stolen during England's 1897 conquest of Benin and shipped to the British Museum in London. Recently British authorities refused to lend the ivory original to Nigeria for display at Festac. It was too fragile for shipment, they claimed. But neither British intransigence nor the historic tension between the West and Africa it illustrated…could stem the rising tide of history."[44]

In short, through Festac, the issue of restitution reached many circles, generating widespread public outrage far beyond Nigeria. At the same time, signs of a radicalisation became apparent in the debate, albeit only verbally. In his autobiography first published in 2005, Wole Soyinka retrospectively claimed to have suggested in the context of Festac '77 that the Queen Idia mask should be stolen back from the British Museum instead of conducting diplomatic negotiations: "In a moment of righteous rage at ancient wrongs, I went so far as to offer advice that the government should stop drawing further attention to the mask, since it would only place its illegal guardians on the alert. The mask was stolen property, and the aggrieved had a right to reclaim their property by any means. What I proposed instead was that a task force of specialists in such matters, including foreign mercenaries if necessary, be set up to bring back the treasure—and as many others as possible—in one swift, once-for-all-time, coordinated operation."[45]

Whether Wole Soyinka really made this suggestion in the mid-1970s can hardly be verified. However, it is clear that two years after the end of the festival in Lagos the motif he described—a robust operation to bring home African objects from European museums—became a popular narrative in pop culture, at least in cinematic terms: in 1979, the Nigerian director Eddie Ugbomah made the film *The Mask* (see 1980: Battle of Lists), and later films were also inspired by the subject, for example *Invasion 1897* by the Nollywood director Lancelot Oduwa Imasuen from 2014, in which a Nigerian student steals a bronze head at night from a showcase at a London museum, is caught in the act and arrested. In the end, a British judge in wig and robe exonerates him, with the scene culminating in a touching embrace with a policeman in court.[46] Also, the now legendary Afro-Futurist film *Black Panther* (2018) from the US Marvel Studios develops in front of a showcase at a fictitious British Museum, soon smashed by a young African American.[47]

In 1977, the subject of restitution and African frustration about it reached a peak in English-language academic and popular perception. The failure of Nigeria's request and London's intransigence led to intensified strategic considerations both in international bodies and national administrations. In both camps (pro and contra restitution) the question was not so much a fundamental *if*, but rather a pragmatic *how*: how could restitutions actually happen, asked their proponents, and how could they be prevented or at least significantly delayed, asked the opponents.

A report by ICOM's Ad Hoc Committee for Restitutions in August 1977 proved to be of fundamental importance for the future of the restitution debate. Under the heading *Study on the Principles, Conditions and Means for the Restitution or Return of Cultural Property*,[48] the report discussed questions regarding the statute of limitations of cultural property transfers and successor states, "psychological obstacles" against restitution that needed to be overcome in Europe, the necessity to raise public awareness as well as technical aspects of museological cooperation, among them issues of access to collection documentation and of the transparency of holdings, both of which are still highly sensitive today. In 1978, this report was to play a key role in UNESCO's great year of restitution.

1978

ATTACK, DEFENCE

In October 1978 the German daily newspaper *Die Welt* led with the headline "The Ethnological Museum—a Den of Thieves?"[1] The article stated that Europe could no longer ignore restitution demands from former colonised countries: "Calls from developing countries for the return of indigenous art treasures are becoming louder and louder."[2] Indeed, over the course of 1978 the voices of those who had fought for over a decade for restitution on the African continent reached ever-wider circles.

At the beginning of the year, the FRG press agency Reuters informed German readers that Tanzania, "which had been a German colony until 1918," demanded the return of its artworks.[3] In April, *Süddeutsche Zeitung* published a long article on page three by its Africa correspondent Peter Seidlitz entitled "Black People Demand the Return of their Soul."[4] The first paragraph mentioned the heads of executed African resistance fighters that had been collected as trophies in German East Africa (in today's Tanzania) by the German *Schutztruppe* and had been preserved in German museums ever since. The final paragraph illustrated the situation in Zaire for German readers with a simile: it was "as if no Dürer were hanging in Nürnberg or elsewhere in Germany anymore and we had to travel to India to see that which is part of our culture."[5] Twice in 1978, in June and in October, the subject of restitution made it into the 8 p.m. evening news of the French TV broadcaster TF1. *The Times* in London as well as Belgian and Dutch newspapers also became more and more involved in the debate. UNESCO and its director-general since late 1974, the Senegalese Amadou Mahtar M'Bow, played a significant role in the rising

media interest. From an African perspective, the year 1978 certainly marked a peak in the restitution debate.

At an international working level, four milestones shaped the course of events: a second meeting for experts on restitution organised by UNESCO in Dakar in March 1978; the famous plea on "the return of an irreplaceable cultural heritage to those who created it" by M'Bow in Paris in June; an international seminar at the beginning of October for media representatives and museum professionals, invited to Palermo by UNESCO to discuss "the right to cultural memory"; and finally in November, the UNESCO 20th General Assembly in Paris, where it was decided to establish an intergovernmental restitution committee. These four events were part of a long-planned and well-prepared campaign by UNESCO and its director-general, which was orchestrated by the organisation's highly professional PR team under the leadership of the Italian journalist and writer Lucio Attinelli. The aforementioned events generated significant press interest and left numerous traces in administrations, offices and archives.

From one month to the next during 1978, the pressure on European museums increased. In the archives of the German Federal Republic, dozens of letters, reports, statements, memos and press clippings document the concerns of leading museum directors in Bonn, Berlin, Stuttgart, Hamburg and Munich, who were working together in close cooperation away from the public gaze on a strategy to ease the pressure to restitute. Herbert Ganslmayr, the pro-restitution outlier and Bremen museum director, was excluded from all meetings, yet he was all the more active at an international level. In September 1978, the president of the Stiftung Preußischer Kulturbesitz in Berlin wrote of the "tough position" that needed to be taken in the ongoing restitution debate.[6] His position was reflected in autumn 1978 in a sensational, confidential thirteen-page document entitled "Return of Cultural Property," which provided a detailed summary of all positions held by those who had combated restitutions in West German museums and ministries since 1972.[7] It also included practical advice on fending off restitutions. This was a matrix for all the blockades which continue to shape the discussion today.

ATTACK

From 20 to 23 March 1978, the UNESCO director-general M'Bow had invited fourteen international experts to Senegal and his hometown of Dakar. The meeting was a continuation of the expert committee meeting in Venice in 1976 where the recommendations formulated in the previous meeting had been incorporated in the important Nairobi Resolution 4.128. In turn, this had led to the creation of the Ad Hoc Committee for Restitutions at the ICOM

conference in Moscow in 1977. The committee's findings in the *Study on the Principles, Conditions and Means for the Restitution or Return of Cultural Property* were now to be discussed and adapted in Dakar with view to being incorporated in a renewed resolution at the next UNESCO General Assembly in Paris. Venice, Nairobi, Moscow, Dakar, Paris: these were UNESCO-typical stations in a discussion and decision-making process. Some of the participants in Dakar, such as the Nigerian Ekpo Eyo, had already been present two years earlier in Venice, three more had been among the authors of the committee's study of 1977. Two concrete points were on the agenda in Dakar: firstly, draft statutes for an international restitution committee, which had already been envisaged since 1976 and was now to be realised; secondly, the idea of a possible declaration on restitution that could have been adopted by the UNESCO General Assembly in parallel with the "Declaration on Race and Racial Prejudice," which was in preparation.[8]

The Dakar meeting was opened by a representative of the Senegalese Ministry of Education, Ibrahima Koné, who on behalf of his government reminded attendees how much the whole of Africa was concerned by the issue of restitution and how great the need of former colonised countries to present their wealth, their history and their "right to be different" through works by their own "genius."[9] He expressed tentative hope that the nations who had "transferred cultural property" would now respond to the nations concerned in a spirit of goodwill and understanding.[10] Next to speak was the Malian Bakari Kamian, geographer and head of the regional department for Africa in the UNESCO Department for Education, who expressed the wish to reach positive results for the requests from "deprived peoples" through creating suitable cooperation structures and an appropriate normative framework.[11] He also warned against rigid positioning and strongly advocated in favour of international cooperation. Then, museum professionals from Belgium, the Netherlands and Indonesia reported about successful restitutions of cultural property through bilateral negotiations in their countries.[12] Ekpo Eyo for his part described the humiliating failure of his exhausting negotiations with the United Kingdom in preparation for Festac '77.[13]

The international restitution committee then presented concrete procedures for claiming cultural property: "A request for restitution or return may be made by a member state or associate member of UNESCO for any cultural property 'which has fundamental significance from the point of view of the spiritual values and the cultural heritage of the people' of the said member state or associate member of UNESCO and which has been lost as a result of colonial or foreign occupation," the experts stated.[14] The wording directly responded to the 1977 paper of the Ad Hoc Committee for Restitution, which expressly stated that collections should not be returned *en masse* but "only those objects which

have an essential socio-cultural value for the countries in question."[15] Protection of the object was to be the top priority, as in the 1977 paper. "However it is not intended that this fundamental principle could serve as a pretext for refusing to restitute or return the property in question," which corresponded to the declaration on granting independence of 1960.[16] The expert group also addressed issues of public relations and academic transparency in European museums: an international awareness campaign was intended to ensure that "both parties learn to realise the ethical as well as the cultural implications connected with a transfer of such objects."[17] Furthermore, European museums should finally strive for greater transparency with regard to collection documentation: "museums holding collections should make them accessible to research workers from the country of origin," it was stated in paragraph 24 of the final report from Dakar.[18]

Overall, the results of the three-day meeting were not as strict as the committee's paper of 1977 would have led to expect. Nevertheless, they remained pointed enough to prompt the German UNESCO ambassador in Paris, Wilhelm Fabricius, to send the following warning to the Foreign Office in Bonn in April 1978: "Even though the report no doubt reflects a defusing of the debate, great caution and vigilance are still needed."[19] The German diplomat viewed the "information campaign" suggested by the experts as particularly dangerous as it could "possibly ignite new hopes, expectations, and covetousness."[20] These warnings from a diplomat are of interest because they indicate a shift in the position of West German diplomatic circles, who had previously been rather open to restitution. In fact, the Foreign Office no longer supported African restitutions from 1978—at least this is suggested by the preserved archival documentation. In addition, the debate about restitution had now developed into open warfare. While secrecy and avoidance of publicity were still the order of the day in museum circles, the formerly colonised countries and their supporters fought for historical clarification, transparency and the media involvement of a wider public.

Against this background, it may seem surprising that the experts gathered in Dakar in spring 1978 came out against a solemn declaration in favour of restitution and its adoption by the UNESCO General Assembly. They argued that such a declaration could perhaps prove too unwieldy and might not represent UNESCO's most effective tool.[21] In fact, the organisation had other options of generating publicity. One of them was the now legendary appearance of its director-general Amadou Mahtar M'Bow on 8 June 1978 in the Paris headquarters of UNESCO, with his resonant "Plea for the return of an irreplaceable cultural heritage to those who created it."[22] This solemn speech given in French, which was filmed live, is among the most important sources on the issue of restitution. The crucial passage is as follows:

The men and women of these countries have the right to recover these cultural assets which are part of their being. They know, of course, that art is for the world and are aware of the fact that this art, which tells the story of their past and shows what they really are, does not speak to them alone. They are happy that men and women elsewhere can study and admire the work of their ancestors. They also realize that certain works of art have for too long played too intimate a part in the history of the country to which they were taken for the symbols linking them with that country to be denied, and for the roots they have put down to be severed. These men and women who have been deprived of their cultural heritage therefore ask for the return of at least the art treasures which best represent their culture, which they feel are the most vital and whose absence causes them the greatest anguish. This is a legitimate claim.[23]

M'Bow's appeal lasted almost ten minutes. UNESCO had it filmed and recorded,[24] had the French text translated into eighteen languages, printed it in its prominent publications and ensured that it was distributed to key recipients in all UNESCO member states.[25] National media also reported on M'Bow's presentation. But instead of quoting him verbatim and commenting on the content of the speech, many European media, even serious ones, distorted the appeal to the point of ridicule. Especially from today's perspective it is worth noting the mechanisms of this massive media misrepresentation, for they reveal reflexes and coarse exaggerations which are still manifested whenever issues of cultural heritage, museum history and the return of cultural property receive attention as a subject of current debate. In 1979, the UN representative for Senegal, Falilou Kané, stated in front of a United Nations committee tasked with restitution matters in New York: "Regrettably, the media have not always helped to make UNESCO's work in this area well known. Indeed, they have even been responsible for all kinds of misunderstandings."[26]

Whether misunderstandings and misinterpretations were really the problem—rather than a deliberate rejection of demands of formerly colonised regions of the world, nurtured by national arrogance and self-righteousness—is a question that may well be asked with view to the immediate reception of M'Bow's speech. Already on the day after his appearance, the venerable conservative Paris daily newspaper *Le Figaro* printed a front-page article about the UNESCO director-general's appeal. But instead of commenting on its content, the paper posed the question in the first phrase of the opening paragraph whether UNESCO would soon have a host of "horse-drawn carriages full of sculptures and paintings from the Louvre and the British Museum travel the world," as this was "roughly" M'Bow's desire. The latter had actually "solemnly asked the US to make every effort to ensure the return of artworks dispersed in

museums and collections across the world today to their countries of origin." Underneath a portrait photo of M'Bow, the article was illustrated by a drawing by the cartoonist Piem depicting a large body of water in Place de la Concorde instead of the Egyptian obelisk erected in 1836, commented by passers-by with the remark: "We gave back the obelisk and got the Suez Canal in return." The sentence alludes to the construction of the Suez Canal in northern Egypt in the 1860s which had been celebrated as a feat of French engineering, and thus to the idea anchored in French collective consciousness that Egypt owed much to France, was even a daughter of France. Together with the scaremongering image of an imminent complete clearance of the Louvre and the British Museum as well as the fictitious reference to the United States as the vicarious agent of UNESCO, M'Bow's appeal was thus completely overlaid with ideas that were entirely out of proportion and bore no resemblance to the actual spoken word.[27]

One day after the Le Figaro article, the French left-wing liberal paper Le Monde promptly corrected this piece of fake news.[28] But instead of commenting on M'Bow's speech and his actual words in denying the Figaro's information, Le Monde essentially entrenched it. "It was not the obelisk on Place de la Concorde…that was the object of UNESCO's recommendations." And nothing could be further from the truth than "emptying out European and American museums." In spite of such denials, the vision of a radical gutting of European museums was rampant in the European press. This is evidenced by headlines such as "Will Nefertiti, Mona Lisa, and the Venus de Milo Need to Go Home?" (Berliner Morgenpost on the opening of the UNESCO General Assembly on 25 October 1978)[29] or even the layout of entire newspaper pages (Het Vrije Volk on 30 October 1978),[30] which would from now on illustrate UNESCO restitution efforts with the head of Nefertiti, the smile of Mona Lisa, or the Venus de Milo.

Even in newspaper articles that avoided such gross distortions, journalists frequently ignored the humanist postcolonial core and the historical depth of M'Bow's appeal. For example, in London The Times commented in a brief article entitled "UNESCO Plea for Return of Art Works" in particular on an expression M'Bow had used in passing, denouncing the "modern pirates" who "damage and strip archaeological sites in Africa, Latin America, Asia, Oceania and even Europe" owing to "frenzied speculation."[31] A German Press Agency (dpa) report that was picked up by both Süddeutsche Zeitung and Frankfurter Allgemeine Zeitung was written in the same vein, viewing the main objective of M'Bow's appeal as regulating the illegal art trade.[32] This was not entirely off the mark, as the struggle against the illegal smuggling of cultural property had indeed been an important concern for UNESCO since 1970. But M'Bow's "Plea for the return of an irreplaceable cultural heritage" was mainly about the righting of historical wrongs, about cultural values, about a rebalancing of the international

geography of art after centuries of colonial asymmetrical relations. Only very few newspapers addressed this core element of M'Bow's appeal.[33]

In this context, the broadcast of the 8 p.m. news of the French channel TF1 on 19 June 1978 appears all the more remarkable—with circa thirteen million viewers, it was the most watched news programme in French television.[34] The broadcast has special relevance in the reconstruction of the restitution debate of the 1970s in Europe. Not only did it provide the first detailed and nuanced report on restitution in a European mass media outlet, but it operated as an audiovisual distillation of practically all emotions and positions associated with the restitution issue in late 1970s postcolonial France. There had not been a societal reckoning with the colonial period in France at the time, and it was therefore all the more striking that the star anchor and journalist Roger Gicquel dedicated himself to the concerns of UNESCO and to the speech by Amadou Matar M'Bow in the *Journal de 20 heures* (plate 11). Gicquel, who was been born in 1933, had firsthand experience of the colonial period himself, like many French citizens of his generation. As a young man, he had worked in several African countries south of the Sahara before he was drafted for military service in the course of decolonisation and forced against his will to fight the Moroccan civilian population.[35] As a former journalist with the children's relief organisation UNICEF, Gicquel was evidently familiar with the objectives and the staff of UNESCO and expressly supported these goals.

On 19 June 1978, he introduced his report on the restitution of cultural property with a remark that the objects in question had left their countries of origin "in historical circumstances" that had "better not be described in too much detail."[36] The colonial and sometimes violent provenance of museum objects had been implicitly raised. A long sequence of interviews on the subject of restitution followed. Apart from M'Bow, the interviewees included the oceanographer Jean Guiart, head of the research department at the Musée de l'homme in Paris, a young actor from the Dogon region of Mali, Akonio Dolo, whose career had taken off in the most famous theatres in Paris, as well as the art dealer Jean Roudillon, a prominent representative of the trade in "primitive art." After a moment of hesitation, even the art dealer responded to the question about the restitution of artworks with "why not?" Roger Gicquel then concluded from the studio: "If cultural identity is to be protected, artistic heritage must be presented, ah, preserved, and in some cases also restituted. There is no alternative."[37]

By this point in 1978, at the latest, the restitution debate had now also reached the French public. This was in part because of UNESCO's media strategy, which involved maintaining strong contacts with international journalists and securing a second discussion of M'Bow's restitution initiative on the evening news at TF1 in the autumn of 1978. Just before the next General Assembly, UNESCO invited museum experts together with two dozen international

journalists to Palermo for several days for a debate on "the right to collective memory." Gicquel attended the media seminar himself and conducted extensive interviews.[38] Among his interlocutors was Firouz Bagherzadeh, the head of the Iranian Centre for Archaeological Research in Tehran, Iran. "And by the way...what do museums mean for Third World countries?," Gicquel asked. Bagherzadeh answered in fluent French: "Keep in mind that a museum today is above all a political institution. If these documents of the past are no longer available especially for young nations, for small nations just climbing the ladder of civilization, they will not be able to teach school children their own history, which nevertheless exists and is documented."[39]

The experts in Palermo included Ekpo Eyo from Nigeria and Huguette Van Geluwe from Belgium as well as the former director of the Louvre, Pierre Quoniam, who was soon to play a key role in the restitution debate (see 1982: Mexico and the Greeks).[40] Several large European print media outlets covered this workshop in detail. The German magazine *Der Spiegel* dedicated a thirteen-page illustrated article to the meeting and to the restitution of cultural property, featuring numerous statements by museum professionals.[41] In *Le Monde*, the journalist Yvonne Rebeyrol outlined with notable empathy the link between cultural property and memory.[42] *The Times* ran the memorable headline on 4 October "'Have nots' want their heritage back." The respected cultural journalist Charles Hargrove wrote: "It is a fact...that every member nation of UNESCO agrees with the principle of restitution of art objects. It remains to find ways of putting it into practice." His article ended with a presumption by the Senegalese delegate regarding the hesitant reaction of Western countries to the requests from developing countries: he said that Western states were not responsive as they probably "were not sufficiently aware of 'the frustration of developing countries at the deprivation of their past, and their desire to bring together the crumbs of their national identity scattered everywhere.'"[43]

The particularly rich archival records of many institutions in 1978 show that there actually was an awareness in Western countries—certainly in some administrations—as well as an understanding of the increasing explosiveness of the subject of restitution. For these organisations, the problems had already started just before the end of the year.

DEFENCE

On 22 December 1977, a letter from the Federal Ministry of the Interior arrived at the Stiftung Preußischer Kulturbesitz in West Berlin.[44] It was marked with the word "Schnellbrief" in red, denoting express delivery and priority processing. The letter asked the president of the foundation for comments on a paper by the German UNESCO commission entitled "Support for Museums in the

Third World."[45] According to the minister König, the draft was intended as an attempt "to defuse the problem of the restitution of cultural property" and was connected to considerations by the Foreign Office "whether an offer of museum assistance would take some of the increasing pressure off us."[46] In its letter, the Ministry of the Interior summarised the position of the Foreign Office with regard to restitution as follows: "In the interest of a relationship based on mutual trust between peoples, everything should be avoided that could let the issue drift onto an international stage where blanket demands would be presented emotionally and states would be dragged into the dock."[47] The Foreign Office proposed that potential restitution discussions take place on a specialist level by museum professionals, without involving the government. The letter ended with a reminder to maintain strictest confidentiality in dealing with this issue: "Any publicity should initially be avoided."[48] Similarly worded letters from the Ministry of the Interior were simultanously sent to other institutions, for example to the German national committee of the International Council of Museums (ICOM).[49]

The paper "Support for Museums in the Third World" referenced in the letter was a three-page, undated and unsigned draft that had been written in response to a session of the German UNESCO commission three months earlier.[50] In line with the concept of soft diplomacy, the unnamed author pleaded for a technical and professional engagement of the German Federal Republic to improve museum infrastructure in the so-called Third World. "These measures," the paper hopefully expressed, "will greatly benefit the prestige of the Federal Republic in the long term, while the costs involved are relatively low."[51] Museum assistance was thought to promise an improvement of relationships among specialists, since Western institutions would "be perceived more and more as recipriocal partners" and "the partly existing bogeyman image would fade."[52] Inventories of the cultural property in the regions in question would need to be drawn up in order to know on the ground what was "really worth protecting," finally dispensing with "clutching to the idea of protecting everything"; in this way, the collecting activities of foreign institutions could also be revived. The paper was a peculiar mixture of realistic perspectives on local sensitivities, academic self-interest and the attempt to abandon paternalistic reflexes. It began with a programmatic statement: "The basis of any support must be the independence of the Third World partner. Any expert teams to be formed are to be led by locals."[53]

This draft and the position of the Foreign Office as outlined in the letter did not raise a cheer in the German museum world: neither in the Linden-Museum in Stuttgart with its director Friedrich Kußmaul, nor in the German Museum Association with its chairman Wolfgang Klausewitz and certainly not in the ICOM German committee with its president Hermann Auer. All of these

institutions prepared detailed responses, which together give a richly contoured sense of atmosphere. The president of the Stiftung Preußischer Kulturbesitz himself only provided a brief statement. He rejected "multilateral control and steering institutions" while also "strongly" objecting to the Foreign Office's intention of passing the responsibility for dealing with restitution claims from developing countries to bilateral negotiations among museum directors, as outlined in the letter. "In this way," Wormit's successor Werner Knopp declared, "the moral and political pressure on 'museum directors' would only increase."[54] Instead, he argued for a response by the government of the FRG.

The first detailed response to the German UNESCO commission's brief paper came, not surprisingly, from Stuttgart. Friedrich Kußmaul immediately drew up five single-spaced typed pages combining harsh criticism with suggestions for complete revision.[55] With regard to the abovementioned necessity for "independence of the partner," Kußmaul noted in his characteristic style, "one should not understand this partnership in such a way that one would end up being labelled a nobody because the indigenous 'expert' knows everything better anyway. After all, a doctor can only help when the patient agrees to treatment after being diagnosed."[56] He vehemently emphasised the absolute necessity of Western assistance in all areas of museological activity "out there," and said that "the nations of the Third World also [needed] to be introduced to their natural surroundings," and that the objective of the Germans had to be "to create rational and necessary museum types for each individual country," which could "grow into a really sensible operation."[57] With the allusions to *we in here* and *those out there*, the letter is a distilled version of the Eurocentric, neocolonial and dismissive reflexes deeply rooted in some institutions in the 1970s.

Another response came from Wolfgang Klausewitz, the chairman of the German Museum Association and a marine zoologist from Frankfurt am Main, born in 1922.[58] It comprised ten points and also started with the programmatic statement that "in most Third World countries, any real relationship to their own history, culture, and natural surroundings" was lacking entirely (point 1). As a consequence, Klausewitz saw a political need for immediate "cultural development aid," however, "not by returning objects" but by cooperative measures, which could in turn contribute to an increase (not a decrease) of German collections: "certainly, the developing country would be required in return for our aid to hand over part of the objects to the assisting and supervising museum" (point 2). "Experienced" or "young" German scholars should provide the support work, the latter on the basis of fixed term contracts (point 3). The education of museum professionals from the Third World should take place in the German Federal Republic (point 4). Restitutions without prior "cultural-historical measures of remediation" were strictly rejected by Klausewitz (point 5). He also did not accept "a duty of return in any way," indeed he bridled against the

creation of "guilt complexes among German museum leaders," who had actually over many generations "saved" numerous cultural records through meticulous scholarly collection work, which had been and still were considered "worthless" in the countries of origin (point 6). Therefore, Klausewitz stated, the German Museum Association "would use every means at its disposal to fight purely politically motivated tendencies to yield to restitution demands in order to reduce a "partly present bogeyman image" (point 7). After all, one should bear in mind that the associated possible creation of a precedent could "lead to a 'culture war' among European states" (point 8). At the end, Klausewitz once again evoked the important scholarly function of museums (point 9) and declared (point 10) full cooperation from his organisation, despite all misgivings.

The most detailed response came from Hermann Auer, who sent an eighteen-page "Statement on the general problem of restitutions and on the memorandum of the German UNESCO commission" to the Ministry of the Interior in April 1978 on behalf of the German national committee of ICOM.[59] Born in 1902, Auer was originally a physicist and university lecturer. After the Second World War he had run into difficulties at his university job over his membership of the National Socialist Party and several other National Socialist organisations, whereupon he had successfully applied for work at the Deutsches Museum in Munich, where he had become "academic director" in the 1950s.[60] When he wrote the restitution statement, he had been in retirement for six years, while continuing as president of the German department at ICOM (since 1968). From 1974 to 1977, he had also been treasurer of the organisation at an international level and was thus perfectly acquainted with the international discourse and its participants.

Auer's statement adopts the pretence of a quasi-scientific methodology in order to regard his object of study (restitutions) from different perspectives "in an objective manner" while trying to map a kind of matrix of interests and forces. Within this matrix ("the problem"), those "who demand" and those "who possess," as Auer refers to them, form a central axis. The objects between them are "values," which are also linked to "counter values."[61] All these elements are part of a dynamic relationship. Within the entire field, the museum professional tries to fathom manoeuvering space between "escalation" and "agreement."[62] At the same time, he addresses the paper of the German UNESCO commission in detail, listing "open questions" at the end of his memorandum, which needed responses "urgently, in the interest of an objective assessment of the overall problem."[63]

The fact that Auer's explanation of the "problem" was anything but objective and his analysis certainly not neutral becomes apparent in the passages where he undertakes to reveal the true, hidden motives of the players behind the "official" reasons given for presenting and rejecting claims. "Viewed objectively,

in addition to rationally justifiable, officially held positions, the controversial positions also reveal emotional motives in the background, which should not be overlooked in assessing the overall situation."[64] As a hidden motive, Auer identified the ideological validity of manoeuvres by the so-called developing countries. To be sure, the claimants kept referring to a consolidation of international cooperation or maintained that certain cultural goods were important for the cultural sensitivity of their nations. But in reality they expected a restitution won "against the 'big ones' to enhance their international standing, with every political and economical consequence of any increase in prestige." Claims for cultural property were a "fundamental, ideologically motivated demand," according to Auer, which was put forward internationally "with increasing aggression."[65] "On the owners side," conversely, these hidden reasons were ethical in nature and academically justified by the large sense of responsibility they felt for the protection of cultural heritage: "The insistent demands of those countries for a return of cultural objects is met…almost always with resistance, not least because of a sense of responsibility, considered a high priority, for the protection of one's own national property, which is often the result of many decades of purposeful collection activity."[66]

In this context, the "claim" that objects had been "taken from nations as 'victims of colonial foreign domination and occupation'" appeared particularly hypocritical to the German museum professional. While it was true that methods and motives of transferring cultural property had also been shaped by violence, this was in no way connected to European colonialism, since—and here, Auer used the technique of spreading false information already successfully employed by Kußmaul—"without doubt, the main part of the objects located outside the developing countries today had only been taken out *after* the 'decolonisation' of these countries, in the last twenty years."[67] Basically, the countries of origin were therefore themselves responsible for this exile, since their "legal and security governance was flawed and confusing."[68] Also, the idea that "physical possession of the most relevant original expressions of [its] history and [its] artistic and cultural production were important for a nation's sense of identity" was spurious.[69] In reality, nations "with low material and economical potential" were trying, Auer repeated, to "push forward ideological values to try and consolidate their national importance at an international level by referencing their history and their cultural property."[70] Auer recognised quite accurately that the developing countries' supposed strategy was successful: "Through playing up 'predatory' removal and plunder in colonial and occupation times… with the insistence that the presence of these particular original objects in their country would stimulate and develop the cultural understanding and cultural will of the entire nation, with these and similar unprovable, purely ideological motivations…the Third World countries managed to gain support from an

overwhelming majority of the international public for themselves and for the acceptance of their restitution claim."[71]

For Auer, this resulted in two decisive questions. Firstly, it should be clarified whether the needs of the demanding countries could not be met in other ways, seeing that they were not really but only ostensibly interested in cultural objects, "through an irreversible loss of cultural values which, while not created in our country, were only collected, explored and preserved through our academic initiative."[72] In other words: were there alternatives to restitution? Secondly, one should consider whether and how a return by German museums, should it become inevitable, might be tied to "a reverse stream of a more than equivalent value." With this, the question of political usefulness and of the academic price for restitutions loomed large.[73]

As an alternative to restitutions, Auer discussed the "support of museums in the Third World" that had been raised by the German UNESCO commission, as well as the possibility of producing faithful copies of claimed cultural goods.[74] He described the former as "provisional [measures] to deflect restitution claims," and he listed "slowing down conditions" in the field of museum infrastructure—that is, those which "could hardly be fulfilled by the developing countries in the near future"—as a possible buffer against restitutions: an "insistence on such preconditions could…only lead to a barely calculable delay of the return."[75] On the subject of copies, he noted that the developing countries had so far strongly objected to these, due to the objects' spiritual dimension. He only hinted at the reverse idea of putting copies in Western museums, since he was aware of the equally strong objections there.[76]

Against the background of past and present discussions, Auer's reflections on the cost-benefit relationship of possible restitutions by the German Federal Republic seem more original. In this instance, the focus was on the relationship between politics and museums in the home country and on the actually crucial question of a "conversion of cultural property in equivalent foreign policy values."[77] In the political arena, Auer stated, one criteria for restitution considerations was the question of how far the handover of an object was "tied to an equivalent whose repercussions on the political, cultural, or moral situation in our country would *more* than offset the loss."[78] For museums, however, whose work was effective across generations and served as the preservation of holdings, cultural assets were "lasting values over centuries" and were therefore out of the question as a bargaining tool in routine political activity.[79] The process of transforming academic cultural property into political benefit should therefore be considered carefully. This concerned the publicity of potential restitutions—should clear visibility be achieved "in order to achieve high political efficiency," or, on the contrary, should discretion be exercised in order to avoid inviting

"a surge of covetousness"? Furthermore, the timing of potential restitutions should be chosen with care: "In the eyes of the public, the goodwill gesture will appear ever more valuable, the longer and more urgently calls for restitution are raised. However, this is correct only as long as the generous fulfillment of the desire is done voluntarily. Should the global opinion shift in favour of a general duty of restitution, compliance with the requirement would be regarded as a matter of course whose denial could lead to moral isolation."[80]

Obviously, as a senior statesman Auer had a keen sense that the course of history would one day make restitutions inevitable. His paper ended with a series of "open questions," from a legal, political, museological and communication-strategic perspective. One of the interesting points about this extensive statement is Auer's matter-of-fact view of "scholarship" as a benchmark for museological action, while assuming German museum infrastructure to be in perfect condition yet still, if it fitted the argument, naming serious shortcomings in this very infrastructure: "How hard and protracted however such an endeavour [of inventory] is, is demonstrated by the fact that a systematic cataloguing of cultural property has also not been resolved satisfactorily in the developed countries, even in the Federal Republic."[81]

It is impossible not to be transfixed by the statements of these West German museum officials in 1978. They show how smug and contradictory many of the arguments against the requests from the so-called "Third World" were in those years. This becomes blatant when, in a later publication by Friedrich Kußmaul, the reader is informed that he himself regarded the academic performance of his institution in the 1970s as low and spoke of "scarcely acceptable conditions in the collection storage space," which was "packed" in the 1970s and where "the heating could no longer be regulated."[82] Naturally, such scathing criticism did not enter into the restitution debate around 1978.

This was the state of thinking in the West German museum world five weeks before Amadou Mahtar M'Bow's humanistic and media-savvy appeal for restitution in Paris. The West German considerations became part of a Foreign Office document from the beginning of May, which captured the mood with regard to the restitution debate at the national and international level.[83] The Foreign Office regarded the situation as relatively calm and recommended maintaining the previous wait-and-see approach, and, in the event of a radicalisation, was to "express" support for a gradual development of museums in former colonised countries while suggesting an exchange of cultural property instead of restitutions.[84] Bonn seemed to be unaware that a significant mobilisation in favour of restitutions was imminent at the international level. It was only after M'Bow's appeal, as archival notes and correspondence suggest, that the alarms went off once again in West German museum administrations and ministries. The

"thorny problem" of restitution was back on the agenda from June 1978.[85] It was advisable after all "to be well-prepared" for the next UNESCO general assembly in the autumn in Paris, as a Foreign Office employee noted on 12 July 1978.[86]

Accordingly, West German diplomats in former colonised countries were asked in July to report on the subject of restitutions, notably *without enquiry to the authorities of the host country.*[87] Furthermore, the Foreign Office circulated Hermann Auer's memorandum and asked the usual players in museum and cultural administrations for statements and responses to the open questions it raised, including: "How big are the holdings of objects eligible for restitution claims by respective category?"[88] In a letter to the director-general of the Berlin museums, the new president of the Stiftung Preußischer Kulturbesitz, Werner Knopp—in office since June 1977—asked what response may conceivably be given. Waetzoldt's reply must have given him food for thought: "It must be assumed that the entire holdings of ethnological museums, archaeological museums, and Middle Eastern departments are basically to be considered. Within the Staatliche Museen Preußischer Kulturbesitz, this would concern in the range of 500,000 objects," Waetzoldt assessed.[89]

Now, only a few weeks before the UNESCO general assembly in Paris, another protagonist emerged in West Germany: the newly elected president of the German UNESCO commission and professor of art history at the Freie Universität in West Berlin, Otto von Simson. In consultation with the Foreign Office, he invited a dozen experts for a crisis meeting in Bonn at the end of August 1978.[90] The explicit purpose was a gathering of ammunition against restitution claims in preparation for the UNESCO General Assembly at the end of October. Invitees included representatives of the Foreign Office, the Federal Ministry of the Interior, the General Assembly of Education Ministers and the Association of German Cities and Towns, as well as the Frankfurt Africanist Eike Haberland, Wolfgang Klausewitz for the German Museum Association, Werner Knopp for the Stiftung Preußischer Kulturbesitz, Hermann Auer for the German department of ICOM, and Friedrich Kußmaul for the Linden-Museum in Stuttgart. The director-general of the Staatliche Museen zu Berlin, the president of the German Archaeological Institute and the director of the Museum für Völkerkunde Hamburg, Jürgen Zwernemann, turned down the invitation.[91] Not on the list of invitees was, as to be expected, the director of the Übersee-Museum in Bremen, Herbert Ganslmayr. The Staatliche Museum für Völkerkunde, the ethnological museum in Munich, which was among the bigger institutions with colonial-period holdings in the Federal Republic, had just changed directors at the time and does not seem to have played a part in the internal discussions. The attendees established themselves as the "Working group 'Return of cultural assets.'"[92]

During the meeting, the museum representatives spoke "unanimously in favour of a broadly tough stance."[93] Only the ethnologist Haberland pleaded for "some flexibility" in order to not endanger working conditions for German researchers in the countries concerned.[94] As president for the Stiftung Preußischer Kulturbesitz, Werner Knopp argued vehemently for a rejection of moral claims, for the imperative prevention of an international restitution committee to which he referred as a "tribunal" throughout, and for an abolishment of the defamatory term "restitution."[95] Two weeks later, the jointly conceived document and strategy against restitution claims was ready.[96] Following a round of feedback by post and reinforced with comments, the paper, now comprising thirteen pages, was distributed to all members of the "Working group 'Return of cultural assets," just in time for the UNESCO General Assembly and the West German delegation.[97] The front page of the document was marked as confidential in underlined letters.

This sensational confidential document contained comments by all the named institutions and gathered nearly all positions and topoi which had been raised in the preceding years in the various statements of German museum officials. It gives a profound insight into the legal, academic, political, ideological and even semantic defence strategies of leading West German museums and cultural departments against the restitution wishes of former colonised regions, especially in Africa. As a type of matrix for later discussions, it explores many of the questions still present in the debate today, more than forty years later. While if this document was written in Bonn and formulated in the unmistakable style of Federal Republican administrative procedures, many of its thought patterns were also prevalent in other national museum landscapes in Europe— certainly among several actors in British and French cultural administrations of the 1970s.[98] Those correlations, however, cannot be reconstructed as easily from archival material as the present example because of the differently structured administrations and decision-making processes.

Overall, the revised version of the guidelines for the defence against restitutions consisted of just under fifty numbered paragraphs with subtitles. These were structured in three main chapters: "Legal Issues" (three pages), "International Committee" (eight pages) and "Constructive Measures" (two and a half pages). The final paragraph was entitled, significantly: "A Threat to German Scholarship"; the first paragraph was headed "Responsibility for German Museums"—this was the lens through which restitution requests of dispossessed countries were regarded from Bonn. The text was edited by the general secretary of the German UNESCO commission, Hans Meinel, and is worth quoting at length. In the following extract, the quoted paragraphs refer to a particular handling of facts, wording and emotions. In addition, those quoted have

a counterfactual relationship to documented reality and cast an unfavourable light on the demanding nations. Finally, passages are quoted which reveal how the German UNESCO commission positioned its committee work against the express goals of the international organisation:

Confidential

Return of cultural property (Revised)

These notes summarise discussions held during the meeting of the working group "Return of cultural assets" on 31 August 1978 at the German UNESCO commission in Bonn. In this paper, suggested revisions since made by working group members have also been included.

Legal issues

Museums' responsibility

1.1. Historical cultural objects and artworks are owned by humanity as a whole. With this in mind, public collections bear responsibility. Had objects from the Third World not been collected and preserved, most of them would no longer exist today.

No duty of return

1.2. The question about the restitution of cultural property can be answered by the Federal Republic of Germany to the effect that no such duty of return can be discerned.

Clean acquisition

1.3.1. Since the Federal Republic of Germany does not have a legal duty to return in accordance with existing legislation, the term "restitution" must be rejected. Otherwise, an impression of a legally tainted acquisition is given. The term "restitution/return" must be interpreted in such a wide sense that no moral obligation is recognisable. During the discussion about a new term, it was suggested to use "transfer."

Foreign policy situation

1.5. The Federal Republic of Germany acknowledges the legitimate interest of Third World countries to have items of their cultural history in their own country. A condition would be, however, that there is indeed no cultural property left in these countries. In fact, they often have a lot but are unaware.

1. International committee

Spirit of international understanding

2.1. It must be made clear to Third World countries that, should European and North American member states of UNESCO be dragged in front of the International Committee that is to be created, be held to account, and demands pushed through, the spirit of international understanding and the autonomy for free decision-making of the nations will be affected and further cooperation will be put at risk.

Object inventories

2.7.2. Both ethnological museums and cultural administrations warn against the compilation of such lists. These would only encourage covetousness. Lists of our collections must be avoided in writings without fail. This is an extremely important principle.

Support for museums

2.10.2. Important art is the property of the entire world. These artworks are ambassadors for the culture in which they were created. It would thus be a contradiction if artworks were brought to a country under duress only because they were created there, yet without any possibility of making them generally accessible there and of preserving them in a way that ensures their durability.

2. **Constructive measures to support museums in the Third World** (given the non-recognition of a legal right of others to claim "restitution" of cultural property)

Emotionality

3.1. In spite of the unequivocal legal situation on the issue of a "return of cultural property" from the perspective of the Federal Republic of Germany, the application of "public" or "moral" pressure on our museums is to be expected. The Third World countries are determined to recover their cultural assets and present them at home. This is for the most part an emotional procedure which cannot be directed, while the way in which objects arrived in the collections of Europe and North America is also of no consequence.

Information campaign in the Third World

3.3. There seems to be an urgent requirement to raise awareness in the population of Third World countries of what constitutes cultural

assets and how they can be preserved. This is a key approach for cultural development aid.

Risks for German scholarship

3.8. If we do not succeed in convincing the countries of the Third World of our genuine intention to provide support, there is a certain risk for German ethnology that lively contact with colleagues may be lost and research work becomes impossible. The same applies to other disciplines.

These excerpts do not need extensive commentary. Above and beyond the issue of restitution, they demonstrate an uncompromising form of assertion over the ownership of cultural assets from former colonised countries, which warranted safeguarding even to the point of terminology. Even based on the assumption that the restitution defence paper of 1978 did not reflect every nuance in the positioning of German museums, it certainly set standards that must have intimidated possible dissenters among museum staff. In any case it is striking that, apart from the intrepid Herbert Ganslmayr, only one museum director in West Germany publicly expressed sympathy with the demands from former colonies: the ethnologist and Australia specialist Andreas Lommel, director of the Staatliche Museum für Völkerkunde in Munich from 1957 to 1977.

Freshly retired, he published a long article in *Frankfurter Allgemeine Zeitung* on 13 November 1978 entitled "Exotic Art—Back to the Third World."[99] Here, he emphatically confirmed the colonial provenance of many European collections and wrote of "pillage, plunder, or taking advantage of helpless primitive people with the result that many of today's free citizens of the Third World can and must admire the vestiges of their cultural past only in European and American museums."[100] He referred to the "indelible legacy of colonialism" and the desire for returns as "only too understandable," as in his view a "change of consciousness, a rupture of tradition, a real, howsoever to be assessed, mental change in the nations concerned."[101] Lommel used explicit stereotypes ("helpless primitive"), misattributed the Senegalese director-general of UNESCO Amadou Mahtar M'Bow as Nigerian, and consequently saw the latter's appeal in close connection with the British so-called punitive expedition to Benin City in 1897—another example of the entirely ignorant perspectives on Africa in Germany at the time, even within the country's museum and media elites. Nevertheless, this article was a clear appeal against the self-isolation of German institutions. "Museums," as the retired museum director noted, "should really not be treasure houses where trophies are kept from the military campaigns of the colonising past that is forgotten today."[102]

PLATE 1: Cover of the January 1965 issue of *Bingo*, a monthly magazine published in Dakar, Senegal. Inside, Paulin Joachim published an article entitled "Give Us Back Negro Art," which was likely the first call for restitution of African cultural property.

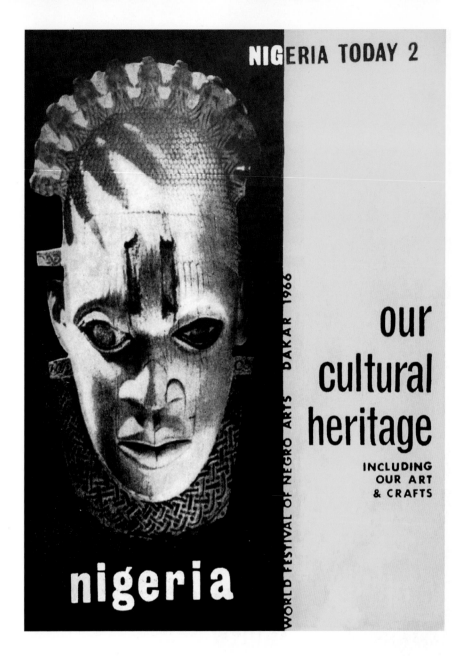

NIGERIA TODAY 2

WORLD FESTIVAL OF NEGRO ARTS · DAKAR 1966

our
cultural
heritage

INCLUDING
OUR ART
& CRAFTS

nigeria

PLATE 2: Title page of a special edition of *Nigeria Today* issued for the Pan-African festival in Dakar, Senegal, in 1966. The design makes it unequivocally clear that the Queen Idia Mask from Benin City, which had been owned by the British Museum since 1910, was part of Nigeria's cultural heritage. The demand for its restitution would only be raised many years later.

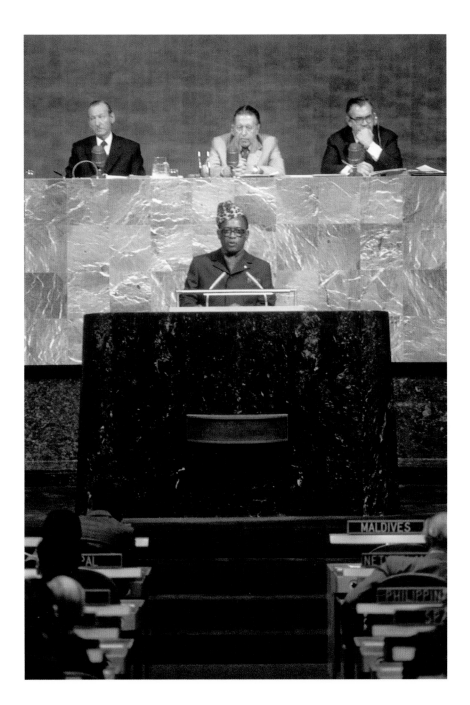

PLATE 3: Mobutu Sese Seko, president of Zaire, addresses the United Nations General Assembly in New York on 4 October 1973. This speech is generally considered as the hour zero for the worldwide restitution debate of the 1970s and 1980s.

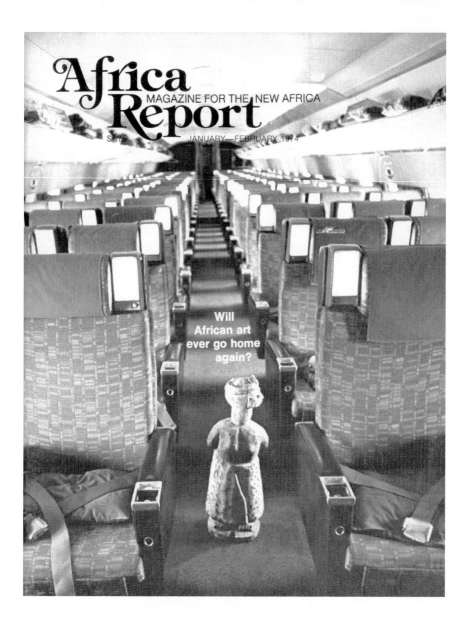

PLATE 4: Cover of the magazine *Africa Report* published in New York in January 1974. This issue featured an extensive report by Susan Blumenthal on the worldwide diaspora of African art and on the future of museums in Africa.

PLATE 5: Stamp depicting the "Memorial head in the Udo style" from Benin City, based on a drawing by Gerhard Voigt, part of a series of stamps circulated in the German Democratic Republic in 1971 from the ethnological collections of the Völkerkundemuseum in Leipzig.

PLATE 6: Hans-Georg Wormit, president of the Stiftung Preußischer Kulturbesitz, in conversation with Stephan Waetzold, director-general of the Staatliche Museen zu Berlin, at the beginning of 1974 in West Berlin. From 1972 onwards, both vehemently resisted loan and restitution requests from formerly colonised countries, especially Nigeria.

PLATE 7: Record cover produced in the context of the Pan-African festival Festac '77 for the band Sonora-Gentil and Tabansi Stars International, showing the festival emblem in English, French and Arabic.

PLATE 8: Cover of the booklet published following the symposium "Lost Heritage" in London in 1981. The drawing uses the common motif of the museum as a prison and combines two sensitive objects from the British Museum: the Queen Idia mask and a fragment from the Parthenon frieze.

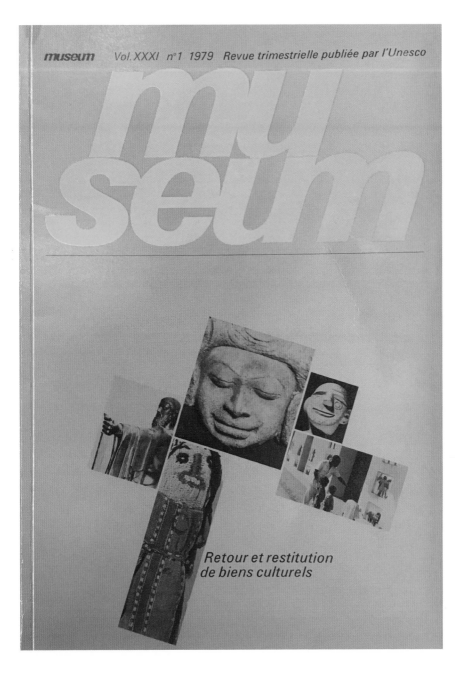

museum Vol. XXXI n°1 1979 Revue trimestrielle publiée par l'Unesco

Retour et restitution
de biens culturels

PLATE 9: Cover of the French edition of the UNESCO journal *Museum International*'s special issue on restitution in 1979.

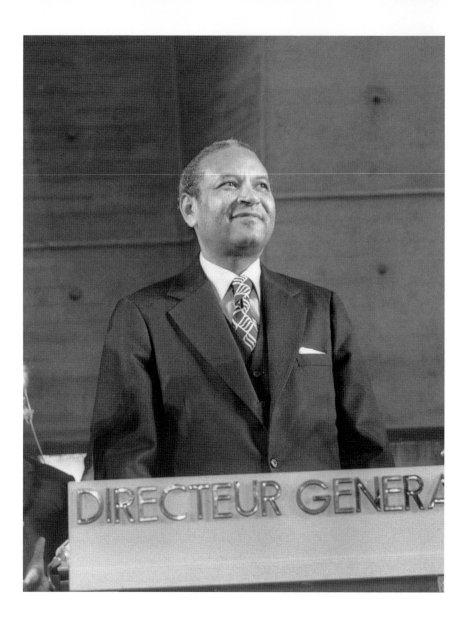

PLATE 10: Amadou Mahtar M'Bow on the day of his election to director-general of UNESCO in November 1974. Under his leadership, the restitution issue advanced to become a major concern of the international organisation.

PLATE 11: Star anchor Roger Gicquel during the evening news by the French TV station TV1 on 19 June 1979. "If cultural identity is to be protected, artistic heritage must be presented, ah, preserved, and in some cases also restituted. There is no alternative."

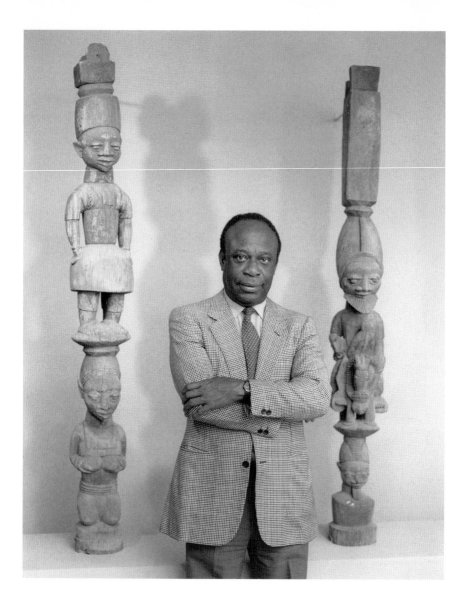

PLATE 12: A press photo of Ekpo Eyo taken in 1989 on the occasion of a lecture by the Nigerian archaeologist at the Houston Museum of Fine Arts in Texas, United States. During the 1970s and '80s, Eyo was one of the most passionate advocates on the African continent for restitution. In 1986 he accepted a professorship for African art and archaeology at the University of Maryland in the United States.

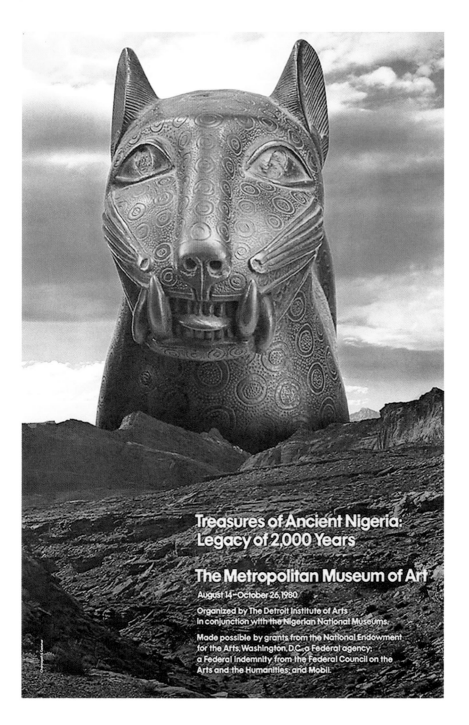

Treasures of Ancient Nigeria:
Legacy of 2,000 Years

The Metropolitan Museum of Art

August 14–October 26, 1980

Organized by The Detroit Institute of Arts
in conjunction with the Nigerian National Museums.

Made possible by grants from the National Endowment
for the Arts, Washington, D.C., a Federal agency;
a Federal Indemnity from the Federal Council on the
Arts and the Humanities; and Mobil.

PLATE 13: Poster for the exhibition *Treasures of Ancient Nigeria: Legacy of 2,000 Years* at the Metropolitan Museum of Art in New York curated by Ekpo Eyo. The travelling exhibition displayed spectacular artworks from different Nigerian museums. At the same time, it served as to publicly shame Western institutions that had refused to lend or restitute objects with a Benin City provenance to Nigeria.

Prof. Dr. Klaus Horn
Sozialpsychologe

Wolfgang Ketterer
Galerist

Dr. Tirmiziou Diallo
Ethnologe

Dr. Else-Marie Boyhus
Museumsdirektorin

Prof. Dr. Helmut Bley
Kolonialhistoriker

Dr. Dorothee Schulze
Juristin

Dr. Herbert Ganslmayr
Museumsdirektor

Prof. Dr. Friedrich Kußmaul
Museumsdirektor

PLATE 14: Stills from the talk show "Stop Thief! Cultural Treasures from the Third World: Looted, Loaned, or Owned" broadcast by the German channel ZDF on 18 December 1984. Twelve guests and two presenters discussed restitution and the colonial provenance of German museums live for two hours. Pictured from top right are some of the guests: gallerist, museum director, lawyer, museum director, museum director, colonial historian, ethnologist, social psychologist.

PLATE 15: Opening of the exhibition *Treasures from Ancient Nigeria: Heritage of 2,000 years* at the Pergamonmuseum in East Berlin on 1 April 1985. At the centre are Samson Emeka Omuerah, Nigerian federal minister of information, social development, youth, sports and culture; and Ernst Mecklemburg, deputy chairman of the GDR state council and the chairman of the German Democratic Farmers Party (DBD). The latter holds the exhibition catalogue.

DIE GRÜNEN

IM LANDTAG VON

BADEN-WÜRTTEMBERG

GEBT ZURÜCK, WAS

UNS NICHT ZUSTEHT

Die GRÜNEN im Landtag begrüßen die Wiedereröffnung des Linden-Museums und nehmen sie zum Anlaß, auf Entwicklung-en hinzuweisen, die hierzulande zwar den Experten, aber weniger der Öffentlichkeit bekannt sein dürften.

Seit ungefähr 15 Jahren, also schon vor der Zeit, als das Lindenmuseum 1978 für die Öffentlichkeit geschlossen wurde, findet im Rahmen der UNO, UNESCO und des internationalen Museumsrates (ICOM) eine weltweite Diskussion statt über das Kulturerbe der Entwicklungsländer, das während der Kolonialzeit in die Museen der ehemaligen Kolonialmächte gelangt war.

Beispiele dafür sind

- die Parthenon-Friese, die Engländer gegen Ende der tür-kischen Herrschaft in Griechenland aus dem Tempel heraus-meißelten
 (heute im British Museum, London)

- die lebensgroße vergoldete Statue der Göttin Tara aus der Kolonialzeit Sri Lankas (British Museum)

- eine elfenbeinerne Gürtelmaske aus dem nigerianischen Königreich Benin (British Museum)

- sowie Einzelstücke geplünderten Kulturerbes aus Benin, das in die ganze Welt zerstreut wurde

- die Nofrotete-Büste aus dem damals unter englischer Kolonialherrschaft stehenden Ägypten
 (Völkerkunde-Museum, Berlin)

- der Königsthron von Karagoué, Tansania

PLATE 16: Reconstruction of the front page of the flyer for the Green Party in the regional parliament of Baden-Württemberg, July 1985.

In a surprising letter printed in *FAZ* a few days later, the chairman of the German Museum Association, Wolfgang Klausewitz, congratulated his retired colleague on his views.[103] Even though (or perhaps because) Klausewitz had been strongly involved in the wording of the German UNESCO commission's defence paper, he complained about the "legal technocrats of the Federation, the states, foundations and municipalities," whose response to such ideas was "a rigid no" and who "forced uncompromising rejection" upon museums.[104] With these words, Klausewitz did not make any friends. His main target was probably the top management of the Stiftung Preußischer Kulturbesitz, which as the umbrella organisation for museums was the only cultural heritage institution in Germany managed by lawyers. In the following months, Klausewitz seems to have steered clear of discussions on restitution.

The UNESCO General Assembly, which had been intensively prepared in Bonn, eventually took place from 24 October to 28 November 1978 in Paris. The international committee for restitution or the return of cultural property to the source countries, which had already been planned and discussed in Venice in 1976 and in Dakar at the beginning of 1978, was established. However, in agreement with France, Germany managed to marginalise the term "restitution" in the committee name, using instead the rather cumbersome title "Intergovernmental Committee for Promoting the Return of Cultural Property to Its Countries of Origin or Its Restitution in Case of Illicit Appropriation" (ICPRCP).[105] The word "restitution" no longer referred to the colonial past, which had also been completely eliminated from the originally envisaged title (see p. 56), and now only applied to cases of contemporary smuggling. At the same time, the expansion of the committee's competence to include the fight against the illegal art trade watered down its profile and the goals of the committee, which anyway had a merely advisory role.

During a meeting with museum colleagues in Berlin on 14 December 1978, Knopp congratulated himself on his success.[106] Among other points, he noted that the reduction of competencies of the ICPRCP could be credited to the "Working group 'Return of cultural assets'" (to which he now referred as the "Bonn commission"). It had decided "in spite of some reluctance by diplomats from the Foreign Office" to "resist the maximum demands from Third World countries."[107] According to Knopp, it was "entirely unacceptable to submit to moral blackmail."[108] It was "a phenomenon repeatedly observed in history that the politically or economically losing party had to hand over objects of various types to the winning side. The colonial period was merely a subcategory of this phenomenon."[109] When prompted, the president of the Stiftung Preußischer Kulturbesitz gave an unflattering view of the UNESCO director-general: "Mr M'Bow had always suffered from an 'inferiority complex,'"[110] and as a next step he suggested "to develop a strategy for future argumentation and manoeuvering."[111]

Argumentation and manoeuvering: this was a skill which Paulin Joachim had described as a particular European strength in his editorial "Give Us Back Negro Art" in 1965, these "dazzling dialectics" which no longer deceived anybody in Africa, as he had said at the time (see 1965: Bingo). A particularly cunning example was presented at the end of 1978 by the Hamburg lawyer Elisabeth Schwarz, as she explained to the members of the Committee for Culture and Communication at the UNESCO general assembly in Paris why the category "national cultural heritage" did not exist. Her presentation was actually aimed at explaining why the FRG had not ratified the 1970 convention on the Means of Prohibiting and Preventing the Illicit Import, Export and Transfer of Ownership of Cultural Property (it only did so in 2007, France in 1997 and the United Kingdom in 2002). But at the same time, Schwarz touched on the core of the restitution issue. She responded to a question raised in the commission by the Nigerian delegate:

> Such national heritage does not exist—from the legal point of view—in my country since 1955. The European peoples who have signed the European Cultural Convention 1955 are of one opinion: there does not exist national heritage [sic] but *one* common European heritage. And indeed:
>
> Paintings of Rembrandt, Leonardo da Vinci, Tizian [sic] belong for German people to their cultural heritage as well as paintings of the German painter Albrecht Dürer do. Of course, they belong to the heritage of mankind. Must we really look after the nationality of Tizian [sic] in order to find the origin of the French king François Ier here in the Louvre? To which manner of national heritage belong the paintings of the Royal Family in the Prado Museum? Charles V was a German Emperor and the King of Spain… I am sure, we are right to look at them as European heritage.…It cannot be the aim of UNESCO to go back to national heritage.[112]

This lecture on the unity of the "European peoples" and the rejection of national categories of cultural heritage may have been legally correct in 1978. Whether Elisabeth Schwarz and her dialectics convinced the delegates in the comission from formerly colonised countries, especially Nigeria, remains nevertheless doubtful. At least she constructed arguments. Roughly at the same time, a decided opponent of restitutions in the French Ministry of Culture, the official Robert Boyer, suggested in a strategy paper: "It would be better to assume the clear-cut attitude of the United Kingdom, which generally refuses to enter into such a dialogue. Refusing a dialogue is not the worst way of rejecting blame. It does however have downsides. The legitimate desire by countries who were robbed of their heritage will then turn into desperation, as in the case of Nigeria, and can lead to growing and disproportionate irritation."[113]

1979

A SPECTRE IS HAUNTING EUROPE

After the culmination of the activities of 1978, the following year brought about a psychological and political pause in the European restitution debate and its media coverage. Firstly, in politics, the establishment of the Intergovermental Committee (ICPRCP) at UNESCO, which had been planned in 1976, realised one of the goals of countries requesting restitution—even though the remit of the committee was very limited owing to its mere consultative status. There was a pause in media coverage, too. As the restitution debate was now so present in the European public sphere, even those in museum administrations and ministries who had previously argued in favour of avoiding publicity and maintaining strict confidentiality now went on a communication offensive. Lastly, there was a psychological pause, which was noticeable in the many statements of the intellectual elites of recently decolonised states that articulated their disappointment as they gradually lost faith in the capability of the "possessing" countries to recognise the cultural needs of poorer nations and to meet them with humanist instead of legal attitudes.

In an ironic reference to Karl Marx, a long article in *Frankfurter Allgemeine Zeitung* in May 1979 began with the following phrase: "For approximately six years, a spectre has been haunting European museums, in short, restitution."[1] The newspaper recalled that the process had started with a "group of black African countries" and that the same process had triggered "extremely intense emotions" in European countries with wealthy ethnological museums. But from now on, to put it bluntly, the subject had become primarily European—it had left Africa.

At the beginning of 1979, Tayeb Moulefera, the director of the Musée National du Moudjahid in Algiers, wrote in the journal *Museum International* (plate 9):

> The principle of the return of cultural property might well meet with the fate of the "earthenware pot" when it encountered the "iron pot"....All the principles of equity and humanism put forward to begin with in fact meet a serious obstacle when faced with the reassertion of the inviolable law of ownership and the national legal procedures that protect it. If the law of ownership is finite to present possession—without regard to how ownership originated or to its validity—then...the moral principle of the return of cultural property to its country of origin will not go beyond the question-begging stage.[2]

In retrospect, the Lebanese poet and diplomat Salah Stétié, who became the first chairman of the ICPRCP, saw the situation in similar terms: "While all countries agreed in principle to be open to dialogue, the 'holding' countries had—and still have—a virtually inexhaustible range of arguments against the 'claiming' countries, which I won't go into more closely and which all boiled down to the fact that objects that had become the common heritage of mankind could be much better protected in the developed countries."[3] The exhaustion of the countries concerned was palpable.

In the spring of 1979, the president of the German UNESCO commission, Otto von Simson, provided a good example of the professed willingness of Western institutions to engage in dialogue, as described by Stétié, while simultaneously tactically opposing the demands of former colonised countries. Throughout 1978, the art historian had worked intensively to run an intense campaign behind the scenes in Bonn, to ensure that the paper defending against restitutions discussed in the previous chapter could be drawn up. On 30 March 1979, Simson made it known, somewhat surprisingly, to the Berlin newspaper *Der Tagesspiegel* that his commission fully "sympathised with the wishes of the developing countries to bring back cultural assets taken to the industrial states," and that it intended to "present the arguments of the young nations in Africa, Asian, and Latin America to German museums."[4] Even assuming that Simson had been converted to the cause, this was a rather unexpected turn of events. Perhaps a conference in March 1979 in Dakar in the presence of the Senegalese President Léopold Sédar Senghor, by now a living legend, and the UNESCO director-general M'Bow had made an impression on him. On that occasion Simson had given a dramatic speech in front of hundreds of African intellectuals entitled "We want to contribute to your freedom." He had solemnly declared

that Europeans had "committed atrocious wrongs against African nations and the African spirit" and were now attaching great importance to the revival and the protection of their "endogenous traditions."[5]

But in spite of this powerful statement on the faraway African continent, Simson carefully avoided making even the smallest move in restitution matters without the close consultation of his colleague in his local Berlin coterie, Werner Knopp, president of the Stiftung Preußischer Kulturbesitz and a restitution defence hardliner. For example, when asked to respond to an ICPRCP initiative in spring 1981, he wrote "Dear President, my Dear Mr Knopp...I would like to proceed in this matter only in the closest possible consultation with you."[6] And indeed, no traces of any attempts by the German UNESCO commission to support a partial offset between German and African museums can be found in the archives.

After the heavy lifting in preparation for the UNESCO General Assembly at the end of 1978 in Paris, there was a dearth of international events in 1979. The circumstances in which the only two relevant events concerning the restitution debate took place almost at the same time is all the more baffling: one was scheduled from 7 to 9 May on the initiative of the International Council of Museums (ICOM) at the UNESCO headquarters in Paris, the other from 7 to 10 May at the initiative of the German national ICOM committee in Lindau on Lake Constance in Bavaria, FRG. They demonstrate a diametrically opposed approach to the restitution issue and the decolonisation of museums. With hindsight they can even be described as representative of the two poles that had emerged from almost a decade of discussions at the end of the 1970s: while partners from the "Third World" were engaging in experimental dialogue in Paris, those in Lindau remained in a defensive monologue among themselves. From today's perspective it must be stated that the second position succeeded and remained dominant in many places far into the 2010s.

The working meeting in Paris had been initiated by the Ad Hoc Committee on Restitution, founded by the International Council of Museums (ICOM) in 1977. It was attended by Hubert Landais, Jacques Vistel and Jean W. Pré from France; Geoffrey Lewis from the United Kingdom; and Paul N. Perrot from the United States via France as well as by Pascal Makambila, director of the national museum in Brazzaville in the People's Republic of Congo, and Herbert Ganslmayr from Germany, who continued to play a driving role. On the agenda was the preparation of content for the first ICPRCP meeting, initially scheduled for the autumn.[7] In addition the group discussed a "preliminary study" commissioned by UNESCO to analyse the "situation [of museums] of individual countries concerned with the return of cultural property."[8] In view of the limited time available until the inaugural meeting of the ICPRCP, the

group decided to form three teams, each consisting of two experts, to conduct concrete case studies in the "Third World."

Herbert Ganslmayr was tasked with investigating the situation in Mali, the former French colony, forming a duo together with the then minister of culture and later president of Mali, Alpha Oumar Konaré. His colleague from Bremen, Götz Mackensen, was responsible for the former German colony of Western Samoa, together with the Samoan poet and director of the South Pacific University, Albert Tuaopepe Wendt. A third team consisted of the director general of the Bangladesh National Museum in Dacca, Bangladesh, Enamul Haque, and the retired director of the Museum of London, Tom Hume; they were to inspect the situation in the former British colony Bangladesh. The principle of working in tandem with high-profile representatives from the former colonies and European museum directors was a conscious decision entirely in line with other UNESCO practices. It indicated equality as well as a shared responsibility for the consequences of the colonial past and the future of translocated cultural property. In addition, it showed that the actors involved had an acute awareness of the necessity to involve intellectuals from the emerging, newly formed nations in sensitive issues regarding the future of cultural heritage. In Paris, the experts also agreed on a uniform set of questions for the proposed studies.

Over the summer, the teams travelled to their allocated regions. Afterwards, Herbert Ganslmayr took advantage of the reopening of his Übersee-Museum, following a three-year period of renovation and decolonisation measures, to invite the entire group to Bremen for a closing meeting at the beginning of September.[9] Here, surveys and observations were compiled in a joint report and passed to UNESCO. As a prerequisite for restitutions, the report specified "fair and honest" preparation measures in the areas of museum infrastructure and staff training. In addition, the experts offered their services for further studies. Finally, they pointed out a lack of inventories both in the countries they inspected and in European museums and pleaded for the urgent compilation of such listings:

> Only complete records of the collections and objects remaining in the countries of origin and records of those collections and objects now outside of the country of origin, could provide the necessary basis for final solutions concerning the return or restitution of cultural property. The extent of the losses should be established on the one hand, and that part of their heritage which is now in foreign countries should be listed on the other. This provides a sounder argument for refuting the statement that the return or restitution is not necessary, since a sufficient number of collections still remains in the countries of origin.[10]

1979

In comparison to the profoundly humanistic world of ideas of a person like Ama-dou Mahtar M'Bow, such a passage sounds rather dry. In reality, the subject of "object lists" was highly political, and the question of inventories evolved into a high-profile battleground during the restitution struggle in the following years (see 1980: Battle of Lists).

In the same week of May 1979, when the ICOM Ad Hoc Comittee had dis-cussed concrete working procedures with colleagues from Mali, Bangladesh and Western Samoa in Paris, the recently founded Bonn Working Group "Return of Cultural Assets," later renamed the Bonn Commission, met in Lindau. While this group had continued to argue firmly in favour of discretion and the avoid-ance of publicity in all matters regarding restitution in its confidential working paper of October 1978, it now went on the offensive and contributed signifi-cantly to the organisation of a major event in Lindau from 7 to 10 May. The conference "The Museum and the Third World" was part of a series of sympo-sia organised every three years by the ICOM German national committee and hosted by the president of the German committee, Hermann Auer, who was also one of the most active members of the group and the author of the Anti-Restitution Memorandum of spring 1978.

In addition to Auer, seven other members of the Bonn Commission spoke at the conference, among them ministry officials and lawyers, which was unusual in the framework of a museological conference. The chairman of the German Museum Association, Wolfgang von Clausewitz, was absent from the Bonn circle—he may have fallen out of favour after his public statement against the "legal technocrats of the federation and foundations" and their "rigid no" to restitutions.[11] Otherwise, all members of the group attended and presented—evenly distributed among approximately twenty other speakers—on various subjects, usually far removed from their area of expertise: the art historian Otto von Simson spoke on the subject of appreciation of art from the "Third World" in comparison with the Romantic and Renaissance periods in Europe;[12] Friedrich Kußmaul, who emphasised that he was "not at all a specialist on South East Asia," presented on museums in South East Asia;[13] Eike Haberland spoke on museums in Africa;[14] the commercial law specialist and president of the Stiftung Preußischer Kulturbesitz Werner Knopp, who equally stressed complete ignorance about the subject, spoke on "influences of foreign cultures on our European culture";[15] Wilhelm Bertram, a lawyer from Bonn and retired ministerial undersecretary, who had extensively commented on Auer's mem-orandum on behalf of the Foreign Office, spoke about the museum-related legal instruments of UNESCO;[16] while the secretary-general of the German UNESCO commission, Hans Meinel, presented generally on the work of his office abroad.[17] Lastly, Kurt Müller, who was on the board, spoke about the unheard complexity of restitution in his position of head of the Foreign Office

cultural department and declared that neither his ministry nor the federal government were authorised to take any decisions, since the art treasures in question were not at their disposal.[18]

The public, however, was left in the dark about the fact that these men had worked in close collaboration against restitution over several weeks. They were joined by twenty-two other speakers, including two women, most of them museum curators. Herbert Ganslmayr, who had used the Lindau symposium three years before as a mouthpiece for restitution, much to his colleagues' discontent, dispatched the thirty-five-year-old musical ethnologist Andreas Lüderwaldt to represent his museum as he was busy in Paris at the time. Representatives of the "Third World" or from the diasporas were neither present on the podium nor in the audience.[19] However, a sizeable number of journalists from the regional and national press attended, from the broadcaster *Deutsche Welle* to the newspapers *Die Welt* and *Süddeutsche Zeitung* to *Frankfurter Allgemeine Zeitung*.[20]

At this point, one could dissect line by line and word by word the language that was adopted and the similes, metaphors and comparisons utilised by most of the particpants at Lindau over the course of two days in discussion about "The Museum and the Third World." The language conveys an impressive profile of a certain attitude, amalgamated from thoroughly colonial reactions, to a subliminal paternalism and a "rational," non-emotional approach to the subject that was repeatedly invoked. These attitudes were definitely not typical for the period, be it in Germany or Europe, as the contemporaneous meeting in Paris confirmed. Rather, they were representative of a clearly demarcated group that blocked restitution demands from former colonised countries in the FRG at the end of the 1970s: namely men, almost all of them over fifty years old, including many lawyers, a few former National Socialist party members, most of them without significant international experience.

The conference, according to Auer, was intended to demonstrate "objectivity and impartiality towards the people [of the] Third World" and a "rational, dispassionate objectivity in evaluating one's own point of view, one's options, and one's duties."[21] Stressing an unemotional, orderly and rational approach was not specific to the restitution debate. Rather, it was a sociologically well-researched method of attributing emotions to an opponent in order to make the other party appear untrustworthy while casting rays of enlightenment on one's own positions.[22] As the men of the Bonn Commission had frequently underlined in their confidential statements and correspondence, emotions were especially dangerous for opponents of restitution, as the public could be all too easily swayed to side with the dispossessed countries, a fact that would be turned into an advantage by pro-restitution campaigners. Therefore, the organisers of the Lindau conference were keen to "de-emotionalise" the debate, which became a key theme of the event.

"De-emotionalisation" meant, for a start, a repeated emphasis of being on the side of a dispassionate, enlightened, rationality that implicitly (and in many talks also explicitly) contrasted with the "natural," disorderly, sometimes aggressive feelings of newly independent nations and their supporters. The normative rulebook of the United Nations was thus described as an "almost bewildering variety of museum-related conventions, resolutions and recommendations,"[23] and it was expressly "appreciated" that the "attempt to turn the International Committee into a 'tribunal' with a court-like character had not prevailed."[24] De-emotionalisation, however, also meant creating new emotions by brandishing objectivity and scholarship, even by conjuring up images that could only cause fear and loathing in the public eye: "The Third World, in an ever stronger and often aggressive defence against our civilisation, regards the spiritual and cultural values of its own tradition with growing self-confidence as being far superior to the norms governing our society," was Otto von Simson's diagnosis in his opening talk, and he promptly followed up with a powerful example: "Just think about the current events in Iran: the hate of anything Western, the turn towards Islam, whose general renaissance is by the way one of the most important phenomena of our time, and also the abominable events in this country ultimately seem to be caused by…the dialectic between tradition and development."[25]

What followed were Simson's remarkably ungenerous suggestions for possible forms of cooperation with formerly colonised countries, such as: "Cooperation in the establishment and expansion of museums in the Third World—for example, by loans of important works by German printmakers."[26] Incidentally, "German printmaking" seems to have been one of the patent solutions of West German culture officials to foster cultural exchange with the "Third World": for example, the Foreign Office–funded Institute for Foreign Relations in Stuttgart showed an exhibition to coincide with the Lindau symposium, entitled "Printmaking and Its Techniques," with the complacent objective of "familiarising people in developing countries with modern artistic technology."[27]

For all of its supposed objectivity and rationality, the discourse that unfolded in Lindau was certainly not neutral, rather, it operated with powerful, interest-driven shifts in emotions and, as a second noticeable point, with a cavalier approach to historical facts and numbers that was especially striking for scholars. Very few speakers—that is, those who were disposed of actual expertise in their lecture subjects—addressed the colonial framework, characterised by symbolical and real violence, of the massive displacement of cultural assets from former colonies to Europe, including Germany. Most others denied, disputed or trivialised them, and even produced unverifiable or false information: certainly, violent appropriation methods had been heard of with regard to England or France, but the FRG—according to Hans Meinel, for example—did

not have to fear "accusations under point one [legality of acquisitions], and under the second point—thefts from the colonial period under the German Empire—there could only be exceptions at the most—if those objects were not already returned in 1918."[28] Meinel probably alluded to the Versailles Treaty of 1919, which had obliged Germany to restitute a few artworks to Belgium after World War I. The same treaty mentioned restitutions to a former German colony in one instance only: with regard to the head, cut off by a German officer, of Mkwavinyika Munyigumba Mwamuyinga, also known as Chief Mkwawa or Makaua, who led the war by the Hehe people (in today's Tanzania) against the German colonial power with successful guerilla tactics from 1891 to 1898. This skull, the Treaty of Versailles stipulated, should not be restituted to Africa but to the United Kingdom: "Within [six months] the skull of the Sultan Makaua, which was removed from the German protectorate East Africa and brought to Germany, must be handed over by Germany to the government of His British Majesty," article 246 stated.[29]

At the conference, the young Bremen museum representative, Andreas Lüderwald, dared to speak of "abysmal" discoveries he had found when researching some provenance histories in his museum, and he urged his colleagues to investigate this history systematically.[30] In response, Friedrich Kußmaul, whose Stuttgart museum was, together with Berlin, a stronghold of colonial period acquisitions, declared with directorial condescension that one had "at the Linden-Museum...worked very hard on researching the antique collections and their history, but without encountering anything 'abysmal.'"[31] Only in a very few cases had "weapons been taken from wartime opponents of the German protection troops. To ask for restitution in these cases is not productive, only a further rationalisation of the discussion," was Kußmaul's line.[32] The director of the Museum für Völkerkunde und Schweizerisches Museum für Volkskunde (Museum of Ethnology and Swiss Museum of Folklore) in German-speaking Basel, Switzerland, Gerhard Baer, declared with post-factual gravity that these objects faced inevitable demise had they not been brought to Europe: "It is certain that many of the objects admired today would then have long been destroyed, lost, and forgotten, and it is equally certain that an awareness of the individuality and the values in crafts and arts of objects from nations without a written language would never have developed."[33]

Whether such statements met the factual and ethical requirements of a lofty scholarly discourse seems doubtful. The emotional game was a politically encoded terrain into which even the host Hermann Auer enjoyed a foray: "After the talk by Prof. Eike Haberland, Frankfurt, about forty central African museums, Prof. Hermann Auer, president of the German ICOM national committee, declared himself profoundly depressed and shaken," reported *Frankfurter*

Allgemeine Zeitung.[34] For someone flying the flag of objectivity and rationality, this was an odd avowal.

Through not involving participants from former colonised countries and by camouflaging their background political work against restitutions, the organisers of the Lindau conference wanted to present restitution claims as irresponsible acts, and their rebuttal as the only sensible response of rationally thinking defenders of the cultural heritage of mankind. The fact that they gave free rein to a deeply rooted sense of superiority at the same time is documented, for example, by the closing remarks of host Hermann Auer: "Especially in a reciprocal relationship between nations of very different economical and cultural potential, [cooperation] requires great self-discipline by the more powerful partner. Again and again he must check himself whether he is really ready to respond, whether he does…not give advice which is actually not wanted and prejudges decisions which should really be taken by the other partner, who must even be entitled to make the occasional mistake."[35]

Notably, it was two of the few female attendees in Lindau, both of them distinguished and older journalists, who challenged such complacency through astute comments raised from the audience and through the reports they published post conference. Doris Schmidt, born in 1918 and cultural editor at *Süddeutsche Zeitung*, who took an active part in the discussions, stopped Auer in his tracks at the very beginning: "We cannot assume that the European countries are *ipso facto* superior to countries of the Third World, it is not only economical-technical wealth which is decisive, there is another wealth of human qualities."[36] In her conference report, Clara Menck of *Frankfurter Allgemeine Zeitung*, born in 1901, recognised an undercover form of national assertion in the portentous claim for the protection of human heritage: "It was left unspoken that claims to cultural heritage may often look strikingly similar to restitution claims on grounds of prestige."[37]

1980

BATTLE OF LISTS

Collection catalogues, museum inventories, object lists: these were the main focus of 1980 in Europe—subjects that appeared deceptively dry and technical while actually being highly political. In African countries the struggle for diplomatic negotiations via official notes of protest that seemed to be increasingly futile was replaced by alternative forms of recovering artworks: buying back celebrated objects on the international art market, organising spectacular touring exhibitions and film-making. As in previous years, Nigeria took the lead. Ekpo Eyo, who had mostly withdrawn from working for international committees and who made no secret of his frustration, travelled exetensively to London and throughout the United States that year (plate 12) with an exhibition he curated: *Treasures of Ancient Nigeria, Legacy of 2,000 Years.*

In January 1980, the first stop of Ekpo Eyo's impressive exhibition tour opened in Detroit (plate 13).[1] The exhibition was based on the version he curated in 1977 at the Lagos National Museum in Nigeria. After Detroit, the show went on to San Francisco, the Metropolitan Museum in New York and to further significant museums across the US and Europe, including the Royal Academy in London. In total, the tour lasted six years, including a stop at Museumsinsel in East Berlin in 1985 (see 1985: Back to the Future). The exhibition comprised outstanding works from the Nok and Ife civilisations, which were not widely known in the West, and was not only culturally but politically explosive. Eyo used the exhibition, as well as the accompanying catalogue, to draw attention to the intransigence of European museums, which since decolonisation had refused to loan works to Nigeria and thus support its cultural development as

a young nation. The *New York Times* art critic, John Russell, summed up the political message of the exhibition: "It could arguably have been made even more compelling by the addition of loans from outside Africa, but it also gains peculiar poignancy from the fact that Nigeria here speaks for itself."[2]

Indeed, the Lagos Federal Department of Antiquities did speak for itself in this instance. It decided—like any other, Western, museum—what was shown where and under what circumstances. It had narrative control and also the right to decide about the circulation of its objects—both a matter of course in the operating of Western museums but often denied to so-called developing countries. In his excellent, widely distributed catalogue published in several languages, Eyo responded bluntly to the question of provenance and restitution of cultural property from Benin City: not only did he mention the plunder of the kingdom of Benin by the British army in 1897 but also drastically illustrated the violence that occurred through a now much-reproduced photograph of British soldiers posing in front of their freshly looted trophies.[3] In addition, he appealed once more to the international solidarity of museums: "Benin is now left to show remnants and second-rate objects, as well as casts and photographs of pieces that once belonged to them. Perhaps it is time that the circumstances in which these objects were removed from Benin should be looked at again. Museums that have acquired the works of art could lend one object, maybe two."[4] Although this statement repeated his longstanding desire it was, significantly, no longer expressed in the context of diplomatic negotiations, specialist committees and academic publications. This time, the exhibition itself was turned into a political mouthpiece.

Another exhibition from Africa, *Kunst aus Zaire* (Art from Zaire), shown at the Übersee-Museum in Bremen at the beginning of 1980, followed a similar strategy: a cooperation between the Übersee-Museum, the National Museum in Kinshasa in Zaire and the Berliner Festspiele in West Berlin, "the most valuable and comprehensive [exhibition] outside of the country to date," as the catalogue boasted.[5] In the publication, the director of the Übersee-Museum, Herbert Ganslmayr, emphasised that one of the show's objectives was to highlight the specific problem of restitution, especially since Zaire played a pivotal role in the "worldwide discussion."[6] Zaire's President Mobutu Sese Seko had his personal say in the catalogue. In his welcoming remarks, he noted the fact that part of the objects on view came from "voluntary restitutions," "from those who recognised that we were an injured party and had to recover the possession of these works in order to familiarise our children with the tradition of our forebears."[7] In fact, in 1976, Belgium had begun to gradually return to Kinshasa objects that had been removed from the country during Belgian colonial rule.[8] Like Nigeria, Zaire was also concerned with acting as a mature and professional partner and conveying the necessity of restitutions through the medium of an exhibition.

Apart from exhibitions, repurchasing cultural assets at auction also provided an alternative to futile official negotiations—and they generated effective publicity. In London, Eyo demonstrated this particularly when he purchased several works with a Benin provenance at Sotheby's on 16 June 1980. The auction was from the collection of the "Property of a European Private Collector"—Adolph Schwar[t]z of Amsterdam, a leading figure in the Dutch perfume industry, as *The Times* reported.[9] Two-dozen objects came up for sale and the unusual presence of an African bidder in the room was interpreted as a powerful signal by the art and museum world, the press and politicians. The widely read French art magazine *Connaissance des arts* spoke of a "premiere";[10] *The Times* dedicated an entire sequence of three articles to the auction;[11] the FRG embassy in Lagos dispatched an excited message to the Foreign Office in Bonn, which was in turn promptly passed on to the German UNESCO commission, the Assembly of Ministers of Education, the permanent representation of the Federal Republic at UNESCO in Paris and the Federal Ministry of the Interior, as well as, via the latter, to the Stiftung Preußischer Kulturbesitz in West Berlin: "The public discussion about the issue of returning cultural property to the countries of origin has taken an unexpected turn in Nigeria," it stated.[12] "Unexpected," probably because Nigeria appeared as a culturally aware and self-determined country that was serious about recovering its cultural heritage. This did not fit the bill of an underdeveloped petitioner from south of the Sahara dependent on Western aid.

According to the Paris-based expert Guy Loudmer, the auctioned collection was "one of the three or four finest Benin collections in private hands" ever.[13] Nigeria bid the highest on four of the most expensive objects and was said to have spent the spectacular sum of half a million pounds. The *Financial Times* reported that the pieces bought by an "anonymous bidder" were soon to return to Nigeria.[14] The London-based magazine *West Africa* referred to the purchase in a long article, quoting Ekpo Eyo extensively.[15] The London-based Nigerian journalist and actor Gordon Tialobi described the sale in a passionate article for the magazine *Punch,* published in Lagos.[16] In it, he denounced the "despicable plunder" and "vandalis[ations]" of the British in Benin in 1897 and accused the living descendants of British soldiers to still live on "the proceeds of their fathers' shameless acts of terrorism."[17] At the same time, Tialobi criticised the Nigerian government for excessive leniency towards the United Kingdom. The journalist even considered the expensive repurchase of works at Sotheby's a minor effort in view of the future economic potential for Nigeria: "Commendable as it is that four of these pieces of our national heritage have been bought back, there were twenty other pieces that were lost because Nigeria did not bid for them. And this is the rub. It only needs five minutes of Nigeria's oil wells to pump up enough money to buy up the whole lot. In fact, a day's oil money would be enough to buy most of our looted treasures."[18]

At the beginning of the 1980s, there was a growing gap in many African countries south of the Sahara: between civil society, the intelligentsia and a political caste increasingly perceived as incompetent and corrupt. Unlike two decades before, culture now hardly played any role in politics, in public discourse and in government structures of many African states. More and more clearly, the marginalised cultural and intellectual elite expressed their discomfort.

This is also evident from the reviews of Eddie Ugbomah's 1980 action film *The Mask*. Faced with the intransigence of British institutions concerning returns or loans, the Nigerian director staged the recovery of the Queen Idia mask from the British Museum as a heroic theft by the Nigerian secret agent Major Obi, played by the director himself.[19] In an advertising flyer, the production team explained that the film dramatised what would be needed in the real world in order to get Nigeria's cultural heritage back: the use of blunt force as recommended by Wole Soyinka in 1977 (see 1977: Festac '77). The plot and the aesthetics of *The Mask* were in line with Western spy movies à la James Bond, although the film was naive, clunky and clumsy, as crtitics remarked.[20]

Ugbomah's film previewed privately in London in the summer of 1980 but subsequently mostly played in Nigerian cinemas. The aforementioned Niyi Osundare wrote a long and scathing review in *West Africa* in which he condemned the film as an accumulation of embarrassments.[21] His main accusation was that the serious and existential subject of cultural heritage and its reappropriation had been degraded to a vulgar affair. In this context, Osundare spoke of the "untold hurt" inflicted on Africans through the presence of plundered artworks in European and American museums. He deplored the trivialisation of art and ritual through money and ignorance—and likewise through a film like *The Mask*, which not only copied bad Western aesthetics in staging a heist but also "reinforced and justified rather than sought to destroy the ethos and process which made the original injustice possible." For Osundare, African objects in Western museums were "monuments to the injustices of the past, menacing testimonies to Euroamerica's persistent exploitation and dispossession of Africa."[22] A solution was no longer envisaged at the beginning of the 1980s, at least from a Nigerian perspective. Hope for restitution seemed to have been extinguished.

This may sound paradoxical, since at the time restitution finally had a clear venue for debate and an institutional framework at an international level—namely the ICPRCP, which had been established in May 1980 after some manoeuvering at the Paris headquarters of UNESCO and is still in charge of restitution matters today.[23] But in its forty-year history the organisation has not been a success, or, in the words of the lawyer Kerstin Odenthal, it has remained "virtually ineffective."[24] One may be tempted therefore to call the birth of the ICPRCP the death of the restitution project, certainly in terms of

the way it had been driven by the African side since the mid-1960s. One reason was undoubtedly the cumbersome nature of the organisation, but another was the systematic resistance it encountered in many areas, especially as its competences had already been severely constrained prior to inception (see 1978: Attack, Defence).

The ICPRCP consisted of twenty member states and numerous "observers." All member states, apart from the Soviet Union, sent one representative each to the first meeting in Paris.[25] The French delegate was Pierre Quoniam, who had begun his career during colonialism in Tunisia as director of the Musée national du Bardo in Tunis before becoming a respected director of the Louvre in Paris, and then inspector-general for the French national museums. The Federal Republic of Germany, which had preferred not to take an active role in the committee for tactical reasons,[26] dispatched the lawyer Elisabeth Schwarz, a senior government official in the cultural department of the city state of Hamburg, as an "observer" to the meeting.[27] Her reports have been preserved and, together with the formal documentation, provide an exact reconstruction of the discussions in and around the committee. Amadou Mahtar M'Bow personally opened the inaugural meeting with a speech following up on his 1978 appeal, where he emphasised once more that the restitution claims by formerly colonised countries only concerned a handful of particularly important objects. Nevertheless, these were of eminent importance for the cultural memory of these countries across generations.[28] The focus of the first meeting was far removed from philosophical or cultural concerns, dedicated as it was to the quite concrete and basic technical matter of object lists.

This was not a new issue. In 1976, the experts assembled in Venice had proposed that ICOM could help former colonised countries to compile registers of their cultural assets abroad in order to gain an overview of potential objects to be reclaimed. The idea had caused resentment at the time: "ICOM as a spy? Great!" the director of the Linden-Museum in Stuttgart had noted in his files.[29] Two years later, at the end of 1978, the heads of the leading West German museums and cultural departments had, in their guidelines on restitution defence, expressly warned against the publication of lists, since these could give rise to "covetousness."[30] Now, the ICPRCP was serious. The systematic compilation of object lists—indeed, enabling such compilations—became one of its main concerns, even to its political programme. "The committee considers it essential and urgent that each country seeking to build up representative collections of its cultural heritage should prepare a systematic inventory of the cultural property still on its territory and of property in other countries," it stated.[31] It was obvious that in the absence of an overview of the assets taken to Europe in the colonial era, no claims would be possible. Yet, for some, this demand was equal to a (renewed) declaration of war. "Museum Opposition to Treasure List Likely"

was the headline of an article in *The Times* in May 1981.[32] The author explained that the leaders of the British Museum were vehemently opposed to the publication of such inventories. *Le Monde* also sounded the alarm: "Tremble, museums, in France and beyond!"[33]

Considering the restitution fatigue of African states, it is interesting to observe how one of the first attempts by a formerly colonised state to affect restitutions via the newly appointed UNESCO committee supported by object lists failed spectacularly. Approximately at the same time as Iraq, which also demanded restitutions,[34] and one year ahead of Ethiopia,[35] Sri Lanka contacted UNESCO. In spring 1980, the small island state, which had gained independence from the United Kingdom in 1948, presented the ICPRCP with a directory compiled by Pilippu Hewa Don Hemasiri De Silva, the director of the National Museum in its capital Colombo, which comprised around ninety objects from twenty-four museums and libraries in Paris, London, Amsterdam, Munich and Berlin whose restitution he sought.[36] This list featured a small selection from a much larger one: the catalogue of all Sri Lankan collections worldwide, comprising thousands of objects, which De Silva had published in 1975 in the context of the global restitution debate under the title *Catalogue of Antiquities and Other Cultural Objects from Sri Lanka (Ceylon) Abroad*.[37] From West Berlin, for example, De Silva claimed sixteen wooden masks, which had been taken during the British occupation of the island. Libraries and museums in Austria, Switzerland and the United States were also on his restitution list.

The reactions by West German institutions when the Sri Lankan claims became known clearly reveal the importance of such lists and registers, as well as the considerations they prompted and how wearing the process was. The "compilation of a dependable inventory of cultural assets (systematical, complete, and final)...should be expected as the starting point for a state's restitution claims," an unnamed German museum professional commented on Sri Lanka's claim during a Foreign Office meeting in Bonn, but he immediately added: "the disorganised list from Sri Lanka that was presented to the committee is unlikely to suffice."[38] Other people's scholarly exactitude was never quite good enough. In an internal decision, the Stiftung Preußischer Kulturbesitz rejected the return of the claimed objects on the grounds that "these masks are unlikely to be of relevance to the 'identity' of the Sri Lankan people."[39] Here, the other side was also denied the ability to distinguish between importance and a lack thereof. Coincidentally, the foundation noted with concern in the same letter that "Sri Lanka had probably become aware of the existence of the masks in our ethnological museum through the special catalogue 'Masken aus Ceylon' published by Dr. Gerd Höpfner in 1969." There was hardly need for this assumption, since De Silva had correctly quoted the title in his list as a scholarly reference.

Friedrich Kußmaul, director of the Linden-Museum in Stuttgart, was even more blunt. In a letter to the Ministry for Science and Art of the regional administration for his area, Baden-Württemberg, he referred to Sri Lanka's "fanciful" restitution claims, essentially denying the small state the right to approach its own cultural heritage through independent academic research: he had "found out only now, and by chance, that the entirely nonsensical mask claims resulted from the desire of a young Ceylonese man to write a PhD thesis about masks from Ceylon, which is nonsensical because there is a wealth of publications in the West about them."[40] Kußmaul added with scholarly guile that he had seemed "to notice that even today, really top pieces are no longer published because it is known that the publication will lead to claims from the country concerned. Generally speaking, foreign embassies or institutions of the home countries check forthcoming publications to see what would or could be claimed. In this context, the demands of Third World countries lead to an obstruction of scholarly work and a reduction in the seminal influence of such objects in our countries."[41] It was precisely the awareness that claimant countries craved information about their cultural heritage scattered across the world that prompted Kußmaul's cynical idea of stopping the flow of information or at least threatening to do so. In April 1981, the German journalist Gert von Paczensky wrote a long article about "Treasures We Do Not Own" in the magazine *Art* and commented accordingly on the Ethnologisches Museum Berlin: "Speaking of catalogues—while the modern Berlin ethnological museum is more welcoming to visitors, there are no complete catalogues either"[42] (see 1982: Mexico and the Greeks).

Yet, this type of scholarly calculation was not the same in all European countries. In France, for example, at least in Paris, work on inventories and their publication remained an essential component of professional museology, and archival records from the 1980s do not reveal any traces of resistance against them.[43]

A similar absence of reserve can also be noted in Switzerland at the beginning of the 1980s, especially with regard to the Museum für Völkerkunde und Schweizerisches Museum für Volkskunde in Basel. At the end of the 1970s, it not only worked in cooperation with Paris on a microfiche publication of its Pacific Ocean holdings, but was also deliberating on postcolonial issues, for example on the language of such catalogues. According to the curator of the Oceania Department, Christian Kaufmann, it was "not acceptable in the long term to write ethnological documentation in a language that makes intensive use of these sources very difficult, if not impossible, for the actual originators."[44] Swiss ethnological museums in particular were also experimenting with the potential of newly emerging electronic data processing at the time. For example, the first five-hundred-page volume, *Übersichtsinventare der Museen*

in Basel, Bern, Genève, Neuchâtel und Zürich (Overview of the Inventories of Museums in Basel, Bern, Geneva, Neuchâtel and Zurich) was published in Bern in 1979. It contained valuable and precise information on the provenance of two hundred thousand objects, among them forty-four thousand from the African countries south of the Sahara, and it remains an indispensable trilingual tool.[45] "Even though Switzerland never had colonies, there is a great wealth of ethnographic material...spread across the country. Just how rich and widespread these large, small, and tiny ethnographic collections in Switzerland actually are, only became clear in the course [of the work] and even surprised the most seasoned researchers," said Ernst J. Kläy, who worked on the project.[46]

This was precisely the type of knowledge that leading museum staff in West Germany wanted to prevent. It is therefore not surprising that at the Lindau conference the subject of the Swiss inventory and the advantages of computer-based cataloguing of ethnographic collections was commented ungraciously and with a professorial air by, of all people, the chairman of the German ICOM committee, Hermann Auer: "Not everything which is technically possible, [is] therefore sensible and justifiable in terms of effort. Electronic data capture must not become an end in itself."[47] This statement given by a seventy-seven-year-old physicist masqueraded as the technological wisdom of old age yet was a political statement. Outlawing inventories and thwarting modern cataloguing methods in ethnological museums, as practiced in the FRG in the late 1970s and early 1980s, continue to have repercussions today.

Yet, even at the time there was one exception in the FRG: the Übersee-Museum in Bremen and its director Herbert Ganslmayr. In the context of the first working meeting of ICPRCP in Paris, he had the idea—since abandoned—of compiling a full inventory of all African cultural assets located outside Africa on the basis of existing publications. The project was based—and this was no accident in light of the constellation of power at the time—at the Übersee-Museum as a joint venture between UNESCO and ICOM and began in 1981, led by Ganslmayr. In 1986, the inventory comprised twenty thousand entries on four hundred microfiches, of which sixteen thousand were images and four thousand text files, all of them photographed from museum catalogues.[48] The project was later abandoned and it is difficult to gauge today whether African museum professionals ever made use of it.

1981

LOST HERITAGE

David M. Wilson had been director of the British Museum since 1977. He had studied in Sweden, married a woman from Stockholm in the mid-1950s, and had spent the first three years of his tenure at the British Museum concentrating on the preparations of a spectacular exhibition on the Vikings, a "massive rehabilitation of the early Scandinavians," as the German magazine *Der Spiegel* referred to the show.[1] Even though the British Museum had been a target for restitution claims since the early 1970s, the institution only recorded its first public statement on such claims from the "Third World" in May 1981.[2] Wilson delivered the statement at the Africa Centre in Covent Garden, just nine hundred metres from the British Museum, at a venue which was charged like no other, both in historical and symbolical terms.

The Africa Centre was located at 38 King Street, where several auction houses had salerooms from the eighteenth century until the beginning of World War II, including the Stevens Auction Rooms, founded in 1831 and one of the biggest venues worldwide for naturalia and ethnographica. Directly after the sack of Benin City in 1897, a large part of the British loot was auctioned here.[3] Until the 1930s, the auction house supplied numerous non-European artefacts and colonial trophies to museums—today the British Museum alone holds over five hundred objects purchased there.[4] After the auction house closed down, the building was used in the postwar period as a storeroom for the fruit and vegetable market nearby, especially, it is said, for banana deliveries from British colonial regions.[5] At the beginning of the 1960s, the Africa Centre moved in as the embodiment of decolonisation and remained there until 2013.

The centre was founded in 1964 with the objective of fostering non-governmental relations between the now independent African nations and quickly developed into one of the liveliest meeting points for the African diaspora in London. Many political movements of the 1970s and '80s had a focus here, not least the anti-apartheid movement. "For my generation, this building, in what was still the capital of empire, was a place where we could come together with Africans from all over the world to celebrate our independence; and, for those of us still struggling to be free, express and receive solidarity," remembered Archbishop Desmond Tutu in 2011.[6]

The Africa Centre had been the venue of the inaugural preview of the film *You Hide Me* about the British Museum stores in 1971 (see 1971: You Hide Me). Ten years later, on 21 May 1981, it housed a symposium in cooperation with the short-lived Commonwealth Arts Association about the return of cultural property. Entitled "Lost Heritage," it was the first event of its kind in the United Kingdom.[7] The panel of speakers who had been invited to give lectures and attend discussions was impressive: David M. Wilson; his press officer; the Africa curator of the British Museum; the Lebanese poet and diplomat Salah Stétié; a member of the ICOM Ad Hoc Committee for Restitutions; Peter Gathercole, the archaeologist and head curator of the Museum for Archaeology and Anthropology at the University of Cambridge; the Ghanaian Kwasi Myles, secretary-general of the organisation for museums, monuments and sites of Africa founded in 1978; Yudhishthir Raj Isar, the editor-in-chief of the UNESCO journal *Museum International*; as well as—last but not least—the historian and influential BBC TV producer, Ben Shephard. The conference documentation records that Herbert Ganslmayr was also invited to the meeting but had been kept away by industrial action at Heathrow airport. The eighty-strong audience comprised museum professionals, several BBC journalists, staff from several international organisations and many students.

Several months after the event, a thirty-page booklet was published in London, documenting all the contributions, discussions, photos of the event and a valuable list of attendees.[8] The cover of this informative publication was designed by John McKenzie, the chairman of the Commonwealth Arts Association and co-organiser of the event (plate 8). It shows the outline of the Queen Idia mask from Benin looking out of a sketched prison cell indicated by hatched stanchions, framed by two classical columns and a relief panel from the Athens Parthenon frieze—each of these "sensitive" objects from the British Museum. The prison motif has long been used as a metaphor for looted art and was increasingly used in caricatures and picture montages from the 1980s onwards. What was new as well as prescient, however, was the direct connection between the Benin object and the Parthenon relief: it was only one

year later that restitution claims from former colonised countries were to be addressed jointly with those from Greece in the public debate (see 1982: Mexico and the Greeks).

It is worth rereading the lectures and discussions of the London event in 1981 in the publication *Lost Heritage*. They give a lively impression of the positions held in the United Kingdom at the time and provide a sample of the arguments, pathos formulas and rhetorical topoi that had been circulating for years. In addition, there is a tangible presence of actors, institutions and concepts, which did not play a significant role in continental Europe, but were and still are fundamental for the debate in the United Kingdom. This applies in particular to the position of African intellectuals in the diaspora, which becomes apparent in the confident discussion contributions from a handful of young people from various former British colonies. Furthermore, the event provided a stage for university museums, which, compared to the rest of Europe, played an active, even proactive, role in the United Kingdom as the university collections of Cambridge and Oxford are as plentiful as they are compromised by colonial associations.[9] Finally, the attendees discussed the term "universalism," which had hardly surfaced in the debate to date but which became a lasting reflexive argument against restitution in the British context.

The global African diaspora had become aware of the restitution issue, at the latest, through the widespread media attention attracted by Festac '77 in Lagos, but no interest groups had formed in European capitals. The London conference in 1981—and a similar event held a few months later by the Société africaine de la Culture in the Paris offices of the publishing house Présence Africaine—opened the possibility for discourse between mostly young and European-educated or exiled people with family ties to the former colonies.[10] In London, this not only applied to people from the African continent but also, for example, Asian people from the Indian subcontinent who showed solidarity and identified with the demands of others who had formerly been colonised. The following statement from the London symposium gives an idea of the tone and texture of these arguments. As a replacement for Ganslmayr, who was stuck in Germany, the speaker was Chandra Kumar, who was introduced as "freelance writer and lecturer." He did not mince words:

> As Mr. McKenzie has told you, I am a last minute substitute for Dr. Gansl-mayr and consequently I have had little time to prepare myself for this panel discussion....My country is India which was, as you all know, subject to British domination for many years. Many of India's cultural properties were taken away by force or conquest. I would like to say that there is a moral imperative to return this property. Failure to do so may have harmful consequences for the coming generation because it is likely to breed the

climate of violence and racial hatred. I have detected a certain amount of arrogance and British chauvinism in some of the remarks made. I would say that Britain's greatest contribution to the international heritage was in science, literature, poetry and drama. In years to come it will be forgotten that the British Empire stretched across the world....India has a well-developed museum service which can equally well display and care for the many thousands of objects which are in UK collections. Many of these objects may have an appeal to scholars and it will be argued that as they are housed in UK museums they are readily accessible to scholars from Europe and America. But in India these objects would have an appeal to many thousands of ordinary people and they would also have a special significance as being signposts to their own cultural history. These objects would be accessible to many more people in India than ever they would in Britain—and they would have a greater meaning as well. Much has been made of Western Europe's expertise in caring for and exhibiting these objects. But what has not been considered is the possibility of a nuclear war in Europe. As long as you have cruise missiles and neutron bombs stationed in this country these objets d'art may not be safe here any longer. There is a real fear among developing countries of the implications of the nuclear policy of Britain and whilst I do not want to worry people here unduly I think consideration should be given to this possibility when claims are made for retaining these objects in British museums.[11]

With the reference to Margaret Thatcher's active embrace of nuclear deterrence, which was highly controversial at the time, and her agreement to station US nuclear weapons in the United Kingdom, Kumar turned the tables on the argument of treasures having been "rescued" by Europeans in the colonial era. At the same time, he directed attention to an issue that was discussed by many Britons, also in public: the poor condition of many (not only ethnological) museums.

The subject was raised again at the London conference of May 1981 in a talk by the anthropologist Peter Gathercole, formerly a curator of the Museum of Archaeology and Anthropology at Cambridge University.[12] He addressed the issue of restitution from the intellectual and sociological perspective of an elite university. In the previous decade, he said, he had "set our house in order," as "the case against restitution is weak...if the material is badly looked after."[13] Facing the audience at the Africa Centre, the Pacific Ocean specialist, who had lived in New Zealand for several years, made no secret of the colonial history in the composition of his extensive collections. The "vast majority" had come from the British colonies, with whom his university had "a long, intellectual, economic, political and moral connection."[14]

Against this background, Gathercole expressed clear support for an open, unforced approach characterised by solidarity instead of cynicism in dealing with restitution wishes from former colonised countries: "My own personal view is that museums in the Western world have got to face up to this problem and have to be prepared to send back certain objects. It cannot be done uniformly because, as far as I am aware, there is no unilateral view within museums in this country. However, unless we are prepared to take a rational, humane and dynamic view then I think we are in for trouble. And it is my belief that if certain important museums in this country do not take that line, then the pressure is going to be put on museums with a more flexible approach, and that would be unfair.... The whole issue is shot through with rhetoric, prejudice, misunderstanding, narrow-mindedness and fear, and we have all got to get away from that."[15]

Could Gathercole have had his colleague David M. Wilson in mind when he spoke of rhetoric, narrow-mindedness and fear while emphasising so strongly that one had to "set the house in order"? A few months before, Wilson had actually come under public criticism because he had been accused in a report published by the Civil and Public Services Association, the biggest British civil service union, of endangering the collections of the British Museum through "mismanagement." The depots were badly guarded, the condition of the building worrisome, a glass roof was threatening to fall on the Parthenon marbles any time. *The Times* had then run a front-page headline: "British Museum Chiefs Called 'Inept' by Union."[16]

In his statement at the Africa Centre, Wilson understandably steered clear of conservation issues. First of all, he noted that as a specialist on Vikings, he had never been to Africa and had no knowledge about ethnological objects. "I do feel slightly like the man in the lion's den....I only happen to be director of the museum which includes many treasures from other countries," he excused himself before declaring universalism—without any clear definition—to be a basis for his museum that was untouchable and applicable beyond any national borders.[17] It is not difficult to see that his argument reveals the term universalism to be a generalised form of Eurocentrism: "The British Museum was founded in 1753—and I think it is wise to remember that we have been collecting for 225 years. We were founded under the influence of the French Encyclopedists, as a 'universal museum', a museum which was to show the whole of human achievement and the whole of human culture."[18] Wilson did not say a word about British colonialism. Instead, he underlined the international character of his institution: "I would wish to emphasise...that the British Museum is not the Museum of Britain, it is not even the Museum of the British Empire."[19]

Wilson did not address the fact that, especially with regard to museums as nineteenth-century institutions, internationalism and nationalism were closely

intertwined and mutually dependent categories, as Gathercole had subtly out-lined in his talk. Following the address by her boss, the British Museum's press officer, Jean Rankine, took the floor and summarised Wilson's main points in succinct, quotable phrases: "The British Museum is a universal museum....the museum is not a mirror of national identity but a reflection of the universal heritage of man."[20] One can hardly help feeling that, at a time when corporate communication became established especially in the Western world, sound-bites were deployed here that would from then on become staples in the muse-um's external communication. This would also explain why David M. Wilson attended the conference in the company of his head of communication.

Even in 1981, the British Museum officials' soundbites referencing the museum being, like all European museums, open for visitors from all over the world and therefore compelled to refuse restitutions, were not seen as con-vincing, at least not at the Africa Centre. This is documented by a comment from the audience: the teacher Charles Mungo, originally from Trinidad, who had lived in London for ten years, noted that changes in political constella-tions might endanger access to museums. In this, he referred to Thatcher's government's current restrictive policy at the time on accepting overseas stu-dents, whose possibilities for education at "universal" British universities had been brutally curtailed.[21] "While I sympathise with the view that the British Museum is a universal institution," Mungo stated, "I should like to ask what guarantee there is that the British Museum will continue to be universally at the beck and call of people all over the world? We have no such guarantee."[22]

Even though the London conference at the Africa Centre in May 1981 was only noticed by a limited circle of people at the time, it marked a decisive turn-ing point in the British—and consequently worldwide—restitution debate. From 1981, more people from the diasporas became actively involved in the res-titution debate—even in Germany. The management of the British Museum, who had been rather reserved until then, moved into a phase of proactive public relations work and sought to make contact with like-minded colleagues on the continent. Themes such as the "universal museum" or the unlimited access to museums coagulated in a standard response to restitution requests that even took hold outside the United Kingdom.[23]

Six days after the symposium at the Africa Centre, the BBC broadcast a forty-five-minute prime-time documentary on restitution: *Whose Art Is It, Any-way?*[24] For this project, the historian and producer Ben Shephard had inter-viewed some of the most important global protagonists of the debate over five months: David M. Wilson, Ekpo Eyo, Amadou Mahtar M'Bow, the king of the Asante Opoku Ware II, Peter Gathercole from Cambridge University, Malcolm McLeod from the Museum of Mankind in London and Lucien Cahen, director of the Royal Museum of Central Africa in Tervuren, Belgium, as well as the

Brussels art dealer Pierre Guimiot. The film showed intermittent images of the exhibition and storage rooms of the British Museum, scenes from the Museum of Mankind and Tervuren, archival footage from Festac '77, religious rituals in Mali, speeches at the headquarters of UNESCO in Paris, tense scenes from an auction of African art at Sotheby's and much more.

The film also referred to Sri Lanka's and Iraq's restitution claims. It started with a programmatic sequence from Owoo's *You Hide Me* (1970) that provides an African perspective on the debate. And it ended with extracts from the official speeches on the opening of the exhibition "Asante: Kingdom of Gold" at the British Museum, which had been inaugurated on 18 February 1981 in the presence of the head of the Asante, Otumfuo Opoku Ware II, and his entourage.[25] In between footage from speeches at the opening, the film director inserted a sequence in quick succession of historical photographs of British soldiers in Africa, skilfully evoking continuity between colonial and neo- or postcolonial conditions. In a review, the *Times* noted that the director of the British Museum did not come across too well in this documentary, with his lack of reasoning, his gruffness and radical rejection of restitution "against political expediency and fashionable interference," and that, "as a diplomat he…would not, on this showing, pass first base."[26] Indeed, from today's perspective, his comments recorded in the director's office of the British Museum are marked by an almost unbearable institutional smugness.

Tellingly, it was precisely Wilson's tough position that seem to have generated keen interest in West Germany, particularly in the Berlin museum administrations: on 12 June 1981, the newspaper *Die Welt* printed a long interview with Wilson with a portrait photo. The article was read at the president's office at the Stiftung Preußischer Kulturbesitz and neatly filed in the restitution folder.[27] In the interview, the journalist Siegfried Helms brought up the demands from Sri Lanka, which included claims for about twenty objects from the British Museum. Even though there are no archival traces of museum-level solidarity between the German and British, the interview is a testimony to the countries' parallel respones: the massive exaggeration of demands from former colonised countries; the heartfelt protestation that one wanted to "make every endeavour" to help; the call for a "European" solution of the debate; the emotionalisation of the discussion through evoking great risks in the event of restitutions; linked to this, the accusation of emotionality directed towards the proponents of restitution; the politicisation of the discussion (in Wilson's case, with a somewhat surprising reference to Marxism-Leninism as an ideological basis for claims) with a concurrent appeal to depoliticise the debate; the stylisation of a bipolar struggle between (positive) international and (negative) national concepts of cultural heritage while drawing an outright veil over one's own nationalistic approach; a complete disregard of colonial contexts; and a desire to remain out of the public

gaze while simultaneously giving an interview. The journalist's approach is also noteworthy here, as he didn't question misinformation about Sri Lanka's restitution requests, and actually encouraged it himself in his questioning:

Welt: Dr Wilson, would it not be easiest to simply return art and ritual objects?

Wilson: If we started with returns, we could cause an avalanche. This would plunge us into a lack of direction.

Welt: How should governments and museums react?

Wilson: First of all, we in the West need to find a common position and search for ways to make every endeavour to help Third World countries. At the moment, we are all so intimidated that we hardly dare to say anything. There is no joint position as yet. I am therefore planning an international seminar in the near future.

Welt: What can be done in the case of Sri Lanka, which now demands the return of all art treasures that left the country in the colonial era?

Wilson: This is an incredibly exaggerated demand, it is simply absurd. If we talked sensibly and in the greatest possible candour about specific objects, things would be different. We need the debate to become more objective.

Welt: Colombo is still awaiting a response from Whitehall. In September, can we expect a new initiative from the intergovernmental UNESCO committee in this matter?

Wilson: Unfortunately, several Socialist Third World states are campaigning under Marxist-Leninist premises. There is a great deal of confusion there. It is simply a perversion of Marxist-Leninist ideas to maintain that a nation can only ensure its cultural identity after the proletariat seizes power, that only the working class has a sole patent on national pride and needs to reverse the destruction of culture through colonialism. Some Third World states gain political capital from the debate. But we need a depoliticisation of this debate.

Welt: Is there a constructive way out?

Wilson: The dialogue should be left to specialists. Many countries need to put their own houses in order....The British Museum was founded in 1753 in the Age of Enlightenment with universal objectives, therefore governed by internationalism. We should not allow such an institution to be destroyed by nationalism.[28]

Archival material has not yet yielded any information as to whether "an international seminar" on the subject of restitutions was indeed organised by the British Museum and its director in 1981 or soon afterwards, or whether

international strategies were sought among specialists. In the relevant bodies at UNESCO, the United Kingdom did not play an active role.

There is only a single case that followed the process of how the United Kingdom—just as the Federal Republic of Germany—critically observed and even impeded the work of the ICPRCP: at its first meeting in 1980, the ICPRCP had not only discussed lists but also planned to cooperate with the International Council of Museums on designing a uniform, multilingual, low-threshold claim and restitution form.[29] The idea of the form was that the "requesting country" and the "holding country" would jointly compile information about one claimed object each. The two-column form consisted of just under twenty questions. For example, it should be outlined when and under which circumstances the translocation of the claimed object had taken place, where it had been located prior to being moved, how one intended to store it in future, what was known about its condition and so on. This was intended to stimulate a spirit of compromise between demanding and possessing states.[30]

In March 1981, the director-general of UNESCO invited all member states of his organisation to comment on this form in preparation for its launch at the second session of the ICPRCP scheduled for the autumn. In the course of research for this book, suggested corrections could be determined for France, the United Kingdom and the FRG: the French authorities welcomed the compilation of the form and suggested minor amendments, mainly linguistic in nature.[31] The United Kingdom sent a diplomatic cable (via COREU) to the EU foreign ministries asking whether it might not make sense to give a joint response by the "ten" to M'Bow's query, but in the end it formulated its own preliminary position: "The draft form is too long and too complicated. The large number of precise groupings should be reduced to a smaller number of broader categories.... There should be two forms: one for use by the requesting country (RC) and one for use by the host country (HC)." Intentionally or not: the British had all of a sudden replaced the abbreviation "HC" the draft suggested for "holding country" by the more friendly "host country."[32] Furthermore, the "host country" would only have to answer three questions in total: whether it agreed with the facts presented; whether it agreed to begin bilateral discussions, and through which channels; and whether there were any further comments.[33]

In West Germany, museum officials asked to give statements fundamentally balked at the form. For Kußmaul in Stuttgart, it should "if possible, not be implemented," especially since—he repeated his standard fabrication once again—the question of provenance "could in the vast majority of cases no longer be answered" and it would be "pure chance" "if we knew about this or the other group of objects on which occasion they were acquired in the country of origin."[34] In Berlin, the president of the Stiftung Preußischer Kulturbesitz advised

the Federal Ministry of the Interior that the German side should "not interfere" with the design of the form, "to avoid giving the impression that we might be prepared to envisage concessions in this matter provided certain requirements for the form were met."[35] Knopp therefore passed on suggesting corrections. As usual, the German UNESCO commission followed the Stiftung Preußischer Kulturbesitz.[36] Eventually, both the Federal Ministry of the Interior (BMI) and the Assembly of Education Ministers (KMK) welcomed the British proposal in their final responses to the Foreign Office: they, too, supported both the use of separate forms for the claiming and the holding states and also the restriction of the statement by the holding state to "a few basic pieces of information."[37]

In September 1981, the ICPRCP then met in Paris for the second time.[38] It dealt with the restitution form, processed corrections and amendments, but did not abandon the dual function originally envisaged. Overall, the "Standard Form Concerning Requests for Return or Restitution" comprised twelve pages in the end.[39] It was printed by UNESCO in three languages in a large-size and modern-style booklet layout, the questions in black against a pastel-green background, interspersed with large white fields for answers. Instructions were included to introduce the document that was to be handed to UNESCO in triplicate. For each claimed object, one form still had to be completed—UNESCO thus expressed once again what restitution-seeking countries had reiterated again and again since the early 1970s and what restitution opponents in the press and in museums had persistently misrepresented: that restitutions should precisely not affect entire collections or unwieldy masses of objects, but selected, clearly identified, and for the communities of origin, particularly important, unique pieces.

1982

MEXICO AND THE GREEKS

Only rarely do archival records from the 1970s and 1980s reveal traces of direct interference by leading politicians in restitution matters. Most archival documents were created by ministry officials and museum staff in municipal and cultural departments; they consist of administrative statements, procedures and memoranda. This made the discovery of a small green note preserved in the political archive of the West German Foreign Office in a file from 1982 labelled "UNESCO World Conference on Cultural Policies" all the more spectacular. The note dates from 8 June 1982, and one can almost sense the temperament of state minister Hildegard Hamm-Brücher, who worked at the Foreign Office from 1976 to 1982. She wrote pointedly and with marked annoyance: "I hope it has now become clear why I defended our *leadership of the delegation*, amicably at first, then vigorously, and I also hope that the department will *finally* draw consequences for future occasions!!"[1] During her tenure, Hamm-Brücher was repeatedly at odds with her own organisation. This is also demonstrated by the green note, which had far-reaching consequences for the restitution debate.

The stumbling block was the representation of the FRG at a major UNESCO event in Mexico City, the second "World Conference on Cultural Policies," twelve years after the first event of this kind in Venice in 1970. This time, 129 delegations were to meet for two weeks from 26 July to 6 August 1982 to discuss the worldwide future of culture.[2] In the run-up to the conference, enquiries from Bonn had found that the "Group 77"—a loose association of states mostly from the "Third World"—planned to turn the meeting into a "North-South event." Instead of the usual economical and technical aspects of development

policy, culture was to play a "dominant role." In addition, a "culture-oriented critique of capitalism" was expected, as well as a "Declaration of Mexico" drafted under the leadership of the Senegalese President Senghor. The question of restitution of cultural property from formerly colonised countries, so much became known in advance, was also due to be discussed at the conference.[3]

From spring 1982, ministries and administrations all over the world were busy preparing the Mexico world conference. Most countries planned to be represented by their respective ministers of culture—these included for France Jack Lang, who had only joined the Socialist government of François Mitterand a year prior; for Greece, the also newly appointed minister for culture of the socialist government of Andreas Papandreou, the film and stage actor Melina Mercouri; and for the United Kingdom, Margaret Thatcher's minister of culture, Paul Channon. In the Federal Republic of Germany, however, a question arose as to the most appropriate representative. In the country's constitution, culture had been devolved to the regional states, and accordingly, the Assembly of Education Ministers (KMK) was to take charge of the composition and leadership of the West German delegation.

However, Hildegard Hamm-Brücher, as the state minister responsible for foreign cultural policy in Helmut Schmidt's government, refused to accept that: she had long been an advocate for a reformation of West German cultural politics in the world. Over the previous years she had given a considerable number of fundamental talks on the subject, as well as publishing articles and essays.[4] Her *Ten Theses on Cultural Encounters and Cooperation with Third World Countries* had just appeared, in which she argued for a fundamental revision of German cultural politics in the "Third World" and demanded a new ethics of mutuality in relations with developing countries.[5] In addition, Hamm-Brücher had put a particular focus on Africa from the start of her mandate. She spoke French well, travelled over twenty-five times to African countries south of the Sahara during her six-year tenure (compared with only eight trips to Asia)[6] and maintained relations with African intellectuals, last not least with Amadou Mahtar M'Bow, with whom she shared a memorable public appearance in Bonn in 1980.[7]

"Europe as the teacher, Africa as the pupil. This seemed to be cast in stone. Today, we are in the process of relearning"—this was Hamm-Brücher's credo on the occasion of the inauguration of the Goethe Institute in Nairobi, Kenya, at the beginning of 1980.[8] In this context, the state minister did not avoid conflicts in her own ministry or with the federal government. Her public appearance in 1979 against the FRG's apartheid politics in South Africa was well known: having travelled to the country by private means, she had found that parents and teachers at German schools defended the apartheid regime "fanatically" and had refused to enroll non-white children. "We should rather abandon our cultural relations with the white population of South Africa than continue

to make concessions in expanding our equal cooperation with the non-white majority. On the contrary, we should become active and take the initiative! We owe this to our own conscience—and, if this is not a political argument—we owe this to political reason."⁹ Conscience and political reason were the same foundations which Hamm-Brücher used to approach the subsequent restitution issue.

The state minister's insistence on being sent to Mexico prevailed in spring 1982. After some back and forth, the Federal Government created a dual leadership of equal partners to lead the German delegation, consisting of Hamm-Brücher from the Foreign Office and to represent the regional states the Christian Democratic politician Hanna-Renate Laurien, Senator for Berlin and vice president of the Assembly of Education Ministers. The German UNESCO commission, which had been busy rejecting restitution for years, was also represented in the delegation by president Otto von Simson, secretary-general Hans Meinel and cultural advisor Hans-Dieter Dyroff. The restitution specialist Elisabeth Schwarz also joined from the Assembly of Education Ministers. West German museum directors, however, were not included—even though museum professionals were among the British and French delegations.¹⁰ The proceedings at this unusual and politically highly charged conference are well documented, thanks to numerous sources, international press coverage, video recordings and from the daily reports wired by the German delegation in Mexico, some written by Hamm-Brücher herself. At the European level, the conference marked the peak of the restitution debate of the 1970s and '80s—and on the German side there was an unexpected development.

From the African perspective however, by 1982, after one and a half decades of futile attempts at negotiation at an international level, restitution efforts had run out of steam. In 1979, the first signs of discouragement had been palpable. By 1982, the journalist Frédéric Grah Mel from the Ivory Coast wrote of a "demobilisation" in the monthly journal *Afrique* from London: "Everybody prefers to stay put in this peculiar atmosphere of expectation and, in a sense, demobilisation which we can observe everywhere....Admittedly, for more than 20 years, since we asked this fatal question of restitution which always falls on deaf ears in the West, complaining has not been particularly original."¹¹ In spite of this, according to Grah Mel, one should not simply accept that African students, for example, would always need to travel to Paris or London to "encounter Africa" in the local libraries and museums. But this statement went unheard.

The fatigue described by Grah Mel was one symptom among many, as voices of those who had become involved in cultural matters in countries south of the Sahara were generally falling silent and cultural elites slowly disappeared. In the first two decades of so-called development, the industrial nations had narrowed

their politics in Africa almost exclusively to economic and technical aspects while passing over the sociocultural aspects of "development." In some cases, financial aid was even tied to the condition that investments in non-profitable areas such as culture and education would cease. According to specialists, the politics of the International Monetary Fund and the World Bank from 1980 had a devastating impact on culture, as their "Structural Adjustment Credits," which were contingent on strict criteria, had a highly detrimental effect on the societal and cultural life in many African countries.[12] One such consequence was a brain drain of many academics and cultural workers. The industrial nations were slow in recognising the failure of their policies, and the necessity of integrating cultural aspects more deeply into holistic development programmes became the new maxim in many northern states—however, at a point when cultural infrastructure in Africa had already collapsed in many places.

Nevertheless, in European administrations the defence against restitution was still very much on the agenda at the beginning of 1982. In an international strategy paper written in preparation for the Mexico conference, the German Foreign Office considered their delegation to be "well prepared" for most expected discussions. The FRG "as an efficient industrial nation without aspirations of domination or a colonial past" was "in a relatively fortunate position" and should only tread carefully in some areas.[13] These expressly included the restitution issue: on this point, "we don't need to, and should not, make detailed comments," stated a recommendation of 4 June 1982, "even less so since we would then also have to address issues where we are in the minority, such as the 'return' of cultural property to countries of origin."[14]

This presented an interesting new perspective. It seemed to have become clear in Bonn in the meantime that the guidelines drawn up by the German UNESCO commission on the defence against restitution—and the adoption of this tough approach by the FRG in general—ran counter to international trends, even within the European Union: the Netherlands and Belgium had been involved for years in concrete restitution proceedings to Indonesia and Zaire.[15] Denmark was in favour of restitution.[16] France contributed constructive work within the ICPRCP and was just about to take an important step (see p. 122). Furthermore, on 8 June 1982, the Italian foreign minister restituted the throne of the Ethiopian emperor Menelik II to his counterpart Feleke Gedle Giorgis.[17] The hard-line approach of the Federal Republic seemed to be shared in the EU only by the United Kingdom. This was to be confirmed in Mexico—and would not fail to make an impression on Hildegard Hamm-Brücher.

If one is to believe the general media coverage, the Mexico conference in the summer of 1982 at times threatened to sink into chaos and strife—for example, between Iran and Iraq, or Israel and the Palestine Liberation Organization. Right at the beginning of the event, a marked politicisation of the debates

occurred when on day two of the conference the young French minister of culture Jack Lang launched a vehement attack against the "cultural imperialism" of the United States, presenting an alternative multipolar universalism and intense fostering of cultural differences and and particularities by all nations. The goal was to prevent the intellectual and financial "colonisation" by a single hegemonic power.[18]

Jack Lang's surprising mobilisation of the term colonialism to denounce forms of global cultural consumerism and cultural production prevalent at the time was certainly audacious, as was the simultaneous implication of equating supposed victims of cultural US imperialism with victims of real historical colonialism. Yet this was not new, Lang had tried it out once before the Mexico conference, in a former French colony of all places, in front of two-dozen African ministers of culture. In October 1981, he had given a talk in Cotonou in the People's Republic of Benin where he had compared the African people's struggle against colonialism with his "struggle for culture" as a Frenchman: "This is the same struggle, between us who want to defend our independence and you who also want to protect your culture and identities."[19] It was a peculiar construction, which is nevertheless instructive in understanding France's positioning in matters of restitution at the beginning of the 1980s. François Mitterand's new government, in office since May 1981, tried at the time to build new alliances in the so-called Third World through cultural subjects, as did many other countries. The goal was to demonstrate respect for formerly colonially oppressed new national states: to encourage their entitlement to culture and cultural heritage, in order to win potential alliance partners in the global confrontation of systems.

In Mexico, Jack Lang's speech was widely applauded—though not by the German delegation. Hamm-Brücher noted: "The French minister of culture and former actor and theatre director Jack Lang turned his speech into a grand performance which was applauded by the majority. He was as polemical as he was demagogic and entirely focused on the Third World.... He proclaimed the right of the people to beauty.... Lang's speech was regarded as shocking by the Western world (except Greece's minister of culture, Melina Mercouri)."[20] All the more shocking, it can be assumed, since Lang did not hide his sympathy for Cuba and "went remarkably easy" on the Soviet Union, as Hamm-Brücher wrote. The German weekly newspaper *Die Zeit* scoffed: "The French minister of culture Jack Lang, a firebrand, let sparks fly again."[21]

However, an even bigger impression—covered even more widely by the international press—was made on day four of the conference by Melina Mercouri. Mercouri was born in Athens and was not only an internationally acclaimed film star, but during the military dictatorship in Greece from 1967 to 1974 she had fought the regime from exile in Paris and then become involved in

politics as a member of the Greek parliament for the socialist party. "With the eloquence and gesticulation of a Greek tragic actress," the German magazine *Der Spiegel* reported after her performance in Mexico, "Melina Mercouri, aged between 56 and 62, minister of culture and science in Athens, demanded that the United Kingdom should, among other things, return 'the Elgin Marbles, which for us, the Greeks, will always be the Parthenon marbles.'"[22]

Right at the beginning of her speech in front of seven hundred and fifty delegates, Mercouri addressed her position as a woman in politics: "If my information is correct, women occupy the post of Minister of Culture in ten countries throughout the world. That is not a bad percentage in a male-dominated world. We would all be better off if women played a more important role; and this conference would reach more concrete conclusions if there were more women involved in it."[23] Mercouri then appealed for social equality for women in the world, described as an "oppressed continent." Only then did she demand the return of the fragments from the Parthenon frieze, which had been displayed by the British Museum since the nineteenth century and had been anglicised in the United Kingdom as the Elgin Marbles.

The demand in Mexico was a bombshell. For those in the know it had not come as a surprise, and it was not by chance that the British government had invited the director of the British Museum, David M. Wilson, to join the British delegation to Mexico. Even in March 1982, Mercouri had announced the claim for the Parthenon frieze at a press conference in Athens.[24] But now, in the aftermath of her impressive speech, her demand echoed worldwide. The restitution issue, which had until then been publicly perceived mainly as an issue for "underdeveloped" countries—and for that reason often dismissed—now touched the Parthenon as the heart of Europe: an architectonic icon of antiquity and the chosen logo of UNESCO.[25]

Mercouri's speech unsettled the North-South and East-West reflexes established over twenty years from dealing with restitution claims and denials. Greece was the only European state that had always supported efforts by former colonised countries for returns since the mid-1970s. Now, the "Third World" was to help the European country of Greece to receive restitutions from another European country. In this context, Mercouri announced that she wanted to bring her case in front of the ICPRCP, which had originally been set up to handle claims from the "Third World":

> The government of Greece has charged me with the duty of announcing to you here that Greece, through the mediation of UNESCO's intergovernmental committee for the promotion of the return of cultural property to its country of origin, using formal procedures and relying also on legislation currently in force in England, is about to make an official request for the

return of the Acropolis marbles....Greece appeals to countries which have had the same experiences, suffered the same ravages, and declares that it maintains and will continue to maintain that mutilated groups scattered throughout the world must be returned to their countries of origin, must be reintegrated into the place and space where they were conceived and created; for they constitute the historical and religious heritage, the cultural patrimony of the people who gave them birth.[26]

Mercouri words echoed M'Bow's appeal of 1978. Her speech was met with sustained applause in Mexico and, for a moment, restitution efforts seemed to merge into one joint struggle no longer solely limited to formerly colonised countries. The Greek minister of culture seemingly turned into the spearhead of a renewed movement, which the majority of the UNESCO states had long been a part of but could now hope for a breakthrough with new vigour. Conversely, with Greece's advance, the entire initiatives for restitution from Africa and other regions disappeared from the public gaze in Europe at one fell swoop. At the same time, the advance marked the final end of European solidarity against restitution claims from the "Third World"—long hoped for, at least from the point of view of the government in Bonn. From now on, France would also join Greece in a more liberal practice regarding restitution matters, as recently discovered documents in the archives of the Musée du Quai Branly-Jacques Chirac in Paris demonstrate.

These documents from the spring of 1982 show how—immediately before the Mexico conference and probably in direct connection with it—the French foreign ministry set up an interdisciplinary working group to reflect on "concrete and swift" considerations on the restitution of cultural property from French museums to Africa.[27] This "Working Group of Africa" was to be led by the respected museum official Pierre Quoniam, who already represented France in the ICPRCP and was fully briefed on the subject. Quoniam assembled twenty scholars, ministry officials and museum curators—including two women—and tried within this group to come up with proposals on tools of action, modalities and objectives for restitutions "as soon as possible."

The committee met three times in total: in May, June and July 1982. On 21 July 1982, six days before the Mexico conference, Pierre Quoniam presented the final report. In it, all experts declared themselves unanimously in favour of restitutions, "based on the conviction that the return of cultural property is an act of solidarity and justice which, if it is properly understood and carried out well, will contribute not only to the restoration of and respect for the respective national cultural heritage, but will also demonstrate that this heritage, by remaining accessible to all, is part of the world heritage."[28] Such an unequivocal statement in favour of restitution had not been formulated in France before.

Possibly, the strong political ties and personal friendship between the French minister of culture Jack Lang and his counterpart Mercouri played a part in setting up the working group. It was also no coincidence that Quoniam was part of Lang's French delegation in Mexico.

By summer 1982 at the latest, it therefore became apparent that a geopolitical remapping of North-South alliances was underway, both within UNESCO and in the wider arena of cultural politics with regard to restitution. Not only did this lead to the increasing isolation of the FRG with its hard line against restitution, but also, it seems, to strategic uncertainty. In Bonn, lamentations were heard that "the French culture minister Jacques [sic] Lang had been more interested in a consensus with Cuba than with Western countries."[29]

Tellingly, the confusion over restitution even reached the hitherto fairly discrete GDR with its rich holdings of colonial-era collections in museums in Dresden and Leipzig. An internal position paper of the GDR Ministry of Culture, today preserved in the German Federal Archives and first published by Holger Stoecker, provides an immediate sense of the ideological and rhetorical perplexity caused by the restitution issue in 1982.[30] Here, the minister of culture noted that demands from developing countries should "in principle be supported by the GDR," however, "a complicated situation had arisen for the GDR, but also for some other Socialist countries": of course it was correct that the treasures of world culture on display at Museumsinsel in East Berlin were to be regarded as "legally the cultural heritage of the GDR," at the same time, "the GDR however also needed to take into account in its position vis-a-vis developing countries that the criterion of legality alone was often insufficient when faced with bourgeois-imperialist legal systems, especially from a foreign policy point of view, because this is tantamount to sanctioning bourgeois practices of looting. There is therefore…a danger of being seen by the developing countries as aligned with Imperialist states."[31] In spite of this assessment, the GDR did not seem to have taken any concrete steps that would have led to restitutions or permanent loans—for example, returning the numerous Benin bronzes held in Leipzig to Nigeria (see 1985: Back to the Future).

An impressive and unexpected short-lived repositioning on restitution matters took place at the FRG's Foreign Office following Hildegard Hamm-Brücher's return from Mexico at the beginning of August 1982. It is unlikely to have been agreed internally and seems to have been prompted by the speeches heard in Mexico and the sentiments experienced around them. We can only surmise what exactly caused the unorthodox initiative by the experienced politician from Germany's liberal Free Democratic Party, known for her strategic foresight and moral integrity. Perhaps it was a sober political calculation, perhaps the conviction that the restitution of cultural property may indeed lead to a new, more ethical relationship with Africa. Perhaps the state minister

had been encouraged in her decision by a "conversation in confidence, some-times cordial"[32] with Amadou Mahtar M'Bow on 1 August 1982 on the fringes of the Mexico conference. Perhaps she had been moved by Mercouri's politi-cal appeal to the decency of women. In any case, Hamm-Brücher disregarded all of her ministry's strategic recommendations on restitution matters, and communicated directly after landing on her return flight from Mexico via the news agency Reuters that the Federal Republic was certainly open to a return of cultural property "to the countries of origin." Bearing in mind that eight weeks earlier, the Foreign Office's instructions for Mexico had advised "defen-sive behaviour" on the subject of restitutions, this was a bold, and probably also politically courageous, move.[33]

The daily *Süddeutsche Zeitung* accordingly published a short article under the heading "Frau Hamm-Brücher: Be generous in Returning Cultural Prop-erty," which deserves to be quoted in detail: "The State Minister in the Foreign Office, Hildegard Hamm-Brücher, argued in favour of generosity in the matter of returning cultural property to the countries of origin. Returning from the world cultural conference in Mexico, Ms. Hamm-Brücher said that the issue would become one of the principal topics in cultural relations in the years to come. It was certainly conceivable that on the occasion of the centenary of sign-ing the Protection Treaty with the former German colonies Togo and Camer-oon in 1984 in Africa, cultural property could be returned, Ms. Hamm-Brücher stated."[34] With her announcement, Hamm-Brücher drew public criticism, not least by a certain Adolf Tüllmann, the long-standing head of the Goethe Insti-tute in Kinshasa and author of various ethnological books on "love life in the Far East," on "primitive" and "civilized" nations, on the "charm and beauty of the Parisienne" or also on "sex and love in the United States"—one of his last publications was dedicated to "sex education for deaf people."[35] He penned a reader's letter that *Süddeutsche Zeitung* printed under the heading "Cultural Property Back to the Jungle." He closed with the observation that "much less has come to us from the historical cultural production of most Third World nations than from the cultural heritage from Antiquity and from Europe," which was why all museums were duty-bound "to preserve what little there was…in the interest of humanity and of the countries of origin."[36]

But Hildegard Hamm-Brücher had a plan. Immediately after her return from Mexico to Bonn she ensured that a staff member in the Berlin office of her ministry obtained information about the African collections in the Ber-lin museums.[37] His report reflected the circumstances intentionally created in Berlin at the time: "My enquiries produced the following results: 1. There is no published catalogue of the holdings of the Africa department in the Ethnolog-ical Museum: a full overview of these holdings could only be gained through inspection of internal museum documentation. 2. My (by all means inexpert)

inspection of the objects displayed in the Dahlem museum found a quite extensive collection from two cultural groups in Cameroon....they include the gifts described in the enclosed information leaflet."[38]

Clearly, in 1982 even a Foreign Office staff member instructed to do so was only able to obtain reliable information about African holdings in Berlin through visiting the exhibition rooms in person and collecting leaflets made available to the general public. In a European context, this was a unique situation with a history, resulting from a self-invented restitution defence strategy. However, this did not prevent Hamm-Brücher from pursuing her restitution project. On 1 September 1982, the state minister prepared a letter that reflected her "thoughts...on the return of a representative museum piece" to Togo and Cameroon:

> Ms St-M would be prepared to chair a potential honorary or preparation committee to plan the centenary of the Protection Treaties (patronage by both heads of state)...The Dahlem museum disposes of extensive collections, particularly from Cameroon. But there are also representative pieces in Munich and Stuttgart....Ms St-M will meet with the President of the Stiftung Preußischer Kulturbesitz in the near future to establish whether a gift each to Togo and Cameroon may be diverted from the museum possessions.[39]

"Diverted" was a term that would surely not have met with the approval of the Stiftung Preußischer Kulturbesitz. But such a meeting never came to pass. Only three weeks after formulating this plan, Hildegard Hamm-Brücher left the FRG government after the fall of the socialist-liberal coalition on 17 September 1982. With her departure, the short-lived restitution plans of the government were shelved. Under the new Chancellor Helmut Kohl, the Foreign Office seems to have hardly been concerned with restitutions to the African continent.

1983

BREMEN

The Mexico conference brought renewed attention to the restitution debate in Europe after its first peak in 1978 to 1979. But the spectacular Greek claim overshadowed claims from other, formerly colonised countries; the press would from now on focus increasingly on archaeological holdings. Few arguments against the defence arsenal of Western museums had been voiced in recent years across the African continent and its diasporas. The foundation of the ICPRCP in 1979 had briefly raised hopes that bilateral agreements could lead to targeted restitutions of individual objects. But Sri Lanka's example had soon demonstrated that even well documented claims were unable to scale the fortress of Western institutions. It would not be an exaggeration to say that, from an African perspective, the first postcolonial restitution debate was long over by 1982. Yet in Europe, some protagonists continued their efforts in favour of restitution.

The northern German Hanseatic city of Bremen, as previous chapters indicated, was one of the first hotspots—if not *the* hotspot—on the international map for postcolonial restitution debates from the outset, owing to its amalgamation of museums, media, politics and academia. In other European cities, active participants in the debate were typically either only museums (Stuttgart), or only universities (Cambridge); in some places the media and political organisations joined forces (as in Paris), or there was a close exchange between museums and politics (as in West Berlin), without the press taking a role in shaping the debate. In Bremen, however, different institutions and personalities from the worlds of the media, politics and academia interacted in very close proximity. Those who had partly already begun to address the reappraisal

of colonialism—not only in Germany—in the early 1970s, pulled together in a decidedly similar anticolonial and antiracist direction.[1]

Historically, Bremen was one of the cities that had been most closely involved in German colonialism. At the university of Bremen, founded in 1971, the legal scholar and political scientist Manfred Hinz lectured and, together with his colleague Helgard Patemann, he played a key role in the reassessment of German colonialism and its African resistance in what is today's Namibia.[2] In the Bremen state archives in the 1980s, its director Hartmut Müller analysed, catalogued and made accessible the colonial-era documents of his institution.[3] In politics, Mayor Hans Koschnick from the Social Democratic Party, who was in office from 1969 to 1985, supported anticolonial projects both conceptually and financially.[4] In the Bremen media landscape, the investigative journalist Gert von Paczensky assumed a decisive role in the restitution debate, first as editor-in-chief for Radio Bremen (1969–70 and 1973–80) and head of the TV politics and current affairs department, and later as a freelance writer. From 1976 at the latest, Paczensky regularly spoke in support of restitution in radio broadcasts and newspaper interviews. These institutions and figures from the university, the senate and the media operated in a close network.

In addition, the Übersee-Museum's aforementioned director, Herbert Ganslmayr, had thrown himself behind the restitution struggle as a kind of whistleblower, when he spoke at length with the press about the to date confidential defence manoeuvres of his museum colleagues in Germany (see 1976: "German Debate"). As a consequence, he had been excluded from all West German committees and strategy meetings, but had been all the more active internationally. For example, he had played a key role as a board member of the International Museum Council by founding the Ad Hoc Comittee for Restitutions in Moscow in 1977 (see 1978: Attack, Defence). In this context he had been highly influential in shaping the form and content of the ICPRCP at UNESCO, while providing active support to the work of the committee during its first years through partnership projects with the "Third World," especially with Mali and Zaire.[5] In addition, from 1976 to 1979 Ganslmayr had overseen a remodelling from a postcolonial perspective of his museum, which had been founded in the heyday of German colonialism and had been christened "Kolonial- und Übersee-Museum" in 1935. The museum now declared programmatically that "it also takes the mantle, as far as possible for a museum, for those nations to whom we are grateful for more than decorative crafts and exoticism—not to mention what we owe them. The new and uncomfortable honesty of this museum confronts us with a reverse culture shock."[6]

This uncomfortable honesty could be deployed as another special tool above and beyond the museum in the form of an in-house publication series founded in the National Socialist era, which Ganslmayr skillfully reemployed

politically. One example is a dissertation by Dorothee Schulze that was "self-published by the museum" in 1983 and had been accepted shortly before by the legal faculty of the University of Bremen, inspired by Ganslmayr and jointly supervised by him and Manfred Hinz. Schulze's thesis was on the UN General Assembly's international law resolutions on restitutions. Entitled *Die Restitution von Kunstwerken* (The Restitution of Artworks), it soon became a much-quoted publication.[7] Schulze discussed, among other aspects, the possibilities for a transformation or removal of existing legal restrictions to enable compliance with obligations under international law. Notably, the Übersee-Museum not only included the volume in its publication series, it also promoted it internationally through reprinting its abstract in English—a copy is preserved in the archives of the Musée du Quai Branly-Jacques Chirac in Paris.[8]

In the same year, Paczensky and Ganslmayr worked together on a comprehensive, well-researched popular-science book on colonial-era collections in European museums and the demands of formerly colonised countries published in 1984. The book, with its sensationalist title *Nofretete will nachhause* (Nefertiti Wants To Go Home), was based on meticulous archival research and referenced an extensive collection of sources that were difficult to access, while an absence of academic references encouraged the impression of the polemical nature of a publication from activist circles.[9] Only a single chapter was dedicated to the famous bust of Nefertiti, which had been kept in Berlin since 1913, and its provenance. The list of the other chapter headings give a sense of the approach and content of the book: in "Flaunting Stolen Gold" and "Plundering Benin" the authors reconstructed several especially brutal episodes in the European appropriation of cultural property. In "Nation without an Archive" they expanded on the effects of colonial-era translocations on a culture of remembrance; in "Problematic Returns," they focused on the work of the ICPRCP and UNESCO in detail. In the chapter "Arrogance" they paraded the arguments against restitution raised by FRG museum directors since 1976—naming and shaming Kußmaul, Waetzoldt, Lommel and Knopp and relentlessly quoting from their confidential statements of the 1970s.

In German-language newspapers and TV, the book was widely reviewed, usually negatively.[10] In FRG museum circles there was once again "an almighty hue and cry": "I consider it intolerable that such a colleague [Ganslmayr] sanctions a publication with his name whose title for sensationalist reasons contains a statement which is simply a lie. Nefertiti does not want to go home, and the Egyptian colleagues do not want her at home," Friedrich Kußmaul wrote to Hermann Auer after an Austrian TV station had broadcast a report about the book.[11]

Almost simultaneously, a book along similar lines appeared in London, though less polemical and more systematically structured, entitled *Loot! The Heritage of Plunder*.[12] The book was authored by the publicist Russell Chamberlin,

born in Jamaica in 1926, who also commented in detail on demands from former colonised countries like Ghana and Nigeria and described the most recent efforts by the ICPRCP and UNESCO, including the Mexico conference of 1982. In these comprehensive digests from 1983 and 1984, the entire restitution debate of the 1970s is condensed, as it were.

In the autumn of 1983, another powerful political voice was raised in London. The Labour party member of Parliament and former arts minister under the second government of Harold Wilson, seventy-five-year-old Hugh Jenkins, attempted to have the restrictive British Museum Act of 1963 (see 1965: Bingo) revised in the context of the restitution claims from Athens. As a minister in the mid-1970s, Jenkins had abolished admission charges to British museums. He was also known as one of the main campaigners for the peace and antinuclear movement in the United Kingdom. On 28 October 1983, he gave a vigorous speech in the House of Lords on the necessity of amending the British Museum Act. Tongue-in-cheek, he referred to his proposal as the British Museum Trustees Liberation Bill.[13] He argued in favour of greater institutional flexibility in dealing with restitution claims and conjured up an image of incarcerated museum officials, who clung all too happily to their "legislative prisonwalls." Some British Museum trustees attended the speech. Their responses are documented among the rare public statements made by the powerful committee during the early restitution debate.[14] Jenkins did not prevail with his proposal for amendment. The British Museum Act of 1963 still applies today.

1984

OPEN END

"As the 15 November 1984 marks the centenary of the opening of the Berlin Congo Conference, colonial history in a general sense is certainly going to be a subject for public discussion over the coming weeks and months. (The ARD, for example, has a two-hour broadcast scheduled on the subject on 14 November, after the evening news.) A fairly high level of attention is therefore to be expected," announced by the German TV presenter Wilfried Hoffer in October 1984.[1] Hoffer was presenting a talk show with the title "Stop Thief! Cultural Treasures from the Third World: Looted, Loaned or Owned" on the FRG state-broadcasting channel ZDF. The open-ended discussion featuring a broad range of guests was to be broadcast live; designated participants included museum directors, cultural politicians, art dealers, lawyers and ethnologists as well as "scholars and diplomats from formerly colonised countries."[2]

One hundred years after the Berlin Congo Conference of 15 November 1884 to 26 February 1885 there were indeed many events, publications, exhibitions, TV documentaries and symposia in Europe commemorating the colonial past and its consequences for the formerly colonised countries. At the invitation of Germany's first chancellor Otto von Bismarck, the European superpowers had gathered in 1884 in the capital of Prussia to create a framework for the colonisation of Africa. One hundred years later, a variety of protagonists from academia, media and politics marked the occasion by facing up to the European entanglement of guilt and appeasement, violence, oppression and genocide. The territorial, political, economic and psychological consequences of colonisation were discussed late into the twentieth century. Even though there were actually

no new developments to report in terms of restitution and UNESCO was in the middle of a crisis, reports on colonial-era museum collections and restitutions resurfaced occasionally throughout 1984.[3]

In this political context, the talk show broadcast on FRG TV channel ZDF on 18 December 1984, clips of which are preserved in the ZDF archive, can be considered sensational.[4] The show was remarkable as it both managed to broadcast for over two hours and to present a range of expertise from the twelve invited guests, including some of the key players of the previous decade. Thanks to the archival clips, the personalities of these players are brought to life, which would only otherwise be unsatisfactorily characterised in written records. From today's perspective, the broadcast offers a rare synthesis of almost all perspectives from different institutional, professional and national positions from the 1970s and '80s. It is striking how openly the mass media dealt with the subject of colonialism, museums and restitution forty years ago, and how natural the inclusion was of experts from so-called communities of origin.

The programme was shot in the large atrium of the Übersee-Museum Bremen, which reopened five years earlier after extensive renovations. In a critical reference to the museological tradition of the host institution, the set in the atrium had been conceived as an abstract version of a Pacific seaside village, and according to the museum modernisers, was intended to establish a "functional and undramatic atmosphere."[5] Twelve experts and two presenters sat in the middle of a set consisting of huge palm trees, huts, South Pacific boats and life-size figures whose faceless heads were covered by bushy dance masks. In front of the group's feet was a large round logo of the TV programme alongside rattan tables placed by their knees (plate 14). A multi-camera setup on wheels recorded the event from different perspectives, including from above. Both the choice of setting and the choice of guests suggested the conceptual involvement of the Übersee-Museum's director.

Herbert Ganslmayr was seated on the podium with his archrival Friedrich Kußmaul from Stuttgart. Also present were the Africanist Eike Haberland and Dorothee Schulze, a lawyer who had just completed her doctorate at the University of Bremen and had authored the first international law study on restitution. From UNESCO, there was Yudhishthir Raj Isar, the Indian-born editor in chief of the Paris-based journal *Museum International,* and the Danish museum director Else-Marie Boyhus, who was on the board of ICPRCP. Representing experts from Africa were Claude Ardouin, director of the National Museum of Mali in Bamako, and the ethnologist and sociologist Tirmiziou Diallo from the Republic of Guinea, who had been based in Germany for twenty years. After studying under Max Horkheimer and Theodor Adorno in Frankfurt am Main and following his doctorate Diallo had become assistant professor at the Institute of Ethnology at the Freie Universität of West Berlin. In addition, the Assembly of

Education Ministers (KMK) was represented by the Bavarian minister Wolfgang Eberl, and the art trade by the well-known Munich gallerist Wolfgang Ketterer. Two figures from academia rounded out the substantial panel: Helmut Bley, described as a colonial historian and a professor of modern and African history at the University of Hanover; and last but not least, Klaus Horn, psychoanalyst and head of the Department for Social Psychology at the Sigmund-Freud-Institute in Frankfurt am Main and psychology professor at the local university.

It is not only the discussion, but even more so the glances and gestures of the guests, the moments of silence and hesitation, even the sometimes palpable tension among the experts in their absurd South Pacific village that make this audiovisual document so appealing. In between the discussion, three short documentary films were shown: extracts from Peter Heller's film *Mandu Yenu* (1984), which had just been completed in coproduction with the ZDF channel, about the throne of pearls of the Cameroonian King Njoya exhibited at Berlin's ethnological museum; a tour of the crumbling depots of the ethnological museums in Bremen and Stuttgart; as well as a report on the illegal art trade in Mexico.[6] The following quotes from the discussion show the high level of debate possible on the mass medium of television in the mid-1980s in the FRG. They are above and beyond the hackneyed paternalistic or stereotyped statements on Africa as conveyed yet again, live in front of the cameras, by Kußmaul and the art dealer Ketterer. The following extracts give an impression of the tone and the candour of the discussion. The professional titles are taken from the programme:

Wilfried Hoffer (3:24–4:00): What would also interest me now, Mr Diallo, you come from Guinea respectively you are an ethnologist, you have lived in the Federal Republic for a long time. . . . How does it look in your view or from your perspective?

Dr. Timirziou Diallo, ethnologist (4:00–7:10): This problem, as I said in the beginning, is a historical problem, which should be treated as such. Indeed, as far as Africa is concerned, the circumstances—political and economic circumstances—were exploitative in their colonial form. This exploitation was not just material in character, it was also cultural. Through these national movements, we came to rediscover our culture, which had until then been in a way withheld from us. And on two levels: once on a theoretical level and another one on a concrete [level], as [it] was taken away from us. And I think that a way should be found to demand that countries return objects which are important for our further development—cultural development.

Reinhard Appel (7:10–7:36): Mr Bley, may I perhaps ask you as a colonial historian, is colonial history identical with a history of plunder and exploitation?

Prof. Dr. Helmut Bley, colonial historian (7:36–9:42): In any case, there was a very high proportion of violence in colonial history. There is probably hardly a case where it was not very violent from the outset, because fairly capital-poor companies, colonial pioneers, wanted to make ends meet in this country, wanted to make money; or governors, who had instructions (or the soldiers) to set up their rule with minimal effort, and minimal effort very quickly translates into violence. In this respect, there are of course also famous plunderings of great African cities: the famous city of Benin was plundered, or the famous city of Kumasi. So, there are actually important questions about the proportion of violence. But I would agree with Mr Diallo that the experience of losing independence was much more important. And I think that we, who have political self-determination, perhaps when we recall times when we did not have it, that we can hardly still appreciate what it is like to have first political self-determination, and then even cultural self-determination taken away, through violence and also infamy—primitive, racially inferior. Here I would also say that the developmental idea, to complete independence and enrich it with national culture, is a really important international issue.

Wilfried Hoffer (29:20–30:25): I have just been handed a note, a call from a viewer, that the moral side received too little attention so far. And maybe we should go into it for another moment now. The moral side means, of course, that many people even here with us have a sense of guilt vis-à-vis the Third World, for historical but also other reasons, and I would be interested to hear what a social psychologist says about it.

Prof. Dr. Klaus Horn, social psychologist (30:25–33:06): Well, if you want to discuss the issue now as a moral problem as well, then I fear that the Europeans will completely withdraw to a legal position, precisely because one believes that to be a kind of an unassailable position, founded on the assumption that most of these assets came into European hands based on some sort of contract. I would therefore rather prefer to leave the moral question out of it to begin with, because it reinforces the European sense of guilt even more and reduces their willingness to engage in dialogue. However, I would like to say something critical about the legal position. Today, we know from a social science perspective that settled laws are always a consolidation of certain relationships of power, this is not disputed by anybody anymore.... And here I must agree with our Danish colleague, not by prompting us to have sort of productive feelings of guilt and then we give back [the objects]. Instead, we must ask ourselves the question: do we really want to come to terms with our colonial history or not? And that is a political and, in that sense a moral, question.[7]

It is significant that in 1984 the FRG TV station ZDF had invited a psycho-analyst to particpate in its discussion about museums and colonialism. It was as if it had been foreseeable, even then, that such institutions would need to artic-ulate suppressed issues through language and that a collective reckoning with dark historical chapters would need to be analogously addressed with a coming to terms of the fate of individuals. But exactly the opposite happened in the decades to follow. A blanket of leaden silence spread over European museums, and their colonial past began to sink into oblivion.

1984

1985

BACK TO THE FUTURE

"'Treasures from Ancient Nigeria: Heritage of 2000 Years' is the title of a world-wide unique exhibition of early African art currently on view until 26 May at the Staatliche Museen zu Berlin in East Berlin. Curated by the director of the Nigerian National Museum in Lagos…[its] purpose is to finally do away with prejudices about African culture from the colonial era."[1] This inconceivably futurist-sounding, pioneering postcolonial museum project does in fact date back several decades to 27 April 1985, yet it was buried deep in the collective memory of East Berlin and its museum histories.

At the time of the exhibition it was reported on extensively by the press, which described how the Pergamonmuseum in East Berlin in the capital of the German Democratic Republic (GDR) was to host an exquisite exhibition previously shown in the United States at the beginning of the 1980s. With loans from Nigeria, including around one hundred objects from the period between 500 BC and the nineteenth century, the exhibition's objects had an insurance value of almost thirty million US dollars. As a non-aligned state, Nigeria had maintained diplomatic relations with the GDR since 1973. African countries were prioritised in East German foreign politics, and the exhibition was the result of an agreement as part of the so-called cultural working plan between both governments. Ekpo Eyo, a Lagos-based archaeologist and the director-general of the Nigerian National Commission for Museums and Monuments, was still East Berlin's contact. Eyo's campaign for the return of cultural property to Africa had become less strident since the beginning of the 1980s. But he

was still one of the most important African archaeologists worldwide and the best connoisseur of Nigeria's cultural history.

Today, the meticulously organised Central Archive of the Staatliche Museen zu Berlin has preserved all object lists, correspondence, photographs, airline tickets and shipping waybills related to the exhibition.[2] It is intriguing to bring up this forgotten episode of German-Nigerian museum cooperation thirty years after the demise of the GDR, in the face of debates about the new Humboldt-Forum on the site of the former GDR Palace of the Republic, where a large number of "Benin bronzes" from "Prussian Cultural Heritage"—artworks with Nigerian provenance—are planned to be displayed. Bringing these suppressed histories to light provides a valuable resource for the current debate on dealing with non-European collections from colonial contexts.

The archival material presents a historical example of "equal cooperations with countries of origin," which tend to be praised as great innovative solutions of today, but in fact existed in East Berlin long before they became part of contemporary museum rhetoric. In 1985, Nigeria, as the exhibition's lender, determined how the exhibition material was to be handled. As borrowers, the GDR Staatliche Museen zu Berlin sought to professionally meet all Nigerian requirements. These concerned the insurance of the objects ("in accordance with government protocol, we assume full responsibility"),[3] security for the exhibition rooms ("during the day by civilian staff and by the police at night"),[4] the preparation of detailed press information material ("after the closing of the exhibition, the Nigerian side expects a handover of all press coverage in the GDR on the exhibition in duplicate"),[5] as well as the printing of the catalogue ("as the Nigerian side stipulated that a catalogue should appear for the exhibition, the opening date is contingent on the delivery of the catalogue").[6] In the catalogue foreword, Günter Schade, the director-general of the Staatliche Museen zu Berlin in the GDR, thanked the Republic of Nigeria for "entrusting these artworks to our care," which he saw as "a great responsibility" for the GDR.[7] By owning high-value objects Nigeria had the associated right of freely disposing of them and letting them circulate regardless of the Cold War conflict, making the country a full-fledged partner in international museum circles at the time, independent of its status as a developing country.

East Berlin seems to have accommodated Ekpo Eyo's wishes not only with regard to technical matters but also in terms of theoretical, cultural and political requests. Even before the exhibition opening, the GDR had promoted a dialogue with African states via an international conference hosted by the Humboldt University in East Berlin on the occasion of the centenary of the Berlin Conference of 1884 to 1885 and framed around "colonialism, neo-colonialism and Africa's path towards a peaceful future." The invitees included around three hundred scholars from various social science disciplines, politicians

from thirty-nine countries in Africa, Europe, Asia and Latin America, as well as representatives from different organisations.[8] Directly after the exhibition opening (plate 15), Eyo gave a lecture in the Pergamonmuseum on "Nigeria's Position in the Context of World Art" with the catchy subtitle "Against the European Term Primitivism."[9] Eyo also seems to have persuaded his East Berlin colleagues to broach the restitution of cultural assets from colonial contexts with the relevant authorities—a matter hardly ever discussed in the GDR. In a letter to the Ministry for Culture before the opening of the exhibition, the Staatliche Museen zu Berlin noted the "issue of restitution claims addressed by Ekpo Eyo, especially artworks from Benin, of which, as you know, there are also a number in our ethnological museums (Leipzig, Dresden)."[10] A letter from the Berlin museums of 11 March 1985 to the Africanist Peter Göbel at the Museum für Völkerkunde zu Leipzig reveals that he had discussed the subject of restitution recently at the Ministry of Culture.[11] A document from the museum dated a day later stated: "A common position on the issue of 'restitution' brought up by Ekpo Eyo is currently under consideration by the Ministry for Culture, [our] colleague Göbel/Leipzig, and ourselves."[12]

As far as it is known, however, there was no restitution of works to Nigeria before the collapse of the GDR, and the museum archives in Leipzig and Dresden do not yield traces of any discussions about it.[13] After Berlin, Eyo's exhibition went on to Zagreb in Croatia, opening on 25 June 1985.

Ten days later, a young woman in Stuttgart wrote an open letter, which can be considered as the swan song of the near-silenced first European restitution debate and as a message in a bottle for its future. Born in 1956, Waltraut Ulshöfer was a politician from a different generation to the previous museum officials; she could have been a granddaughter to Hermann Auer or Hans-Georg Wormit, who positioned themselves so vigorously and successfully against restitution in the 1970s, or the daughter of Herbert Ganslmayr, Werner Knopp or Ekpo Eyo. Yet, as a former student of English and German literature and one of eleven delegates for the nascent Green Party in the FRG regional parliament of Baden-Württemberg, together with her parliamentary group she used the reopening of the Linden-Museum, after seven years of renovation, as the occasion to bring the restitution debate to the attention of the fifty-nine-year-old Christian Democratic politician Helmut Engler, stating "in this country [it] should be familiar to experts but less so to the general public."[14]

"Faced with the destruction of the cultural identity of people in developing countries by the power of colonialism in its everyday manifestations, the Green faction in the regional parliament considers the demands from developing countries for a return of demonstrably looted cultural property as well as objects of national heritage to be justified," Ulshöfer wrote, following up with a series of demands that refered to the Übersee-Museum Bremen as an example

to follow.[15] A Green Party flyer, with typical 1980s-style design depicting a large sunflower and a reproduction of the bust of Nefertiti, was enclosed with her official letter (plate 16).[16] In a large font, the words "Give Back What We Are Not Entitled To" were framed. With this campaign, the Green Party took up the cause of countries demanding restitution (whose voices were by then nearly silenced), emphasising once more that "the countries of origin [did] certainly not demand the return of entire collections but individual pieces, a small number in total, which can be considered as essential for the preservation and redefinition of national and cultural identity."[17]

The ministry in turn asked Friedrich Kußmaul for a statement, which was typically lengthy and brusque: "The Open Letter addresses a whole bundle of problems which have been discussed since the so-called Kinshasa conference in the summer of 1973. It could be observed that during the first years rather a lot of noise was made worldwide, which has mostly died down (apart from the international organisations whose members are of course paid for their efforts), apart from the Federal Republic, where there are evidently circles and persons with an interest in keeping the issue on the boil. It is sometimes embarrassing to hear foreign colleagues still refer to the German debate even now as something which has passed or could only become relevant in the distant future."[18]

The distant future is here. Over thirty years ago, European museums and cultural administrations succeeded in not just thwarting Africa's struggle for its art, but also in suppressing public debate and the collective memory of it through such statements. Yet, after decades the repressed subject has now returned.

EPILOGUE

Nearly every conversation today about the restitution of cultural property to Africa already happened forty years ago. Nearly every relevant film had already been made and nearly every demand had already been formulated. Even the most recent viral videos on social media about the spectacular "taking back" of artworks from museums, as filmed on mobile phones in France and Belgium in the summer of 2020 by the Congolese activist Emery Mwazula Diyabanza, had already been scripted in many minds by the mid-1970s. What do we learn from this?

Firstly: The European men who tried to stem the tide against restitution requests from formerly colonised countries after 1960 left an enormous legacy cultural debt to the following generations. By arguing that collections that were accumulated in Berlin, London, Paris, Brussels and so on during the colonial era needed to be preserved for scholarship and future museum visitors, they off-loaded the responsibility of finding fair solutions to future generations. They knew perfectly well that they were playing for time in bad faith, since they kept referring to "slowing things down" (p. 80), spoke of time that could be gained through cooperative projects and promises (p. 51), or of the course of history, which was likely to lead to restitutions one day regardless (pp. 80–81). These men also knew, as they put it in writing, that their strategy of denial would cause frustration and "desperation" for the supplicants (p. 88). Nevertheless, they preferred to sit out the problem and delay an appropriate solution to the point when the matter would sort itself out (or they would be retired).

But cultural assets that were lost through war or colonisation release collective emotions in the dispossessed and cause wounds not healed by time. On the contrary, historical distance seems to bring about a hardening of positions, doggedness and mistrust instead of rapprochement. In 1979, the German newspaper *FAZ* dubbed restitution as a "spectre" haunting Europe (p. 89). The phantom pain caused by the loss of cultural property outside Europe has been felt since the 1960s. It shapes our present and becomes more acute over time. It is up to our generation to assume responsibility and to finish the work that museum directors and culture officials of the 1970s and '80s deliberately left undone: a sincere and swift restitution of objects brought to Europe in a context of wrongdoing during colonial occupation. We must do it now, and we must not shift the responsibility again to our children and grandchildren.

Secondly: This is about restitution. In the 1970s, all over Europe, authorities and museum administrations were not just fighting off the return of cultural property to Africa, they also argued for an abolishment of the "defamatory" term "restitution," and suggested other terms as a replacement (pp. 83, 84). To intepret the stoic philosopher Epictetus liberally, it is not just the acts that shake people, but also the words about the acts.[1] The application or indeed the non-application of certain words are rooted and reflected in political-societal structures. The "re" in restitution is a capsule of temporality. The Latin prefix means "back," "again," but also "new," "renewed." Other than ersatz concepts like "circulation" or "transfer," which have no historical dimension but operate in a purely spatial sense, the term "restitution" refers both to the past and to the future. By banning the term in the 1970s, the past—that is the colonial dimension of the problem, and with it the shameful history of the African holdings in European museums—was meant to be hidden. It went part and parcel with undisclosed inventory lists and unpublished collection catalogues, at least in Germany.

And this is precisely the reason why we insist today on the term "restitution" and must put it into practice: museums with non-European art in the heart of Europe are walk-in showcases of colonial appropriation practices. There is no way around it. They are veritable mementos that ask us as a society whether, in what form, and for how long we still want to live with these institutions in the twenty-first century, bearing in mind the long-standing desire for restitution expressed in African countries for fifty years. The great men who successfully defended the museums in the 1970s and '80s did so in many cases because of an openly declared cultural or scholarly nationalism, coupled with racial prejudice (pp. 21-28, 37-39, 82-86, 103-104). We should agree swiftly and democratically that we do not want to adhere to such questionable concepts. Instead of restitution, do we want to raise prospects of long-term loans and museum cooperations yet again, knowing perfectly well that these strategies were already

deployed in the 1970s as "subterfuge" and as an attempt to "liberate" ourselves from the pressure of restitution (p. 76)?[2]

Of course restitution does not preclude cooperation and exchange programmes. Rather, they are a prerequisite for them. They guarantee that the current virtual monopoly exercised by Western museums on narrative, display and the circulation of such objects can be relinquished. Traditional relationships of dependency do not have to be perpetuated in a new format. Only then can a new economy of relations with Africa be initiated, which will not be restricted to the cultural sphere or museum exchange. For Europe, restitution does not mean disposing of the past. Restitution contributes to casting off an outdated, hierarchical structure—from the 1970s and '80s—and to defining a mutual relationship in accordance with a post-racial coexistence.

Thirdly: Museums also lie. The reconstruction of the first restitution debate would not have been possible without the existence of generally accessible central archives with precise finding aids and user-friendly search systems (pp. 185–187).[3] As a result, it became clear that many protagonists in the museum administrations of the 1970s and '80s spoke with forked tongues. As they candidly documented (p. 33) in publications until the mid-1970s or later in internal correspondence (p. 81), they knew perfectly well that the great majority of the African objects in their collections stemmed from the colonial era. To quote a much-referenced letter from 1897 to the director of the Ethnologisches Museum Berlin, even in the context of injustice during colonial rule it was "quite difficult to obtain an object without using at least a little bit of force."[4] Yet, externally, especially in committees and political circles, museum officials in the 1970s, with blatant impudence and rare exceptions, painted a picture of impeccably acquired collections with clean bills of provenance (p. 57), which of course they never had to evidence. This was part of a strategy to reject any modest appeals to the solidarity of Western museums (p. 14) as well as culturally and humanistically argued restitution claims from Africa (p. 71) on legal terms. The alleged legality of acquisition became an autosuggestive mantra that persists to this day.

In December 2018, the official response of the German Federal Republic to an enquiry about "findings about the number of artefacts in the Ethnologisches Museum and the Museum für Asiatische Kunst in Berlin that may be considered potential restitution material" was that "no reliable information about this is at hand in the museums, and *therefore* neither in the Federal Government."[5] Of course it is at hand (p. 82); one only needs to be allowed to access it. The political class and members of civil society must no longer allow themselves to be fobbed off as they were forty years ago with wrong or extensively filtered information from the museums themselves. The reconstruction of colonial-era acquisitions from African countries (and the rest of the world) must not be left exclusively to the holding institutions. Internally gained findings by museum

staff on inconvenient provenance histories are not infrequently swept under the carpet by their superiors. Consequently, independent research committees with equal representation of African and European scholars should take on this task. In addition, a free and autonomous approach from within Africa to the cultural assets must be enabled, independently of European partners. In turn, this assumes a radical opening and digitalisation of individual collection archives, or—even better—their transfer to professionally organised specialist archives.

The Berlin newspaper *Tagesspiegel* ran with the following headline at the end of 2020: "The valuable Benin bronzes should become the centrepiece of the Humboldt-Forum. But now, Nigeria's ambassador publicly demands their restitution for the first time."[6] Shortly beforehand, Yusuf Tuggar, the Nigerian ambassador in Berlin since 2017, had let it be known on Twitter that he had presented an official request for restitution to the German Federal Government. He had already been waiting for an answer for a year. Some could not but feel that this looked like a case of indecorous political manoeuvering: six days before the opening of the largest cultural project in Germany in the heart of Berlin, Nigeria was seeking media attention, what a coup! But in reality, as the present history has shown, Nigeria had been waiting for almost fifty years for affirmative action from Berlin. The same is true in other European contexts for Ghana, the Democratic Republic of Congo, the Republic of the Congo, Madagascar, Cameroon, Mali, Ethiopia and Tanzania—to name but a few of the African nations whose cultural property was transferred systematically and *en masse* to Europe during the colonial era and who have tried since the 1970s to recover part of it.

Some restitutions to Africa did actually take place in recent times: a bible here, a sword there.[7] Yet the issue still continues to trigger compulsive instances of institutional defence, as if the search for an equitable approach to collections created in an inequitable context was one of the greatest threats to European cultural heritage. But restitution claims from Africa are not a mere footnote in history. The manner in which European museums dealt with cultural demands from former colonised countries since their independence has been shameful. But there is value in turning to figures and initiatives of the 1970s and '80s (pp. 47–50, 122–128) for guidance today.

There is dire need to incorporate the present restitution debate in the *longue durée* of historical processes in order to recognise the political, personal, administrative and ideological constellations that have shaped the debate for half a century. Only in this way will it be possible to interrupt the institutional patterns enacted for decades in Europe in favour of new relational ethics with Africa. To play for time again, like in the 1970s, and to withhold the cultural heritage of humanity for the purposes of national self-assertion, is not an option for the future.

TIMELINE

1960

January–November: 17 African colonial states achieve formal independence.

From April: The government for the newly independent Republic of the Congo in Kinshasa seeks restitution of the collections from the Royal Museum for Central Africa, formerly Royal Museum of the Belgian Congo in Tervuren near Brussels, Belgium, as part of independence negotiations with Belgium.

14 December: UN Resolution no. 1514 is passed, which grants independence to colonial countries and recognises the right to cultural self-determination.

1962

May: 300 paintings are transferred from the Musée National des Beaux-arts d'Alger in Algiers, Algeria, to Paris.

1963

10 July: Amendments are made to the British Museum Act, which has been in force since 1902, to forbid practically any deaccession of objects by the institution.

1965

January: The editorial "Rendez-nous l'art nègre" (Give Us Back Negro Art) by Paulin Joachim is published in the Senegalese magazine *Bingo*.

1966

1 April: In Dakar, Sengal, the exhibition *Art nègre* opens with numerous loans from European and American museums and private collections. The Senegalese organisers were asked by their French partners beforehand to agree to drop the issue of restitution as a prerequisite to proceeding with the loans.

April: The Queen Idia mask from the British Museum appears on the cover of the magazine *Nigeria Today* with the headline "Our Cultural Heritage."

1969

August: Pan-African Cultural Manifesto published in Algiers, which refers to the recovery of cultural heritage as part of the process of decolonisation.

1971

20 January: London premiere of the film *You Hide Me* by the Ghanaian director Nii Kwate Owoo about the African collections in the stores of the British Museum.

10 September: The International Council of Museums (ICOM) in Grenoble, France, calls on Western museums with important collections from former colonised countries to support the development of modern museums in their countries of origin through donations, temporary and permanent loans and so on.

1972

March: Loan request from the Nigerian Federal Department of Antiquities in Lagos to various museums in Europe, including in Paris, West Berlin and Vienna.

1973

February: France rejects a restitution request from Madagascar.

12 September: At the third conference of the International Association of Art Critics (AICA) in Kinshasa, in the newly renamed Republic of Zaire, President Mobutu Sese Seko, appeals for solidarity in the struggle for recovery of cultural property which left Belgian Congo during the Belgian colonial era.

4 October: In an address to the General Assembly of the United Nations, Mobutu asks for the adoption of a resolution that calls on "rich" countries to restitute some objects to "poor" countries.

18 December: Passing of the UN Resolution no. 3187: Restitution of Works of Art to Countries Victims of Expropriation. Issue handed over to UNESCO.

December: France rejects a restitution request from the People's Republic of Congo.

1974

February: In Ghana, the head of the Asante, Otumfuo Opoku Ware II, makes a claim for the so-called Asante regalia held in British museums. The British press reports extensively.

Spring: Influential museum and cultural administrations in the Federal Republic of Germany reject the principle of restitution.

15 November: Amadou Mahtar M'Bow from Senegal is elected as director-general of UNESCO. The issue of restitution gains more importance.

10 December: British Parliament rejects the Asante's restitution request.

1975

UNESCO separates the issues of return and exchange.

The Federal Republic of Germany rejects UNESCO's recommendations on the exchange of cultural property.

1976

29 March–3 April: Meeting of the Expert Group on Restitutions in Venice at the invitation of UNESCO.

March: The Belgian foreign minister, Renaat van Elslande, agrees to restitute a Ndop figurative sculpture to Zaire. Approximately 150 other objects follow from now until 1981.

July: The Übersee-Museum in Bremen announces the restitution of an object to Nigeria, creating turmoil in West German museum circles. The US newspaper *Christian Science Monitor* characterises the restitution debate as a "German debate."

Summer: Ekpo Eyo, head of the Nigerian Federal Department of Antiquities, spends several weeks in London with the objective of securing some loans for an exhibition in the context of Festac '77.

26 October–30 November: UNESCO General Conference in Nairobi, Kenya. Resolution 4.128 passed on the creation of an "intergovernmental committee… facilitating bilateral negotiations about the restitution or return of cultural property to the countries that have lost them as a result of colonial or foreign occupation."

1977

15 January: Festac '77 opens in Lagos, Nigeria. The festival uses the Queen Idia mask held at British Museum as its emblem. Worldwide coverage of the refusal of the British Museum to lend the object to Nigeria.

May: The Ad Hoc Commission for Restitutions is established at the General Conference of the International Council of Museums (ICOM) in Moscow.

June: The British Museum manufactures of a copy of the Queen Idia mask.

1978

January–April: Tanzania claims restitution for objects in the Linden-Museum in Stuttgart (the so-called Karagwe material). A headline in the newspaper *Süddeutsche Zeitung* on 26 April: "The Blacks Demand Their Soul Back."

20–23 March: UNESCO Meeting of the Expert Group on Restitutions in Dakar in Senegal.

7 June: In Paris, Amadou Mahtar M'Bow appeals for the "return of an irreplaceable cultural heritage to those who created it." His claims are covered by the international press and French TV takes up the subject of restitution.

Summer: West German museums and cultural administrations mobilise against UNESCO's restitution agenda. The "Working group 'Return of Cultural

Property'" is established in Bonn, which draws up a confidential handbook on the defense against restitution.

2–4 October: International UNESCO seminar on the "Right to Cultural Memory" for media representatives and museum professionals in Palermo in Italy, which prompts renewed coverage on French TV.

24–28 November: UNESCO General Assembly in Paris establishes the Intergovernmental Committee for Promoting the Return of Cultural Property to Its Countries of Origin or Its Restitution in Case of Illicit Appropriation (ICPRCP).

1979

Debut of the Nigerian feature film *The Mask* by Eddie Ugbomah, which features the recapture of a Benin object from the British Museum by a secret agent from Lagos.

January: The UNESCO publication *Museum International* publishes a special issue on the "Return and Restitution of Cultural Property." First indications of resignation in African professional circles.

7–9 May: ICOM's Ad Hoc Committee for Restitutions meets in Paris. The Übersee-Museum in Bremen presents case studies regarding restitution in Mali, Western Samoa and Bangladesh in cooperation with partners from the regions concerned.

7–10 May: Public conference of the West German section of the ICOM committee on "The Museum and the Third World" in Lindau, Bavaria, dominated by members of the Bonn "Working group 'Return of Cultural Property.'"

18 May: An article is published on the history of restitution debate in the newspaper *Frankfurter Allgemeine Zeitung*: "For about six years, a spectre has been haunting European museums, in short: restitution."

1980

5 January: Exhibition *Art from Zaire* opens in Bremen, curated by the National Museum in Kinshasa, Zaire.

7 January: Detroit opening of the travelling exhibition curated by Ekpo Eyo *Treasures of Ancient Nigeria: Legacy of 2000 Years*.

5–9 May: First session of the ICPRCP in Paris points out the urgent requirement for object lists and inventories of cultural property from former colonised countries in European museums.

16 June: The Nigerian government acquires four highly priced objects with a Benin provenance at a Sotheby's auction in London.

1981

26 March: UNESCO director-general M'Bow gathers statements on a restitution form drafted by ICPRCP, which is rejected by the United Kingdom and the Federal Republic of Germany.

21 May: The symposium "Lost Heritage" takes place at the Africa Centre in London in the presence of museum directors and representatives of the UK African and Asian diasporas and is met with extensive media coverage.

27 May: Broadcast of the 45-minute documentary *Whose Art Is It, Anyway?* by Ben Shephard on BBC2.

11 September: Symposium "Retour et restitution de biens culturels: un problème d'identité culturelle et d'équité internationale" takes place in Paris at the premises of *Présence Africaine* in Paris.

14–18 September: Second session of the ICPRCP in Paris, where an official form on restitution is adopted.

1982

2 April: The Working Group Africa is established at the French Foreign Office, led by the former director of the Louvre, Pierre Quoniam.

21 July: At the UNESCO World Conference on cultural policies in Mexico, the Greek minister of culture Melina Mercouri demands the restitution of the Parthenon frieze held at the British Museum to Athens. Wide media coverage follows.

6 August: Adoption of the "Mexico City Declaration on Cultural Policies": "The restitution to their countries of origin of works illicitly removed from them is a basic principle of cultural relations between peoples" (sec. 26).

10 August: Hildegard Hamm-Brücher, state minister for culture at the FRG Foreign Office, announces potential restitutions to Togo and Cameroon.

1983

Publication of *Loot!: The Heritage of Plunder* by Russell Chamberlin in London.

Publication of Dorothee Schulze's dissertation in Bremen on *The Restitution of Artworks from an International Legal Perspective*.

27 October: Extensive debate on the amendment of the British Museum Act of 1963 in the British House of Lords.

1984

Publication of *Nefertiti Wants to Go Home* by Herbert Ganslmayr and Gert von Pacenszky.

Memorial events held in the Federal Republic of Germany and the German Democratic Republic on the centenary of the Berlin Congo Conference.

18 December: Broadcast of the TV talk show "Stop Thief! Cultural Treasures from the Third World: Looted, Loaned, or Owned?" on the FRG state channel ZDF.

1985

1 April: Opening of the Nigerian loan exhibition *Treasures from Ancient Nigeria: Legacy of 2000 Years* at the Pergamonmuseum in East Berlin.

9 July: Open letter in favour of restitution presented by the Green Party in the regional parliament of Baden-Württemberg, Federal Republic of Germany.

NOTES

PREFACE

1. Bénédicte Savoy, "Accumulation primitive: La géographie du patrimoine artistique africain dans le monde aujourd'hui," in "Les images migrent aussi," ed. Elsa Gomis, Perin Emel Yavuz and Francesco Zucconi, special issue, *De facto* (January 29, 2021), https://www.icmigrations.cnrs.fr/wp-content/uploads/2021/01/DF24-Savoy.pdf.

INTRODUCTION

1. See Felwine Sarr and Bénédicte Savoy, *Zurückgeben: Über die Restitution afrikanischer Kulturgüter* (Berlin: Matthes & Seitz, 2019).

2. Pierre Quoniam quoted in A. S., "Restituer le passé de l'Afrique: découvertes archéologiques; le retour des biens culturels," *Agecop liaison* 62 (November/December 1981): 13.

3. There are hardly any comprehensive studies about these early claims. Nevertheless, on The Democratic Republic of the Congo and Zaire see Sarah Van Beurden's research: "The Art of (Re)Possession: Heritage and the Cultural Politics of Congo's Decolonization," *Journal of African History* 56, no. 1 (March 2015): 143–64; "Restitution or Cooperation?: Competing Visions of Post-Colonial Cultural Development in Africa," Global Cooperation Research Papers, no. 12, Käte Hamburger Kolleg / Centre for Global Cooperation Research, University of Duisburg-Essen, December 2015, https://doi.org/10.14282/2198-0411-GCRP-12; and *Authentically African: Arts and the Transnational Politics of Congolese Culture* (Athens, OH: Ohio University Press); as well as Boris Wastiau, *Congo-Tervuren: Aller-retour; le transfert de pièces ethnographiques du Musée royal de l'Afrique centrale à l'Institut des Musées nationaux du Zaïre* (Tervuren: Le Musée royal, 2000). On Sri Lanka see Dario Willi, "Tropendiebe: Die Debatte um die Restitution srilankischer Kulturgüter im Museum für Völkerkunde Basel, 1976–1984" (master's seminar paper, University of Zurich, 2019), https://www.mkb.ch/dam/jcr:7727ad95-fe39-4b32-bff7-d414d1845335/SeminararbeitMuseum_SriLanka_Dario-Willi.pdf; on Nigeria see Barbara Plankensteiner, "The Benin Treasures: Difficult Legacy and Contested

Heritage," in *Cultural Property and Contested Ownership: The Trafficking of Artefacts and the Quest for Restitution*, ed. Brigitta Hauser-Schäublin and Lyndel V. Prott (London: Routledge), 133–55. On Ghana see Kwame Opoku, "When Will Britain Return Looted Golden Ghanaian Artefacts?: A History of British Looting of More Than 100 Objects," *Modern Ghana*, January 5, 2011, https://www.modernghana.com/news/310930/when-will-britain-return-looted-golden-ghanaian.html; on Indonesia see Cynthia Scott, *Cultural Diplomacy and the Heritage of Empire: Negotiating Post-Colonial Returns* (New York: Routledge, 2020). On the role of UNESCO in these early years see for example Thomas Fitschen, "30 Jahre 'Rückführung von Kulturgut': Wie der Generalversammlung ihr Gegenstand abhanden kam," *Vereinte Nationen* 52, no. 2 (April 2004): 46–51; Ana Filipa Vrdoljak, *International Law: Museums and the Return of Cultural Objects* (Cambridge: Cambridge University Press, 2006); Lyndel V. Prott, *Witnesses to History: A Compendium of Documents and Writings on the Return of Cultural Objects* (Paris: UNESCO, 2009); Kerstin Odendahl, "Das Zwischenstaatliche Komitee zur Förderung der Rückgabe von Kulturgut an die Ursprungsländer oder dessen Restitution im Falle eines illegalen Erwerbs (UNESCO Rückgabe-Komitee)," *Kunst und Recht* 17, no. 3–4 (2015): 83–86.

4. Stephan Waetzoldt quoted in "Eingepackt: und ab in den Louvre," *Der Spiegel*, no. 49 (December 2, 1979): 190.

5. David M. Wilson quote in ibid., 189.

6. See Quentin Deluermoz and Pierre Singaravélou, *A Past of Possibilities: A History of What Could Have Been*, trans. Stephen W. Sawyer (New Haven, CT: Yale University Press 2021).

7. See Nathaniel Rich, *Losing Earth: A Recent History* (New York: Farrar, Straus and Giroux, 2019).

8. See Frank Bösch, *Zeitenwende 1979: Als die Welt von heute began* (Munich: C. H. Beck, 2019).

9. President of the Stiftung Preußischer Kulturbesitz, Hermann Parzinger quoted in "Hermann Parzinger im Gespräch mit Maria Ossowski," *Deutschlandfunk*, July 30, 2017, https://www.deutschlandfunk.de/parzinger-zur-kritik-am-humboldt-forum-natuerlich-wird.911.de.html?dram:article_id=392325.

1965: BINGO

1. UN General Assembly, Resolution 1514, Declaration on the Granting of Independence to Colonial Countries and Peoples, A/RES/1514(XV), (December 14, 1960), reprinted in *United Nations General Assembly Official Records, 15th Session, Suppl. no. 16* (New York, 1960), 66–67.

2. See "Le premier Congrès International des Écrivains et Artistes Noirs (Paris, Sorbonne, 19–22 Septembre 1956)," special issue, *Présence Africaine*, nos. 8–10 (June–November 1956).

3. Aimé Césaire, "Culture et colonization," in ibid., 190.

4. "Neger-Kongress: Der erste Zahn," *Der Spiegel*, no. 41 (October 9, 1956): 45.

5. Ibid.

6. See the "Wortverlaufskurve" the data graph regarding the historical usage of the word "Neger" (Negro) in German in *Digitales Wörterbuch der deutschen Sprache*, s.v. "neger," last modified, August 20, 2015, https://www.dwds.de/wb/Neger.

7. See Étienne Féau, "L'art africain au musée des arts d'Afrique et d'Océanie:

Collections et perspectives pour le musée du quai Branly," in *Cahiers d'Études Africaines* 39, no. 155/56 (1999): 923–38, esp. 924.

8. Sarah Van Beurden, "The Art of (Re)Possession: Heritage and the Cultural Politics of Congo's Decolonization," *Journal of African History* 56, no. 1 (March): 147–51, 161.

9. Elisabeth Cazenave and Jean-Christian Serna, *Le patrimoine artistique français de l'Algérie: Les œuvres du Musée national des Beaux-arts d'Alger, de la constitution à la restitution, 1897–1970* (Saint-Raphaël: Éditions Abd-el-Tif, 2017).

10. British Museum Act, 1963, c. 24, https://www.legislation.gov.uk/ukpga/1963/24/contents.

11. Paulin Joachim, "Rendez-nous l'art nègre," *Bingo*, no. 144 (January 1965): 7. On *Bingo* see Lotte Arndt, *Les revues font la culture!: Négociations postcoloniales dans les périodiques parisiens rélatifs à l'Afrique (1947–2012)* (Trier: WVT Wissenschaftlicher Verlag, 2016), 49.

12. On Paulin Joachim see Pierre Amrouche, "Paulin Joachim, un Africain d'autrefois (1931–2012)," *Présence Africaine* 187/88, no. 1–2 (2013): 347–48.

13. Joachim, "Rendez-nous l'art nègre."

14. Ibid.

15. Ibid.

16. Ibid.

17. Ibid.

18. Ibid.

19. See Hans Belting and Andrea Buddensieg, *Ein Afrikaner in Paris: Léopold Sédar Senghor und die Zukunft der Moderne* (Munich: C. H. Beck, 2018).

20. See Cédric Vincent, "'The Real Heart of the Festival': The Exhibition of L'art nègre at the Musée Dynamique," in *The First World Festival of Negro Arts, Dakar, 1966*, ed. David Murphy (Liverpool: Liverpool University Press), 45–63.

21. Joachim, "Rendez-nous l'art nègre."

22. "Both the Senegal National Committee and President Senghor have stated privately and written publicly that 'no revendication' of any sort will be tolerated by their government," letter from Robert Goldwater to Nelson A. Rockefeller, February 9, 1966, quoted in Maureen Murphy, *De l'imaginaire au musée: Les arts d'Afrique à Paris et à New York (1931–2006)* (Dijon: Les Presses du Réel, 2009), 247; see also Vincent "The Real Heart of the Festival," 56.

23. See *L'art nègre: Sources, évolution, expansion* (Musée dynamique, Dakar and the Grand Palais, Paris, 1966); Robert Boyer, "Le retour des biens culturels dans les pays anciennement colonisés," 8 in A.N., 19870713/25.

24. "Our Cultural Heritage: Including Our Art and Craft," *Nigeria Today*, 1966, 2.

25. Edo Pendant Mask supposedly of Queen Mother Idia, Benin City, Nigeria, 16th century, ivory, 24.50 x 12.50 x 6 cm. British Museum, London, Af1910,0513.1, https://www.britishmuseum.org/collection/object/E_Af1910-0513-1.

26. See Felicity Bodenstein, "Notes for a Long-Term Approach to the Price History of Brass and Ivory Objects Taken from Benin City in 1897," in *Acquiring Cultures: World Art on Western Markets*, ed. Christine Howald, Bénédicte Savoy and Charlotte Guichard (Boston: De Gruyter, 2018), 267–88; Felicity Bodenstein, "Cinq masques de l'Iyoba Idia du royaume de Bénin: Vies sociales et trajectoires d'un objet multiple,"

Perspective, no. 2 (2019): 227–38. On the history of the so-called Benin bronzes much has been published to date, for example Staffan Lundén, "Displaying Loot: The Benin Objects and the British Museum" (PhD diss., University of Gothenburg, 2016); Barbara Plankensteiner, "The Benin Treasures: Difficult Legacy and Contested Heritage," in *Cultural Property and Contested Ownership: The Trafficking of Artefacts and the Quest for Restitution*, ed. Brigitta Hauser-Schäublin and Lyndel V. Prott (London: Routledge, 2016), 133–55; and Dan Hicks, *The Brutish Museums* (Pluto Press: London 2020).

27. Werner Forman, Bedrich Forman and Philip Dark, *Benin Art* (London: Batchworth Press, 1960).

28. Ekpo Okpo Eyo, "The Protection of Africa's Artistic Heritage," *UNESCO Courier* 20, no. 6 (June 1967): 16–19.

29. *Records of the General Conference 15th Session, Paris, 1968*, Resolutions, vol. 1, Doc. 15C ¶ 981 (Paris: UNESCO, 1969), 241, https://unesdoc.unesco.org/ark:/48223 /pf0000114047.locale=en. Seep. "A large number of delegates mentioned provisions regarding restitution of cultural property…Several of them made pleas for recovering property removed in the past, especially under colonial conditions. One delegate felt, that countries where the cultural property had originated should be allowed to have copies of such property or documentation about it; another delegate favoured sanctions against States in illegal possession of cultural property. Other delegates, however, expressed doubt about the possibility of restitution." See also ibid., 286, annex ¶ 54.

30. The exhibition entitled "Arts africains anciens" was on view at the Musée National des Beaux-Arts in Algiers from July 21 to August 31, 1969. No catalogue was published. In the MQB archives see the preserved versions of the poster in Arabic (MQB no. PP0184662) and French (MQB no. PP0184661). See Philippe Decraene, "Une exposition d'art africain ancien," *Le Monde*, July 31, 1969 and "Contributions from European Museums: First Pan-African Cultural Festival—Algiers," *The Times*, June 17, 1969, 5.

31. See "Manifeste culturel panafricain," *Présence Africaine*, no. 71 (1969): 115–23.

32. Janheinz Jahn, "Nicht nur Sonnenschein und Rosen in Afrika," *Frankfurter Allgemeine Zeitung*, August 11, 1969, cited in Harald Voss, "Das panafrikanische Kulturmanifest," in "Interdisziplinäre Afrika-Forschung," special issue, *Africa Spectrum* 4, no. 2 (1969): 57.

33. Letter from Lucien Cahen to the Belgian minister of education, May 21, 1970, quoted in Sarah Van Beurden, *Authentically African: Arts and the Transnational Politics of Congolese Culture* (Athens, OH: Ohio University Press, 2015), 106.

1971: YOU HIDE ME

1. Nii Kwate Owoo, *You Hide Me* (Ghana, 1971), b/w, 16 mm, 40 or 20 min. On the date of the premiere see *Cultural Events in Africa* 70 (1971): 2. My sincere thanks go to Jörg Frieß at Zeughauskino des Deutschen Historischen Museums, Berlin for his wonderful support in tracking down a copy of the film.

2. François Fronty reconstructed the history of censure: François Fronty, "Les statues meurent aussi, histoire d'une censure," Textes (sélection) no.6, Groupe d'Étude Cinéma du Réel Africain, http://www.grecirea.net/textes/06TexteFF08.html.

3. Dirk Naguschewski, "Kinema*topo*graphie im afrikanischen Kino: Dakar in Filmen von Sembene Ousmane und Djibril Diop Mambety," in *TopoGraphien der Moderne: Medien zur Repräsentation und Konstruktion von Räumen*, ed. Robert Stockhammer (Munich: W. Fink, 2005), 289.

4. The length of the film is reported differently in secondary literature. It is either listed as 40 minutes (with artist interviews), or 20 minutes (the museum section only). See Jeff Francis, "The Black Man's Burden," *International Development Review* 14, no. 1 (1972): 42.

5. On this first part of the film, which is no longer shown today, see Kaye Whiteman, "Matchet's Diary: Plastic Bags and Glass Cases," *West Africa*, March 26, 1971, 332-33; Francis, "The Black Man's Burden"; and Michaël Reaburn, "Entretien avec Michaël Reaburn," interview by Kwaté Nee-Owoo. *L'Afrique littéraire et artistique*, (1978): 96-98, 95-96.

6. See James Leahy, "You Hide Me," *Vertigo* 1, no. 2 (Summer/Autumn, 1993), https://www.closeupfilmcentre.com/vertigo_magazine/volume-1-issue-2-summer -autumn-1993/you-hide-me/.

7. Ibid.

8. Owoo, *You Hide Me*, 08:53-09:03 min.

9. Ibid, 12:00-12:05 min.

10. Ibid., 14:32-14:45 min.

11. Ibid., 15:11-15:27 min.

12. Nii Kwate Owoo quoted in Whiteman, "Matchet's Diary," 332.

13. James Leahy, "You Hide Me."

14. Whiteman, "Matchet's Diary," 332-33.

15. See for example ibid.; Raeburn "Entretien avec Michaël Reaburn"; Francis, "The Black Man's Burden; Mbye-Baboucar Cham, "Film Production in West Africa, 1979-1981," *Présence Africaine*, no. 124 (1982): 168-89; as well as Paulin Soumanou Vieyra, *Le cinéma africain des origines à 1973*, vol. 1 (Paris: Présence africaine, 1975), 101-2.

16. Francis, "The Black Man's Burden," 41.

17. Vieyra, *Le cinéma africain des origines à 1973*, 101.

18. Extract from *You Hide Me* shown on the BBC2 in 1981 as part of Ben Shephard, *Whose Art Is It, Anyway?* (London: BBC2, May 27, 1981), 00:15-01:30 out of 45 min.

19. See Caleb Adebayo Folorunso, "Ekpo Okpo Eyo (1931-2011)," *Azania: Archaeological Research in Africa* 46, no. 3 (2011): 363-64.

20. ICOM, Resolution no. 3, Documentation of Collections and Field Missions (1971), reprinted in *Resolutions Adopted by ICOM's 10th General Assembly* (Grenoble, France, 1971), https://icom.museum/wp-content/uploads/2018/07/ICOMs -Resolutions_1971_Eng.pdf.

1972: PRUSSIAN CULTURAL PROPERTY

1. Dr. Heinz Dietrich Stoecker (AA) to Hans-Georg Wormit (SPK), May 25, 1972, I HA, Rep. 600, no. 38, GStA PK.

2. On Eyo's negotiations with the United Kingdom see especially Ekpo Eyo, "Repatriation of Cultural Heritage: The African Experience," in *Museums and the Making of "Ourselves": The Role of Objects in National Identity*, ed. Flora E. S. Kaplan (London: Leicester University Press), 330-50; Felicity Bodenstein, "Cinq masques de l'Iyoba

Idia du royaume de Bénin: Vies sociales et trajectoires d'un objet multiple," *Perspective*, no. 2 (2019): 227–38; Barbara Plankensteiner, "The Benin Treasures: Difficult Legacy and Contested Heritage," in *Cultural Property and Contested Ownership: The Trafficking of Artefacts and the Quest for Restitution*, ed. Brigitta Hauser-Schäublin and Lyndel V. Prott (London: Routledge, 2016), 133–55; and Dan Hicks, *The Brutish Museums* (Pluto Press: London, 2020).

3. 20 pfennig stamp, "Bronze head," GDR, issued January 12, 1971, designed by Gerhard Voigt, MICHEL no.: DDR-MiNr.1633.

4. 70 pfennig stamp, BRD Nofretete Berlin, issued July 14, 1988, designed by Sibylle and Fritz Haase. MICHEL no.: MiNr. 1374.

5. See for example the discussions about restitution of the bust of Nefertiti from its location in West Berlin to East Berlin with their effective press: Ellen Lentz, "East Germany Claims Art Treasures," *New York Times*, March 11, 1974, 4; and Joachim Nawrocki, "Die absurde Forderung der DDR—Kulturabkommen gegen Kunstschätze: Nix Nofretete," *Die Zeit*, no. 28, July 4, 1975.

6. On the first presentation of the "African department" in the new complex see Peter Krieger, "Abteilung Afrika," *Baessler-Archiv: Beiträge zur Völkerkunde*, n.s. 21 (November 1973): 136–40.

7. See "Leihwünsche gegenüber unseren Museen; hier: Benin-Bronzen aus Nigeria," in I HA, Rep. 600, no. 38, GStA PK.

8. See *Munzinger Online*, Personen: Internationales Biographisches Archiv, s.v. "Stoecker, Heinz-Dietrich," accessed August 26, 2021, https://www.munzinger.de /search/go/document.jsp?id=00000013379.

9. Timothy Adebayo Fasuyi, *Cultural Policy in Nigeria* (Paris: UNESCO, 1973), 61. The publication was first published in French and then in English in 1973.

10. Ibid: 22.

11. The First Conference of African Museums, Livingstone Museum, Zambia, July 17–23, 1972, *Event Program*, 1972; "Rapport sur la première conférence africaine des musées," in *Veröffentlichungen aus dem Überseemuseum*, Reihe B, Völkerkunde vol. 3 (Bremen, 1973), 89–97; and Abdoulaye Sokhna Guèye Diop, "Museological Activity in African Countries, Its Role and Purpose," *Museum International* 25, no. 4 (1973): 250–56.

12. See Plankensteiner, "The Benin Treasures," 141.

13. Ibid.

14. Heinz Dietrich Stoecker quoting report from the Lagos embassy to the Foreign Office in early 1972, in Stoecker (AA) to Hans-Georg Wormit (SPK), May 25, 1972 in I HA, Rep. 600, no. 38, GStA PK.

15. Hans-Georg Wormit (SPK) to Stoecker (AA), May 30, 1972, in ibid.

16. See Eckart Conze, Norbert Frei, Peter Hayes and Moshe Zimmermann, *Das Amt und die Vergangenheit: Deutsche Diplomaten im Dritten Reich und in der Bundesrepublik* (Munich: Karl Blessing Verlag, 2010); Uwe Danker and Sebastian Lehmann-Himmel, "Geschichtswissenschaftliche Aufarbeitung der personellen und strukturellen Kontinuität nach 1945 in der schleswig-holsteinischen Legislative und Exekutive," printed matter 18/1144 (Schleswig/Flensburg: Schleswig-Holsteinischen Landtages, July 1, 2016), https://www.landtag.ltsh.de/infothek/wahl18/drucks/4400/drucksache -18-4464.pdf; and Frank Bösch and Andreas Wirsching, eds. *Hüter der Ordnung: Die*

Innenministerien in Bonn und Ost-Berlin nach dem Nationalsozialismus (Göttingen: Wallstein, 2018).

17. Danker and Lehmann-Himmel, "Geschichtswissenschaftliche Aufarbeitung," 138, 149.

18. See *Deutsche Biographische Enzyklopädie*, vol. 10, s.v. "Wormit, Hans-Georg," (München, 1999), 588.

19. Hans-Georg Wormit (SPK) to Stephan Waetzoldt (SMB), May 30, 1972 in IHA, Rep. 600, no. 38 GStA PK.

20. Ibid.

21. See 01-295, box no. 041/4, Nachlass Franz Amrehn (1912–1981), ADCP.

22. See Alexandre III Kum'a Ndumbe, *Was will Bonn in Afrika?: Zur Afrikapolitik der Bundesrepublik Deutschland* (Pfaffenweiler: Centaurus Verlag, 1992).

23. Extract from the minutes of the 46th meeting of the board Stiftung Preußischer Kulturbesitz, Berlin, June 2, 1972 in I HA, Rep. 600, no. 38, GStA PK.

24. Uwe Martin (AA) to Stephan Waetzoldt (SMB), June 21, 1972 in I HA, Rep. 600, no. 38, GStA PK.

25. Ibid.

26. "Vermerk Benin-Bronzen," August 1, 1972 in I HA, Rep. 600, no. 38, GStA PK.

27. Stephan Waetzoldt (SMB) to Hans-Georg Wormit (SPK), June 23, 1972 in ibid.

28. Hans-Georg Wormit (SPK) to Foreign Office, July 14, 1972 in ibid.

29. Hans-Georg Wormit (SPK) to Carl Gussone (BMI), draft letter, August 7, 1972 in ibid.

30. Stefanie Palm, "Auf der Suche nach dem starken Staat. Die Kultur-, Medien- und Wissenschaftspolitik des Bundesinnenministeriums," in *Hüter der Ordnung: Die Innenministerien in Bonn und Ost-Berlin nach dem Nationalsozialismus*, ed. Frank Bösch and Andreas Wirsching (Göttingen: Wallstein, 2018), 612. On Carl Gussone's membership of National Socialist organizations see ibid., and on his career before and after 1945, ibid., 604–12. See Eckart Conze on the issue: "Die Causa Gussone, der NS-Verbrechen bagatellisierte und sich weigerte, Antisemitismus: vergangenen und gegenwärtigen—als solchen wahrzunehmen, bildet die Spitze eines Eisbergs" (The case of Gussone, who trivialized National Socialist crimes and refused to acknowledge anti-Semitism—past and present—is only the tip of an iceberg) in Eckart Conze, "Schwarz-weiß-rot-braune Kontinuitätslinien," *Frankfurter Allgemeine Zeitung*, October 22, 2018.

31. On Féaux's numerous memberships of National Socialist organizations see "Féaux' de la Croix, Ernst," in Ernst Klee, *Das Personenlexikon zum Dritten Reich* (Frankfurt am Main: Fischer-Taschenbuch-Verlag, 2007), 145. On the history of the Stiftung Preußischer Kulturbesitz see Timo Saalmann, *Kunstpolitik der Berliner Museen, 1919–1959* (Berlin: De Gruyter, 2014), 303–20.

32. Indeed, little was known about the fate of the Benin collection in 1962: it had been evacuated to Silesia together with the main part of the African collection of the Völkerkundemuseum in the middle of the Second World War and had been carried off to Leningrad by the Red Army in 1945; it was only in 1975 that the Soviet Union returned these holdings to the GDR, which kept them partly unpacked in Leipzig until after reunification, see Kurt Krieger, "Das Schicksal der Benin-Sammlung des Berliner Museums für Völkerkunde," *Baessler-Archiv: Beiträge zur Völkerkunde* n.s., 5, no. 1 (July

1957): 225–27 and Gert Höpfner, "Die Rückführung der 'Leningrad-Sammlung' des Museums für Völkerkunde," *Jahrbuch Preussischer Kulturbesitz* 29 (1992): 157–71. Other than Hans-Georg Wormit, in 1972, the director of the Ethnologisches Museum in Berlin preferred however to connect the uncertain whereabouts of the collection with the hope that the bronzes would "eines Tages wieder auftauchen und der Wissenschaft zugänglich gemacht werden" (one day resurface and be made accessible to scholarship), Peter Krieger, "Abteilung Afrika," *Baessler-Archiv: Beiträge zur Völkerkunde*, n.s. 21 (November 1973): 129.

33. Hans-Georg Wormit (SPK) to Carl Gussone (BMI), draft letter, August 7, 1972, in I HA, Rep. 600, no. 38 GStA PK. The hand-written corrections were left out of the transcript.

34. Werner Knopp, "Die Stiftung Preußischer Kulturbesitz trauert um ihren ersten Präsidenten Hans-Georg Wormit," in *Jahrbuch Preußischer Kulturbesitz*, vol. 30 (Berlin: Gebr. Mann Verlag, 1993), 13–20, esp. 18.

35. Ibid.

36. Hans-Georg Wormit (SPK) to Carl Gussone (BMI), fair copy, August 7, 1972 in I HA, Rep. 600, no. 38, GStA PK. Instead of the original sentence on museums as places of international understanding, the text reads: "Für die Berliner Sammlungen, deren Bestände im Krieg und in der Nachkriegszeit besonders gelitten haben und deren Ergänzung durch Neuerwerbungen nur sehr zögernd erfolgen kann, liegt hier ein ganz besonderes Problem" (For the Berlin collections, who suffered especially in the war and in the post-war period, and whose supplementation through new acquisitions can only be done very hesitantly, the problem is particularly acute). My thanks to Andrea Meyer (Technische Universität Berlin) for her assistance in interpreting this and the following letter.

37. Hans-Georg Wormit (SPK) to Franz Amrehn (MdB), August 15, 1972 in I HA, Rep. 600, no. 38, GStA PK.

38. Sarah Van Beurden, "The Art of (Re)Possession: Heritage and the Cultural Politics of Congo's Decolonization," *Journal of African History* 56, no. 1 (March 2015): 145.

39. "Vermerk betr. Nigerianische Kunstgegenstände," August 23, 1972 in I HA, Rep. 600, no. 38, GStA PK.

40. Franz Amrehn (MdB) to Hans-Georg Wormit (SPK), August 22, 1972 in ibid.

41. Hans-Georg Wormit (SPK) to Werner Stein (Berlin Senate), December 7, 1972 in ibid.

42. Hans-Georg Wormit (SPK) to Stephan Waetzoldt (SMB), December 7, 1972 in ibid.

1973: ZERO

1. In 1971 the Democratic Republic of the Congo was renamed the Republic of Zaire. On this history see for example Raymond Goy, "Le retour et la restitution des biens culturels à leur pays d'origine en cas d'appropriation illégale," *Revue Générale de droit international* 33, no. 3 (1979): 962–85; H. Ganslmayr, "Wem gehört die Benin-Maske?" *Vereinte Nationen* 3 (1980): 88–92; Herbert Ganslmayr's contribution "Rückgabe von Kulturgut: konkrete Schritte–Ausbildung von Museumspersonal in der Hauptstadt Nigers–Stand der Konvention von 1970" in Herbert Ganslmayr et al., "Aus dem Bereich der Vereinten Nationen: Tätigkeiten, Nachrichten, Meinungen,"

Vereinte Nationen 32, no. 4 (August): 139–140; Dorothee Schulze, *Die Restitution von Kunstwerken: Zur völkerrechtlichen Dimension der Restitutionsresolutionen der Generalversammlung der Vereinten Nationen*, series D, vol. 12 (Bremen: Übersee-Museum, 1983); Thomas Fitschen, "30 Jahre 'Rückführung von Kulturgut': Wie der Generalversammlung ihr Gegenstand abhanden kam," *Vereinte Nationen* 52, no. 2 (April 2004): 46–51; and Lyndel V. Prott, *Witnesses to History: A Compendium of Documents and Writings on the Return of Cultural Objects* (Paris: UNESCO, 2009), 13ff.

2. "Devant les critiques d'art," *Salongo: Quotidien du matin*, September 14, 1973; see the conference files in the AICA archive in Rennes, France; on the conference in general see Anaïs Racine, "Le IIIe congrès extraordinaire de l'AICA à Kinshasa en 1973: AICA à la rencontre de l'Afrique" (master's thesis, University Paris I Panthéon-Sorbonne, 2020), https://afriquart.hypotheses.org/files/2020/10/MATER-2.pdf.

3. Mobutu Sese Seko, "Les pays riches possédant des oeuvres d'art des pays pauvres doivent en restituer une partie," *Salongo: Quotidien du matin*, September 14, 1973, 3, cited in Sese Seko Mobutu, *Discours, allocutions et messages* Vol. 2, 1965–1975 (Paris: Editions du Jaguar 1975), 353–58. See the original text of the address in protocol no. 2 (actually 3) of September 12, 1973 in FR ACA AICAI THE CON028 04/04, fol. 13–19, AICA.

4. John Canaday, "Zaire in Search of Its Identity," *New York Times*, October 14, 1973, 25.

5. Mobutu, *Discours, allocutions et messages*, 355.

6. "Le Congrès de l'AICA de Kinshasa," *Afrique Contemporaine* 70 (1973): 20.

7. Address by General Mobutu Sese Seko, President of the Republic of Zaire, Doc. A/PV.2140, reprinted in *United Nations General Assembly Official Records, 28th Session, 2140th Plenary Meeting* (New York, October 4, 1973), 8–18, cited in Mobutu, *Discours, allocutions et messages*, 360–89.

8. Letter from the Permanent Representative of Zaire, Eyebu-Bankand'Asi, Ipoto, to the United Nations Addressed to the President of the General Assembly, November 2, 1973, Doc. A/9199 reprinted in *United Nations General Assembly, 28th Session*, https://digitallibrary.un.org/record/852847?ln=en.

9. Ibid.

10. See United Nations General Assembly 28th Session 1974. United Nations. 1974. "Draft Resolution: Restitution of Works of Art to Countries Victims of Expropriation." In *General Assembly Official Records, 28th Session, Supplement no. 30: Resolutions Adopted by the General Assembly during Its 28th Session. Vol. 1,18 September–18 December 1973.* A/RES/3187(XXVIII). https://digitallibrary.un.org/record/190996?ln=en.

11. See Thomas Fitschen, "30 Jahre 'Rückführung von Kulturgut': Wie der Generalversammlung ihr Gegenstand abhanden kam," *Vereinte Nationen* 52, no. 2 (April 2004): 46.

12. See the voting results in UN General Assembly, Restitution of Works of Art to Countries Victims of Expropriation (concluded), Doc. A/PV.2206, reprinted in *General Assembly Official Records, 28th Session: 2206st Plenary Meeting* (December 18, 1973, New York), 1–3.

13. "Rückgabe afrikanischer Kunst?: Ein Vorstoß bei der Uno," *Frankfurter Allgemeine Zeitung*, November 9, 1973.

14. "Für Rückgabe geraubter Kunst," *Frankfurter Allgemeine Zeitung*, December 20, 1973.

15. Extract from the minutes of the 51st session of the board of the Stiftung Preußischer Kulturbesitz, Berlin, December 20, 1973 in I HA, Rep. 600, no. 3058, GStA PK.

16. Ibid.

17. Peter Krieger, "Abteilung Afrika," *Baessler-Archiv: Beiträge zur Völkerkunde*, n.s. 21 (November 1973): 101–40.

18. Ibid., 106; see also Lili Reyels, Paola Ivanov and Kristin Weber-Sinn, *Humboldt Lab Tanzania—Objekte aus den Kolonialkriegen im Ethnologischen Museum, Berlin—Ein tansanisch-deutscher Dialog* (Berlin: Reimer, 2018), 268–87.

19. On the "colonial amnesia" in Germany, see the introduction to Jürgen Zimmerer and Michael Perraudin eds., *German Colonialism and National Identity* (New York: Routledge, 2011), 1–8; Monika Albrecht, "(Post-) Colonial Amnesia?: German Debates on Colonialism and Decolonization in the Post-War Era," in Zimmerer and Michael Perraudin, *German Colonialism and National Identity*, 187–196; and Andreas Eckert, "Eine Geschichte von Gedächtnislücken: Die Erinnerung an Krieg, Gewalt und anti-kolonialen Widerstand in den deutschen Kolonien," in Reyels, Ivanov, and Weber-Sinn, *Humboldt Lab Tanzania*, 268–87.

20. In France, a systematical mobilisation of the administration can only be detected later. This is also confirmed by Boyer in the retrospective part of his report of 1979. For the period from 1973 to 1978 he refers to a "politics of absence and abstaining" and repeatedly regrets France's "silence," see Robert Boyer, "Le retour des biens culturels dans des pays anciennement colonisés," pp. 3–4, 14 in 19870713/25 A.N.

21. Sarah Van Beurden, "The Art of (Re)Possession: Heritage and the Cultural Politics of Congo's Decolonization," *Journal of African History* 56, no. 1 (March 2015): 158ff.

22. Renaat Van Elslande quoted in *La Libre Belgique*, October 24, 1973, cited in Jean Salmon and Michel Vincineau, "La pratique du pouvoir exécutif et le contrôle des chambres législatives en matière de relations internationales," *Revue belge de droit international*, no. 1 (1976): 226. See also Van Beurden, "The Art of (Re)Possession," 158.

23. Ibid.

24. "Return Our Lost Art," *Guardian*, September 14, 1973, 3.

1974: INCREASINGLY GLOBAL

1. Cover of *Africa Report: Magazine for the New Africa*, 1–2 (January/February 1972). I am grateful to Simon Lindner (Technische Universität Berlin) for his support in interpreting the image.

2. See Susan Blumenthal, "The World's Best Traveled Art," *Africa Report* 19, no. 1 (1974): 4–10;
Susan Blumenthal, *Bright Continent: A Shoestring Guide to Sub-Saharan Africa* (New York: Anchor Press, 1974).

3. Blumenthal, "The World's Best Traveled Art," 4.

4. Ibid., 8.

5. Ibid., 10.

6. Ibid.

7. Sarah Van Beurden, "The Art of (Re)Possession: Heritage and the Cultural Politics of Congo's Decolonization," *Journal of African History* 56, no. 1 (March 2015): 158.

8. Reference to the circular by the KMK, December 11, 1973, in I HA, Rep. 600, no. 3058, GStA PK. The circular as such is not included in the file.

9. Statement by Foreign Office Department 232 (Thomas Schmitz) with regard to the "Ausführungen der Stiftung Preußischer Kulturbesitz und des Linden-Museums Stuttgart," August 5, 1974 in B 30-ZA/115747, PA AA.

10. Enquiry from Güntzer (Berlin Senate Administration for Science and Arts) to Stephan Waetzoldt (SMB), February 18, 1974 in I HA Rep. 600, no. 3058, GStA PK.

11. See Stephan Waetzoldt (SMB) to Hans-Georg Wormit (SPK), March 29, 1974, in I HA, Rep. 600, no. 3058, GStA PK. It is not clear if Jürgen Zwernemann was the author of this statement. At the beginning of 1976, a draft statement written by Wolfgang Klausewitz on behalf of the Museum Association was prepared see EL 232, Bü 988, StAL.

12. Stephan Waetzoldt (SMB) to Güntzer (Berlin Senate administration for Science and the Arts), March 22, 1974 in I HA, Rep. 600, no. 3058, GStA PK.

13. Stephan Waetzoldt (SMB) to Hans-Georg Wormit (SPK), March 29, 1974, in I HA, Rep. 600, no. 3058, GStA PK.

14. Hans-Georg Wormit (SPK) to Weindel (AA), July 4, 1974, in I HA, Rep. 600, no. 3058, GStA PK.

15. On Friedrich Kußmaul see Jürgen Zwernemann, "Friedrich Kußmaul, 1920–2009," *Zeitschrift für Ethnologie* 135, no. 1 (2011): 1–4.

16. Friedrich Kußmaul, statement to the Ministry of Culture in Baden-Württemberg, spring 1974. See copy attached to a letter from Stephan Waetzoldt (SMB) to Hans-Georg Wormit (SPK), May 17, 1974 in I HA, Rep. 600, no. 3058, GStA PK.

17. Stephan Waetzoldt (SMB) to Hans-Georg Wormit (SPK), May 17, 1974 in ibid.

18. Statement by Foreign Office Department 232 (Thomas Schmitz) with regard to the "Ausführungen der Stiftung Preußischer Kulturbesitz und des Linden-Museums Stuttgart," August 5, 1974, p.2 in B30-ZA/115747, PA AA .

19. "'Return Regalia' Appeal," *Guardian*, February 5, 1974, 4. On the history of the claim see for example Kwame Opoku, "When Will Britain Return Looted Golden Ghanaian Artefacts? A History of British Looting of More Than 100 Objects," *Modern Ghana*, January 5, 2011 and Kwame Opoku, "Looted Asante (Ghana) Gold in Wallace Collection, London: Return Stolen Items to Manhyia Palace, Kumasi," *Modern Ghana*, July 26, 2018.

20. Nicholas Ashford, *The Times*, 1974.

21. Ibid.

22. Albert Kwadwo Adu Boahen, "Ashanti Regalia," *The Times*, February 28, 1974, 19.

23. H.J.F. Crum Ewing, "Ashanti Regalia," *The Times*, March 5, 1974, 15.

24. Joanna M. Hughes, "Ashanti Regalia," *The Times*, March 8, 1974, 17.

25. Ibid.

26. "Ghana Plea for Return Regalia Refused," *The Times*, September 6, 1974, 16.

27. "Ghana Plea for Return of Ashanti Regalia Rejected," *The Times*, December 11, 1974, 10. See also the official UK parliamentary report on the Ashanti regalia: 355 Parl. Deb. H. L. (December 10, 1974) cols. 534–35.

28. "Ghana Plea for Return of Ashanti Regalia Rejected," *The Times*, December 11, 1974, 10.

29. P. L. Shinnie, "Asante Regalia," *The Times*, September 27, 1974, 15.

1. UNESCO, Resolution 3.428, Contribution of UNESCO to the Return of Cultural Property to Countries that Have Been Victims of De Facto Expropriation, Doc.18C/ Resolutions, reprinted in *Records of the General Conference 18th Session Paris, 17 October to 23 November 1974*, vol. 1, Resolutions (Paris: UNESCO), 60–61, https:// unesdoc.unesco.org/ark:/48223/pf0000114040.locale=en.

2. See the speech by the director-general René Maheu before the UNESCO executive committee on June 27, 1974, in Varna, Bulgaria: UNESCO, Executive Board 94th Session, Varna, June 27, 1974, "Item 4.4.3. of the Agenda: Text of the Statement Made by the Director-General to the Executive Board," Doc. 94 EX/ INF. 13, https:// unesdoc.unesco.org/ark:/48223/pf0000010712.locale=en; German translation dated January 1975 in I HA, Rep. 600, no. 3058, GStA PK); as well as UNESCO, Executive Board 94th Session, Paris, May 30, 1974, "Item 4.4.3.1 of the Provisional Agenda: Possible International Instrument on the Exchange of Original Objects and Specimens Among Institutions in Different Countries," Doc. 94 EX/16, https://unesdoc.unesco .org/ark:/48223/pf0000008592_spa.locale=en. See a great deal of correspondence on this project in I HA, Rep. 600, no. 3058 GStA PK.

3. See Hermann Auer, "Stellungnahme zu dem "Entwurf einer Empfehlung der Unesco über den internationalen Austausch von Kulturgut," December 18, 1975, p. 5 in I HA, Rep. 600, no. 3058, GStA PK. Reprint with minor amendments in Hermann Auer, "Stellungnahme zu dem 'Entwurf einer Empfehlung der UNESCO über den internationalen Austausch von Kulturgut,'" in *Raum, Objekt und Sicherheit im Museum: Bericht über ein internationales Symposium (veranstaltet von den ICOM-Nationalkomitees der Bundesrepublik Deutschland, Österreichs und der Schweiz vom 9. bis zum 15. Mai 1976 am Bodensee (Lindau)*, ed. Hermann Auer (Munich: K. G. Saur), 206–15.

4. "Unesco: Austausch von Unikaten und Überstücken aus dem Kulturbesitz zwischen Institutionen in verschiedenen Ländern" preliminary statement by the KMK, December 15, 1975, p. 3 in I HA, Rep. 600, no. 3058, GStA.

5. "Empfehlung zum internationalen Austausch von Kulturgut," Stellungnahme der Bundesrepublik Deutschland (AA), January 12, 1976, p. 2 in I HA, Rep. 600, no. 3058, GStA PK.

6. UNESCO, Recommendation Concerning the International Exchange of Cultural Property, November 26, 1976; see Records of the General Conference 19th Session, Nairobi, 26 October to 30 November 1976. Vol. 1, Resolutions. Doc. 19C. Paris: UNESCO. https://unesdoc.unesco.org/ark:/48223/pf0000114038.locale=en.

7. Quoted in Ernst Friedrich Jung (BRD embassy in Lagos) to the Foreign Office, August 3, 1973 in I HA, Rep. 600, no. 38, GStA PK.

8. "Nigerianische Kunstgegenstände im Völkerkundemuseum. Hier: Besuch von Repräsentanten des Erziehungsministeriums von Nigeria," memorandum, July 17, 1975, p. 2 in GStA I HA, Rep. 600, no. 38.

9. Ibid.

10. UN General Assembly, Restitution of Works of Art to Countries Victims of Expropriation: Report of the Secretary-General, Doc. A/PV.2410 reprinted in *General Assembly Official Records, 30th Session: 2410st Plenary Meeting*, (New York, November 19, 1975), 923–31; on the voting results see p. 928.

11. Encrypted telegram no. 2979, November 20, 1975, to the Foreign Office in I HA,

Rep. 600, no. 3058, GStA PK. See also the official protocol of the spirited session, UN General Assembly, Restitution of Works of Art to Countries Victims of Expropriation: Report of the Secretary-General, Doc. A/PV.2410 reprinted in *General Assembly Official Records, 30th Session: 2410st Plenary Meeting*, (New York, November 19, 1975), 923–31.

12. See the following articles from an Agence France Presse newsflash: "Die Uno fordern Kunst-Rückgabe," *Frankfurter Allgemeine Zeitung*, November 21, 1975, and "UNO fordert Rückgabe überseeischer Kunst," *Die Welt*, November 21, 1975.

13. See the speech by the director-general René Maheu before the UNESCO executive committee on June 27, 1974, in Varna, Bulgaria: UNESCO, Executive Board 94th Session, Varna, Bulgaria, June 27, 1974, Item 4.4.3. of the Agenda: Text of the Statement Made by the Director-General to the Executive Board, Doc. 94 EX/ INF. 13. https://unesdoc.unesco.org/ark:/48223/pf0000010712.locale=en; a great deal of correspondence on this project and a German translation dated January 1975 in I HA, Rep. 600, no. 3058, GStA PK; as well as UNESCO Executive Board 94th Session, Paris, May 30, 1974, Item 4.4.3.1 of the Provisional Agenda: Possible International Instrument on the Exchange of Original Objects and Specimens Among Institutions in Different Countries, Doc. 94 EX/16, https://unesdoc.unesco.org/ark:/48223 /pf0000008592_spa.locale=en.

1976: "GERMAN DEBATE"

1. Jochen Raffelberg, "German Debate: Should Art Return to Former Colonies?," *Christian Science Monitor*, June 11, 1976, 21.

2. Information according to Ludwig Hennemann, *Pressefreiheit und Zeugnisverweigerungsrecht* Berliner Abhandlungen zum Presserecht vol. 23 (Duncker & Humblot: Berlin, 1978), 102.

3. Raffelberg, "German Debate," 21.

4. Ibid.

5. Herbert Ganslmayr, "Das Krokodil im Kult und Mythos afrikanischer Stämme" (PhD diss., University of Munich, 1969).

6. See Herbert Ganslmayr and Herrmann Jungraithmayr, *Afrika-Kartenwerk* (Berlin: Bornträger, 1986); *Current Africanist Research, International Bulletin* (1971), 56. On Ganslmayr's career see the following obituaries: Christoph Sodemann, "Tod in Athen," *taz: Die Tageszeitung*, May 13, 1991, 23; Harrie Leyten, "In Memoriam Herbert Ganslmayr," *TenDenZen*, 1992, 98.

7. In 1973, Herbert Ganslmayr had already made a long report about the first conference of African museums held in Livingstone, Zambia, in 1972 printed in the Übersee-Museum publication he edited. Ganslmayr attended the conference himself, see "Rapport sur la première conférence africaine des musées," in *Veröffentlichungen aus dem Überseemuseum Bremen*, Reihe B, Völkerkunde, vol. 3 (1973), 89–97.

8. Ganslmayr was press officer in 1973 for the board of the Deutsche Gesellschaft für Völkerkunde (German Society for Ethnology); see *Zeitschrift für Ethnologie* 98, no. 1 (1973): 139.

9. See the periodical published by Museumspädagogischer Dienst der Freien und Hansestadt Hamburg: Herbert Ganslmayr and Helga Rammow, eds., *Museum, Information, Forschung: Rundbrief der Arbeitsgruppe Museum in der Deutschen Gesellschaft für*

Völkerkunde (January 1973–April 1975); and Herbert Ganslmayr, R. Vossen, D. Heintze, W. Lohse and H. Rammow, "Bilanz und Zukunft der Völkerkunde-Museen," in *"Völkerkundemuseen morgen: Aufgaben und Ziele,"* special issue, *Zeitschrift für Ethnologie:* 101, no. 2 (1976): 198–205.

10. "Unesco Expertentreffen in Venedig 'Rückgabe von Kulturgut,'" note from the Foreign Office about the participation of Dr. Herbert Ganslmayr at the meeting, March 10, 1976, in B 91-REF. 642, PA AA.

11. Weindel (AA) to Herbert Ganslmayr, March 23, 1976, in ibid.

12. Weindel to Ganslmayr, March 11, 1976, in ibid.

13. Schulte-Strathaus (AA) to Herbert Ganslmayr, July 29, 1976, in EL 232, Bü 988, StAL.

14. Official closing statement: UNESCO, "Committee of Experts to Study the Question of the Restitution of Works of Art: Final Report." Venice, April 21, 1976. Doc. SHC.76/CONF.615/5, https://unesdoc.unesco.org/ark:/48223/pf0000019009.locale=en; see also Herbert Ganslmayr's own summary for the Foreign Office: Herbert Ganslmayr to Weindel (AA), July 21, 1976, in B 30-ZA/121186, PA AA; and IHA, Rep. 600, no. 3058, GStA PK.

15. See UNESCO, Doc. 19C. ¶ 19 (p. 4) and ¶ 22 (p. 5) in *Records of the General Conference 19th Session, Nairobi, 26 October to 30 November 1976*, Resolutions, Vol. 1 (Paris: UNESCO, 1977), https://unesdoc.unesco.org/ark:/48223/pf 0000114038.locale=en.

16. Ibid. ¶ 14 (p. 3).

17. Herbert Ganslmayr to Weindel (AA), July 21, 1976 p. 13 in B 30-ZA/121186, PA AA.

18. Friedrich Kußmaul to Weindel (AA), March 22, 1976 p. 13 in B 91-REF. 642, PA AA.

19. On the colonial history of the Linden-Museum see Gesa Grimme, "Provenienzforschung im Projekt 'Schwieriges Erbe: Zum Umgang mit kolonialzeitlichen Objekten in ethnologischen Museen,'" *Final Report* (Linden-Museum, Stuttgart, 2018), https://www.lindenmuseum.de/fileadmin/Dokumente/SchwierigesErbe_Provenienzforschung_Abschlussbericht.pdf.

20. Friedrich Kußmaul to Weindel (AA), March 22, 1976, p.2 in B 91-REF. 642, PA AA.

21. Ibid., 1.

22. Ibid.

23. Ibid.

24. Hermann Auer, "Stellungnahme zu dem 'Entwurf einer Empfehlung der UNESCO über den internationalen Austausch von Kulturgut,'" in *Raum, Objekt und Sicherheit im Museum: Bericht über ein internationales Symposium (veranstaltet von den ICOM-Nationalkomitees der Bundesrepublik Deutschland, Österreichs und der Schweiz vom 9. bis zum 15. Mai 1976 am Bodensee (Lindau)* ed. Hermann Auer (Munich: K. G. Saur, 1978), 206–15. See also the transcript of the recorded original lecture as attached to a letter from Ganslmayr to Ernst Petrasch (director of the Badisches Landesmuseum in Karlsruhe), July 19, 1976, in EL 232 Bü 987, StAL.

25. Herbert Ganslmayr, "Rückführung von Kulturgütern: Experten der Unesco gegen kolonialen Raub," *Welt Magazin* nos. 3–4 (1976): 63.

26. Herbert Ganslmayr, "Rückgabe von Kulturgütern," in Auer, *Raum, Objekt und Sicherheit im Museum,* 199–205.

27. Friedrich Kußmaul to Weindel (AA) March 22, 1976, in B 91-REF. 642 p. 1, PA AA.

28. Ibid.

29. Herbert Ganslmayr, "Rückgabe von Kultürgutern," in Auer, *Raum, Objekt und Sicherheit im Museum*, 204.

30. Jochen Raffelberg, Reuters no. 581/76, June 1, 1976, in EL 232, Bü 988, StAL.

31. Jochen Raffelberg, "German Debate: Should Art Return to Former Colonies?," *Christian Science Monitor*, June 11, 1976, 21.

32. "Une bonne querelle," *Jeune Afrique*, July 9, 1976, 14.

33. Ibid.

34. Klaus Figge, "Rezension zu Gert von Paczensky: Die Weißen kommen," *Frankfurter Allgemeine Zeitung*, July 18, 1970. Gert von Paczensky, *Die Weißen kommen. Die wahre Geschichte des Kolonialismus* (Hamburg: Hoffmann u. Campe, 1970).

35. See Gert von Paczensky, "Problematischer Kulturbesitz," January 22, 23, 1977 in *Blickpunkt* (West Germany: Radio Bremen / Sender Freies Berlin), 14 min.; transcript of the broadcast in I HA, Rep. 600, no. 3058, GStA PK.

36. Ibid.

37. Friedrich Kußmaul to the Ministry of Culture of Baden-Württemberg, July 15, 1976, p.2 in EL 232, Bü 987, StAL. The letter was copied to the museum directors Axel Freiherr von Gagern (Cologne, Rautenstrauch-Joest Museum), Jürgen Zwernemann (Hamburg, Museum für Völkerkunde), Hermann Auer (Munich, Deutsches Museum and ICOM Germany), Stephan Waetzoldt (Berlin, Staatliche Museen) and Eike Haberland (Frankfurt am Main, Frobenius-Institut), et al.

38. Ibid.

39. Ibid.

40. Ibid.

41. My great thanks go to Salia Malé (National Museum in Bamako, Mali), Silvia Dolz, Leontine Meijer-van Mensch and Gilbert Lupfer (Staatliche Kunstsammlungen Dresden) for their assistance with research on these supposed restitutions. On sales of museum inventory to Western countries by the GDR see Xenia Schiemann, "Die Geschäftsbeziehungen zwischen der Kunst und Antiquitäten GmbH der DDR und dem Londoner Auktionshaus Christie's (Teil I)" *Kunst und Recht* 22, no. 2 (2020): 49–54 and Xenia Schiemann, "Die Geschäftsbeziehungen zwischen der Kunst und Antiquitäten GmbH der DDR und dem Londoner Auktionshaus Christie's (Teil II)," *Kunst und Recht* 22, nos. 3/4: 77–81.

42. Friedrich Kußmaul to the Ministry of Culture for Baden-Württemberg, July 15, 1976, p.2 in EL 232, Bü 987, StAL.

43. The case is reconstructed in Alessandro Chechi, Anne-Laure Bandle and Marc-André Renold, "Case Note: Afo-A-Kom: Furman Gallery and Kom People," ArThemis: Art-Law Centre University of Geneva, 2012, https://plone.unige.ch/art-adr/cases-affaires/afo-a-kom-2013-furman-gallery-and-kom-people/case-note-2013-afo-a-kom-2013-furman-gallery-and-kom-people/view.

44. Friedrich Kußmaul to the Ministry of Culture of Baden-Württemberg, July 15, 1976, p.2 in EL 232, Bü 987, StAL.

45. See Ekpo Eyo to Herbert Ganslmayr, October 26, 1976, in EL 232, Bü 987, StAL.

46. Ekpo Eyo to Friedrich Kußmaul, June 20, 1977, in ibid.

47. Jürgen Zwernemann to Friedrich Kußmaul, July 28, 1976, in ibid.

48. Hans-Georg Wormit to Friedrich Kußmaul, August 5, 1976, in I HA, Rep. 600, no. 3058, GStA PK.

49. Eike Haberland to Friedrich Kußmaul, August 11, 1976, in EL 232, Bü 987, StAL.

50. Friedrich Kußmaul to Eike Haberland, August 16, 1976, in ibid.

51. Jürgen Zwernemann to Friedrich Kußmaul, July 30, 1976, enclosing a copy of his letter dated July 29, 1976, to Herbert Ganslmayr in ibid.

52. Friedrich Kußmaul to the Ministry of Culture for Baden-Württemberg, July 15, 1976, p.1 in ibid.

53. Hans-Georg Wormit (SPK) to Stephan Waetzoldt (SMB), September 2, 1976, in I HA, Rep. 600, no. 3058, GStA PK.

54. Renate Schettler, "Gehört Nofretete nach Kairo?," *Mannheimer Morgen*, August 23, 1976.

55. "Rückgabe von Kunstwerken? Vor der Unesco-Tagung," *Frankfurter Allgemeine Zeitung*, November 10, 1973, in I HA, Rep. 600, no. 3058, GStA PK.

56. Ibid.

57. Hans-Georg Wormit (SPK) to König (BMI), January 3, 1977, in I HA, Rep. 600, no. 3058, GStA PK.

58. On the history of the committee see Kerstin Odendahl, "Das Zwischenstaatliche Komitee zur Förderung der Rückgabe von Kulturgut an die Ursprungsländer oder dessen Restitution im Falle eines illegalen Erwerbs (UNESCO Rückgabe-Komitee)," *Kunst und Recht* 17, nos. 3/4: 83–86 and A Brief History of the Creation by UNESCO of an Intergovernmental Committee for Promoting the Return of Cultural Property to Its Countries of Origin or Its Restitution in Case of Illicit Appropriation," in "Return and Restitution of Cultural Property," special issue, *Museum International* 31, no. 1 (1979): 59–61. On the semantics of gifts see Sarah Van Beurden, "The Art of (Re)Possession: Heritage and the Cultural Politics of Congo's Decolonization," *Journal of African History* 56, no. 1 (March): 158ff; on the semantics of restitution see Thomas Fitschen, "30 Jahre 'Rückführung von Kulturgut': Wie der Generalversammlung ihr Gegenstand abhanden kam," *Vereinte Nationen* 52, no. 2 (April 2004): 47–48.

59. See Tayeb Moulefera, "Éléments d'une éthique international," in *Museum and Cultural Exchange: The Papers from the 11th General Conference of ICOM, Moscow 23–29 May, 1977*, ed. Anne Razy (Paris: International Council of Museums, 1979), 114–27.

60. See, among others, the cooperation agreement between UNESCO and ICOM, March 1977 in 19930218/52 A.N.; on the inception and role of the ICOM ad hoc committee see "Return and Restitution of Cultural Property," 2–67, as well as the report Ganslmayr published after the Moscow conference in Herbert Ganslmayr, "Neue kulturelle Ordnung," *Welt Magazin* 3, no. 7/8 (1977): 88.

61. Doris Schmidt, "Museen im Feld der Spannungen: Die elfte Weltkonferenz des ICOM in Leningrad und Moskau," *Süddeutsche Zeitung* (June 13, 1977), 13.

62. Extract from the minutes of the 58th session of the board of the Stiftung Preußischer Kulturbesitz on December 3, 1976, Berlin in I HA, Rep. 600, no. 3058, GStA PK.

1. Festac quoted in Alex Poinsett, "Festac'77," *Ebony* 32, no. 7 (1977): 40.

2. Wole Soyinka, "Twice Bitten: The Fate of Africa's Culture Producers," in "Special Topic: African and African American Literature," special issue, *PMLA* 105, no. 1 (January 1990): 110.

3. See for example Andrew Apter, *The Pan-African Nation: Oil and the Spectacle of Culture in Nigeria* (Chicago: University of Chicago Press, 2005) and Dominique Malaquais and Cédric Vincent, "Three Takes and a Mask," in *Festac '77: The 2nd World Black and African Festival of Arts and Culture: Decomposed, An-arranged and Reproduced by Chimurenga* (London: Afterall Books, 2019), 53–56.

4. See Ekpo Eyo, *Highlights from 2000 Years of Nigerian Art: Catalogue of Exhibition Held in Lagos* (Lagos: Federal Department of Antiquities, 1976).

5. Ochegomie Promise Fingesi quoted in Poinsett, "Festac'77," 46.

6. See Malaquais and Vincent, "Three Takes and a Mask," 53–56; and for Festac'77 documentation see the online sources gathered by Professor Abdul Alkalimat: "Festival Documents and Books," Alkalimat (website), http://alkalimat.org/festac /documents.html.

7. Roberto Pontual, "Festival de Lagos: Conciènca e destino do negro a través da arte," *Jornal do Brasil*, January 15, 1977.

8. "Black Arts and Culture," special supplement, *The Times*, January 18, 1977, i–viii.

9. Paul Balta, "Reconquête de l'Afrique par elle-même," *Le Monde*, January 27, 1977.

10. John Darnton, "African Festival Ends: A Decided Success," *New York Times*, February 13, 1977, 3.

11. Andrew Young, "Searching for Black Roots," *Newsweek*, January 3 1977, 40.

12. "Afrika: Lieber aufs Dorf," *Der Spiegel*, no. 8 (February 14, 1977): 142, an article from the Lagos-based *Punch* on the festival translated into German: "Festac'77: Festival der Herausforderungen," *Welt Magazin*, no. 3, 72, 1977.

13. "Afrika: Lieber aufs Dorf," *Der Spiegel*, no. 8 (February 14, 1977): 143.

14. See Apter, *Pan-African Nation*, 67.

15. On the logo dispute see ibid., 61ff. and Malaquais and Vincent "Three Takes and a Mask."

16. Quoted in Malaquais and Vincent "Three Takes and a Mask," 54.

17. Ibid.

18. See "Applications for Use of the Symbol of the 2nd World Black and African Festival of Arts and Culture on Products," reprinted in *Festac '77: The 2nd World Black and African Festival of Arts and Culture: Decomposed, An-arranged and Reproduced by Chimurenga* (London: Afterall Books, 2019), 51.

19. 1 Naira note, Central Bank of Nigeria, series 1979 ND, issued, 1979–1984.

20. See "The Festival Emblem," in Festac 77, (Lagos, 1977), 137; see also Festac'77: A Preview of the 2nd World Black and African Festival of Arts and Culture (Lagos, 1976), F14.

21. Wole Soyinka, *You Must Set Forth at Dawn: A Memoir* (New York: Random House, 2007), 189.

22. Regarding Vienna see Barbara Plankensteiner, "The Benin Treasures: Difficult Legacy and Contested Heritage," in *Cultural Property and Contested Ownership: The*

Trafficking of Artefacts and the Quest for Restitution, ed. Brigitta Hauser-Schäublin and Lyndel V. Prott (London, New York: Routledge, 2016), 141; regarding Stuttgart and Berlin see German Embassy (Lagos) to Foreign Office, August 3, 1973, as well as (to Berlin) file note of July 17, 1975, both in I HA, Rep. 600, no. 38, GStA PK.

23. Ekpo Eyo to Herbert Ganslmayr, October 26, 1976, in EL 232, Bü 987, StAL.

24. See Malaquais and Vincent, "Three Takes and a Mask," as well as Felicity Bodenstein, "Cinq masques de l'Iyoga Idia du royaume de Bénin: Vies sociales et trajectoires d'un objet multiple," *Perspective*, no. 2 (2019): 227–38, and Felicity Bodenstein, "Antiquitäten aus Nigeria: Elfenbein aus Benin," in *Beute: Eine Anthologie zu Kunstraub und Kulturerbe*, ed. Isabelle Dolezalek, Bénédicte Savoy and Robert Skwirblies, (Berlin: Matthes & Seitz, 2021), 348–53.

25. See FCO 65/1797, National Archives Kew, London cited in Bodenstein, "Antiquitäten aus Nigeria: Elfenbein aus Benin," 348–53. On the United Kingdom's position on restitution matters in general see ED 245/41, National Archives Kew, London.

26. Malaquais and Cédric Vincent, "Three Takes and a Mask," 55.

27. Edo Pendant Mask, Benin City, Nigeria, 16th century, resin, cast by Derrick C. Giles, June 1977, 23.50 × 12.20 × 5.10 cm, British Museum, London, CRS.50, https://www.britishmuseum.org/collection/object/E_CRS-50.

28. Ekpo Eyo, *From Shrines to Showcases: Masterpieces of Nigerian Art* (Abuja: Federal Ministry of Information and Communication, 2008), 32.

29. Eyo, introduction to *Highlights from 2000 Years of Nigerian Art*.

30. Ekpo Eyo, *Two Thousand Years of Nigerian Art* (Lagos: Federal Department of Antiquities Nigeria, 1977).

31. Murtala Mohammed, preface to ibid., 6. On the state of historical and art historical research in Nigeria at the time see Babatunde Lawal, "The Present State of Art Historical Research in Nigeria," *Journal of African History* 18 (1977), no. 2: 193–216.

32. Mohammed, preface to *Two Thousand Years of Nigerian Art* 6.

33. Alma Robinson, "African Art in Foreign Hands," in *Festac 1977* (Lagos, 1977), 56–69. In 1976, Robinson had published on claims from Ghana.

34. Ibid., 56.

35. Ibid.

36. Emmanuel Kofi Agorsah, "Restitution of Cultural Material to Africa," *Africa Spectrum* 12, no. 3 (1977): 305–8.

37. Ibid., 306.

38. Ibid., 307.

39. Niyi Osundare, "On Seeing a Benin Mask in a British Museum," in *Songs of the Marketplace* (Ibadan: New Horn Press, 1983), 39–40. Osundare translates the proverb as follows: Suffering afflicts the stranger in an alien land / One is most valued in one's own home. See Niyi Osundare, "On Seeing a Benin Mask in a British Museum," in *Songs of the Marketplace* (Ibadan: New Horn Press, 1983), 39–40.

40. The 1977 *Daily Times* quoted in Felicity Bodenstein, "Commentary on 'Nigeria's Antiquities Abroad, A *Daily Times* Investigation (1976)," in *Translocations Anthologie: Eine Sammlung kommentierter Quellentexte zu Kulturgutverlagerungen seit der Antike* (blog), October 19, 2018, https://translanth.hypotheses.org/ueber/bozimo.

41. *New Nigerian* 1977, quoted in Apter, *The Pan-African Nation*, 289n20.

42. Paul Balta, "Reconquête de l'Afrique par elle-même," *Le Monde*, January 27, 1977.

43. Alma Robinson, "The Controversial Mask of Benin," *Washington Post*, February 11, 1977, 7.

44. Poinsett, "Festac'77," 33.

45. Soyinka, *You Must Set Forth at Dawn*, 189.

46. Lancelot Oduwa Imasuen, *Invasion 1897* (Nigeria: Ice Slide Films, 2014), 113 min.

47. Ryan Coogler, *Black Panther* (Burbank, CA: Walt Disney Studios Motion Pictures, 2018), 135 min.

48. See UNESCO, Committee of Experts on the Establishment of an Intergovernmental Committee Concerning the Restitution or Return of Cultural Property, Dakar, March 20–23, 1978, Final Report, Doc. CC-78/CONF.609/6, https://unesdoc.unesco.org/ark:/48223/pf0000033337.locale=en; and annexe I reprinted in the following: Ad Hoc Committee for the Return of Cultural Property, "Study on the Principles, Conditions and Means for the Restitution or Return of Cultural Property in View of Reconstituting Dispersed Heritages," in "Return and Restitution of Cultural Property," special issue *Museum International* 31, no. 1. (1979): 62–7.

1978: ATTACK, DEFENCE

1. Peter Dittmar, "Das Völkerkundemuseum: eine Räuberhöhle?" *Die Welt*, October 7, 1978.

2. Ibid.

3. "Tansania fordert Rückgabe von Kunstwerken," *Die Welt*, January 5, 1978.

4. Peter Seidlitz, "Die Schwarzen fordern ihre Seele zurück," *Süddeutsche Zeitung*, June 13, 1978, 3.

5. Ibid.

6. Stiftung Preußischer Kulturbesitz, remark on the meeting of the cultural committee of the German UNESCO commission in Bonn on August 31, 1978, in I HA, Rep. 600, no. 3059, GStA PK.

7. German UNESCO Commission, "Rückgabe von Kulturgut," October 6, 1978 (with corrections, 13 pages), in I HA, Rep. 600, no. 3059, GStA PK.

8. Yugoslavia had brought up this idea in Nairobi: "Draft Resolution submitted by Yugoslavia" at the 19th session of the General Conference, Nairobi, Kenya, 1976, in UNESCO, Committee of Experts on the Establishment of an Intergovernmental Committee Concerning the Restitution or Return of Cultural Property, Dakar, June 12, 1978, Final Report, "Annex I: Draft Statutes of the Intergovernmental Committee Concerning the Restitution [...]," Doc. CC-78/CONF.609/6 in *Committee of Experts on the Establishment of an Intergovernmental Committee Concerning the Restitution or Return of Cultural Property: Final Report, Dakar, 12 June 1978*.

9. UNESCO Committee of Experts on the Establishment of an Intergovernmental Committee Concerning the Restitution or Return of Cultural Property (Dakar, March 20–23, 1978), Final Report, Doc. CC-78/CONF.609/6, https://unesdoc.unesco.org/ark:/48223/pf0000033337.locale=en.

10. Ibid.

11. Ibid., 2.

12. Ibid.

13. Annex I: "Draft Statutes of the Intergovernmental Committee Concerning the Restitution [...]," in ibid., 3.

14. Ibid., 2 (article 3.2).

15. Ad Hoc Committee for the Return of Cultural Property, "Study on the Principles, Conditions and Means for the Restitution or Return of Cultural Property in View of Reconstituting Dispersed Heritages," in "Return and Restitution of Cultural Property," special issue *Museum International* 31, no. 1 (1979): 63.

16. UNESCO, Committee of Experts on the Establishment of an Intergovernmental Committee Concerning the Restitution or Return of Cultural Property, Dakar, March 20–23, 1978, Final Report, p. 5 (¶ 20a), Doc. CC-78/CONF.609/6.

17. Ibid. 5–6 (¶ 23).

18. Ibid., p. 6 (¶ 24).

19. Wilhelm Fabricius (German Federal Republic representative at UNESCO) to the Foreign Office, April 19, 1978, p. 3 in I HA, Rep. 600, no. 3059, GStA PK.

20. Ibid.

21. UNESCO Committee of Experts on the Establishment of an Intergovernmental Committee Concerning the Restitution or Return of Cultural Property, Dakar, March 20–23, 1978, Final Report, p. 9 (¶ 42), Doc. CC-78/CONF.609/6.

22. Amadou-Mahtar M'Bow, "An Appeal by Mr. Amadou-Mahtar M'Bow, Director-General of Unesco: A Plea for the Return of an Irreplaceable Cultural Heritage to Those Who Created It," *UNESCO Courier* 31 (July 1978): 4–5.

23. Ibid., 4.

24. See Amadou Mahtar M'Bow's speech given in French at the UNESCO HQ in Paris. The full version was recorded as audio, a short version is available as video: Amadou-Mahtar M'Bow, "Pour le retour à ce qui l'ont crée d'un patrimoine culturel irremplaçable: Appel du Directeur général de l'UNESCO," UNESCO TV (Paris June 7, 1978), 6 min., https://www.unesco.org/archives/multimedia/document-4856 and (Paris June 7, 1978), 10 min., https://www.unesco.org/archives/multimedia/document-168.

25. Reprint of Amadou Mahtar M'Bow's speech on June 8, 1978, in I HA, Rep. 600, no. 3059, GStA PK.

26. See Restitution of Works of Art to Countries Victims of Expropriation: Report of the Secretary-General, Doc. A/34/PV.51 reprinted in *General Assembly Official Records, 34th session: 51st plenary meeting* (New York, November 1, 1979), 989.

27. Jean Prasteau, "Œuvres d'art: retour au pays!" *Le Figaro*, June 8, 1978.

28. Roger Cans, "M. M'Bow lance un appel pour le restitution de certaines œuvres d'art à leur pays d'origine," *Le Monde*, June 9, 1978.

29. Christian Volbracht, "Müssen Nofretete, Mona Lisa und die Aphrodite von Milo wieder in ihre Heimat?" *Berliner Morgenpost*, October 25, 1978; see also "Derde Wereld eist kunstschatten terug," *De Telegraaf*, October 26, 1978, 11.

30. "Kunst hoort thuis in land van herkomst," *Het Vrije Volk*, October 30, 1978, 9.

31. "Unesco Plea for Return of Art Works," *The Times*, June 8, 1978.

32. "Unesco Appell für Rückgabe von Kunstschätzen," *Süddeutsche Zeitung*, June 9, 1978, 33; and dpa, "Für Rückgabe von Kunstwerken. Appell der Unesco." *Frankfurter Allgemeine Zeitung*, June 1978.

33. A notable exception is an article by Arnold Mardersteig, "Die Ausbeate wird mager," *Süddeutsche Zeitung*, October 27, 1978, 54.

34. See Roger Gicquel, "L'Unesco," *Journal de 20h* (France: TFI, October 24, 1978), 4 min., 54 sec., https://m.ina.fr/video/CAA7801592401.

35. See Roger Gicquel, *Le placard aux chimères* (Paris: Plon, 1988), 36ff.

36. Gicquel, "L'Unesco, 00:17 min.

37. Ibid., 03:57–04:07 min.

38. Roger Gicquel, "Table ronde Unesco: Interview Amadou Mahtar M'bow," *Journal de 20h* (France: TFI, June 19, 1978), 24 min. 4 sec., https://m.ina.fr./video /CAA7801439001. The voiceover was recorded by Gicquel who seems to have taken a personal interest in the subject.

39. Ibid., 03:56–04:34 min.

40. On the seminar in Palermo see Mohammed Bedjaoui, "The Right to a Collective 'Cultural Memory,'" in *Yearbook of the International Law Commission* 2, no. 1 (1979): 80, paragraphs 46–53.

41. "Eingepackt—und ab in den Louvre," *Der Spiegel*, no. 49 (December 2): 178–97.

42. Yvonne Rebeyrol, "Colloque: Le droit à la mémoire," *Le Monde*, December 30, 1978.

43. Charles Hargrove, "'Have Nots' Want Their Heritage Back," *The Times*, October 4, 1978; see also "Seminar in Palermo: Kunstwerke zurückgefordert," *Frankfurter Allgemeine Zeitung*, October 5, 1978.

44. König (BMI) to Werner Knopp (SPK), express delivery, December 22, 1977 in I HA, Rep. 600, no. 3059, GStA PK.

45. German UNESCO commission, "Unterstützung von Museen der Dritten Welt," undated and unauthored in I HA, Rep. 600, no. 3059, GStA PK.

46. König (BMI) to Werner Knopp (SPK), December 22, 1977, p. 2 in I HA, Rep. 600, no. 3059, GStA PK.

47. Ibid.

48. Ibid.

49. Lügge (BMI) to Hermann Auer (German national committee ICOM) and Wolfgang Klausewitz (German Museum Association/DMB), December 13, 1977, in EL 232, Bü 988, StAL.

50. See Friedrich Kußmaul to Dyroff (German UNESCO commission), November 29, 1977 in EL 232, Bü 988, StAL.

51. "German UNESCO commission, "Unterstützung von Museen der Dritten Welt," undated, unauthored, p.1 in I HA, Rep. 600, no. 3059, GStA PK.

52. Ibid., 2.

53. Ibid.,1.

54. Werner Knopp (SPK) to König (BMI), February 7, 1978, in I HA, Rep. 600, no. 3059, GStA PK.

55. Friedrich Kußmaul to Hans-Dieter Dyroff (German UNESCO commission), November 29, 1977, in EL 232, Bü 988, StAL.

56. Ibid., 2.

57. Ibid., 3.

58. Wolfgang Klausewitz, "Stellungnahme zum Entwurf der Deutschen UNESCO-Kommission 'Unterstützung von Museen der Dritten Welt,'" April 13, 1978, in EL 232, Bü 988, StAL.

59. Hermann Auer (German national committee ICOM), "Rückerstattung von Kulturgut: Stellungnahme zum Gesamtproblem der Restitution und zum Memorandum der Deutschen UNESCO-Kommission 'Unterstützung von Museen der Dritten Welt,'" April 13, 1978, in I HA, Rep. 600, no. 3059, GStA PK.

60. On Herman Auer see Karen Königsberger,*"Vernetztes System"? Die Geschichte des Deutschen Museums, 1945-1980: dargestellt an den Abteilungen Chemie und Kernphysik* (Munich: Herbert Utz, 2009). 132-40.

61. See Auer, "Rückerstattung von Kulturgut," April 13, 1978, in I HA, Rep. 600, no. 3059, GStA PK.

62. Ibid., 9-10.

63. Ibid.,16.

64. Ibid., 1.

65. Ibid., 1-2.

66. Ibid.

67. Ibid., 3.

68. Ibid.

69. Ibid., 4.

70. Ibid.

71. Ibid.

72. Ibid., 2.

73. Ibid., 6.

74. Ibid., 10-13.

75. Ibid., 11.

76. Ibid., 8.

77. Ibid., 6-9, esp. 7.

78. Ibid., 6.

79. Ibid.

80. Ibid., 8.

81. Ibid., 14.

82. Friedrich Kußmaul, *Ferne Völker: Frühe Zeiten* (Recklinghausen: Bongers, 1982), 9ff.

83. Deutz, Foreign Office to BMI, KMK, German UNESCO commission, May 3, 1978, in I HA, Rep. 600, no. 3059, GStA PK.

84. Ibid., 6.

85. Otto von Simson (German UNESCO commission) to Knopp (SPK), June 21, 1978, in I HA, Rep. 600, no. 3059, GStA PK.

86. Wellhausen, Foreign Office to BMJ, BMI, KMK, Deutscher Städtetag, and Wilhelm Bertram, July 12, 1978, in I HA, Rep. 600, no. 3059, GStA PK.

87. Ibid., 2, emphasis in the original.

88. Auer, "Stellungnahme," 17.

89. Stephan Waetzoldt (SMB) to Werner Knopp (SPK), August 17, 1978, in I HA Rep. 600, no. 3059, GStA PK.

90. List of attendees in Hans-Dieter Dyroff (German UNESCO commission) to Werner Knopp (SPK), August 10, 1978, in I HA Rep. 600, no. 3059, GStA PK.

91. Krämer (DAI) to Otto von Simson (German UNESCO commission), August 23, 1978; and Hans-Dieter Dyroff (German UNESCO commission) to Stephan Waetzoldt (SMB), August 25, 1978, in I HA Rep. 600, no. 3059, GStA PK.

92. See "Arbeitsgruppe 'Rückgabe von Kulturgut', Sitzung am 31. August 1978, 14 Uhr, Vorläufige Tagesordnung," and the list of attendees sent as an attachment to a letter from Hans Meinel to the members of the group, September 13, 1978, both in I HA Rep. 600, no. 3059, GStA PK.

93. Stiftung Preußischer Kulturbesitz, "Vermerk über die Sitzung des Kulturausschusses der Deutschen UNESCO-Kommission in Bonn" August 31, 1978, in I HA Rep. 600, no. 3059, GStA PK.

94. Ibid.

95. Werner Knopp (SPK) to Hans Meinel (German UNESCO commission), September 13, 1978, in I HA Rep. 600, no. 3059, GStA PK.

96. German UNESCO commission, "Rückgabe von Kulturgut," September 13, 1978 (first version, 7 pages) in I HA Rep. 600, no. 3059, GStA PK: "Diese Aufzeichnung ist die Summe der Gespräche anläßlich der Sitzung…am 31. August 1978."

97. German UNESCO commission, "Rückgabe von Kulturgut," October 6, 1978 (corrected version, 13 pages) in I HA Rep. 600, no. 3059, GStA PK.

98. This is indicated *inter alia* in files at the French ministry of culture on the subject of restitutions, see 19870713/25, A.N. See in particular a 30-page position statement against restitutions by the culture official Robert Boyer. In this paper, Boyer expands on a series of arguments that mostly coincide with those of his West German colleagues. See also Robert Boyer's statement of November 15, 1978, in 19930218/52, A.N.

99. Andreas Lommel, "Exotische Kunst: zurück in die Dritte Welt," *Frankfurter Allgemeine Zeitung*, November 3, 1978.

100. Ibid.

101. Ibid.

102. Ibid.

103. Wolfgang Klausewitz, "Exotische Kunst und dritte Welt," *Frankfurter Allgemeine Zeitung*, December 9, 1978.

104. Ibid.

105. In a joint draft resolution, France and the German Federal Republic suggested on November 7, 1978, to eliminate the word "restitution" entirely from the status and the title of the committee in planning, see UNESCO Doc. 20 C/DR. 288 in I HA, Rep. 600 no. 3059, GStA PK.

106. "Auszug aus der Niederschrift über die Sitzung der Museumskommission des Beirates am 14. Dezember 1978 in Berlin," in I HA, Rep. 600, no. 3059, GStA PK. See also "Gegen den Zwang zur Rückgabe von Kulturgütern," *Die Welt*, November 14, 1978; "Deutsche Unesco-Initiative: Gegen Zwang zur Rückgabe," *Frankfurter Allgemeine Zeitung*, November 14, 1978; "Bonn gegen Zwang zur Rückgabe von Kulturgütern," *Der Tagesspiegel*, November 14, 1978; "Bundesrepublik gegen Zwang zur Rückgabe von Kulturgütern." *Süddeutsche Zeitung*, November 14, 1978, 29; "Unesco fördert Rückgabe von Kulturgütern," *Süddeutsche Zeitung*, November 23, 1978, 14;

Doris Schmidt, "Geschichte ist nicht reversibel," *Süddeutsche Zeitung*, November 23, 1978, 4.

107. "Auszug aus der Niederschrift über die Sitzung der Museumskommission des Beirates am 14. Dezember 1978 in Berlin," 1 in I HA, Rep. 600, no. 3059, GStA PK.

108. Ibid.

109. Ibid., 3.

110. Ibid.

111. Ibid.

112. Elisabeth Schwarz, "In der Plenary Working Group von Commission IV, 17. November 1978," 3, 7 in B 91-REF. 642, PP AA.

113. Robert Boyer, "Le retour des biens culturels dans les pays anciennement colonisés," 20 in 19870713/25, A.N.

1979: A SPECTRE IS HAUNTING EUROPE

1. Clara Menck, "Der Braunschweiger Löwe in Istanbul," *Frankfurter Allgemeine Zeitung*, May 18, 1979.

2. Tayeb Moulefera, "Viewpoints: Algeria," in "Return and Restitution of Cultural Property," special issue, *Museum International* 31, no. 1 (1979): 10.

3. Salah Stétié, *L'extravagance. Mémoires* (Paris: Robert Laffont, 2014), 313.

4. "Deutsche Unesco-Kommission will Dialog mit Afrika stärken," *Der Tagesspiegel*, March 30, 1979.

5. Otto von Simson, "Nous désirons participer à votre liberté," in *Symposium Leo Frobenius II: Die Rolle der Traditionen für die Entwicklung Afrikas: Bericht über ein internationales Symposium, veranstaltet von der Deutschen und Senegalesischen Unesco-Kommission vom 14–17 März in Dakar*, ed. Eike Haberland (Bonn: UNESCO Kommission), 11, 14.

6. Otto von Simson (Deutsche UNESCO-Kommission) to Werner Knopp (SPK), May 15, 1981, in I HA, Rep. 600, no. 3059, GStA PK.

7. This becomes clear from a letter, among other sources, by Wilhelm Fabricius (representation of the FRG at UNESCO) to the Foreign Office, May 14, 1979, in I HA, Rep. 600, no. 3059, GStA PK. In the following year, this group prepared the ICPRCP meeting again, see Herbert Ganslmayr, "News from the Working Groups: Working Group on Return and/or Restitution of Cultural Property," *ICME Newsletter*, no. 2 (October 1981): 2–3; ICOM, Ad Hoc Committee for the Return of Cultural Property, "Annex of Preliminary Study of the Three National Situations in Regard to the Return of Cultural Property to Its Country of Origin," Intergovernmental Committee for Promoting the Return of Cultural Property to Its Countries of Origin or Its Restitution in Case of Illicit Appropriation, Doc.CC-79/CONF206.6 (Paris, March 14, 1980).

8. UNESCO Doc.CC-79/CONF206.5; ICOM, Ad Hoc Committee for the Return of Cultural Property, "Annex of Preliminary Study of the Three National Situations in Regard to the Return of Cultural Property to Its Country of Origin."

9. Ibid., 2.

10. Ibid., 15.

11. See the attendee list in Hermann Auer ed., *Das Museum und die Dritte Welt: Bericht über ein internationales Symposium veranstaltet von den ICOM-Nationalkomitees der Bundesrepublik Deutschland, Österreichs und der Schweiz vom 7. bis 10. Mai 1979 am Bodensee (Lindau)* (Munich: K. G. Saur, 1981), 57 and Wolfgang Klausewitz, "Exotische Kunst

und dritte Welt," *Frankfurter Allgemeine Zeitung*, December 9, 1978. See also 1978: Attack, Defence in this publication.

12. Otto von Simson, "Tradition und kulturelle Entwicklung—aus europäischer Sicht," in Auer, *Das Museum und die Dritte Welt*, 17–21.

13. Friedrich Kußmaul, "Museen in Südostasien," in Auer, *Das Museum und die Dritte Welt*, 62–70.

14. See Eike Haberland, "Museum in Afrika," in Auer, *Das Museum und die Dritte Welt*, 78–85.

15. See Werner Knopp, "Die Bedeutung fremden Kulturgutes für die Entwicklung des abendländischen Bewußtseins" in Auer, *Das Museum und die Dritte Welt*, 185–195.

16. See Wilhelm Bertram, "Museumsbezogene Völkerrechtsinstrumente der UN und der UNESCO," in ibid., 125–143.

17. See Hans Meinel, "Die museumsbezogenen Aktivitäten der UNESCO für die Dritte Welt," in ibid., 109–124.

18. Kurt Müller, "Auswärtige Kulturpolitik gegenüber den Ländern der Dritten Welt am Beispiel der Bundesrepublik Deutschland," in ibid., 169–179.

19. The exception was Dr. Dharma Prakash, staff member at the Ethnologisches Museum in Berlin, who was born in Burma, see attendee list in ibid., p. 359.

20. See reports on the conference in Hans-Joachim Müller, "Völkerkundler im Zwielicht: Aus Kriegsbeute werden plötzlich Freundschaftssymbole," *Badische Zeitung*, June 2, 1979; Clara Menck, "Der Braunschweiger Löwe in Istanbul," *Frankfurter Allgemeine Zeitung*, May 18, 1979; and Doris Schmidt, "Hilfsbereitschaft allein genügt nicht," *Süddeutsche Zeitung*, August 10, 1979, 2.

21. Hermann Auer, "Einführung," in Auer, *Das Museum und die Dritte Welt*, 9–16.

22. See for example Birgit Sauer, "'Politik wird mit dem Kopfe gemacht': Überlegungen zu einer geschlechtersensiblen Politologie der Gefühle," in *Masse, Macht, Emotionen: Zu einer Politischen Soziologie der Emotionen*, ed. Ansgar Klein and Frank Nullmeier (Opladen: Westdeutscher Verlag, 1999), 200–18.

23. Auer, "Einführung," 11.

24. Bertram, "Museumsbezogene Völkerrechtsinstrumente," 140.

25. Simson, "Tradition und kulturelle Entwicklung," 18–19.

26. Ibid., 21.

27. Auer, "Einführung," 12.

28. Meinel, "Die museumsbezogenen Aktivitäten," 122.

29. Peace Treaty of Versailles, June 28, 1919, sec. 246. The United Kingdom ultimately restituted the skull to Tanzania in 1954. See the British National Archives blog post based on unpublished archival material, Juliette Desplat, "The Skull of Sultan Mkwawa," *Records and Research* (blog), *The National Archives*, August 15, 2019, https://blog.nationalarchives.gov.uk/the-skull-of-sultan-mkwawa/.

30. Contribution to the discussion by Andreas Lüderwald in Auer, *Das Museum und die Dritte Welt*, 155.

31. Ibid. On the colonial history of the Linden-Museum collections, see Gesa Grimme, "Provenienzforschung im Projekt 'Schwieriges Erbe: Zum Umgang mit kolonialzeitlichen Objekten in ethnologischen Museen,'" *Final report* (Linden-Museum Stuttgart, 2018).

32. Contribution to the discussion by Friedrich Kußmaul, in Auer, *Das Museum und die Dritte Welt*, 155.

33. Gerhard Baer, "Überlegungen zur Frage der Rückgabe von Museumsgut an die Ursprungsländer," in ibid., 158–65, esp. 158. On the positions of Gerhard Baer, see Dario Willi, "Tropendiebe: Die Debatte um die Restitution sri-lankischer Kulturgüter im Museum für Völkerkunde Basel, 1976–1984" (master's seminar paper, University of Zurich, 2019), 22–26.

34. Menck, "Der Braunschweiger Löwe in Istanbul."

35. Auer during the closing panel, in Hermann Auer ed., *Das Museum und die Dritte Welt: Bericht über ein internationales Symposium veranstaltet von den ICOM-Nationalkomitees der Bundesrepublik Deutschland, Österreichs und der Schweiz vom 7. bis 10. Mai 1979 am Bodensee (Lindau)* (Munich, New York: K. G. Saur, 1981), 351–53, esp. 353.

36. Contribution to the discussion by Doris Schmidt, in ibid., 35; see also her report on the conference: Schmidt, "Hilfsbereitschaft allein genügt nicht," 2.

37. Menck, "Der Braunschweiger Löwe in Istanbul."

1980: BATTLE OF LISTS

1. See Ekpo Eyo and Frank Willett, *Treasures of Ancient Nigeria: Legacy of 2,000 Years* (New York: Knopf, 1980). The catalogue was produced for the exhibitions held at the Fine Arts Museums of San Francisco and the California Palace of the Legion of Honor.

2. John Russell, "Met Pays Homage to Ancient Nigeria," *New York Times*, August 15, 1980, T1.

3. Eyo and Willett, *Treasures of Ancient Nigeria*. 23. See photograph by Robert Allman of British Benin Expedition 1897, Benin City, Nigeria, 1897, gelatin silver print, 16.5 x 12 cm, British Museum, London, Af.A79.13, https://www.britishmuseum.org /collection/object/EA_Af-A79-13.

4. Ibid, 25.

5. Herbert Ganslmayr (ed.), *Kunst aus Zaire: Masken und Plastiken aus der National-sammlung Institut des Musées Nationaux du Zaire (IMNZ)* (Bremen: Übersee-Museum, 1980), introduction.

6. Ibid., preface by Ganslmayr (unpaginated).

7. Ibid., preface by Mobutu (unpaginated).

8. Sarah Van Beurden, "The Art of (Re)Possession: Heritage and the Cultural Politics of Congo's Decolonization," *Journal of African History* 56, no. 1 (March 2015): 160–61; Huguette van Geluwe, "Belgium's Contribution to the Zairian Cultural Heritage," *Museum International* 31, no. 1 (1979): 32–37; Boris Wastiau, *Congo-Tervuren: Aller-retour; Le transfert de pièces ethnographiques du Musée royal de l'Afrique centrale à l'Institut des Musées nationaux du Zaïre* (Tervuren: Le Musée royal, 2000).

9. *Catalogue of Works of Art from Benin: The Property of a European Private Collector (June 16)* (London: Sotheby's, 1980); Geraldine Norman, "£1m Bid Likely for Benin Collection," *The Times*, June 16, 1980, 4.

10. Souren Melikian, "La vision du collectionneur," *Connaissance des Arts* no. 343 (September 1980): 114.

11. Norman, "£1m Bid Likely for Benin Collection," 4; Geraldine Norman, "Benin

Bronze Fetches £200,000." *The Times*, June 17, 1980, 16; William Fagg, "Benin Bronze Repair," *The Times*, June 24, 1980, 15.

12. FGR Embassy in Lagos to Foreign Office, July 4, 1980, in I HA, Rep. 600, no. 3059, GStA PK.

13. Quoted in Norman, "£1m Bid Likely for Benin Collection."

14. Anthony Thorncroft, "Benin Collection sale fetches £747,600," *The Financial Times*, June 17, 1980.

15. Kaye Whiteman, "Matchet's Diary," *West Africa*, June 23, 1980.

16. Gordon Tialobi, "Can Nigerian Works of Art be Entirely Recovered?" *Punch*, June 21, 1980, 5; article reprinted in *Nigeria: Bulletin on Foreign Affairs* 10, no. 6 (June 1980): 215.

17. Ibid.

18. Ibid.

19. Eddie Ugbomah, *The Mask* (Nigeria, 1980), color, 16 mm enlarged to 35 mm, 100 min.

20. For an interesting analysis of the film see Mbye-Baboucar Cham, "Film Production in West Africa, 1979–1981," *Présence Africaine*, n.s., no. 124 (1982): 178.

21. Niyi Osundare, "Following in 007's Footsteps," *West Africa*, November 3, 2178–79; see also "The Mask is a Very Rough Film," *West Africa* August 11, 1980, 1487–1489.

22. Osundare, "Following in 007's Footsteps."

23. Kerstin Odendahl, "Das Zwischenstaatliche Komitee zur Förderung der Rückgabe von Kulturgut an die Ursprungsländer oder dessen Restitution im Falle eines illegalen Erwerbs (UNESCO Rückgabe-Komitee)," *Kunst und Recht* 17, nos. 3/4 (2015): 83–86. By now the committee refers to itself as the "'Return & Restitution' Intergovernmental Committee," "Illicit Trafficking: How We Work," UNESCO, https://en .unesco.org/fighttrafficking/icprcp.

24. Ibid., 87.

25. See the detailed minutes by Elisabeth Schwarz (Kulturbehörde Hamburg) to the Foreign Office and Assembly of Education Ministers (KMK), May 23, 1980, in I HA, Rep. 600, no. 3059, GStA PK.

26. The SPK president had already advised accordingly in the autumn of 1978: Werner Knopp (SPK) to Meinel (German UNESCO Commission), September 13, 1978, in I HA, Rep. 600, no. 3059GStA PK: "If the formation of the committee is unavoidable, its authority vis-à-vis the Federal Republic of Germany and its museums should be kept as weak as possible. This purpose is served by either not consenting to the decisive agreement or by holding back in dispatching a delegate to the committee." France had very similar considerations but joined in the end, see Letter from A. Grisoni dated December 15[?], 1977, in 19930218/52, A.N.

27. On Elisabeth Schwarz see Meike Klüver, "Nachruf auf Dr. iur. Elisabeth Schwarz," *djbZ: Zeitschrift des Deutschen Juristinnenbundes* 17, no. 3 (2014): 131–32.

28. Address by Amadou-Mahtar M'Bow, Director-General of UNESCO, at the opening of the First Session of the Intergovernmental Committee for Promoting the Return of Cultural Property to Its Countries of Origin or Its Restitution in Case of Illicit Appropriation, Paris, May 9, 1980, Doc. DG/80/10, https://unesdoc.unesco.org /ark:/48223/pf0000038784.locale=en.

29. Margin annotation made in August 1977 by Friedrich Kußmaul on a German translation of the final report of the Venice conference 1976, see report August 18, 1978 (p. 7), on behalf of the KMK, in EL 232, Bü 988, StAL.

30. Deutsche UNESCO-Kommission, "Rückgabe von Kulturgut," October 6, 1978 (corrected version, 13 pages), p. 6 in I HA Rep. 600, no. 3059, GStA PK.

31. "UNESCO Report of the Intergovernmental Committee for Promoting the Return of Cultural Property [...]."Item 12 of the Provisional Agenda: in *General Conference Twenty-first Session, Belgrade 1980. August 11*. Doc. 21 C/83. (Paris 1980), 6, https://unesdoc.unesco.org/ark:/48223/pf0000041941.locale=en. This is a verbatim quote of a recommendation by the ICOM group (sec. 1, p. 1), see ICOM, Ad Hoc Committee for the Return of Cultural Property, Annex of Preliminary Study of the Three National Situations in Regard to the Return of Cultural Property to Its Country of Origin, Intergovernmental Committee for Promoting the Return of Cultural Property to Its Countries of Origin or Its Restitution in Case of Illicit Appropriation (Paris, March, 14, 1980) Doc.CC-79/CONF206.6, https://unesdoc.unesco.org/ark:/48223/pf0000038746.locale=en.

32. Kenneth Gosling, "Museum Opposition to Treasure List Likely [Museum Opposition Likely to Third World Appeal]," *The Times*, May 18, 1981, 3. On the explosiveness of the subject of inventories at the time see for example, Peter Gathercole, "Recording Ethnographic Collections: The Debate on the Return of Cultural Property," in *Museum International* 38, 3 (1986): 187–92.

33. Frédéric Edelmann, "Patrimoine, patrimoines," *Le Monde*, May 5, 1980.

34. On the demands from Iraq see for example the verbal note of the Iraqi Embassy in the Federal Republic of Germany (date illegible, likely May 1980), and the Stiftung Preußischer Kulturbesitz's reaction in I HA, Rep. 600, no. 3059, GStA PK. The German press reported on the claims from Iraq as early as in 1979; see "Das Ishtar-Tor soll zurück nach Babylon kommen," *Die Welt*, November 20, 1979.

35. See the "Note on Ethiopian Cultural Objects Abroad," July 25, 1981, which had no effect, in: UNESCO, "Extract from the Report of the World Conference on Cultural Policies [Mexico City July 26–August 6, 1982] Pertaining to the Discussions on the Subject of Return or Restitution of Cultural Property," in Intergovernmental Committee for Promoting the Return of Cultural Property [...], 3rd session, Istanbul, May 9–13, 1983, Doc. CLT.83/CONF.216/5. See also Richard Pankhurst, "The Case for Ethiopia," *Museum International* 38, no. 1 (1986): 58–60.

36. On Sri Lanka's effort see Dario Willi, "Tropendiebe: Die Debatte um die Restitution sri-lankischer Kulturgüter im Museum für Völkerkunde Basel, 1976–1984" (master's seminar paper, University of Zurich, 2019). A list of claimed objects can be found in: Statement presented by the Democratic Socialist Republic of Sri Lanka concerning the restitution of significant cultural objects from Sri Lanka, Paris, April 2, 1980, see UNESCO 1980a. The list circulated in European institutions at the latest from spring 1980, for example see a copy in an attachment to a letter from Werner Knopp (SPK) to Stephan Waetzoldt (SMB), June 16, 1980, in I HA, Rep. 600, no. 3059, GStA PK. In 1976, the British and German press already reported on Sri Lanka's claims; see Donovan Moldrich, "Dr. de Silva of Treasure Island Warns Ex-colonials," *The Times*, May 18, 1976, 1; amd "Kunstschätze zurückverlangt: Frühere Kolonien stellen Forderung an damalige Herren," *Frankfurter Rundschau*, May 20, 1976.

37. Pilippu Hewa Don Hemasiri De Silva, *A Catalogue of Antiquities and Other Cultural Objects from Sri Lanka (Ceylon) Abroad*, Spolia Zeylanica 33 (Colombo: National Museums of Sri Lanka, 1975).

38. Note about a meeting in the Foreign Office (AA) on January 29, 1981, February 3, 1981, p. 3, item 4a in I HA, Rep. 600, no. 3059, GStA PK.

39. "Stellungnahme zu Forderungen der Demokratischen Sozialistischen Republik Sri Lanka sowie der Republik Irak auf Herausgabe von Gegenständen, die sich im Besitz der Stiftung Preußischer Kulturbesitz befinden," draft, March 6, 1981, in I HA, Rep. 600, no. 3059, GStA PK. In the draft, the quoted phrase is crossed out.

40. Friedrich Kußmaul to the Ministry for Science and Art of Baden-Württemberg, June 3, 1981 in EL 232, Bü 988, StAL.

41. Ibid.

42. Gert von Paczensky, "Schätze, die uns nicht gehören: Kulturgut aus der Dritten Welt" *art*, no. 4 (1981): 49.

43. On the inventory of objects from Tahiti in France see Anne Lavondès, "The Museum of Tahiti and the Islands: Towards Realistic Policies and Practice," *Museum International* 33, no. 2 (1981): 118–21. On the current state of inventorisation, see the online database of the Musée du quai Branly–Jacques Chirac in Paris: "Explorer les collections," Musée du quai Branly, http://collections.quaibranly.fr/.

44. Christian Kaufmann, "Völkerkundliche Dokumentation aus und für Papua New Guinea," in *Das Museum und die Dritte Welt: Bericht über ein internationales Symposium veranstaltet von den ICOM-Nationalkomitees der Bundesrepublik Deutschland, Österreichs und der Schweiz vom 7. bis 10. Mai 1979 am Bodensee (Lindau)*, ed. Hermann Auer (Munich: K. G. Saur), 224–230, esp. 230.

45. See Christian Kaufmann, Ruth Kobel-Streiff and Roland Kaehr, eds., *Völkerkundliche Sammlungen in der Schweiz* vol. 1 and vol. 2 (Bern: Schweizerische Ethnologische Gesellschaft, 1979).

46. Ernst J. Kläy, "Orientierung über eine vereinheitlichende Inventarisierung völkerkundlicher Sammlungen in der Schweiz," in Auer, *Das Museum und die Dritte Welt*, 231–52, esp. 231–2.

47. Contribution to the discussion by Auer, in Auer, *Das Museum und die Dritte Welt*, 253.

48. See "Report by the UNESCO Secretariat on the Measures Taken to Implement the Recommendations Adopted by the Intergovernmental Committee for Promoting the Return of Cultural Property, etc," in Intergovernmental Committee for Promoting the Return of Cultural Property [...], 5th session, Paris, April 27–30, 1987. Doc. CC.87/CONF. 207/3 p. 4. Another inventory project based in Bremen concerned the collections in Mali; see ibid. and "Return or Restitution of Cultural Property: A Brief Résumé," *Museum International* 38, no. 1 (1986): 62.

1981: LOST HERITAGE

1. "Archäologie: Schräges Licht," in *Der Spiegel* 8, February 18 (1980): 218–24, esp. 218.

2. At least this is how the BBC presented it; see Michael Ratcliffe, "Television Chronicle, BBC 2," *The Times*, May 28, 1981, 6. However, Wilson had demonstrably

given interviews on the subject in 1980, for example to the journalist Peter Fischer who used it for a feature on Radio Free Berlin, see Peter Fischer, ed., "Die Nationalität der Nofretete: Kulturgüter zwischen Raub, Rettung und Restitution," *SFB III* (West Berlin: Sender Freies Berlin, January 26, 1980), 30 min.

3. On the history of the building see Kodwo Mensah-Brown, "The London Africa Centre," *African Arts* 3, no. 3 (1970): 56–60; on the Benin auctions Dan Hicks, *The Brutish Museums* (Pluto Press: London, 2020), 147, 158–59, 169, 171, and 245–46.

4. For more on Stevens' Auction Rooms Ltd., see British Museum (website), https://www.britishmuseum.org/collection/term/BIOG128533.

5. Kodwo Mensah-Brown, "The London Africa Centre," *African Arts* 3, no. 3 (1970): 56.

6. Desmond Tutu, "The Africa Centre Must Not Simply Be Swept Away," *Guardian*, June 3, 2011.

7. Irene Staunton and Murray McCartney eds., *Lost Heritage: The Question of the Return of Cultural Property; Report on the Symposium Held in London, Commonwealth Arts Association and the Africa Centre, London* (London: Commonwealth Arts Association), 2. I am most grateful to the library of the Hochschule für Philosophie in Munich for their assistance in tracing a copy of this rare publication, which is extremely hard to find today.

8. Ibid., 2, 28. See "New Pressure for Return of Colonial Treasures," *The Times*, May 11, 1981, 4; Douglas Newton, "'Lost Heritage," A Report on the Symposium on the Return of Cultural Property Held at the Africa Centre," *Pacific Arts Newsletter* no. 16 (January 1983): 18–20.

9. See for example Hicks, *Brutish Museums*.

10. "Retour et restitution de biens culturels: un problème d'identité culturelle et d'équité internationale," programme of colloquium organised by the Société Africaine de Culture, September 11, 1981, in 11AAI/71, MQB.

11. Chandra Kumar in Staunton and McCartney, *Lost Heritage*, 18.

12. Peter Gathercole, "British University Museums and the Problems Relating to Restitution," in Staunton and McCartney, *Lost Heritage*, 11–13.

13. Ibid., 12.

14. Ibid., 11–12.

15. Ibid., 13.

16. David Felton, "British Museum Chiefs Called 'Inept' by Union," *The Times*, August 7, 1980, 1–2.

17. David M. Wilson in Staunton and McCartney, *Lost Heritage*, 17–18, esp. 17.

18. Ibid.

19. Ibid.

20. Rankine in Staunton and McCartney, *Lost Heritage*, 18.

21. See Geoffrey Walford, *Restructuring Universities: Politics and Power in the Management of Change* (Routledge: London, 1987), chapter 3.2.

22. Charles Mungo in Staunton and McCartney, *Lost Heritage*, 21.

23. In the British context see the polarising article by Richard Dowden, "Should We Give Back These Treasures?," *The Times*, October 19, 1981, 10, as well as the

instructive summary of the positions of David M. Wilson, Nicholas Thomas and Thurstan Shaw, in "Editorial," *Antiquity* 56, no. 216 (March 1982): 2–4.

24. *Whose Art Is It Anyway?* BBC2, May 27, 1981. I am very grateful to Nora Philippe (Paris) who made this document available; see Ben Shephard, "Western Museums versus the Third World," *The Listener* (May 28, 1981): 694–95.

25. The exhibition "Asante: Kingdom of Gold" was shown in September 1980 in the Museum of Mankind, at the time a department of the British Museum.

26. Michael Ratcliffe, "Television Chronicle, BBC 2," *The Times*, May 28, 1981, 6.

27. David M. Wilson and Siegfried Helms, "'Was wir nicht bewahren, ist verloren': Interview mit David Wilson," *Die Welt*, June 12, 1981.

28. Ibid.

29. The idea had originated with the ICOM's Ad Hoc Comittee; see UNESCO, 1980a. "Recommendations Proposed by the Ad hoc Sub-Committee for Adoption by the Intergovernmental Committee." In *Intergovernmental Committee for Promoting the Return of Cultural Property [...] 1st session*, Paris, May 9. Doc. CC-79/ CONF.206/9.

30. First draft for the form as an attachment to a circular by the UNESCO director-general Amadou-Mahtar M'Bow, March 26, 1981, Annex II in I HA, Rep. 600, no. 3059, GStA PK.

31. "Ministère des relations extérieures : Remarques formulées par la France, no. 736," June 9, 1981, in I HA, Rep. 600, no. 3059, GStA PK.

32. COREU (encrypted telegram), May 1, 1981, in I HA, Rep. 600, no. 3059, GStA PK.

33. Ibid.

34. Friedrich Kußmaul to the regional Ministry for Science and Art of Baden-Württemberg, June 3, 1981, in EL 232, Bü 988, StAL. On the rich and instructive colonial-era archives of the Linden-Museum, see Gesa Grimme, "Provenienzfor-schung im Projekt 'Schwieriges Erbe: Zum Umgang mit kolonialzeitlichen Objekten in ethnologischen Museen'" (Linden-Museum, Stuttgart, 2018) and Sebastian Sprute, "Die Jagd nach der größtmöglichen Trommel: Sammelwut, Krieg und Trägerleid oder die menschenverachtende Beschaffung von Ethnographica im kolonialen Kamerun, 1902–1908," in *Tribus*, Jahrbuch des Linden-Museums Stuttgart, vol. 67 (Linden-Museum, Stuttgart, 2018), 131–53.

35. Werner Knopp (SPK) to the BMI, May 12, 1981, in I HA, Rep. 600, no. 3059, GStA PK.

36. Otto von Simson (German UNESCO commission) to Werner Knopp (SPK), May 15, 1981, in ibid.

37. Hans Rädle (KMK) to the Foreign Office, June 1, 1981, as well as Lügge (BMI) to Foreign Office (et al.), May 22, 1981, in ibid.

38. Summary minutes of the meeting: UNESCO, Item 11 of the Provisional Agenda: Report of the Intergovernmental Committee for Promoting the Return of Cultural Property. [...], 22 September 1983," in General Conference, 22nd Session, Paris 1983. Doc. 22 C/88, https://unesdoc.unesco.org/ark:/48223/pf0000057604 .locale=en. UNESCO, Report of the Intergovernmental Committee for Promoting the Return of Cultural Property to Its Countries of Origin or Its Restitution in Case of Illicit Appropriation, Item 11 of the Provisional Agenda, General Conference, 22nd

Session, (Paris, September 22, 1983), Doc. 22 C/88, https://unesdoc.unesco.org/ark: /48223/pf0000057604.locale=en.

39. An original copy of the form is preserved in the archives of the Musée du Quai Branly-Jacques Chirac see 5AAI/386, MQB.

1982: MEXICO AND THE GREEKS

1. Hildegard Hamm-Brücher to Hans Werner Lautenschlager (Foreign Office), June 8, 1982, in B 91-REF. 612, PA AA.

2. See the conference publications of the FRG: "Schlussbericht der von der UNESCO vom 26. Juli bis 6. August 1982 in Mexiko-Stadt veranstalteten internationalen Konferenz," *Weltkonferenz über Kulturpolitik* (Munich: Saur, 1983); and the GDR: German Ministry of Culture, *Mondiacult Weltkonferenz der UNESCO über Kulturpolitik Mexiko 1982* (Berlin: Staatsverl. der DDR, 1983).

3. "Welt-Kulturenkonferenz Mexiko, Bericht zum Stand der Vorbereitungen und eigene Strategie," June 4, 1982, in B 91-REF. 612, PA AA.

4. See for example Hildegard Hamm-Brücher's work: "Kulturbeziehungen zwischen Nord und Süd: ein Beitrag zu einer humanen Dritte-Welt-Politik," *Die Dritte Welt* 8, no. 2 (1980): 4–13; "Afrika: ein Kontinent auf dem Weg zu sich selbst" (unpublished paper delivered by the state minister at the Federal Foreign Office, Bonn at the opening of the 32nd Frankfurt Book Fair, October 7, 1980); "Einweihung des Goethe-Instituts Nairobi," in *Kulturbeziehungen weltweit, ein Werkstattbericht zur auswärtigen Kulturpolitik*, ed. Hildegard Hamm-Brücher (Munich: Hanser, 1980), 129–35; "Auswärtige Kulturpolitik in Afrika," in *Afrika und die Deutschen: Jahrbuch der Deutsche Afrika-Stiftung* (Pfullingen: Neske, 1981), 19–30; Report to the international conference for Anglophone journalists and cultural attachés from embassies of developing countries based in Bonn und Brussels, in Berlin, October 29, 1981, "Kulturpolitische Beziehungen mit den afrikanischen Ländern," *Bulletin des Presse- und Informationsamtes der Bundesregierung* (Bonn: Deutscher Bundesverlag, 1981), 868–71.

5. Hildegard Hamm-Brücher, *Zehn Thesen zur kulturellen Begegnung und Zusammenarbeit mit Ländern der Dritten Welt* (Bonn: Auswärtiges Amt, 1982).

6. Hildegard Hamm-Brücher, *Freiheit ist mehr als ein Wort: Eine Lebensbilanz, 1921–1996* (Cologne: Kiepenheuer & Witsch, 1997), 249.

7. They appeared at the syposium "Internationale Kulturbeziehungen: Brücke über Grenzen," Bonn, May 26–30, 1980. See Alexandre, III Kum'a Ndumbe, *Was will Bonn in Afrika? Zur Afrikapolitik der Bundesrepublik Deutschland* (Pfaffenweiler: Centaurus Verlag, 1992), 343.

8. Hamm-Brücher, "Einweihung des Goethe-Instituts Nairobi," 131.

9. Hamm-Brücher, *Freiheit ist mehr als ein Wort*, 252n6.

10. See the list of delegates in UNESCO, "Schlussbericht der von der UNESCO vom 26. Juli bis 6. August 1982 in Mexiko-Stadt veranstalteten internationalen Konferenz," Weltkonferenz über Kulturpolitik. Munich, 1983, 159–194; for the FRG delegation see ibid., 160.

11. Frédéric Grah Mel, "A César ce qui est à César," *Afrique*, January 8, 1982.

12. See for example Peter Körner, Gero Maass, Thomas Siebold and Rainer Tetzlaff, *Im Teufelskreis der Verschuldung: Der Internationale Währungsfonds und die Dritte Welt* (Hamburg: Junius, 1984), 165ff.

13. "Welt-Kulturenkonferenz Mexiko, Bericht zum Stand der Vorbereitungen und eigene Strategie," June 4, 1982: 5 in B 91-REF. 612, PA AA.

14. Ibid.

15. See Sarah Van Beurden, "The Art of (Re)Possession: Heritage and the Cultural Politics of Congo's Decolonization," *Journal of African History* 56, no. 1 (March 2015): 143–64 and Jos Van Beurden, *Treasures in Trusted Hands: Negotiating the Future of Colonial Cultural Objects* (Leiden: Sidestone Press, 2017).

16. See letter from the Permanent Representative of the FRG to UNESCO in Paris to the German Foreign Office, July 7, 1980, in I HA, Rep. 600, no. 3059, GStA PK: "The willingness to engage in talks about bilateral negotiations was found to vary: especially the Dutch and Belgians, and probably also the Danes seem ready to do so and refer to their relevant experiences."

17. See "Throne of Menelik II Recovered from Italy," *Ethiopian Herald*, June 15, 1982, as well as "Incontro tra i ministeri degli Esteri on. Colombo e Feleke Gedle-Ghiorgis," in *Ministero degli affari esteri, servizio storico e documentazione 1982*. Testi e documenti sulla politica estera dell'Italia (Rome 1985), 212.

18. Jack Lang, *Discours de Jack Lang, ministre de la culture, lors de la conférence mondiale des ministres de la culture, sur la défense de la culture contre les dominations économiques* (Mexico July 27, 1982). See the report about his speech in the TV archive INA: Alain Cances, "Lang à Mexico," Journal de 13h. (Antenne 2, France, July 30, 1980), 4 min., 14 sec. https://www.ina.fr/ina-eclaire-actu/video/cab8200927101/lang-a-mexico.

19. Jack Lang, *Allocution de Mons. Jack Lang, ministre français de la culture; Première conférence des ministres de la culture des pays francophones* (Cotonou: September 17–19, 1981), unpaginated. See the report in: Philippe Decraene, "Un meilleur équilibre des échanges culturels," *Le Monde*, September 22, 1981.

20. Hildegard Hamm-Brücher and Jürgen Sudhoff to Foreign Office, encrypted telegram, Mexico, July 27, 1982 in B 91-REF. 612, PA AA.

21. Rolf Michaelis, "Kreuzzug in die Köpfe," *Die Zeit*, no. 23, June 3, 1982.

22. "Nein, nein, Darling," *Der Spiegel*, no. 32 (August 8, 1982): 86–87.

23. See the Address of Mme. Melina Mercouri, Minister of Culture and Sciences of Greece, to the World Conference on Cultural Policies, organized by UNESCO in Mexico, July 29, 1982, on the submission by Greece of a Draft Recommendation on the Return of Cultural Property to Its Country of Origin, recorded on the website of the Melina Mercouri Foundation, https://melinamercourifoundation.com/en/speeches1/.

24. Press conference in Athens on March 16, 1982; Frédéric Edelmann, "Une demande de restitution: Le Parthénon et quelques autres," *Le Monde*, March 18, 1982; "Mercouri Wants Elgin Marbles," *The Times*, March 17, 1982, 6; and "Melina Mercouri pide que los frisos del Partenón vuelvan a Grecia," *El País*, March 18, 1982.

25. M'Bow explained how the logo was selected in autumn 1982. The reasons given then still apply today, see "The Logo" in *UNESCO Logo Toolkit* (Paris: UNESCO, 2009), sec. 2.1, https://en.unesco.org/system/files/unesco_brand_toolkit_dpi_120809.pdf.

26. Address of Mme. Melina Mercouri. Mercouri's speech was widely noticed internationally, see for example Frédéric Edelmann, "L'air du Parthénon et le couplet de la Vénus," *Le Monde*, September 2, 1982; "Nein, nein, Darling," 86–87; and Petra Kipphoff, "Wem soll die Kunst gehören?" *Die Zeit*, no. 23, June 3, 1983.

27. Dipolomatic note from Patrick Imhaus (Ministry of Foreign Affairs), Paris, April 2, 1982, in 11AAI/71, MQB.

28. Pierre Quoniam, Rapport, "Groupe de réflexion pour l'Afrique," July 21, 1982, in ibid.

29. "Frau Hamm-Brücher: Bei Rückgabe von Kulturgütern großzügig sein," *Süddeutsche Zeitung*, August 10, 1982, 2.

30. On the position of the Ministry for Culture on the issue of the "Rückführung von Kulturgut in die Ursprungsländer," see DR 136-99, Bl. 88-91, BArch Berlin cited in Holger Stoecker, "Rückgabeforderungen, die UNESCO und die Tendaguru-Großknochen," in *Dinosaurierfragmente: Zur Geschichte der Tendaguru-Expedition und ihrer Objekte, 1906-2018*, ed. Ina Heumann, Holger Stoecker, Marco Tamborini and Mareike Vennen (Göttingen: Wallstein, 2018), 269.

31. Ibid.

32. Hildegard Hamm-Brücher and Sudhoff to the Foreign Office, encrypted telegram, Mexico, August 1, 1982, p. 3 in B 91-REF. 612, PA AA.

33. "Welt-Kulturenkonferenz Mexiko: Bericht zum Stand der Vorbereitungen und eigene Strategie," June 4, 1982, 5 in ibid.

34. "Frau Hamm-Brücher," 2.

35. See the entry on Adolf Tüllmann in the catalogue of the German National Library *online:portal.dnb.de*; as well as "Sexualerziehung bei Gehörlosen," in *Entendre avec des yeux, Ökumenisches Seminar für Taubstummenseelsorger* (Neukirchen 1975), 257-59.

36. Adolf Tüllmann, "Kulturgüter zurück in den Urwald," *Süddeutsche Zeitung*, September 4-5, 1982

37. Reference to a telephone conversation by Horst Kullak-Ublick (Foreign Office) to the Foreign Office Berlin, August 26, 1982, in BA 95-ZA/155447, PA AA.

38. Foreign Office Berlin to Horst Kullak-Ublick, August 26, 1982, in BA 95-ZA/155447, PA AA.

39. Horst Kullak-Ublick, letter regarding the "100-Jahrfeier der Schutzverträge mit Togo und Kamerun," September 1, 1982, in ibid.

1983: BREMEN

1. See Anna Greve, *Koloniales Erbe in Museen: Kritische Weißseinsforschung in der praktischen Museumsarbeit* (Bielefeld: transcript Verlag, 2019), 158-61.

2. See for example Manfred O. Hinz, Helgard Patemann and Arnim Meier, eds. *Weiß auf Schwarz: 100 Jahre Einmischung in Afrika; Deutscher Kolonialismus und afrikanischer Widerstand* (Berlin: Elefanten Press, 1984).

3. See Sabine Birkenstock and Hartmut Müller, *Führer durch die Quellen zur Geschichte Afrikas im Staatsarchiv Bremen* (Bremen: Staatsarchiv, 1982) and Frank Thomas Gatter, "Internationales Symposium 'Berliner Afrika-Konferenz 1884-85': ein Projekt des Bremer Afrika Archivs," *Africa Spectrum* 18, no. 1 (1983): 107-9.

4. See for example Hans Koschnick, foreword to *Weiß auf Schwarz*, 5.

5. On the cooperative museum projects between Bremen and Mali see Sybille Benninghof-Lühl, "Wirkungsaspekte der Museumsarbeit in einem Entwicklungsland am Beispiel der Rezeption des Sahel-Museums in Mali, West Afrika," *Baessler-Archiv* 30, no. 2 (1982): 371-93; and UNESCO Experimental Project for the Inventory of Cultural Property in Mali, Intergovernmental Committee for Promoting the

Return of Cultural Property [...], 2nd session, (Paris, August 14, 1981), Doc. CC-81/CONF.203/6.

6. Rainer Mammen and Hed Saebens-Wiesner, introduction to *Übersee-Museum Bremen: Ein Rundgang* (Bremen: Schmalfeldt, 1979).

7. Dorothee Schulze, *Die Restitution von Kunstwerken: Zur völkerrechtlichen Dimension der Restitutionsresolutionen der Generalversammlung der Vereinten Nationen* Series D, vol. 12 (Bremen: Übersee-Museum, 1983); see previously from a legal perspective: Raymond Goy, "Le retour et la restitution des biens culturels à leur pays d'origine en cas d'appropriation illégale," *Revue Générale de droit international 33*, no. 3 (1979): 962–85.

8. English abstract of Dorothee Schulze, *The Restitution of Works of Art* in 5AAI/386, MQB.

9. Herbert Ganslmayr and Gert von Paczensky, *Nofretete will nach Hause: Europa; Schatzhaus der "Dritten Welt"* (Munich: C. Bertelsmann, 1984).

10. See for example Haug von Kuenheim, "Nofretete ist kein Fall: Der müßige Streit um die Kulturschätze aus der Dritten Welt," *Die Zeit*, no. 37, September 7, 1984; Esther Knorr-Anders, "Was die Nofretete denkt," *Die Welt*, August 14, 1984, and a review of Paczensky and Ganslmayr's book *Nofretete will nach Hause* (1984), "Dürer nach Tokio?," *Der Spiegel*, no. 41 (October 7, 1984): 252–53.

11. Friedrich Kußmaul to Hermann Auer, July 31, 1984, in EL 232, Bü 988, StAL.

12. Russell Chamberlin, *Loot! The Heritage of Plunder* (London: Thames & Hudson, 1983).

13. Parliamentary Debates, House of Lords, 1983. British Museum Act 1963 (Amendment) Bill, October 27, 1983, vol. 444, cols. 399–422, 400.

14. Ibid., 405–13.

1984: OPEN END

1. Synopsis in an attachment to a letter from Wilfried Hoffer (ZDF) to Friedrich Kußmaul, October 5, 1984, p. 2 in EL 232 Bü 988, StAL. See also the documents on the programme in the ZDF archive. I am grateful to Bettina Petry (Berlin) who made these documents available to me.

2. Ibid., 3.

3. Helmut Volger, *Geschichte der Vereinten Nationen* (Munich: R. Oldenbourg Verlag, 2008), 60–162.

4. See the live recorded studio discussion moderated by Wilfried Hoffer and Ingo Hermann "Haltet den Dieb: Kunstschätze aus der Dritten Welt. Raubgut, Leihgabe oder Eigentum?," *Fünf nach Zehn*. (West Germany: ZDF, December 18, 1984).

5. Rainer Mammen and Hed Saebens-Wiesner, introduction to *Übersee-Museum Bremen: Ein Rundgang* (Bremen: Schmalfeldt, 1979).

6. Peter Heller, *Mandu Yenu: Des Kaisers schwarzer Thron* (West Germany: ZDF, Filmkraft, 1984), 60 min; see also Christaud Geary and Adamou Ndam Njoya, *Images from Bamum: German Colonial Photography at the Court of King Njoya, Cameroon, West Africa, 1902–1915* (Washington, DC: Smithsonian Institution, 1988).

7. Many thanks to Damian Van Melis (Greven Verlag, Cologne) and Luca Frepoli (Technische Universität Berlin) for their support in transcribing the programme.

1985: BACK TO THE FUTURE

1. Karla Billang, "Einmalige Ausstellung afrikanischer Kunst," *Der neue Tag*, April 27, 1985.

2. *Schätze aus Alt-Nigeria*, April–May 1985 in VA 9265, SMB-ZA.

3. See the minutes about setting up the working group for *Schätze aus Alt-Nigeria*, January 22, 1985, in ibid.

4. Werner (SMB?) to the DARAG, February 18, 1985, in ibid.

5. Siegmar Nahser (Staatliche Museen) to Lemke (Press officer), April 2, 1985, in ibid.

6. Dr. G. Schade with Dr. Ekpo Eyo "Gesprächsnotiz für Verhandlungen des Generaldirektors der SMB," January 2, 1985, in ibid.

7. See the catalogue of the exhibitions held at the Fine Arts Museums of San Francisco and the California Palace of the Legion of Honor: Ekpo Eyo and Frank Willett, *Treasures of Ancient Nigeria: Legacy of 2,000 Years* (New York: Knopf, 1980), 8; on GDR cultural politics regarding Africa, see Christian Saehrendt, *Kunst im Kampf für das "Sozialistische Weltsystem": Auswärtige Kulturpolitik der DDR in Afrika und Nahost* (Stuttgart: Franz Steiner Verlag, 2017).

8. See the conference report, Gustel Koch, "Kolonialismus, Neo-Kolonialismus und der Weg Afrikas in eine friedliche Zukunft," *Deutsche Zeitschrift für Philosophie* 33, no. 11 (1985): 1036–40; on African Studies in the GDR see Ulrich Van der Heyden, "Afrika im Blick der akademischen Welt der DDR: Ein wissenschaftsgeschichtlicher Überblick der afrikabezogenen Ethnographie," *Berichte zur Wissenschaftsgeschichte* 42, no. 1 (March 2019): 83–105.

9. Lecture by Epko Eyo, April 2, 1985, and invitation dated March 27, 1985, in VA 9265, SMB-ZA.

10. Nahser and Manfred Ohlsen (Staatliche Museen) to Werner Wolf (Ministry for Culture), January 23, 1985, in ibid.

11. Nahser (Staatliche Museen) to Peter Göbel (Leipzig Ethnological Museum), March 11, 1985, in ibid.

12. Nahser and Ohlsen (Staatliche Museen) to Walter Rusch (Humboldt University), March 12, 1985, in ibid.

13. I am most grateful to Silvia Dolz (Museum für Völkerkunde Dresden, GRASSI-Museum für Völkerkunde zu Leipzig, Völkerkundemuseum Herrnhut), Léontine Meijer-van Mensch (Völkerkundemuseen in Leipzig, Dresden, Herrnhut) and Gilbert Lupfer (Staatliche Kunstsammlungen Dresden) for their support of my research in the museum archives of Leipzig and Dresden.

14. Open letter from Waltraut Ulshöfer to Helmut Engler, July 9, 1985, in EL 232, Bü 987, StAL.

15. Ibid.

16. Green Party, Baden-Württemberg parliament, "Gebt zurück, was uns nicht zusteht," undated flyer in ibid. Thanks to Eva Sander (Archiv Grünes Gedächtnis) for her assistance in tracing the original document.

17. Ibid.

18. See Friedrich Kußmaul to the Ministry for Science and Arts of Baden-Württemberg, July 25, 1985, in EL 232, Bü 987, StAL.

EPILOGUE

1. See Reinhart Koselleck, "Begriffsgeschichte und Sozialgeschichte," in Peter Christian Ludz, ed., *Soziologie und Sozialgeschichte: Aspekte und Probleme* (Opladen: Westdeutscher Verlag, 1972), 116–31.

2. See Robert Boyer, "Le retour des biens culturels dans les pays anciennement colonisés," p.19 in 19870713/25, A.N.

3. My thanks go to Petra Winter and Christine Howald (SMB Zentralarchiv, Berlin), Ulrike Höroldt and Laura Gerber (GStA PK, Berlin), Simon Heßdörfer (PA AA, Berlin), Corinna Knobloch (StAL, Ludwigsburg), Sarah Frioux-Salgas and Jean-André Assié (MBQ, Paris), as well as Yann Potin (Archives Nationales, Paris).

4. Richard Kandt to Felix von Luschan, October 19, 1897, pp. 228–231, esp. 230 in Archiv des Ethnologischen Museums, Berlin, EN, 712, 1897/1544, SMB-PK.

5. Deutscher Bundestag, 19. Wahlperiode, "Antwort der Bundesregierung: Aufarbeitung der Provenienzen von Kulturgut aus kolonialem Erbe in Museen und Sammlungen" printed matter 19/6539, December 13, 2018, https://dserver.bundestag.de/btd/19/065/1906539.pdf.; author's emphasis.

6. Paul Starzmann, "Raubkunst-Streit überschattet Eröffnung des Humboldt-Forums," *Der Tagesspiegel*, December 11, 2020.

7. See Raphael Gross, ed., "Thema: Die Säule von Cape Cross—Koloniale Objekte und historische Gerechtigkeit." *Historische Urteilskraft: Magazin des DHM Berlin* 01 (Stiftung Deutschen Historischen Museums, 2019); as well as the law on restitution of 27 objects to the republics of Benin and Senegal passed in France: LOI n° 2020-1673 relative à la restitution de biens culturels à la République du Bénin et à la République du Sénégal, December 24, 2020, https://www.legifrance.gouv.fr/jorf/id/JORFTEXT000042738023.

BIBLIOGRAPHY

ARCHIVAL REFERENCES

The following references from archival collections (GStA PK, PA AA, Archives MQB, SMB-ZA, StAL, AICA) include holdings that have never before received scholarly attention as well as those that have already been included in research. The latter are marked with a → and reference to the relevant sources.

Berlin, Berlin-Lichterfelde, Bundesarchiv (Federal Archives)

BArch Berlin, DR 136-99, Bl. 88–91: Kommission des Ministeriums für Kultur (MfK) zum Schutz des Kulturgutes (The Ministry for Culture's Commission on the Protection of Cultural Heritage); The Ministry for Culture's position on the "Rückführung von Kulturgut in die Ursprungsländer (Repatriation of cultural goods to their countries of origin") 1982. → Stoecker 2018.

Berlin, Geheimes Staatsarchiv Preußischer Kulturbesitz (GStA PK; Prussian Privy State Archives)

I HA, Rep. 600, No. 38: Präsident und Hauptverwaltung SPK, Leihgesuch Nigerias (President and Central Administration of the Stiftung Preußischer Kulturbesitz [SPK; Prussian Cultural Heritage Foundation], Nigeria's loan request), 1972–1975.

I HA, Rep. 600, No. 3058: Präsident und Hauptverwaltung Stiftung Preußischer Kulturbesitz (SPK), Rückgabe von Kulturgut an die Herkunftsländer, (President and Central Administration of the Prussian Cultural Heritage Foundation, Restitution of cultural goods to their countries of origin) 1973-1976.

I HA, Rep. 600, No. 3059: Präsident und Hauptverwaltung SPK, Rückgabe von Kulturgut an die Herkunftsländer (President and Central Administration of the Prussian Cultural Heritage Foundation, Restitution of cultural goods to their countries of origin), 1977-1981.

Berlin, Politisches Archiv des Auswärtigen Amts (PA AA; Political Archive of the Federal Foreign Office)

B 30-ZA/115747: Austausch von Kulturgut aus Museumsbeständen (Exchange of cultural goods from the museum's collections), 1973–1975.

B 30-ZA/121186: UNESCO, Austausch und Rückgabe von Kulturgütern aus Museumsbeständen (Exchange and restitution of cultural goods from museum collections), 1976–1979.

B 30-ZA/128116: Austausch/Rückgabe von Kulturgütern aus Museumsbeständen (Exchange/restitution of cultural goods from museum collections), 1980–1981.

B 46-ZA/110829: UNESCO, Kulturgüter (cultural goods), 1978.

B 91-REF. 612: UNESCO-Weltkonferenz über Kulturpolitik in Mexiko, 1982 (alte Signatur: 152297).

B 91-REF. 642: Forderung der Rückgabe von Kulturgut, 1976 (alte Signatur: 205193).

B 95-ZA/155447: 100 Jahrfeier der Schutzverträge mit Togo, Kamerun und Tansania (centenary celebration of the protective treaties with Togo, Cameroon, and Tanzania), 1982–1986.

Berlin, Zentralarchiv der Staatlichen Museen zu Berlin (SMB-ZA; Central Archive of the Berlin State Museums)

VA 9265: "Schätze aus Alt-Nigeria (Treasures from Ancient Nigeria)," Special exhibition, April–May 1985.

Kew, The National Archives

ED 245/41: Restitution of works of art to countries which were victims of expropriation: UK response to UNESCO proposals, 1973–1977.

FCO 65/1797: Antiquities of Nigeria: Refusal of British Museum to Loan Benin Ivory Mask, January 1–December 31, 1976. → Bodenstein 2019.

Ludwigsburg, Staatsarchiv (StAL; Ludwigsburg State Archives)

EL 232 Linden-Museum Stuttgart (Staatliches Museum für Völkerkunde [State Museum for Ethnology]), 1882–2011; Bü 987: Restitution, Rückführung von Kulturgütern (Restitution and Repatriation of Cultural Goods), 1973–1974; Bü 988: Restitution, Rückführung von Kulturgütern (Restitution and Repatriation of Cultural Goods), 1976–2011.

Paris, Archiv des Musée du quai Branly-Jacques Chirac (MQB; The Quai Branly Museum Archives)

5AAI/386: Restitution des biens culturels (restitution of cultural goods), 1976–1995.

11AAI/71: Restitution des biens culturels, collaborations: correspondance, documentation, documents de travail, décrets de loi sur protection d'oeuvres (Mali), rapports, comptes rendus de réunions, note (restitution of cultural goods, collaborations: correspondence, documentation, working documents, legal decrees on the protection of works, reports, meeting reports, notes), 1973–1987.

Paris, Archives Nationales (A.N.; National Archives, Paris)

19810532/17: Restitution des biens culturels: notes au ministre au sujet du problème congolais (restitution of cultural goods: the minister's notes on the subject of the Congolese problem), 1977.

19870713/25:'Rapports de travail sur retour des biens culturels a leurs pays d'origine (restitution of cultural goods: Boyer's report), 1979.

19930218/52: Restitution des biens culturels (restitution of cultural goods), 1975-1978.

Rennes, Archives de la critique d'Art (AICA; the Archives of Art Criticism, Rennes)

FR ACA AICAI THE CON028: Fonds AICA International—IIIème Congrès extraordinaire de l'AICA (The International AICA Fund: 30th Special Congress of the AICA), Kinshasa, September 10-23, 1973.

FR ACA AICAI THE CON028 01/01: The program for the above event.

FR ACA AICAI THE CON028 07/09: The press report for the above event.

Sankt Augustin, Archiv für Christlich-Demokratische Politik der Konrad-Adenauer-Stiftung (ACDP, Archive for Christian Democratic Policy at the Konrad Adenauer Foundation). https://www.kas.de/de/web/wissenschaftliche-dienste-archiv/publikationen/einzeltitel/-/content/findbuch-franz-amrehn

01-295: Nachlass Franz Amrehn (1912–1981) (Franz Amrehn Papers).

Tervuren, Musée royal de l'Afrique centrale (MRAC; Historical Archive of the Royal Museum of Central Africa

Abt.Service de Culture et société, IMNZ-Akten (files of the Institute of the National Museums of Zaire): inter alia "MNZ-MRAC Apport"; "Restitutie RDC 1970-1980."

Abt.Service d'Histoire et politique, IMNZ-Akten (files of the Institute of the National Museums of Zaire): inter alia "J. Powis de Tenbossche"; "ICOM/UNESCO" (box 15-2-77). → Van Beurden 2015a-c.

FILM, RADIO AND TELEVISION MEDIA

Coogler, Ryan, dir. *Black Panther*. 2018. Burbank, CA: Walt Disney Studios Motion Pictures, 135 min.

Fischer, Peter, ed. 1980. *Die Nationalität der Nofretete: Kulturgüter zwischen Raub, Rettung und Restitution*. 1980. West Berlin: SFB III, Sender Freies Berlin, January 26, 1980, 30 min.

Gicquel, Roger. 1978a. "L'Unesco." *Journal de 20h*. France: TFI, October 24, 1978, 4 min. 54 sec. https://www.ina.fr/video/CAA7801592401.

Gicquel, Roger. 1978b. "Table ronde Unesco: Interview Amadou Mahtar M'bow." *Journal de 20h*. France: TFI, June 19, 1978, 24 min. 4 sec. https://m.ina.fr./video/CAA7801439001.

"Haltet den Dieb. Kunstschätze aus der Dritten Welt. Raubgut, Leihgabe oder Eigentum?" 1984. Live recorded studio discussion moderated by Wilfried Hoffer and Ingo Hermann. *Fünf nach Zehn*. West Germany: ZDF, December 18, 1984.

Heller, Peter, dir. 1984. *Mandu Yenu: Des Kaisers schwarzer Thron*. West Germany: ZDF, Filmkraft, 60 min.

Imasuen, Lancelot Oduwa, dir. 2014. *Invasion 1897*. Nigeria, 113 min.

Cances, Alain, "Lang à Mexico." 1980. *Journal de 13h*. France: Antenne 2, July 30, 1980, 4 min., 14 sec. https://www.ina.fr/ina-eclaire-actu/video/cab8200927101/lang-a-mexico.

Owoo, Nii Kwate, dir. 1971. *You Hide Me*. Ghana: b/w, 16 mm, 40 or 20 min.

Paczensky, Gert von. 1977. "Problematischer Kulturbesitz." *Blickpunkt*, Bremen, West Germany: Radio Bremen, January 22, and Berlin: Sender Freies Berlin, January 23, 1977. 14 min.

Shephard Ben, dir. 1981. *Whose Art Is It, Anyway?* London: BBC2, May 27, 1981, 45 min.

Ugbomah, Eddie, dir. 1980. *The Mask*. Nigeria. Color, 16 mm enlarged to 35 mm, 100 min.

WORKS CITED

A. S. 1981. "Restituer le passé de l'Afrique: découvertes archéologiques: le retour des biens culturels." *Agecop liaison* 62 (November/December): 12–13.

Agence France Presse. 1975a. "Die Uno fordern Kunst-Rückgabe." *Frankfurter Allgemeine Zeitung*, November 21, 1975.

Agence France Presse. 1975b. "UNO fordert Rückgabe überseeischer Kunst." *Die Welt*, November 21, 1975.

Afrique Contemporaine. 1973. "Le Congrès de l'AICA de Kinshasa." *Afrique Contemporaine* 70: 20.

Agorsah, Emmanuel Kofi. 1977. "Restitution of Cultural Material to Africa." *Africa Spectrum* 12, no. 3: 305–8. https://www.jstor.org/stable/40173905.

Ahmed, Mahmoon. 1977. "Festac: Time to Re-Assess Our Culture." *New Nigerian*, January 15, 1977.

Albrecht, Monika. 2011. "(Post-) Colonial Amnesia? German Debates on Colonialism and Decolonization in the Post-War Era." In *German Colonialism and National Identity*, edited by Jürgen Zimmerer and Michael Perraudin, 187–96. New York: Routledge.

Amrouche, Pierre. 2013. "Paulin Joachim, un Africain d'autrefois (1931–2012)." *Présence Africaine* 187/188, no. 1–2: 347–48.

Anonymous. 1969. "Contributions from European Museums: First Pan-African Cultural Festival—Algiers." *The Times*, June 17, 1969.

Anonymous. 1973. "Devant les critiques d'art." *Salongo: Quotidien du matin*, September 14, 1973.

Anonymous. 1974a. "Ghana Plea for Return Regalia Refused." *The Times*, September 6, 1974.

Anonymous. 1974b. "Ghana Plea for Return of Ashanti Regalia Refused." *The Times*, December 11, 1974.

Anonymous. 1976. "Une bonne querelle." *Jeune Afrique*, July 9, 1976.

Anonymous. 1977. "Festac'77: Festival der Herausforderungen." *3. Welt Magazin*, no. 3, 72.

Anonymous. 1978a. "Derde Wereld eist kunstschatten terug." *De Telegraaf*, October 26, 1978.

Anonymous. 1978b. "Unesco Plea for Return of Art Works." *The Times*, June 8, 1978.

Anonymous. 1978c. "Kunst hoort thuis in land van herkomst." *Het Vrije Volk*, October 30, 1978.

Anonymous. 1979. "Nur die Holzwürmer würden sich freuen." *Die Welt*, November 20, 1979.

Anonymous. 1981. "New Pressure for Return of Colonial Treasures." *The Times*, May 11, 1981.

Antiquity. 1982. "Editorial." *Antiquity* 56, no. 216 (March): 2–4.

Apter, Andrew. 2005. *The Pan-African Nation: Oil and the Spectacle of Culture in Nigeria*. Chicago: University of Chicago Press.

Arndt, Lotte. 2016. *Les revues font la culture! Négociations postcoloniales dans les périodiques parisiens rélatifs à l'Afrique (1947–2012)*. Trier: WVT Wissenschaftlicher Verlag.

L'art negre: Sources, évolution, expansion. 1966. Musée dynamique, Dakar and the Grand Palais, Paris.

Ashford, Nicholas. 1974. "Ashanti Nation Still Yearns for Sacred Golden Stool." *The Times*, February 5, 1974.

Associated Press. 1979. "Deutsche Unesco-Kommission will Dialog mit Afrika stärken." *Der Tagesspiegel*, March 30, 1979.

Auer, Hermann. 1978. "Stellungnahme zu dem 'Entwurf einer Empfehlung der UNESCO über den internationalen Austausch von Kulturgut.'" In *Raum, Objekt und Sicherheit im Museum: Bericht über ein internationales Symposium veranstaltet von den ICOM-Nationalkomitees der Bundesrepublik Deutschland, Österreichs und der Schweiz vom 9. bis zum 15. Mai 1976 am Bodensee (Lindau)*, edited by Hermann Auer, 206–15. Munich: K. G. Saur.

Auer, Hermann, ed. 1981. *Das Museum und die Dritte Welt: Bericht über ein internationales Symposium veranstaltet von den ICOM-Nationalkomitees der Bundesrepublik Deutschland, Österreichs und der Schweiz vom 9. bis zum 15. Mai 1976 am Bodensee (Lindau)*. Munich: K. G. Saur.

"Aus der Deutschen Gesellschaft für Völkerkunde und aus der Berliner Gesellschaft für Anthropologie, Ethnologie und Urgeschichte." *Zeitschrift Für Ethnologie* 98, no. 1 (1973): 139. http://www.jstor.org/stable/25841416.

Balta, Paul. 1977. "Reconquête de l'Afrique par elle-même." *Le Monde*, January 27, 1977.

Bedjaoui, Mohammed. 1979. "The Right to a Collective 'Cultural Memory.'" In *Yearbook of the International Law Commission* 2, no. 1: 80, paragraphs 46–53. https://legal.un.org/ilc/publications/yearbooks/english/ilc_1979_v2_p1.pdf.

Belting, Hans and Andrea Buddensieg. 2018. *Ein Afrikaner in Paris: Léopold Sédar Senghor und die Zukunft der Moderne*. Munich: C. H. Beck.

Benninghof-Lühl, Sybille. 1982. "Wirkungsaspekte der Museumsarbeit in einem Entwicklungsland am Beispiel der Rezeption des Sahel-Museums in Mali, West Afrika." *Baessler-Archiv: Beiträge zur Völkerkunde* 30, no. 2: 371–93.

Billang, Karla. 1985. "Einmalige Ausstellung afrikanischer Kunst." *Der Neue Tag*, April 27, 1985.

Birkenstock, Sabine, and Hartmut Müller. 1982. *Führer durch die Quellen zur Geschichte Afrikas im Staatsarchiv Bremen*. Bremen: Staatsarchiv.

Black Arts and Culture. 1977. Special Supplement. *The Times*, Jan 18, 1977.

Blumenthal, Susan. 1974a. "The World's Best Traveled Art." *Africa Report* 19, no. 1: 4–10.

Blumenthal, Susan. 1974b. *Bright Continent: A Shoestring Guide to Sub-Saharan Africa.* New York: Anchor Press.

Boahen, Albert Kwadwo Adu. 1974. "Ashanti Regalia." *The Times,* February 28, 1974, 19.

Bodenstein, Felicity. 2018a. "Notes for a Long-Term Approach to the Price History of Brass and Ivory Objects Taken from Benin City in 1897." In *Acquiring Cultures: World Art on Western Markets,* edited by Christine Howald, Bénédicte Savoy and Charlotte Guichard, 267–88. Boston: De Gruyter.

Bodenstein, Felicity. 2018b. "Commentary on 'Nigeria's Antiquities Abroad, A *Daily Times* Investigation' (1976)." In *Translocations Anthologie: Eine Sammlung kommentierter Quellentexte zu Kulturgutverlagerungen seit der Antike* (blog), October 19, 2018. https://translanth.hypotheses.org/ueber/bozimo.

Bodenstein, Felicity. 2019. "Cinq masques de l'Iyoba Idia du royaume de Bénin: Vies sociales et trajectoires d'un objet multiple." *Perspective,* no. 2 (2019): 227–38.

Bodenstein, Felicity. 2021. "Antiquitäten aus Nigeria—Elfenbein aus Benin." In *Beute: Eine Anthologie zu Kunstraub und Kulturerbe,* edited by Isabelle Dolezalek, Bénédicte Savoy and Robert Skwirblies, 348–53. Berlin: Matthes & Seitz.

Bösch, Frank. 2019. *Zeitenwende 1979: Als die Welt von heute begann.* Munich: C. H. Beck.

Bösch, Frank and Andreas Wirsching, eds. 2018. *Hüter der Ordnung: Die Innenministerien in Bonn und Ost-Berlin nach dem Nationalsozialismus.* Göttingen: Wallstein.

British Museum. 1963. British Museum Act 1963, chapter 24. https://www.legislation.gov.uk/ukpga/1963/24/contents.

Cahen, Lucien. 1974. "La collaboration entre le Musée Royal de l'Afrique Centrale et les Musées Nationaux du Zaïre." *Africa-Tervuren* 19, no. 4: 111–14.

Canaday, John. 1973. "Zaire in Search of Its Identity." *New York Times,* October 14, 1973, 25. https://www.nytimes.com/1973/10/14/archives/zaire-in-search-of-its-identity-art.html.

Cans, Roger. 1978. "M. M'Bow lance un appel pour le restitution de certaines œuvres d'art à leur pays d'origine." *Le Monde,* June 9, 1978.

Carrington, C. E. 1974. "Ashanti Regalia." *The Times,* March 20, 1974, 17.

Cazenave, Elisabeth and Jean-Christian Serna. 2017. *Le patrimoine artistique français de l'Algérie : Les œuvres du Musée national des Beaux-arts d'Alger, de la constitution à la restitution, 1897-1970.* Saint-Raphaël: Éditions Abd-el-Tif.

Césaire, Aimé. 1956. "Culture et colonization." In "Le premier Congrès International des Écrivains et Artistes Noirs (Paris, Sorbonne, 19–22 Septembre 1956)." Special issue, *Présence Africaine,* nos. 8–10 (June–November): 190–205. http://www.jstor.org/stable/24346900.

Cham, Mbye-Baboucar. 1982. "Film Production in West Africa, 1979–1981." *Présence Africaine,* n.s., no. 124: 168–89. http://www.jstor.org/stable/24350739.

Chamberlin, Russell. 1983. *Loot! The Heritage of Plunder.* London: Thames & Hudson.

Chechi, Alessandro, Anne-Laure Bandle and Marc-André Renold. 2012. "Case Note: Afo-A-Kom—Furman Gallery and Kom People." *ArThemis: Art-Law Centre University of Geneva.* https://plone.unige.ch/art-adr/cases-affaires/afo-a-kom-2013-furman-gallery-and-kom-people/case-note-2013-afo-a-kom-2013-furman-gallery-and-kom-people/view.

Chimurenga. 2019. *Festac '77: Second World Black and African Festival of Arts and Culture: Decomposed, an-arranged, and reproduced by Chimurenga.* London: Afterall Books.

Conze, Eckart, Norbert Frei, Peter Hayes and Moshe Zimmermann. 2010. *Das Amt und die Vergangenheit: Deutsche Diplomaten im Dritten Reich und in der Bundesrepublik.* Munich: Karl Blessing Verlag.

Conze, Eckart. 2018. "Schwarz-weiß-rot-braune Kontinuitätslinien." *Frankfurter Allgemeine Zeitung,* October 22, 2018.

Crum Ewing, H.J.F. 1974. "Ashanti Regalia." *The Times,* March 5, 1974.

Cultural Events in Africa, vol. 70 (1971), 2.

Danker, Uwe and Sebastian Lehmann-Himmel. 2016. "Geschichtswissenschaftliche Aufarbeitung der personellen und strukturellen Kontinuität nach 1945 in der schleswig-holsteinischen Legislative und Exekutive (printed matter 18/1144) im Auftrag des Schleswig-Holsteinischen Landtages" Schleswig/Flensburg. https://www.landtag.ltsh.de/infothek/wahl18/drucks/4400/drucksache-18-4464.pdf.

Darnton, John. 1977. "African Festival Ends: A Decided Success." *New York Times,* February 13, 1977. https://www.nytimes.com/1977/02/13/archives/african-festival-ends-a-decided-success-a-time-for-solidarity.html.

De Silva, Pilippu Hewa Don Hemasiri. 1975. *A Catalogue of Antiquities and Other Cultural Objects from Sri Lanka (Ceylon) Abroad* Spolia Zeylanica 33. Colombo: National Museums of Sri Lanka, 1975.

Decraene, Philippe. 1969. "Une exposition d'art africain ancien." *Le Monde,* July 31, 1969.

Deluermoz, Quentin and Pierre Singaravélou. 2021. *A Past of Possibilities: A History of What Could Have Been.* Translated by Stephen W. Sawyer. New Haven, CT: Yale University Press.

Digitales Wörterbuch der deutschen Sprache, s.v. "Neger," last modified August 20, 2015, https://www.dwds.de/wb/Neger.

Diop, Abdoulaye Sokhna Guèye. 1973. "Museological Activity in African Countries, Its Role and Purpose." *Museum International* 25, no. 4: 250–56. https://unesdoc.unesco.org/ark:/48223/pf0000012419.locale=en.

Dittmar, Peter. 1978. "Das Völkerkundemuseum—eine Räuberhöhle?" *Die Welt,* October 7, 1978.

Dowden, Richard. 1981. "Should We Give Back These Treasures?" *The Times,* October 19, 1981.

dpa. 1973. "Rückgabe afrikanischer Kunst? Ein Vorstoß bei der Uno." *Frankfurter Allgemeine Zeitung,* November 9, 1973.

dpa. 1976. "Rückgabe von Kunstwerken? Vor der Unesco-Tagung." *Frankfurter Allgemeine Zeitung,* November 10, 1973.

dpa. 1978a. "Für Rückgabe von Kunstwerken. Appel der Unesco." *Frankfurter Allgemeine Zeitung,* June 9, 1978.

dpa. 1978b. "Seminar in Palermo. Kunstwerke zurückgefordert." *Frankfurter Allgemeine Zeitung,* October 5, 1978.

dpa. 1978c. "Deutsche Unesco-Initiative. Gegen Zwang zur Rückgabe." *Frankfurter Allgemeine Zeitung,* November 14, 1978.

dpa. 1978d. "Bundesrepublik gegen Zwang zur Rückgabe von Kulturgütern." *Süddeutsche Zeitung,* November 14, 1978.

dpa. 1978e. "Unesco fördert Rückgabe von Kulturgütern." *Süddeutsche Zeitung,* November 23, 1978.

dpa. 1978f. "Bonn gegen Zwang zur Rückgabe von Kulturgütern." *Der Tagesspiegel,* November 14, 1978.

dpa. 1978g. "Gegen den Zwang zur Rückgabe von Kulturgütern." *Die Welt,* November 14, 1978.

dpa. 1978h. "Unesco Appell für Rückgabe von Kunstschätzen." *Süddeutsche Zeitung,* June 9, 1978.

Eckert, Andreas. 2018. "Eine Geschichte von Gedächtnislücken. Die Erinnerung an Krieg, Gewalt und antikolonialen Widerstand in den deutschen Kolonien." In *Humboldt Lab Tanzania: Objekte aus den Kolonialkriegen im Ethnologischen Museum, Berlin—Ein tansanisch-deutscher Dialog,* edited by Lili Reyels, Paola Ivanov, and Kristin Weber-Sinn, 268–87. Berlin: Reimer Verlag.

Edelmann, Frédéric. 1980. "Patrimoine, patrimoines." *Le Monde,* May 5, 1980.

Edelmann, Frédéric. 1982a. "Une demande de restitution: Le Parthénon et quelques autres." *Le Monde,* March 18, 1982.

Edelmann, Frédéric. 1982b. "L'air du Parthénon et le couplet de la Vénus." *Le Monde,* September 2, 1982.

Erenz, Benedikt. 1984. "Zuhören lernen! Hundert Jahre nach der Kongo-Konferenz: Beginnt der kulturelle Dialog mit Afrika?" *Die Zeit,* no. 48, November 23, 1984.

Eyebu-Bankand'Asi, Ipoto. 1973. "Letter Dated 2 November 1973 from the Permanent Representative of Zaire to the United Nations Addressed to the President of the General Assembly." In *United Nations General Assembly, 28th Session.* UN Doc. A/9199. https://digitallibrary.un.org/record/852847?ln=en.

Eyo, Ekpo Okpo. 1967. "The Protection of Africa's Artistic Heritage." *UNESCO Courier* 20, no. 6 (June): 16–19. https://unesdoc.unesco.org/ark:/48223/pf0000078226.locale=en.

Eyo, Ekpo. 1976. *Highlights from 2,000 Years of Nigerian Art.* Lagos: Federal Department of Antiquities.

Eyo, Ekpo. 1977a. "A Heritage Lost." In *Festac 1977.* Lagos.

Eyo, Ekpo. 1977b. *Two Thousand Years of Nigerian Art.* Lagos: Federal Department of Antiquities Nigeria.

Eyo, Ekpo and Frank Willett. 1980. *Treasures of Ancient Nigeria: Legacy of 2,000 Years.* New York: Knopf.

Eyo, Ekpo. 1994. "Repatriation of Cultural Heritage: The African Experience." In *Museums and the Making of "Ourselves": The Role of Objects in National Identity,* edited by Flora E. S. Kaplan, 330–50. London: Leicester University Press.

Eyo, Ekpo. 2008. *From Shrines to Showcases: Masterpieces of Nigerian Art.* Abuja: Federal Ministry of Information and Communication.

Fagg, William. 1976. "The Black World Must Look to Africa." In *Festac '77: A Preview of the 2nd World Black and African Festival of Arts and Culture.* Lagos. F37–F39.

Fagg, William. 1980. "Benin Bronze Repair." *The Times,* June 24, 1980.

Fall, Assane. 1982. "Masques nègres, peuples blancs." *Différences: le magazine de l'amitié entre les peuples,* no. 18 (December): 34–36.

Fasuyi, Timothy Adebayo. 1973. *Cultural Policy in Nigeria.* Paris: UNESCO.

Féau, Étienne. 1999. "L'art africain au musée des arts d'Afrique et d'Océanie: collections et perspectives pour le musée du quai Branly." *Cahiers d'Études Africaines* 39, no. 155/56: 923–38. https://www.jstor.org/stable/4392987.

Felton, David. 1980. "British Museum Chiefs Called 'Inept' by Union." *The Times*, August 7, 1980.

Festac '77: A Preview of the 2nd World Black and African Festival of Arts and Culture. 1976. Lagos.

Figge, Klaus. 1970. "Rezension zu Gert von Paczensky. Die Weißen kommen." *Frankfurter Allgemeine Zeitung*, July 18, 1970.

The First Conference of African Museums, July 17–23, 1972. Event Program. Livingstone, Zambia: Livingstone Museum.

Fitschen, Thomas. 2004. "30 Jahre 'Rückführung von Kulturgut': Wie der Generalversammlung ihr Gegenstand abhanden kam." *Vereinte Nationen* 52, no. 2 (April): 46–51. https://www.jstor.org/stable/45231335.

Folorunso, Caleb Adebayo. 2011. "Ekpo Okpo Eyo (1931–2011)." *Azania: Archaeological Research in Africa*. 46, no. 3: 363–64. DOI: 10.1080/0067270X.2011.609765.

Forman, Werner, Bedrich Forman and Philip Dark. *Benin Art*. London: Batchworth Press, 1960.

Fradier, Georges. 1978. "Return to the Homeland: Entire Regions Have Been Deprived of Their Cultural Past." *Unesco Courier* 31, no. 7 (July): 6–11, 33. https://unesdoc.unesco.org/ark:/48223/pf0000074805.locale=en.

Francis, Jeff. 1972. "The Black Man's Burden." *International Development Review* 14, no. 1: 40–42.

Frankfurter Rundschau. 1976. "Kunstschätze zurückverlangt. Frühere Kolonien stellen Forderung an damalige Herren." *Frankfurter Rundschau*, May 20, 1976.

Fronty, François. "Les statues meurent aussi, histoire d'une censure," Textes (sélection) no. 6, Groupe d'Étude Cinéma du Réel Africain, http://www.grecirea.net/textes/06TexteFF08.html.

Ganslmayr, Herbert. 1969. "Das Krokodil im Kult und Mythos afrikanischer Stämme." PhD diss., University of Munich.

Ganslmayr, Herbert. 1976. Rückführung von Kulturgütern: Experten der Unesco gegen kolonialen Raub. *3.Welt Magazin*, no. 3–4.

Ganslmayr, Herbert. 1977. "Neue kulturelle Ordnung." *3. Welt Magazin*, no. 7–8.

Ganslmayr, Herbert. 1978. "Rückgabe von Kulturgütern." In *Raum, Objekt und Sicherheit im Museum. Bericht über ein internationales Symposium veranstaltet von den ICOM-Nationalkomitees der Bundesrepublik Deutschland, Österreichs und der Schweiz vom 9. bis zum 15. Mai 1976 am Bodensee, (Lindau)*, edited by Hermann Auer, 199–205. Munich: K. G. Saur.

Ganslmayr, Herbert. 1980. "Wem gehört die Benin-Maske? Die Forderung nach Rückgabe von Kulturgut an die Ursprungsländer." *Vereinte Nationen*, no. 3: 88–92.

Ganslmayr, Herbert, R. Vossen, D. Heintze, W. Lohse, and H. Rammow. 1976. "Bilanz und Zukunft der Völkerkunde-Museen." Special issue, *Zeitschrift für Ethnologie: Völkerkundemuseen morgen—Aufgaben und Ziele* 101, no. 2: 198–205. https://www.jstor.org/stable/25841571.

Ganslmayr, Herbert. 1981. "News from the Working Groups: Working Group on Return and/or Restitution of Cultural Property." *ICME Newsletter*, no. 2 (October): 2–3. http://icme.mini.icom.museum/wp-content/uploads/sites/16/2019/01/ICME_news_02_1981.pdf.

Ganslmayr, Herbert. 1984. "Rückgabe von Kulturgut: konkrete Schritte; Ausbildung

von Museumspersonal in der Hauptstadt Nigers—Stand der Konvention von
1970" in Herbert Ganslmayr et al.,"Aus dem Bereich der Vereinten Nationen:
Tätigkeiten, Nachrichten, Meinungen." *Vereinte Nationen* 32, no. 4 (August):
139-40. https://www.jstor.org/stable/45229822.

Ganslmayr, Herbert and Lema Gwete, eds. 1980. *Kunst aus Zaire: Masken und Plastiken
aus der Nationalsammlung Institut des Musées Nationaux du Zaire. (IMNZ).* Bremen:
Übersee-Museum.

Ganslmayr, Herbert and Helga Rammow, eds. 1975. *Museum, Information, Forschung:
Rundbrief der Arbeitsgruppe Museum in der Deutschen Gesellschaft für Völkerkunde* (January 1973–April 1975). Museumspädagogischer Dienst der Freien und Hansestadt
Hamburg.

Ganslmayr, Herbert and Gert von Paczensky. 1984. *Nofretete will nach Hause. Europa—
Schatzhaus der "Dritten Welt."* Munich: C. Bertelsmann.

Ganslmayr, Herbert and Herrmann Jungraithmayr. 1986. *Afrika-Kartenwerk.* Berlin:
Bornträger.

Gathercole, Peter. 1981. "British University Museums and the Problems Relating to
Restitution." In *Lost Heritage: The Question of the Return of Cultural Property. Report
on the Symposium Held in London, Commonwealth Arts Association and the Africa Centre,
London,* edited by Irene Staunton and Murray McCartney, 11–13. London: Commonwealth Arts Association.

Gathercole, Peter. 1986. "Recording Ethnographic Collections: The Debate on the
Return of Cultural Property," *Museum International* 38, no. 3 (1986): 187–92.

Gatter, Frank Thomas. 1983. "Internationales Symposium 'Berliner Afrika-Konferenz
1884-85': ein Projekt des Bremer Afrika Archivs." *Africa Spectrum* 18, no. 1: 107–9.
https://www.jstor.org/stable/40174080.

Geary, Christaud and Adamou Ndam Njoya. 1988. *Images from Bamum: German Colonial Photography at the Court of King Njoya, Cameroon, West Africa, 1902-1915.* Washington, DC: Smithsonian Instiution, 1988.

Geluwe, Huguette van. 1979. "Belgium's Contribution to the Zairian Cultural Heritage." *Museum International* 31, no. 1: 32–37. https://unesdoc.unesco.org/ark:/48223
/pf0000035385.locale=en.

German Ministry of Culture 1983. *Mondiacult Weltkonferenz der UNESCO über Kulturpolitik Mexiko 1982* (Berlin: Staatsverl. der DDR, 1983).

Gicquel, Roger. 1988. *Le placard aux chimères.* Paris: Plon.

Gosling, Kenneth, 1981. "Museum Opposition to Treasure List Likely [Museum Opposition Likely to Third World Appeal]." *The Times,* May 18, 1981, 3.

Goy, Raymond. 1979. "Le retour et la restitution des biens culturels à leur pays d'origine
en cas d'appropriation illégale." *Revue Générale de droit international 33,* no. 3: 962–85.

Grah Mel, Frédéric. 1982. "A César ce qui est à César." *Afrique ,* January 8, 1982.

Greenfield, Jeanette. 1989. *The Return of Cultural Treasures.* Cambridge: Cambridge
University Press.

Greve, Anna. 2019. *Koloniales Erbe in Museen: Kritische Weißseinsforschung in der praktischen Museumsarbeit.* Bielefeld: transcript Verlag.

Grimme, Gesa. 2018. "Provenienzforschung im Projekt 'Schwieriges Erbe:
Zum Umgang mit kolonialzeitlichen Objekten in ethnologischen Museen.'"

Linden-Museum, Stuttgart. https://www.lindenmuseum.de/fileadmin/Doku-
 mente/SchwierigesErbe_Provenienzforschung_Abschlussbericht.pdf.

Gross, Raphael, ed. 2019. "Thema: Die Säule von Cape Cross; Koloniale Objekte
 und historische Gerechtigkeit," *Historische Urteilskraft: Magazin des DHM Berlin* 01.
 Stiftung Deutschen Historischen Museums.

Hamm-Brücher, Hildegard. 1980a. "Kulturbeziehungen zwischen Nord und Süd: ein
 Beitrag zu einer humanen Dritte-Welt-Politik." *Die Dritte Welt* 8, no. 2: 4–13.

Hamm-Brücher, Hildegard. 1980b. "Afrika: ein Kontinent auf dem Weg zu sich selbst."
 Unpublished paper delivered by the Minister of State at the Federal Foreign Office,
 Bonn for the opening of the 32nd Frankfurt Book Fair, October 7, 1980.

Hamm-Brücher, Hildegard. 1980c. "Einweihung des Goethe-Instituts Nairobi." In
 Kulturbeziehungen weltweit, ein Werkstattbericht zur auswärtigen Kulturpolitik, edited by
 Hildegard Hamm-Brücher, 129–35. Munich: Hanser.

Hamm-Brücher, Hildegard. 1981. "Auswärtige Kulturpolitik in Afrika." In *Afrika
 und die Deutschen: Jahrbuch der Deutsche Afrika-Stiftung.* Pfullingen: Verlag Günther
 Neske. 19–30.

Hamm-Brücher, Hildegard. 1981. "Kulturpolitische Beziehungen mit den afrikani-
 schen Ländern." Bulletin des Presse- und Informationsamtes der Bundesregierung:
 868–71. Bonn: Deutscher Bundesverlag.

Hamm-Brücher, Hildegard. 1982. *Zehn Thesen zur kulturellen Begegnung und Zusammen-
 arbeit mit Ländern der Dritten Welt.* Bonn: Auswärtiges Amt.

Hamm-Brücher, Hildegard. 1996. *Freiheit ist mehr als ein Wort. Eine Lebensbilanz,
 1921–1996.* Cologne: Kiepenheuer & Witsch.

Hargrove, Charles. 1978. "'Have Nots' Want Their Heritage Back." *The Times,* October
 4, 1978.

"Hermann Parzinger im Gespräch mit Maria Ossowski," *Deutschlandfunk,* July 30,
 2017, https://www.deutschlandfunk.de/parzinger-zur-kritik-am-humboldt-forum
 -natuerlich-wird.911.de.html?dram:article_id=392325.

Hicks, Dan. 2020. *The Brutish Museums.* London: Pluto Press.

Higgins, Charlotte. 2006. "Into Africa: British Museum's Reply to Ownership
 Debate." *Guardian,* February 13, 2006. https://www.theguardian.com/world/2006
 /apr/13/arts.artsnews.

Hinz, Manfred O., Helgard Patemann and Arnim Meier, eds. 1984. *Weiß auf Schwarz:
 100 Jahre Einmischung in Afrika. Deutscher Kolonialismus und afrikanischer Widerstand.*
 Berlin: Elefanten Press.

Holfelder, Moritz. 2020. *Unser Raubgut. Eine Streitschrift zur kolonialen Debatte.* Bonn:
 Bundeszentrale für Politische Bildung.

Höpfner, Gert. 1992. "Die Rückführung der 'Leningrad-Sammlung' des Museums für
 Völkerkunde." *Jahrbuch Preussischer Kulturbesitz* 29: 157–71.

Hughes, Joanna M. 1974. "Ashanti Regalia." *The Times,* March 8, 1974, 17.

ICOM. 1971. *Resolutions Adopted by ICOM's 10th General Assembly.* Grenoble, France.
 icom.museum/wp-content/uploads/2018/07/ICOMs-Resolutions_1971_Eng.pdf.

ICOM. 1979. Ad Hoc Committee for the Return of Cultural Property. "Study on the
 Principles, Conditions and Means for the Restitution or Return of Cultural Prop-
 erty in View of Reconstituting Dispersed Heritages." In "Return and Restitution

of Cultural Property," special issue *Museum International* 31, no. 1, 62–67. https://
unesdoc.unesco.org/ark:/48223/pf0000035392.locale=en.

ICOM 1980. Ad Hoc Committee for the Return of Cultural Property. "Annex of
Preliminary Study of the Three National Situations in Regard to the Return of
Cultural Property to Its Country of Origin." Intergovernmental Committee for
Promoting the Return of Cultural Property to Its Countries of Origin or Its Resti-
tution in Case of Illicit Appropriation, Paris, 14 March. Doc.CC-79/CONF206.6.
Paris: UNESCO. https://unesdoc.unesco.org/ark:/48223/pf0000038746.locale=en.

Imfeld, Al, ed. 1980. *Verlernen, was mich stumm macht. Lesebuch zur afrikanischen Kultur.*
Zürich: Unionsverlag.

"Incontro tra i ministeri degli Esteri on. Colombo e Feleke Gedle-Ghiorgis," in *Mini-
stero degli affari esteri, servizio storico e documentazione* (ed.): 1982. Testi e documenti
sulla politica estera dell'Italia, Rome 1985, 212.

Isar, Yudhishthir Raj. 2015. "UNESCO, Museums and 'Development.'" In *Museums,
Heritage, and International Development*, edited by Paul Basu and Wayne Modest,
33–55. New York: Routledge.

Jahn, Janheinz. 1969. "Nicht nur Sonnenschein und Rosen in Afrika." *Frankfurter
Allgemeine Zeitung*, August 11, 1969.

Joachim, Paulin. 1965. "Rendez-nous l'art nègre." *Bingo*, no. 144 (January): 7.

Kaufmann, Christian, Ruth Kobel-Streiff and Roland Kaehr, eds. 1979. *Völkerkundliche
Sammlungen in der Schweiz*. Vol. 1, *Übersichtsinventare der Museen in Basel, Bern, Genève,
Neuchâtel, Zürich*. Vol. 2, *Übersichtsinventare von 19 Sammlungen*. Bern: Schweizerische
Ethnologische Gesellschaft.

Kipphoff, Petra. 1983. "Wem soll die Kunst gehören?" *Die Zeit*, no. 23, June 3, 1983.

Kimmane, Derk. 1980. "Pour le retour des œuvres d'art à leur pays d'origine." *Informa-
tions Unesco*, no. 755: 1–14.

Kin-Kiey, Mulumba. "L'authenticité mobilise et transforme l'homme zaïrois." *Salongo.
Quotidien du matin*, September 14, 2–3

Kinnane, Derk. 1979. "Der Schmuggel mit afrikanischem Erbe." *Daily News*, Decem-
ber 15, 1979.

Klausewitz, Wolfgang. 1978. "Exotische Kunst und dritte Welt." *Frankfurter Allgemeine
Zeitung*, December 9, 1978.

Kläy, Ernst J. 1979. "Orientierung über eine vereinheitlichende Inventarisierung
völkerkundlicher Sammlungen in der Schweiz." In Hermann Auer, *Das Museum
und die Dritte Welt*, 231–52, esp. 231–32f. Munich: Saur.

Klüver, Meike. 2014. "Nachruf auf Dr. iur. Elisabeth Schwarz." djbZ: *Zeitschrift des
Deutschen Juristinnenbundes* 17, no. 3: 131–32. https://www.nomos-elibrary.de/10.5771
/1866-377X-2014-3-129-1/der-djb-gratuliert-volume-17-2014-issue-3?page=0.

Knopp, Werner. 1993. "Die Stiftung Preußischer Kulturbesitz trauert um ihren ersten
Präsidenten Hans-Georg Wormit," in *Jahrbuch Preußischer Kulturbesitz*, no. 30:
13–20.

Knorr-Anders, Esther. 1984. "Was die Nofretete denkt." *Die Welt*, August 14, 1984.

Koch, Gustel. 1985. "Kolonialismus, Neo-Kolonialismus und der Weg Afrikas in eine
friedliche Zukunft." *Deutsche Zeitschrift für Philosophie*. 33, no. 11: 1036–40.

Königsberger, Karen. 2009. *"Vernetztes System"? Die Geschichte des Deutschen Museums,
1945–1980: dargestellt an den Abteilungen Chemie und Kernphysik*. Munich: Herbert Utz.

Körner, Peter, Gero Maass, Thomas Siebold and Rainer Tetzlaff. 1984. *Im Teufelskreis der Verschuldung: Der Internationale Währungsfonds und die Dritte Welt.* Hamburg: Junius.

Koselleck, Reinhart. 1972. "Begriffsgeschichte und Sozialgeschichte," in *Soziologie und Sozialgeschichte: Aspekte und Probleme,* edited by Peter Christian Ludz, Opladen: Westdeutscher Verlag. 1972, 116–31.

Krieger, Kurt. 1957 "Das Schicksal der Benin-Sammlung des Berliner Museums für Völkerkunde." *Baessler-Archiv: Beiträge zur Völkerkunde* n.s., vol. 5, no. 1 (July): 225–27.

Krieger, Peter. 1973. "Abteilung Afrika." *Baessler-Archiv: Beiträge zur Völkerkundev,* n.s. 21 (November): 101–40.

Kuenheim, Haug von. 1984. "Nofretete ist kein Fall. Der müßige Streit um die Kulturschätze aus der Dritten Welt." *Die Zeit,* no. 37, September 7, 1984. https://www.zeit.de/1984/37/nofretete-ist-kein-fall.

Kum'a Ndumbe, Alexandre, III. 1992. *Was will Bonn in Afrika? Zur Afrikapolitik der Bundesrepublik Deutschland.* Pfaffenweiler: Centaurus Verlag.

Kum'a Ndumbe, Alexandre, III. 2019. *Restituez à l'Afrique ses objets de culte et d'art. Reconstitutions notre mémoire collective africaine!* Douala: AfricAvenir.

Kußmaul, Friedrich. 1982. *Ferne Völker, Frühe Zeiten.* Recklinghausen: Bongers, 1982.

Lang, Jack. 1981. Allocution de Mons. Jack Lang, ministre français de la culture. Première conférence des ministres de la culture des pays francophones. Cotonou. (September 17–19). Vie-publique.fr/sites/default/files/discours/PDF/lang8109-17-18-19.pdf.

Lang, Jack. 1982. Discours de Jack Lang, ministre de la culture, lors de la conférence mondiale des ministres de la culture, sur la défense de la culture contre les dominations économiques, Mexiko (July 27). Vie-publique.fr/sites/default/files/discours/PDF/lang19820727.pdf.

Lang, Jack. 1983. "'Es gibt hier keine intellektuelle Diktatur.' Der französische Kulturminister Jack Lang über die Kulturpolitik der Sozialisten." Interview by Barbara von Jhering, Klaus-Peter Schmid, and Dieter Wild. *Der Spiegel,* no. 3 (January 16): 148–59. https://www.spiegel.de/politik/es-gibt-hier-keine-intellektuelle-diktatur-a-86f720d8-0002-0001-0000-000014021498.

Lavondès, Anne. 1981. "The Museum of Tahiti and the Islands—Towards Realistic Policies and Practice." *Museum International* 33, no. 2: 118–21. https://unesdoc.unesco.org/ark:/48223/pf0000046313.locale=en.

Lawal, Babatunde. 1977. "The Present State of Art Historical Research in Nigeria." *Journal of African History* 18, no. 2: 193–216.

Leahy, James. 1993. "You Hide Me," *Vertigo* 1, no. 2 (Summer/Autumn). https://www.closeupfilmcentre.com/vertigo_magazine/volume-1-issue-2-summer-autumn-1993/you-hide-me/.

Lentz, Ellen. 1974. "East Germany Claims Art Treasures." *New York Times,* March 11, 1974. https://www.nytimes.com/1974/03/11/archives/east-germany-claims-art-treasures.html?searchResultPosition=8.

"Le premier Congrès International des Écrivains et Artistes Noirs (Paris, Sorbonne, 19–22 Septembre 1956)," special issue, *Présence Africaine,* nos. 8–10 (June–November, 1956): 190.

Lewis, Geoffrey. 1981. "The Return of Cultural Property." *Journal of the Royal Society of the Arts.* 129, no. 5299 (June): 435–43. http://www.jstor.org/stable/41372583.

Leyten, Harrie. 1992. "In Memoriam Herbert Ganslmayr." *TenDenZen*: 98.

Lommel, Andreas. 1978. "Exotische Kunst—zurück in die Dritte Welt." *Frankfurter Allgemeine Zeitung*, November 3, 1978.

Lucain, Pierre. 1981. "La question des archives algériennes." *La Revue administrative* 34, no. 204 (November/December): 641–47.

Lundén, Staffan. 2016. "Displaying Loot: The Benin Objects and the British Museum." PhD diss., University of Gothenburg. Researchgate.net/publication /308917673_Displaying_loot_The_Benin_objects_and_the_British_Museum.

M'Bow, Amadou-Mahtar. 1978. "An Appeal by Mr. Amadou-Mahtar M'Bow, Director-General of Unesco: A Plea for the Return of an Irreplaceable Cultural Heritage to Those Who Created It." *UNESCO Courier* 31 (July): 4–5. https://unesdoc.unesco.org /ark:/48223/pf0000074805.locale=en.

M'Bow, Amadou-Mahtar. 1980. "Address by Amadou-Mahtar M'Bow, Director-General of UNESCO, at the opening of the 1st Session of the Intergovernmental Committee for Promoting the Return of Cultural Property [...], Paris, May 9." Doc. DG/80/10. Paris: Unesco. https://unesdoc.unesco.org/ark:/48223/pf00000 38784.locale=en.

Mardersteig, Arnold. 1978. "Die Schwarzen fordern ihre Seele zurück." *Süddeutsche Zeitung*, October 27, 1978, 54.

Malaquais, Dominique and Cédric Vincent. 2019. "Three Takes and a Mask." In *Festac '77: Second World Black and African Festival of Arts and Culture: Decomposed, An-arranged, and Reproduced by Chimurenga*, 53–56. London: Afterall Books.

Mammen, Rainer and Hed Saebens-Wiesner. 1979. *Übersee-Museum Bremen: Ein Rundgang*. Bremen: Schmalfeldt.

"Manifeste culturel panafricain." 1969. *Présence Africaine*, n.s., no. 71: 115–123.

Mardersteig, Arnold. 1978. "Die Schwarzen fordern ihre Seele zurück." *Süddeutsche Zeitung*, October 27, 1978, 54.

Melikian, Souren. 1980. "La vision du collectionneur." *Connaissance des Arts* no. 343 (September): 114–15.

Menck, Clara. 1979. "Der Braunschweiger Löwe in Istanbul." *Frankfurter Allgemeine Zeitung*, May 18, 1979.

Mensah-Brown, Kodwo. 1970. "The London Africa Centre." *African Arts* 3, no. 3: 56–60.

Mercouri, Melina. 1982. Address of Mme Melina Mercouri, Minister of Culture and Sciences of Greece, to the World Conference on Cultural Policies, organized by UNESCO in Mexico, July 29, 1982, on the submission by Greece of a Draft Recommendation on the Return of Cultural Property to its Country of Origin. Melinamercourifoundation.com/en/speechesI/.

Michaelis, Rolf. 1982. "Kreuzzug in die Köpfe." *Die Zeit*, no. 23, June 3, 1982.

Ministry of Culture and Sports of Ethiopia. 1983a. "Note on Ethiopian Cultural Objects Abroad (July 1981)." In *Intergovernmental Committee for Promoting the Return of Cultural Property [...], 3rd session, Istanbul, 9–13 May 1983*. Doc. CLT.83/CONF.216 /INF.4. Paris: Unesco. https://unesdoc.unesco.org/ark:/48223/pf0000054651 .locale=en.

Mobutu, Sese Seko. 1973. "Address by General Mobutu Sese Seko, President of the Republic of Zaire." In *United Nations General Assembly Official Records, 28th Session,*

2140th Plenary Meeting, October 4, 1973, New York. 8–18. UN Doc. A/PV.2140 https://digitallibrary.un.org/record/749800?ln=en.

Mobutu, Sese Seko. 1973. "Les pays riches possédant des oeuvres d'art des pays pauvres doivent en restituer une partie." *Salongo: Quotidien du matin*, September 14, 1973.

Mobutu, Sese Seko. 1975. *Discours, allocutions et messages*. Vol. 2, *1965–1975*. Paris: Editions du Jaguar.

Moldrich, Donovan. 1976. "Dr. de Silva of Treasure Island Warns Ex-colonials." *The Times*, May 18, 1976, 1.

Monde. 1977. "M. Pierre Quoniam nommé directeur du Louvre." *Le Monde*, January 27, 1977.

Monde. 1981. "Les retours de biens culturels aux pays d'origine se multiplient." *Le Monde*, September 29, 1981.

Mondiacult. 1982. Weltkonferenz der Unesco über Kulturpolitik. Mexico 1982. Documents, East Berlin 1983.

Moulefera, Tayeb. 1979a. "Éléments d'une éthique international." In *Museum and Cultural Exchange. The Papers from the 11th General Conference of ICOM, Moscow 23–29 May, 1977*, edited by Anne Razy, 114–27. Paris: International Council of Museums.

Moulefera, Tayeb. 1979b. "Viewpoints: Algeria." In "Return and Restitution of Cultural Property," special issue, *Museum International* 31, no. 1 (1979): 10–11. https://unesdoc.unesco.org/ark:/48223/pf0000062658.locale=en.

Müller, Hans-Joachim. 1979. "Völkerkundler im Zwielicht. Aus Kriegsbeute werden plötzlich Freundschaftssymbole." *Badische Zeitung*, June 2, 1979.

Murphy, Maureen. 2009. *De l'imaginaire au musée: Les arts d'Afrique à Paris et à New York (1931–2006)*. Dijon: Les Presses du Réel.

Museum. 1979. "A Brief History of the Creation by UNESCO of an Intergovernmental Committee for Promoting the Return of Cultural Property [...]." In "Return and Restitution of Cultural Property," special issue, *Museum International* 31, no. 1 (1979): 59–61. https://unesdoc.unesco.org/ark:/48223/pf0000035391.fre.locale=en.

Museum. 1986. "Return or Restitution of Cultural Property: A Brief Résumé." *Museum International* 38, no. 1: 61–63. https://unesdoc.unesco.org/ark:/48223/pf0000127348_fre.locale=en.

Myles, Kwasi Addai. 1981. "Study of the Situation in Ghana, 14.08.1981." In *Intergovernmental Committee for Promoting the Return of Cultural Property [...], 2nd Session, Paris*. July 29, 1981, Paris: UNESCO. Doc. CC-81/CONF.203/8. https://unesdoc.unesco.org/ark:/48223/pf0000045926.locale=en.

Naguschewski, Dirk. 2005. "Kinema*topo*graphie im afrikanischen Kino: Dakar in Filmen von Sembene Ousmane und Djibril Diop Mambety." In *TopoGraphien der Moderne: Medien zur Repräsentation und Konstruktion von Räumen*, edited by Robert Stockhammer, 287–316. Munich: W. Fink.

Nawrocki, Joachim. 1975. "Die absurde Forderung der DDR—Kulturabkommen gegen Kunstschätze: Nix Nofretete." *Die Zeit*, no. 28, July 4, 1975. https://www.zeit.de/1975/28/nix-nofretete.

Ndiaye, Momar Kébé. 1981. "Les receleurs de culture." *Jeune Afrique*, August 12, 1981, 58–59.

Newton, Douglas. 1983. "'Lost Heritage.' A Report on the Symposium on the Return

of Cultural Property Held at the Africa Centre." *Pacific Arts Newsletter* no. 16 (January): 18–20.

Nigeria Today. 1966. "Our Cultural Heritage: Including Our Art and Craft." *Nigeria Today.*

Norman, Geraldine. 1980a. "£1m Bid Likely for Benin Collection." *The Times*, June 16, 1980.

Norman, Geraldine. 1980b. "Benin Bronze Fetches £200,000." *The Times*, June 17, 1980.

Nsama, Bondo Paul. 1973. "Message aux congressistes de l'Aica." *Salongo: Quotidien du matin*, September 14, 1973, 2–3.

Odendahl, Kerstin. 2015. "Das Zwischenstaatliche Komitee zur Förderung der Rückgabe von Kulturgut an die Ursprungsländer oder dessen Restitution im Falle eines illegalen Erwerbs (UNESCO Rückgabe-Komitee)." *Kunst und Recht* 17, no. 3–4: 83–86. DOI: https://10.15542/KUR/2015/3/4.

Odoom, A. S. 1974. "Ashanti Regalia." *The Times*, March 16, 1974, 15.

Okpu, Nathalie. 2018. "Osundare: A Benin Mask in *A British Museum* (1983)." In *Translocations: Anthologie: Eine Sammlung kommentierter Quellentexte zu Kulturgutverlagerungen seit der Antike* (blog), October 2, 2018. https://translanth.hypotheses.org/ueber/osundare-1983.

Opoku, Kwame. 2010. "One Counter-Agenda from Africa: Would Western Museums Return Looted Objects If Nigeria and Other African States Were Ruled by Angels?" In *Benin1897.com. Art and the Restitution Question*, edited by Peju Layiwola and Sola Olorunyomi, 91–107. Ibadan: Wy Art Editions.

Opoku, Kwame. 2011. "When Will Britain Return Looted Golden Ghanaian Artefacts?: A History of British Looting of More Than 100 Objects." *Modern Ghana*, January 5, 2011. https://www.modernghana.com/news/310930/when-will-britain-return-looted-golden-ghanaian.html.

Opoku, Kwame. 2018. "Looted Asante (Ghana) Gold in Wallace Collection, London: Return Stolen Items to Manhyia Palace, Kumasi." *Modern Ghana*, July 26, 2018. https://www.modernghana.com/news/871280/looted-asante-ghana-gold-in-wallace-collection.html.

Osundare, Niyi. 1980. "Following in 007's Footsteps." *West Africa*, November 3.

Osundare, Niyi. 1983. "On Seeing a Benin Mask in a British Museum." In *Songs of the Marketplace*. 39–40. Ibadan: New Horn Press.

Paczensky, Gert von. 1970. *Die Weißen kommen. Die wahre Geschichte des Kolonialismus.* Hamburg: Hoffmann u. Campe.

Paczensky, Gert von. 1981. "Schätze, die uns nicht gehören: Kulturgut aus der Dritten Welt" *art*, no. 4: 38–41.

País. 1982. "Melina Mercouri pide que los frisos del Partenón vuelvan a Grecia." *El País*, March 18, 1982.

Palm, Stefanie. 2018. "Auf der Suche nach dem starken Staat. Die Kultur-, Medien- und Wissenschaftspolitik des Bundesinnenministeriums." In *Hüter der Ordnung: Die Innenministerien in Bonn und Ost-Berlin nach dem Nationalsozialismus,* edited by Frank Bösch and Andreas Wirsching, 594–634. Göttingen: Wallstein.

Pankhurst, Richard. 1986. "The Case for Ethiopia." *Museum International* 38, no. 1: 58–60. https://unesdoc.unesco.org/ark:/48223/pf0000071194.locale=en.

Parliamentary Debates, House of Lords, 1974. Official Report. Ashanti Regalia (December 10), London, vol. 355: cols. 534-35.

Parliamentary Debates, House of Lords, 1983. British Museum Act 1963 (Amendment) Bill, October 27, vol. 444, cols. 399-422.

Plankensteiner, Barbara. 2016. "The Benin Treasures: Difficult Legacy and Contested Heritage." In *Cultural Property and Contested Ownership: The Trafficking of Artefacts and the Quest for Restitution*, edited by Brigitta Hauser-Schäublin and Lyndel V. Prott, 133-55. London, New York: Routledge.

Prott, Lyndel V. 2009. *Witnesses to History: A Compendium of Documents and Writings on the Return of Cultural Objects*. Paris: UNESCO.

Poinsett, Alex. 1977. "Festac'77." *Ebony* 32, no. 7: 33-48.

Pontual, Roberto. 1977. "Festival de Lagos: Conciènca e destino do negro a través da arte." *Jornal do Brasil*, January 15, 1977.

Prasteau, Jean. 1978. "Œuvres d'art: retour au pays!" *Le Figaro*, June 8, 1978.

Racine, Anaïs. 2020. "Le IIIe congrès extraordinaire de l'AICA à Kinshasa en 1973: AICA à la rencontre de l'Afrique." Master's thesis, University Paris I Panthéon-Sorbonne, https://afriquart.hypotheses.org/files/2020/10/MATER-2.pdf.

Raffelberg, Jochen. 1976. "German Debate: Should Art Return to Former Colonies?" *Christian Science Monitor*, June 11, 1976, 21.

"Rapport sur la première conférence africaine des musées." 1973. In *Veröffentlichungen aus dem Überseemuseum Bremen*. Reihe B, Völkerkunde. Vol. 3. 89-97.

Ratcliffe, Michael. 1981. "Television Chronicle, BBC 2." *The Times*, May 28, 1981.

Rebeyrol, Yvonne. 1978. "Colloque: Le droit à la mémoire," *Le Monde*, December 30, 1978

Reaburn, Michaël. 1972. "Entretien avec Michaël Reaburn." Interview by Kwaté Nee-Owoo. *L'Afrique littéraire et artistique*, 95-96.

Reuters. 1973. "Für Rückgabe geraubter Kunst." *Frankfurter Allgemeine Zeitung*, December 20, 1973.

Reuters. 1974. "'Return Regalia' Appeal." *Guardian*, February 5, 1974.

Reuters. 1978. "Tansania fordert Rückgabe von Kunstwerken." *Die Welt*, January 5, 1978.

Reuters. 1982. "Frau Hamm-Brücher: Bei Rückgabe von Kulturgütern großzügig sein." *Süddeutsche Zeitung*, August 10, 1982.

Reuters (rtr) Baghdad. 1979. "Das Ishtar-Tor soll zurück nach Babylon kommen." *Die Welt*, November 20, 1979.

Reyels, Lili, Paola Ivanov, and Kristin Weber-Sinn, eds. 2018. *Humboldt Lab Tanzania: Objekte aus den Kolonialkriegen im Ethnologischen Museum, Berlin—Ein tansanisch-deutscher Dialog*. Berlin: Reimer Verlag. 268-87.

Rich, Nathaniel. 2019. *Losing Earth: A Recent History*. New York: Farrar, Straus and Giroux.

Robinson, Alma. 1976. "The Seized Treasures of Asante." *New Society* 38: 69-71.

Robinson, Alma. 1977a. "African Art in Foreign Hands." In *Festac 1977*. 56-69.

Robinson, Alma. 1977b. "The Controversial Mask of Benin." *Washington Post*, February 11, 1977.

Robinson, Alma. 1979. "Statement of Alma Robinson, Lecturer, African and Afro-American Studies Program, Stanford University." In *Cultural Property Treaty Legislation: Hearing before the Subcommittee on Trade of the Committee on Ways and Means*,

House of Representatives, Ninety-Sixth Congress, First Session on H. R. 3403 to Implement the UNESCO Convention on Cultural Property. September 27, 1979, Serial 96-52. Washington DC: US Government Printing Office. 69-73.

Robinson, Alma. 1980. "The Art Repatriation Dilemma." *Museum News* 58, no. 4 (March/April): 55-59.

Russell, John. 1980. "Met Pays Homage to Ancient Nigeria." *New York Times*, August 15, 1980. https://www.nytimes.com/1980/08/15/archives/met-pays-homage-to-ancient-nigeria-met-pays-homage-to-ancient.html.

Saalmann, Timo. 2014. *Kunstpolitik der Berliner Museen, 1919-1959*. Berlin: De Gruyter, 2014.

Saehrendt, Christian. 2017. *Kunst im Kampf für das "Sozialistische Weltsystem." Auswärtige Kulturpolitik der DDR in Afrika und Nahost*. Stuttgart: Franz Steiner Verlag.

Sarr, Felwine and Bénédicte Savoy. 2019. *Zurückgeben: Über die Restitution afrikanischer Kulturgüter*. Berlin: Matthes & Seitz.

Sauer, Birgit. 1999. "'Politik wird mit dem Kopfe gemacht': Überlegungen zu einer geschlechtersensiblen Politologie der Gefühle." In *Masse, Macht, Emotionen:. Zu einer Politischen Soziologie der Emotionen*, edited by Ansgar Klein and Frank Nullmeier, 200-218. Opladen: Westdeutscher Verlag.

Savoy, Bénédicte, "Accumulation primitive: La géographie du patrimoine artistique africain dans le monde aujourd'hui," in "Les images migrent aussi," edited by Elsa Gomis, Perin Emel Yavuz and Francesco Zucconi. Special issue, *De facto*, (January 29, 2021), https://www.icmigrations.cnrs.fr/wp-content/uploads/2021/01/DF24-Savoy.pdf.

Scheer, Brigitte, UNESCO. 1983. *Weltkonferenz über Kulturpolitik*. Munich: Saur

Schettler, Renate. 1976. "Gehört Nofretete nach Kairo?" *Mannheimer Morgen*, August 23, 1976.

Schmidt, Doris. 1977. "Museen im Feld der Spannungen: Die elfte Weltkonferenz des ICOM in Leningrad und Moskau." *Süddeutsche Zeitung*, June 13, 1977, 13.

Schmidt, Doris. 1978. "Geschichte ist nicht reversibel." *Süddeutsche Zeitung*, November 23, 1978, 4.

Schmidt, Doris. 1979. "Hilfsbereitschaft allein genügt nicht." *Süddeutsche Zeitung*, August 10, 1979, 2.

Schulze, Dorothee. 1983. *Die Restitution von Kunstwerken: Zur völkerrechtlichen Dimension der Restitutionsresolutionen der Generalversammlung der Vereinten Nationen*. Series D, Vol. 12. Bremen: Übersee-Museum.

Scott, Cynthia. 2020. *Cultural Diplomacy and the Heritage of Empire: Negotiating Post-Colonial Returns*. New York: Routledge.

Seidlitz, Peter. 1978. "Die Schwarzen fordern ihre Seele zurück." *Süddeutsche Zeitung*, June 13, 1978, 3.

Shephard, Ben. 1981. "Western Museums versus the Third World." *The Listener* (May 28): 694-95.

Shinnie, P. L. 1974. "Asante Regalia." *The Times*, September 27, 1974, 15.

Shyllon, Folarin. 2013. "Museums and Universal Heritage: Right of Return and Right of Access for Africans." In *Realising Cultural Heritage Law: Festschrift for Patrick Joseph O'Keefe*, edited by Lyndel V. Prott, Ruth Redmond-Cooper, and Stephen K. Urice, 133-44. Builth Wells: Institute of Art and Law.

Simson, Otto von. 1980. "Nous désirons participer à votre liberté." In *Le rôle des traditions dans le développement de l'Afrique*. In *Symposium Leo Frobenius II: Die Rolle der Traditionen für die Entwicklung Afrikas: Bericht über ein internationales Symposium, veranstaltet von der Deutschen und Senegalesischen Unesco-Kommission vom 14-17 März in Dakar*, edited by Eike Haberland, 11–14. Bonn: UNESCO Kommission.

Sodemann, Christoph. 1991. "Tod in Athen." *taz. Die Tageszeitung*, May 13, 1991, 23.

Sotheby's. 1980. *Catalogue of Works of Art from Benin: The Property of a European Private Collector* (June 16). London: Sotheby's.

Soyinka, Wole. 1990. "The Fate of Africa's Culture Producers." In "African and African American Literature," special issue *PMLA* 105, no. 1 (January): 110–20.

Soyinka, Wole. 2007. *You Must Set Forth at Dawn: A Memoir*. New York: Random House.

Spiegel. 1956. "Neger-Kongress: Der erste Zahn." *Der Spiegel*, no. 41 (October 9): 45. https://www.spiegel.de/panorama/der-erste-zahn-a-33c02634-0002-0001-0000 -000043064286.

Spiegel. 1977. "Afrika. Lieber aufs Dorf." 1977. *Der Spiegel*, no. 8 (February 14): 142–43. https://www.spiegel.de/politik/lieber-aufs-dorf-a-ffe885c1-0002-0001-0000 -000040992635.

Spiegel. 1979. "Eingepackt: und ab in den Louvre." *Der Spiegel*, no. 49 (December 2): 178–97. https://www.spiegel.de/politik/eingepackt-und-ab-in-den-louvre-a -ba03f0e6-0002-0001-0000-000039867543.

Spiegel. 1982. "Nein, nein, Darling." *Der Spiegel*, no. 32 (August 8): 86–87. https://www .spiegel.de/politik/nein-nein-darling-a-35b93ab7-0002-0001-0000-000014344835.

Spiegel. 1984. "Dürer nach Tokio?" *Der Spiegel*, no. 41 (October 7): 252–53. https://www .spiegel.de/kultur/duerer-nach-tokio-a-44773072-0002-0001-0000-000013511463.

Sprute, Sebastian. 2018. "Die Jagd nach der größtmöglichen Trommel: Sammelwut, Krieg und Trägerleid oder die menschenverachtende Beschaffung von Ethnographica im kolonialen Kamerun, 1902–1908." *Tribus* Jahrbuch des Linden-Museums Stuttgart, vol. 67 (Linden-Museums Stuttgart), 131–53.

Starzmann, Paul. 2020. "Raubkunst-Streit überschattet Eröffnung des Humboldt-Forums," *Der Tagesspiegel*, December 11, 2020.

Statement by Mexico City on cultural politics. World conference on Cultural Politics, Mexico, June 26–August 6, 1982.

Staunton, Irene and Murray McCartney, eds. 1981. *Lost Heritage: The Question of the Return of Cultural Property; Report on the Symposium Held in London, Commonwealth Arts Association and the Africa Centre, London*.

Stétié, Salah. 1981. "The Intergovernmental Committee: Mechanisms for a New Dialogue" (in a section devoted to the "Restitution of Cultural Property"). *Museum International* 33, no. 2: 116–17. https://unesdoc.unesco.org/ark:/48223/pf0000 46309.locale=en.

Stétié, Salah. 1982. "Une lettre du président du comité pour le retour des biens culturels." *Le Monde*, July 16, 1982.

Stétié, Salah. 2014. *L'extravagance. Mémoires*. Paris: Robert Laffont.

Stoecker, Holger. 2018. "Rückgabeforderungen, die UNESCO und die Tendaguru-Großknochen." In *Dinosaurierfragmente: Zur Geschichte der Tendaguru-Expedition und ihrer Objekte, 1906–2018*, edited by Ina Heumann, Holger Stoecker, Marco Tamborini and Mareike Vennen, 267–70. Göttingen: Wallstein.

Telegraaf. 1978. "Derde Wereld eist kunstchatten terug." *De Telegraaf,* October 26, 1978.

Tialobi, Gordon. 1980. "Can Nigerian Works of Art be Entirely Recovered?" *Punch,* June 21, 1980, 5. Reprinted in *Nigeria: Bulletin on Foreign Affairs* 10, no. 6 (June 1980): 215.

Thorncroft, Anthony. 1980. "Benin Collection sale fetches £747,600." *The Financial Times,* June 17, 1980.

"Throne of Menelik II Recovered from Italy." 1982. *Ethiopian Herald,* June 15, 1982.

Times. 1982. "Mercouri Wants Elgin Marbles." *The Times,* March 17, 1982, 6.

Tüllmann, Adolf. 1982. "Kulturgüter zurück in den Urwald." *Süddeutsche Zeitung,* September 4–5, 1982.

Tutu, Desmond. "The Africa Centre Must Not Simply Be Swept Away." *Guardian,* June 3, 2011.

UNESCO. 1969. *Records of the General Conference 15th Session, Paris, 1968.* Resolutions. Vol. 1. Doc. 15C. Paris: UNESCO. https://unesdoc.unesco.org/ark:/48223/pf0000 114047.locale=en.

UNESCO. 1974a. *Executive Board 94th Session, Paris, May 30, 1974.* "Item 4.4.3.1 of the Provisional Agenda: Possible International Instrument on the Exchange of Original Objects and Specimens Among Institutions in Different Countries." Doc. 94 EX/16. https://unesdoc.unesco.org/ark:/48223/pf0000008592_spa.locale=en.

UNESCO. 1974b. *Executive Board 94th Session, Varna, June 27, 1974.* "Item 4.4.3. of the Agenda: Text of the Statement Made by the Director-General to the Executive Board." Doc. 94 EX/ INF. 13. https://unesdoc.unesco.org/ark:/48223/pf0000010712 .locale=en.

UNESCO. 1975. "Resolution 3.428: Contributions of UNESCO to the Return of Cultural Property to Countries That Have Been Victims of De Facto Expropriation." In *Records of the General Conference 18th Session, Paris, 17 October to 23 November 1974.* Vol. 1, *Resolutions.* 60–61. Paris: UNESCO. Doc. 18C/ Resolutions. https://unesdoc .unesco.org/ark:/48223/pf0000114040.locale=en.

UNESCO. 1976. "Committee of Experts to Study the Question of the Restitution of Works of Art: Final Report." Venice, April 21, 1976. Doc. SHC.76/CONF.615/5 https://unesdoc.unesco.org/ark:/48223/pf0000019009.locale=en.

UNESCO. 1977. *Records of the General Conference 19th Session, Nairobi, 26 October to 30 November 1976.* Resolutions Vol. 1. Doc. 19C. Paris: UNESCO. https://unesdoc .unesco.org/ark:/48223/pf0000114038.locale=en.

UNESCO. 1978a. *Committee of Experts on the Establishment of an Intergovernmental Committee Concerning the Restitution or Return of Cultural Property: Final Report, Dakar, 20-23 March 1978.* Doc. CC-78/CONF.609/6. https://unesdoc.unesco.org/ark:/48223 /pf0000033337.locale=en.

UNESCO. 1978. "Annex I: Study on the Principles, Conditions and Means for the Restitution or Return of Cultural Property" in "View of Reconstituting Dispersed Heritages," H. Ganslmayr, H. Landais, G. Lewis, P. Makambila, P. N. Perrot, J. W. Pré, J. Vistel. August 1977. And "Annex II: Extract of the Programme for the 1977–1980 adopted by the 12th General Assembly of the International Council of Museums (ICOM) in Moscow, May 28 1977." https://unesdoc.unesco.org/ark: /48223/pf0000033337.locale=en.

UNESCO. 1978b. "Annex I: Draft Statutes of the Intergovernmental Committee Concerning the Restitution [...]." In *Committee of Experts on the Establishment of an Intergovernmental Committee Concerning the Restitution or Return of Cultural Property: Final Report, Dakar, 12 June 1978.* Doc. CC-78/CONF.609/6.

UNESCO. 1980a. "Recommendations Proposed by the Ad hoc Sub-Committee for Adoption by the Intergovernmental Committee." In *Intergovernmental Committee for Promoting the Return of Cultural Property [...] 1st session, Paris, 9 May.* Doc. CC-79/CONF.206/9. Paris: UNESCO. https://unesdoc.unesco.org/ark:/48223/pf0000 38747.locale=en.

UNESCO. 1980b. "Item 12 of the Provisional Agenda: Report of the Intergovernmental Committee for Promoting the Return of Cultural Property [...]." In *General Conference Twenty-first Session, Belgrade 1980.* August 11. Doc. 21 C/83. Paris: UNESCO. https://unesdoc.unesco.org/ark:/48223/pf0000041941.locale=en.

UNESCO. 1981. "Experimental Project for the Inventory of Cultural Property in Mali." In *Intergovernmental Committee for Promoting the Return of Cultural Property [...]*, 2nd session, Paris, August 14, 1981. Doc. CC-81/CONF.203/6. Paris: UNESCO. https://unesdoc.unesco.org/ark:/48223/pf0000045927.locale=en.

UNESCO. 1982. *World Conference on Cultural Policies, 2nd, Mexico City, 26 July–6 August 1982: Final Report.* Paris: UNESCO. Doc. CLT.83/MD/1. https://unesdoc.unesco.org /ark:/48223/pf0000052505.locale=en.

UNESCO. 1983a. "Extract from the Report of the World Conference on Cultural Policies [Mexico City July 26–August 6, 1982] Pertaining to the Discussions on the Subject of Return or Restitution of Cultural Property." In *Intergovernmental Committee for Promoting the Return of Cultural Property [...], 3rd session, Istanbul, 9–13 May 1983.* Doc. CLT.83/CONF.216/5. Paris: UNESCO. https://unesdoc.unesco.org/ark: /48223/pf0000054651.locale=en.

UNESCO. 1983b. "Press file: September 1981–March 1983." In *Intergovernmental Committee for Promoting the Return of Cultural Property [...], 3rd session, Istanbul, 9–13 May 1983.* Doc. CLT-83/CONF.216/INF.3. https://unesdoc.unesco.org/ark:/48223 /pf0000054653.locale=en.

UNESCO. 1983c. "Item 11 of the Provisional Agenda: Report of the Intergovernmental Committee for Promoting the Return of Cultural Property. [...], 22 September 1983." In *General Conference, 22nd Session, Paris 1983.* Doc. 22 C/88. Paris: UNESCO. https://unesdoc.unesco.org/ark:/48223/pf0000057604.locale=en.

UNESCO. 1983d. "Schlussbericht der von der UNESCO vom 26. Juli bis 6. August 1982 in Mexiko-Stadt veranstalteten internationalen Konferenz." *Weltkonferenz über Kulturpolitik.* Munich: Saur, 1983.

UNESCO. 1987. "Report by the UNESCO Secretariat on the Measures Taken to Implement the Recommendations Adopted by the Intergovernmental Committee for Promoting the Return of Cultural Property, etc." In *Intergovernmental Committee for Promoting the Return of Cultural Property [...], 5th session, Paris 27–30 April 1987.* Doc. CC.87/CONF. 207/3. https://unesdoc.unesco.org/ark:/48223/pf0000071951 .locale=en.

United Nations. 1961. "Declaration on the Granting of Independence to Colonial Countries and Peoples," adopted at the 947th plenary meeting, December 14, 1960, A/RES/1514(XV). In *General Assembly Official Records, 15th Session.* Suppl. No. 16.

New York. 66–67. https://www.un.org/ga/search/view_doc.asp?symbol=A/RES /1514(XV).

United Nations. 1973 "Restitution of Works of Art to Countries Victims of Expropriation (concluded)." In *General Assembly Official Records, 28th session: 2206st plenary meeting, 18 December 1973*. A/PV.2206. New York. 1–3.

United Nations. 1974. "Draft Resolution: Restitution of Works of Art to Countries Victims of Expropriation." In *General Assembly Official Records, 28th Session, Supplement no. 30: Resolutions Adopted by the General Assembly during Its 28th Session. Vol. 1, 18 September–18 December 1973*. A/RES/3187(XXVIII). https://digitallibrary.un.org /record/190996?ln=en.

United Nations. 1975. "Restitution of Works of Art to Countries Victims of Expropriation: Report of the Secretary-General." In *General Assembly Official Records, 30th session: 2410st plenary meeting, 19 November 1975*. A/PV.2410. New York, 923–931.

United Nations. 1979. "Restitution of Works of Art to Countries Victims of Expropriation: Report of the Secretary-General." In *General Assembly Official Records, 34th session: 51st plenary meeting, 1 November 1979*. A/34/PV.51. New York, 988–997.

United Press International. 1973. "Return Our Lost Art." 1973. *Guardian*, September 14, 1973, 3.

Van Beurden, Sarah. 2015a. "The Art of (Re)Possession: Heritage and the Cultural Politics of Congo's Decolonization." *Journal of African History* 56, no. 1 (March): 143–64. https://www.jstor.org/stable/43305243.

Van Beurden, Sarah. 2015b. "Restitution or Cooperation? Competing Visions of Post-Colonial Cultural Development in Africa." Global Cooperation Research Papers, no. 12, Käte Hamburger Kolleg / Centre for Global Cooperation Research. University of Duisburg-Essen, December 2015, 5–25. https://doi.org/10.14282/2198-0411 -GCRP-12.

Van Beurden, Sarah. 2015c. *Authentically African: Arts and the Transnational Politics of Congolese Culture*. Athens, OH: Ohio University Press.

Van Beurden, Jos. 2017. *Treasures in Trusted Hands: Negotiating the Future of Colonial Cultural Objects*. Leiden: Sidestone Press.

Van der Heyden, Ulrich. 2019. "Afrika im Blick der akademischen Welt der DDR: Ein wissenschaftsgeschichtlicher Überblick der afrikabezogenen Ethnographie." *Berichte zur Wissenschaftsgeschichte* 42, no. 1 (March): 83–105.

Vieyra, Paulin Soumanou. 1975. *Le cinéma africain des origines à 1973*. Vol. 1. Paris: Présence africaine.

Vincent, Cédric. 2016. "'The Real Heart of the Festival': The Exhibition of L'art nègre at the Musée Dynamique." In *The First World Festival of Negro Arts, Dakar, 1966*, edited by David Murphy, 45–63. Liverpool: Liverpool University Press.

Volbracht, Christian. 1978. "Müssen Nofretete, Mona Lisa und die Aphrodite von Milo wieder in ihre Heimat?" *Berliner Morgenpost*, October 25, 1978.

Volger, Helmut. 2008 *Geschichte der Vereinten Nationen*. Munich: R. Oldenbourg Verlag.

Voss, Harald. 1969. "Das panafrikanische Kulturmanifest." Special Issue, *Africa Spectrum: Interdisziplinäre Afrika-Forschung* 4, no. 2: 46–58.

Vrdoljak, Ana Filipa. 2006. *International Law: Museums and the Return of Cultural Objects*. Cambridge: Cambridge University Press.

Wastiau, Boris. 2000. *Congo-Tervuren. Aller-retour: le transfert de pièces ethnographiques du Musée royal de l'Afrique centrale à l'Institut des Musées nationaux du Zaïre*. Tervuren: Le Musée royal.

West Africa. 1980. "The Mask is a Very Rough Film." *West Africa* August 11, 1487–89.

Whiteman, Kaye. 1971. "Matchet's Diary: Plastic Bags and Glass Cases." *West Africa* March 26, 1971.

Whiteman, Kaye. 1980. "Matchet's Diary." *West Africa* June 23, 1980.

Willet, Frank. 1990. "Two Case Studies of Reaction to Colonialism." In *The Politics of the Past*, edited by Peter Gathercole and David Lowenthal, 172–83. London: Unwin Hyman.

Willi, Dario. 2019. "Tropendiebe. Die Debatte um die Restitution sri-lankischer Kulturgüter im Museum für Völkerkunde Basel, 1976–1984." MA seminar paper, University of Zurich. https://www.mkb.ch/dam/jcr:7727ad95-fe39-4b32-bff7 -d414d1845335/SeminararbeitMuseum_SriLanka_Dario-Willi.pdf.

Wilson, David. 1981. "'Was wir nicht bewahren, ist verloren'. Interview mit David Wilson." By Siegfried Helms. *Die Welt*, June 12, 1981.

Young, Andrew. 1977. "Searching for Black Roots." *Newsweek* (January 3): 40–41.

Zimmerer, Jürgen. 2013. "Kolonialismus und deutsche Identität." In *Kein Platz an der Sonne: Erinnerungsorte der deutschen Kolonialgeschichte*, edited by Jürgen Zimmerer, 9–38. Frankfurt am Main: Campus Verlag.

Zwernemann, Jürgen. 1977. "Gedanken zur Rückforderung von Kulturgut." *Africa Spectrum* 12, no. 3: 297–304. https://www.jstor.org/stable/40173904.

Zwernemann, Jürgen. 1978. "Rückgabe von Kulturgut oder kulturelle Entwicklungs-hilfe?" *Museumskunde* 43, 114.

Zwernemann, Jürgen. 2011. "Friedrich Kußmaul, 1920–2009." *Zeitschrift für Ethnologie* 135, no. 1: 1–4. www.jstor.org/stable/41941003.

INDEX

PHOTO CREDITS

1. *Bingo*, Dakar
2. *FESMAN*, Dakar, 1966
3. Copyright United Nations. UN7467247, NICA ID 380336
4. The Africa-America Institute, New York
5. Design by Gerhard Voigt
6. From the photography collection of the Landesarchiv, Berlin
7. Sonora-Gentil and Tabansi Stars International
8. The Africa Centre, London
9. UNESCO, Paris
10. William Karel and the Gamma-Rapho agency, via Getty Images
11. Collage https:www.ina.fr/video/CAA7801439001 and photo by Bénédicte Savoy
12. Museum of Fine Arts, Houston, TX
13. Detroit Institute of Arts, Michigan
14. ZDF (Zweites Deutsches Fernsehen [Second German Television station])
15. bpk-Bildagentur: Image Bank of Cultural Institutions, Zentralarchiv, SMB (Staatliche Museen zu Berlin [Central Archive of the Berlin State Museums]) / Art Resource, NY
16. Bündnis 90/Die Grünen (Alliance 90/The Greens)